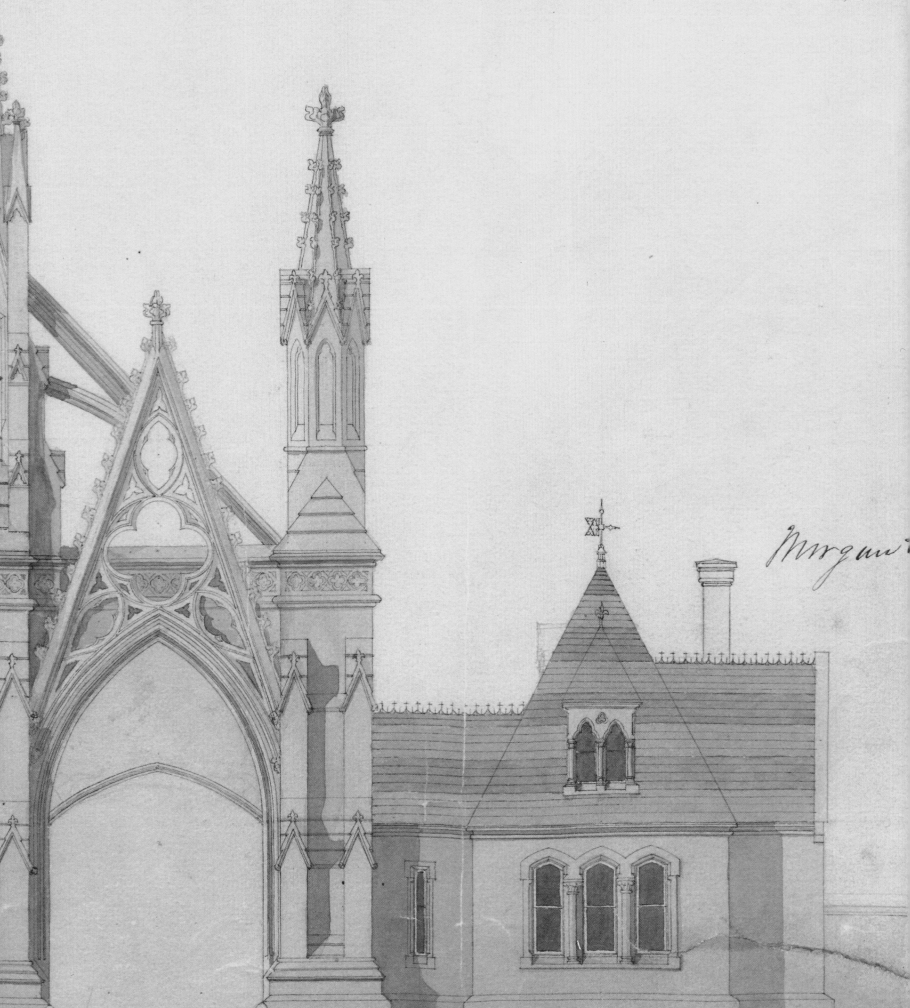

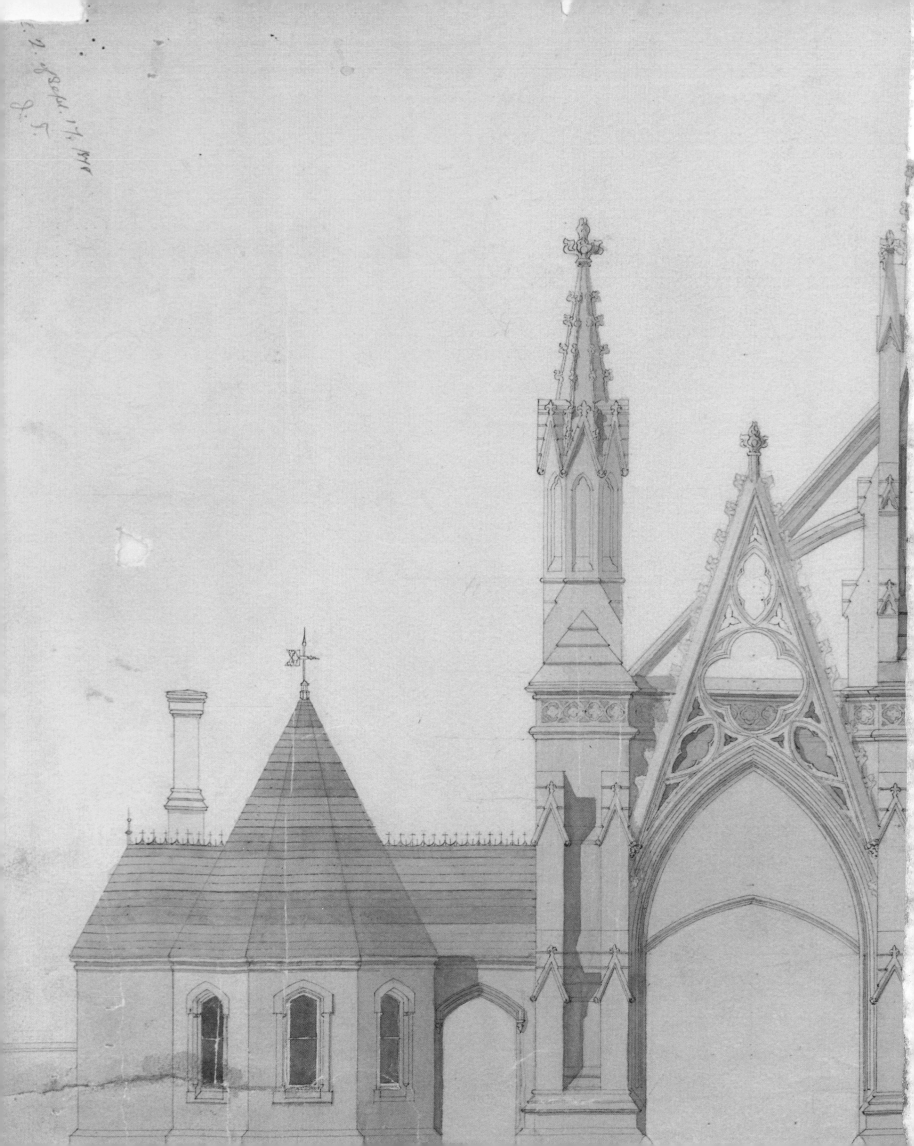

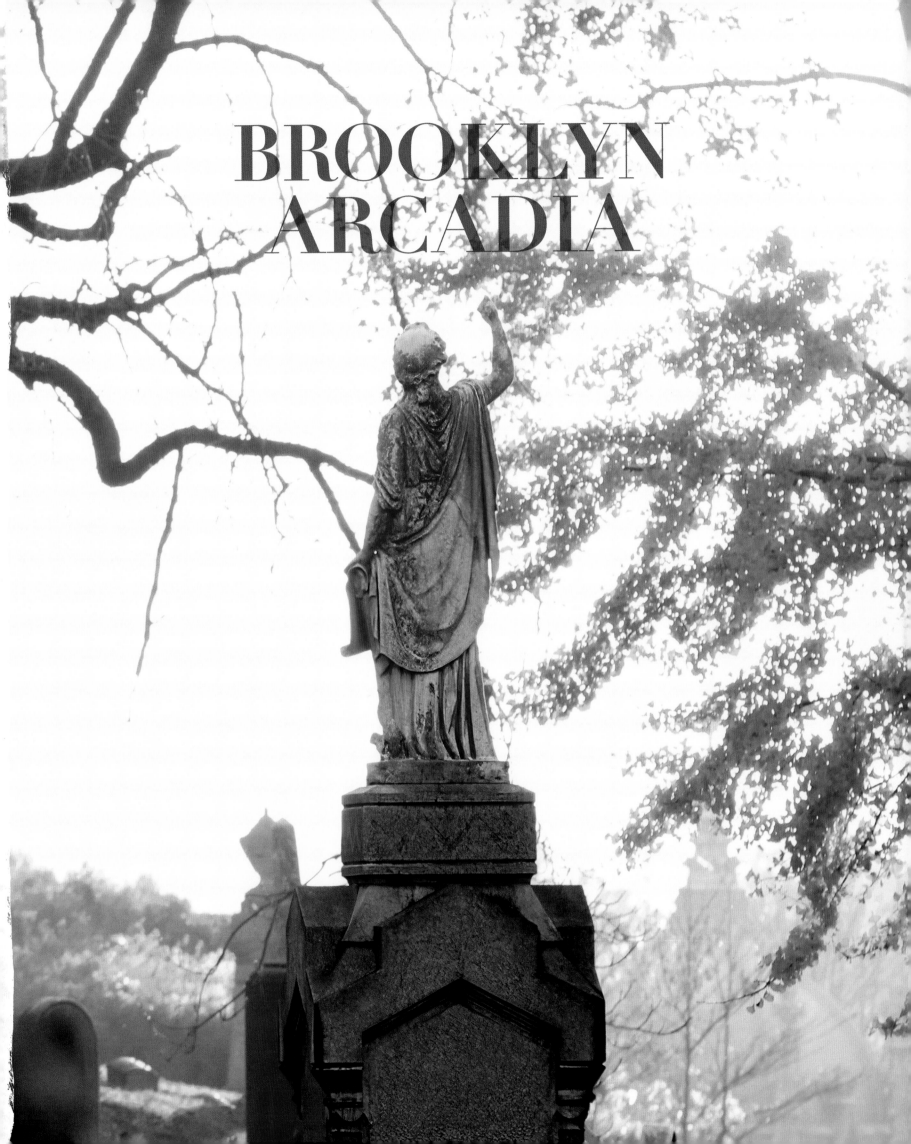

BROOKLYN
ARCADIA

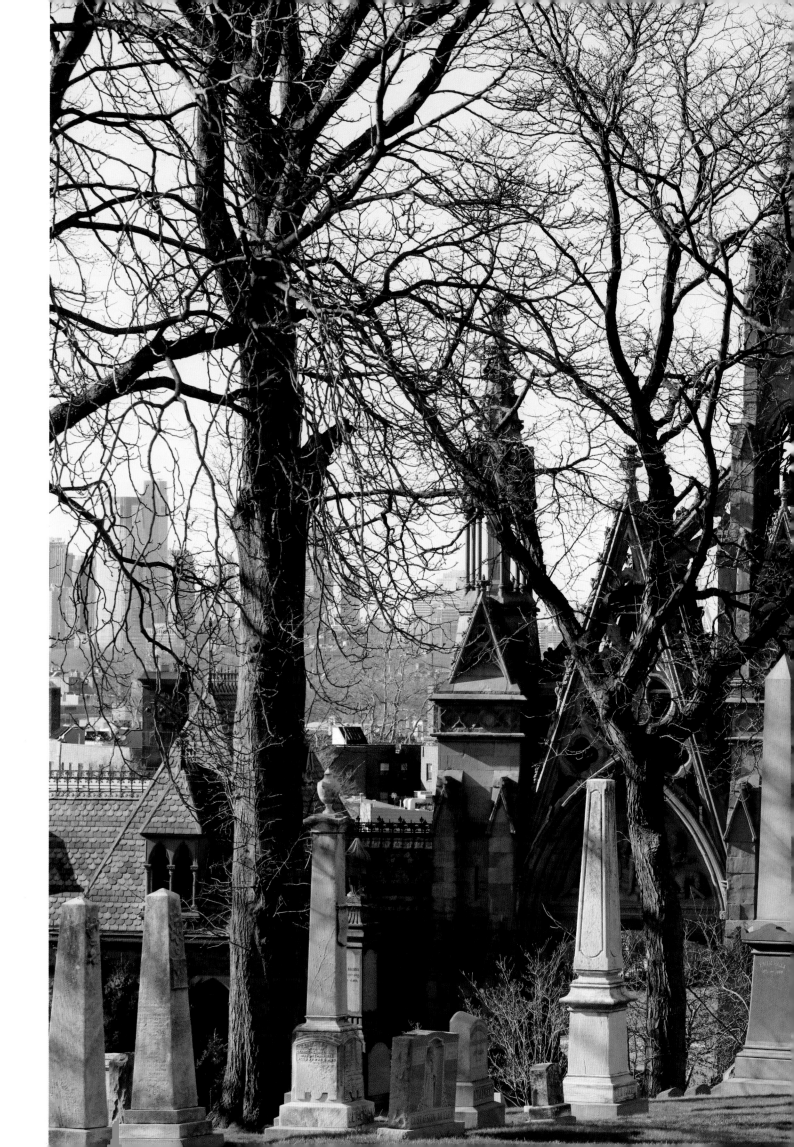

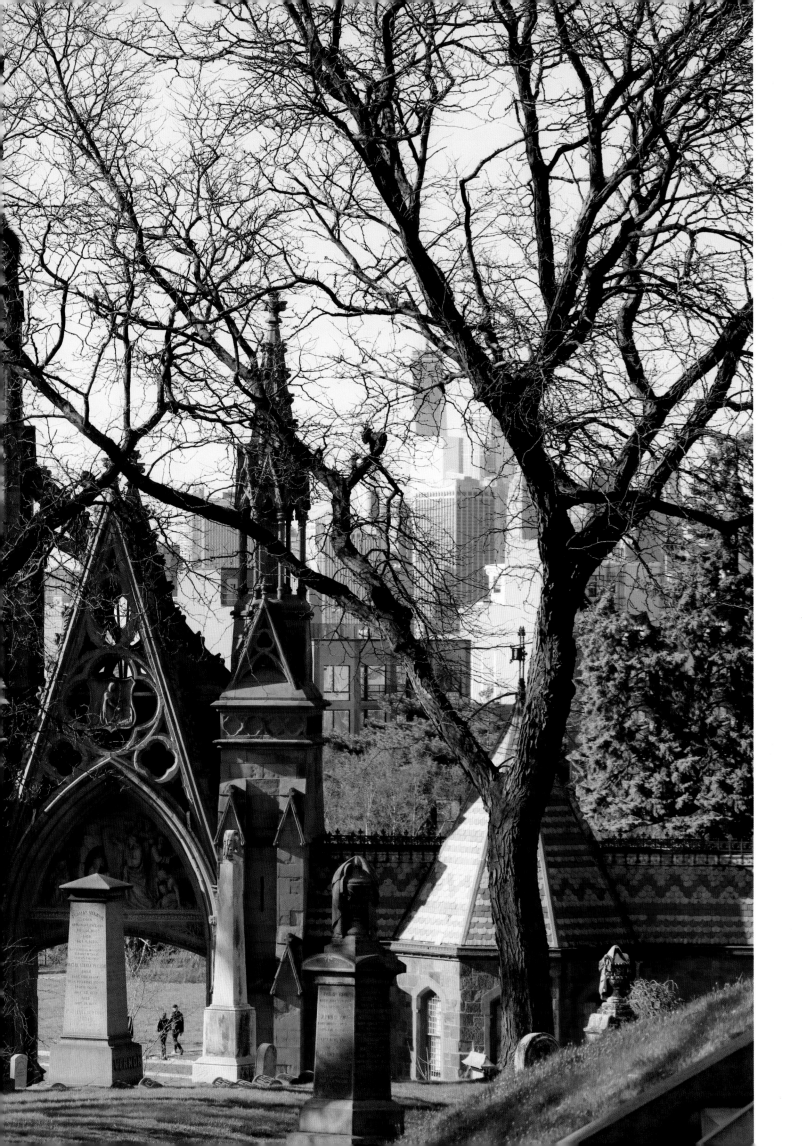

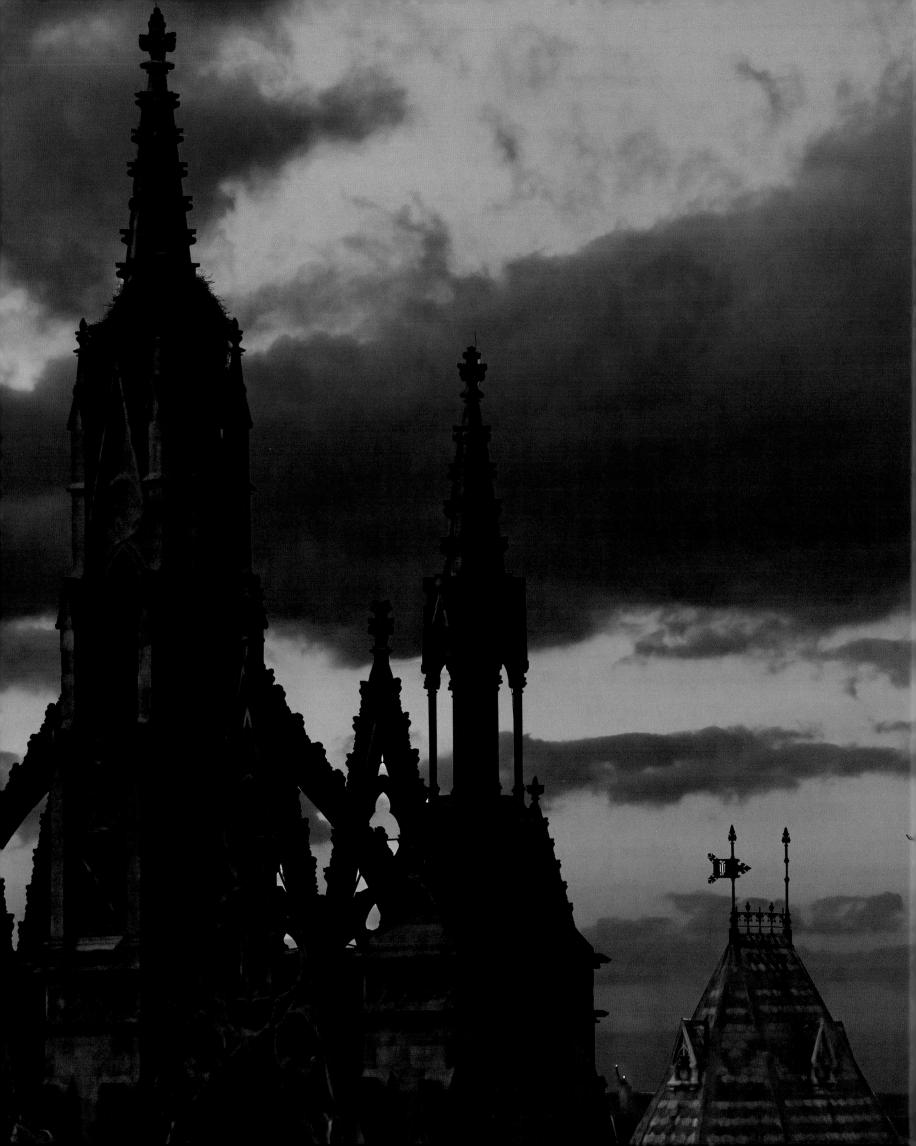

BROOKLYN ARCADIA

Art, History, and Nature at
Majestic Green-Wood

ANDREW GARN

With essays by THOMAS J. CAMPANELLA, ART PRESSON,
JULIE L. SLOAN, ALLISON C. MEIER,
ANGELA VOULANGAS, GABRIEL WILLOW, and
NEELA K. WICKREMESINGHE

With a foreword by RICHARD J. MOYLAN,
President, The Green-Wood Cemetery

RIZZOLI
NEW YORK

New York · Paris · London · Milan

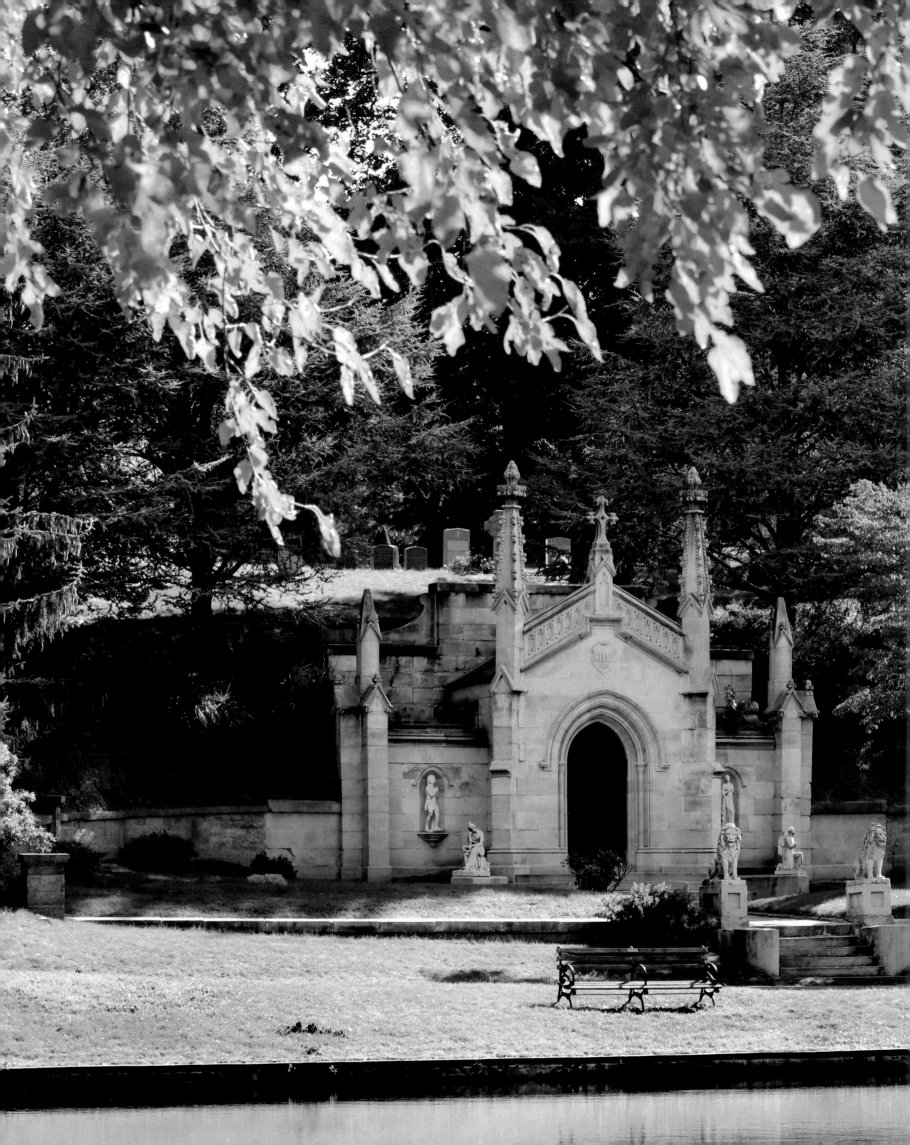

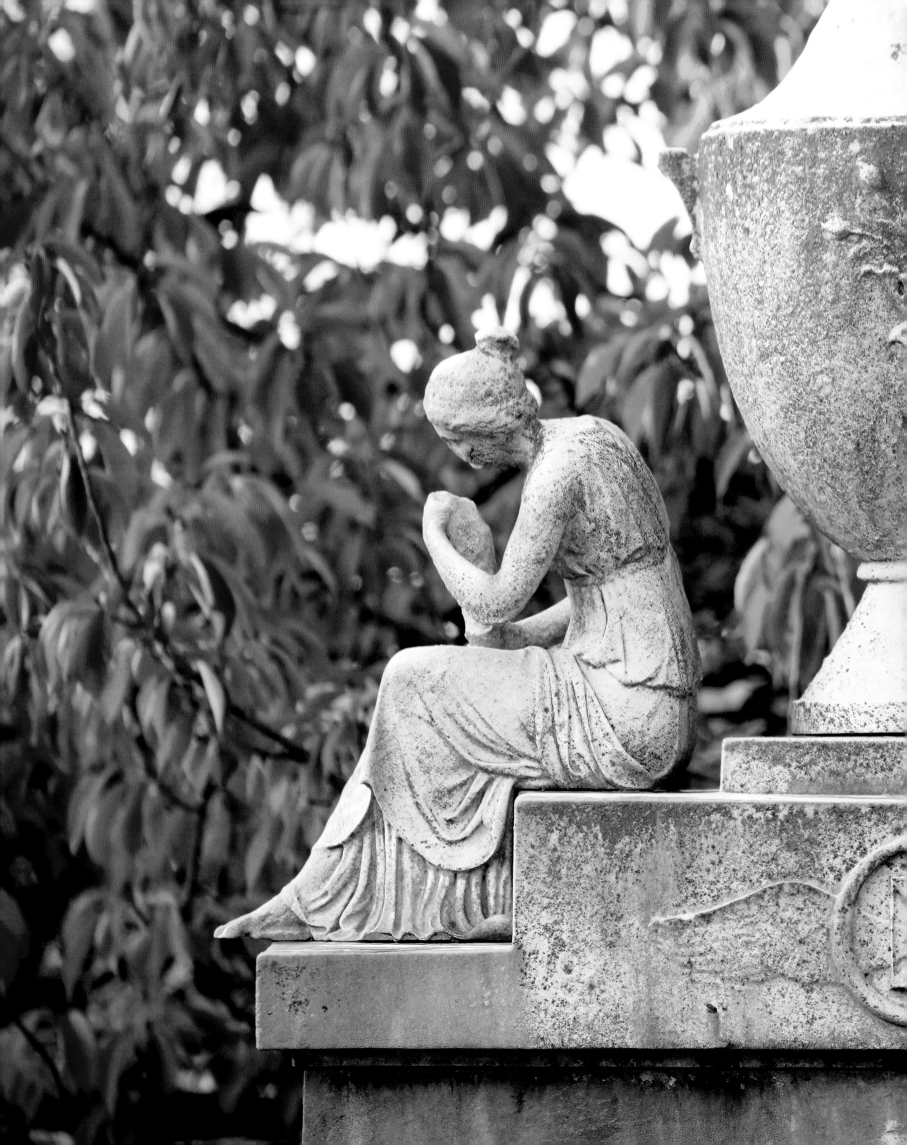

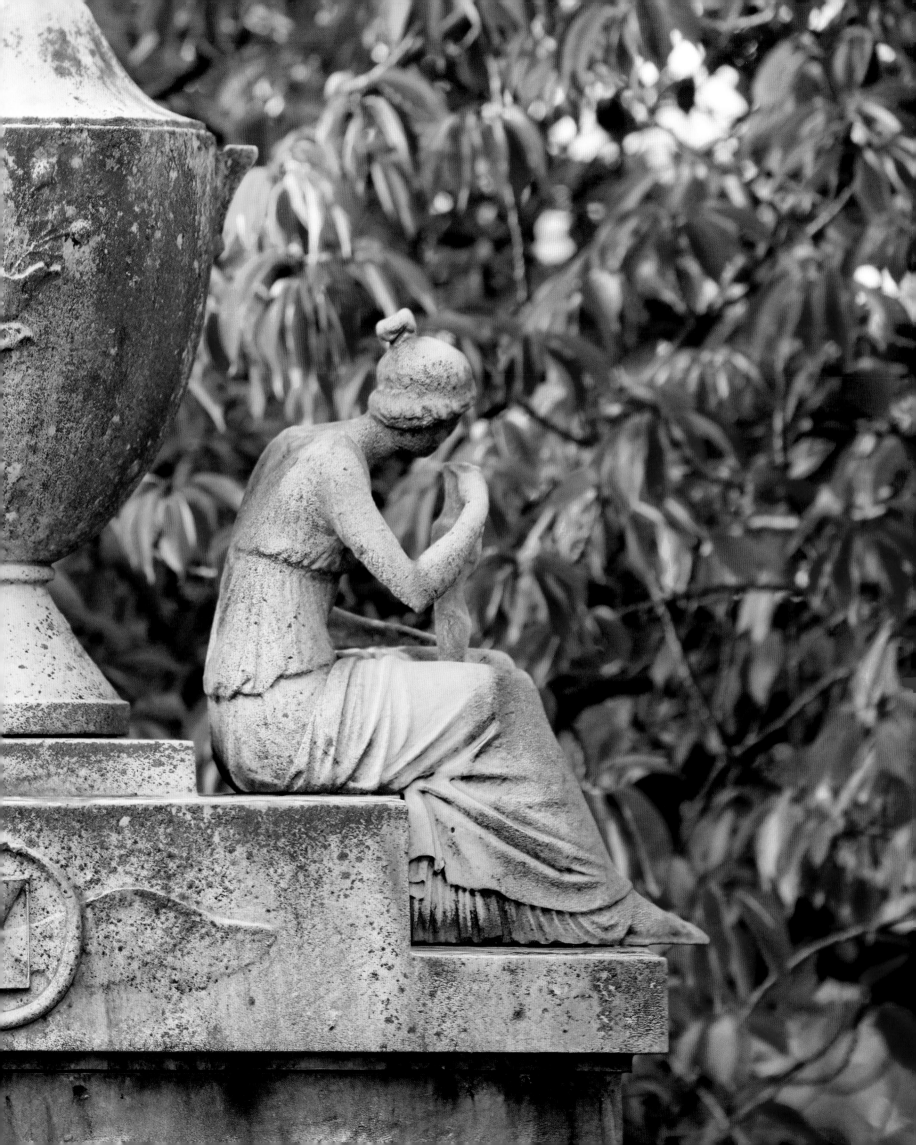

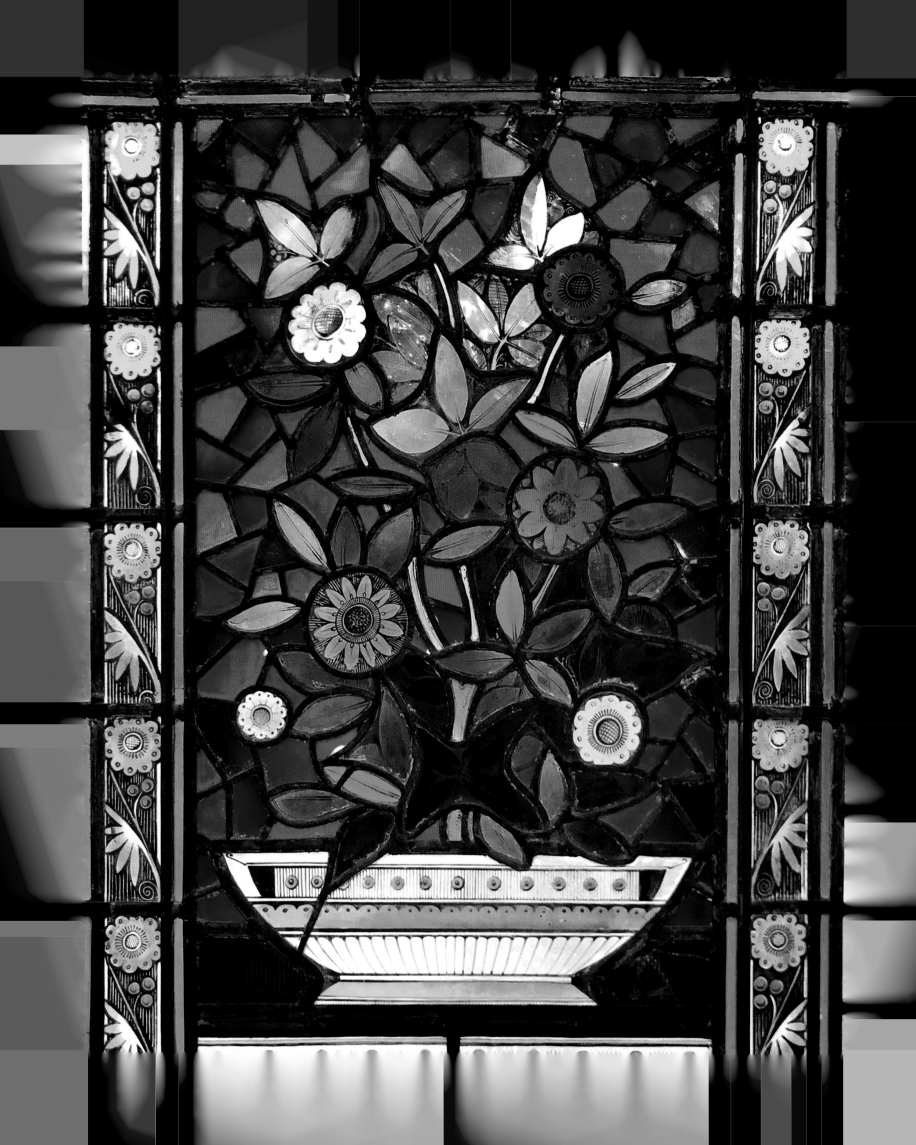

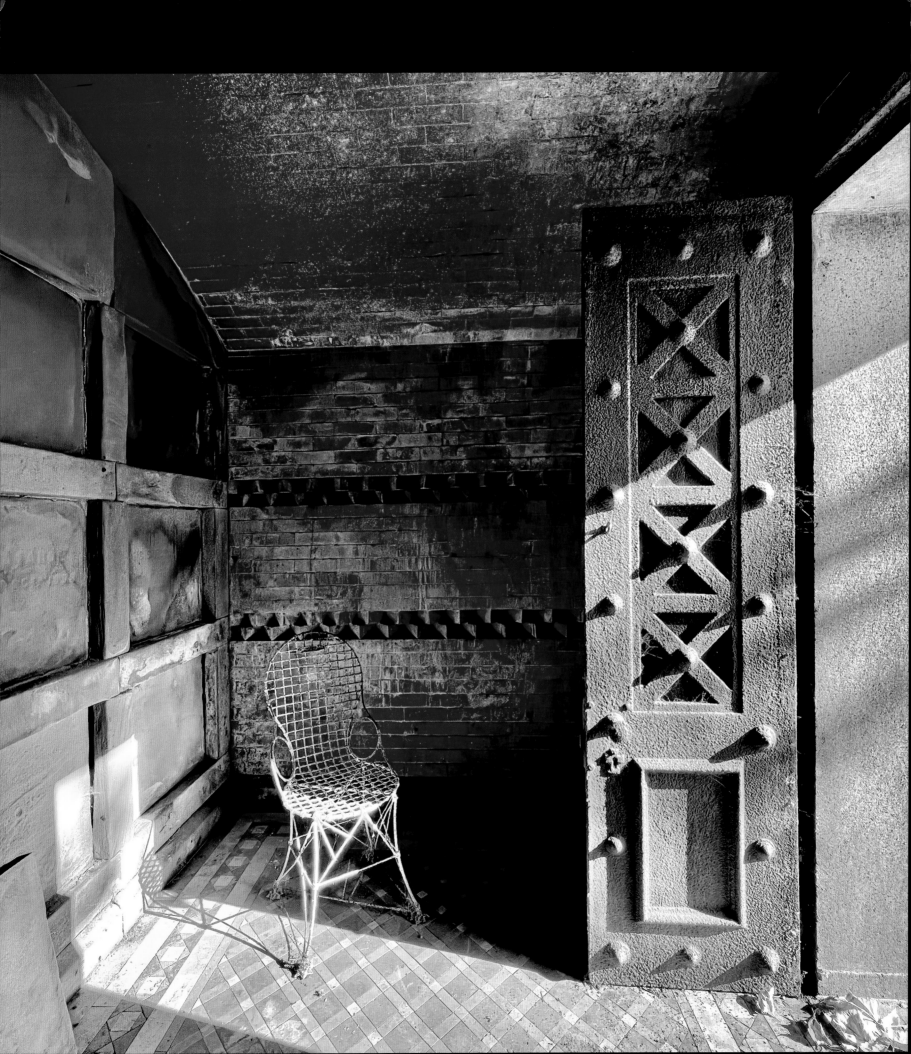

First published in the United States of America in 2023 by
RIZZOLI INTERNATIONAL PUBLICATIONS, INC.
300 Park Avenue South, New York, NY 10010
www.rizzoliusa.com

Publisher: Charles Miers
Editor: Douglas Curran
Production Manager: Kaija Markoe
Managing Editor: Lynn Scrabis
Copyeditor: Victoria Brown
Proofreader: Tricia Levi

Designed by Aldo Sampieri

Printed and bound in China

2023 2024 2025 2026 2027 / 10 9 8 7 6 5 4 3 2 1

ISBN-13: 978-0-8478-7324-1
Library of Congress Control Number: 2023935061

Visit us online:
Facebook.com/RizzoliNewYork
Twitter: @Rizzoli_Books
Instagram.com/RizzoliBooks
Pinterest.com/RizzoliBooks
Youtube.com/user/RizzoliNY

"It is not death a man should fear, but he should fear never beginning to live." —Marcus Aurelius

p. 1: Autumn afternoon, statue facing a backlit ginkgo tree. According to the fossil record of trees, the ginkgo has remained unchanged for two hundred million years. Originally from China, it was introduced to the US in the late eighteenth century. In fall, the fan shaped leaves (see pp. 210–211) turn from bright green to shocking yellow.

pp. 2–3: A couple strolls through the Richard M. Upjohn & Son designed Arch (1861–63), photographed from Artemisia Path. The architecture critic Paul Goldberger called the 106-foot-high gates, "a staggering triumph of Gothic Revival, which combines in one soaring form a double gate, clock tower and offices." Upjohn and his son, Richard Michell, were best known for their religious architecture in the Gothic Revival style.

p. 4: Dusk overtakes the western sky over New York Harbor, creating a dramatic silhouette of the Main Entrance Arch.

p. 5: The always raucous monk parakeets greet visitors daily from their dense nests woven into the Gothic spires of the Arch. Native to South America, the parakeets were rumored to have escaped from a pet shipment at JFK Airport, and have happily called Green-Wood home since.

pp. 6–7: A crisp spring day looking across Crescent Water towards the white marble vault of the Niblo family. William Niblo made his mark as an entrepreneur in Manhattan opening "Niblo's Garden" in 1828. It was known for its fantastical extravaganzas, including fireworks, festive music, dancers, acrobats, opera and jugglers. After William's wife Mary died in 1851, he hosted picnics and parties on the lawn in front of the mausoleum until his death in 1878. Today, in the spirit of Mr. Niblo, Green-Wood produces elaborate evening performances on the same ground.

pp. 8–9: Two female figures bookend an urn on the Fisher Bird monument, near Landscape and Lawn Avenues.

p. 10: Floral stained-glass panel in the Fort Hamilton Parkway Gatehouse designed by Charles Booth (1844–1893) who also created the stained glass at the Brooklyn Historical Society.

p. 11: Interior of the vault of the American artist John LaFarge (1835–1910) and family members on Dawn Path, featuring a basket-weave tiled floor and modern industrial metal door. A prolific painter, illustrator, muralist and stained-glass designer, LaFarge was the first to use opalescent glass in his works. In spite of his prominence as a stained-glass artisan, none of LaFarge's work is known to be featured in Green-Wood.

p. 13: Grief portrayed in stone. A female angel slumps onto the O'Donohue monument, her head resting on her arm, the other hand holding a laurel wreath which represents victory, distinction or immortality. The monument is a reinterpretation of William Wetmore Story's "Angel of Grief" (1894), located in Rome, and is one of the most copied funerary statues.

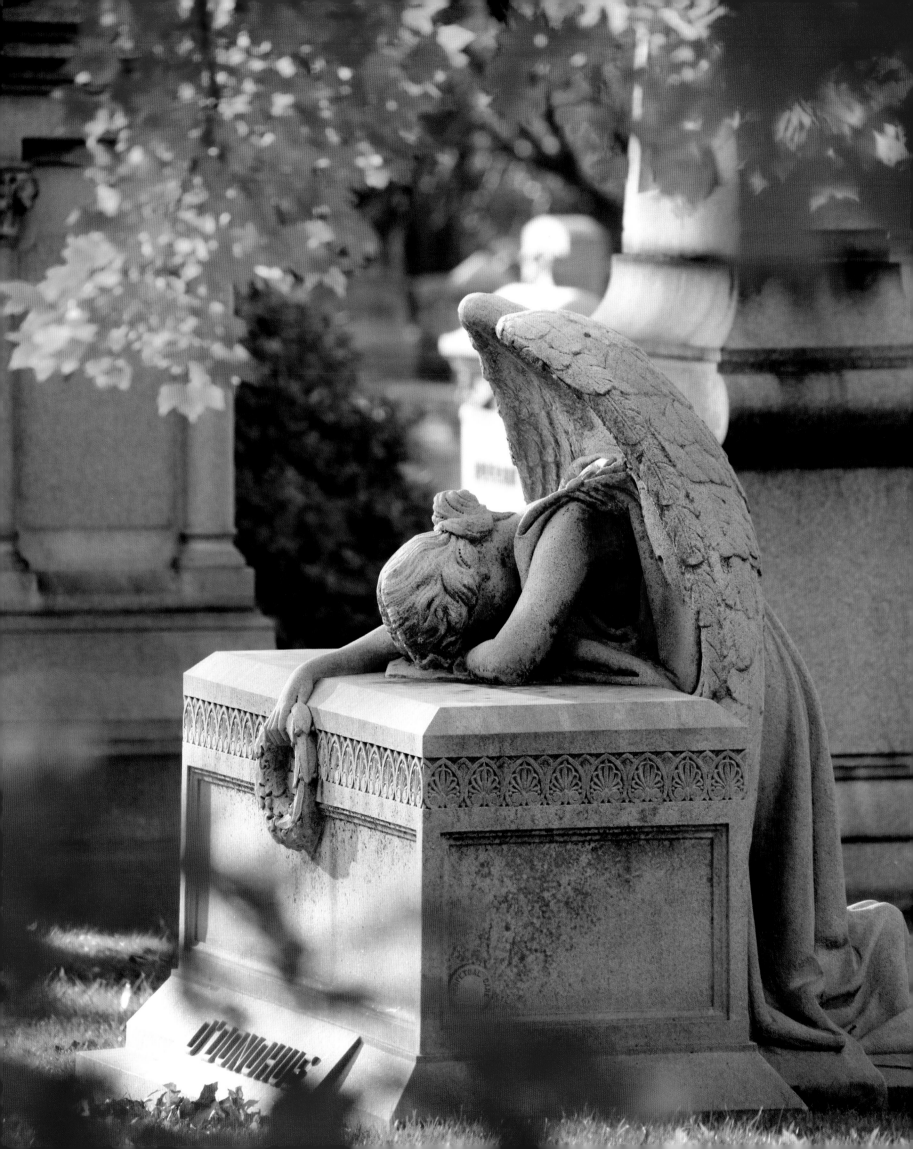

TABLE OF CONTENTS

FOREWORD

Richard J. Moylan

Green-Wood is a place born of evolution and shaped by revolution. More than eighteen thousand years ago, as the earth evolved and the last ice age ended, Green-Wood's stunning landscape of valleys, hills, and ponds was forged from ice and rock, as glaciers, two-miles deep, receded and carved a path through the land.

But it was a revolution in ideas about death and burial that sparked the nineteenth-century Rural Cemetery movement and, in 1838, the creation of The Green-Wood Cemetery. Today, 185 years later, equally revolutionary thinking continues to shape our role as a compassionate provider of death services and, equally so, as an important center of history, education, the arts, and environmental activism.

From its earliest days, Green-Wood has been an integral part of New York's history.

Everyone who was anyone in the nineteenth century sought eternal repose here. Renowned architects, artisans, and artists of the day vied for the privilege to create magnificent buildings and the final resting places for the rich and powerful, the famous and infamous. Green-Wood was "a virtual forest of Type A personalities," as the renowned preservationist Kent Barwick once remarked. At the same time, like New York City itself, Green-Wood offered a home to people of all backgrounds, religions, and income levels. The Cemetery's public burial lots comprise about one third of all burials here.

By the 1850s, the grounds became a magnet for Brooklynites and New Yorkers thirsty for respite from urban life. The Cemetery enticed hundreds of thousands of visitors, and soon became one of New York's most popular attractions. Arriving by ferry and carriage, visitors dotted the landscape, picnicking alongside glacial ponds and enjoying views of New York Harbor from high atop Battle Hill.

At a time when open green spaces really did not exist in the New York area, Green-Wood provided the inspirational blueprint for the creation of Central and Prospect Parks.

And while this early history certainly predates my association with the Cemetery, Green-Wood has always been an integral part of my life, too.

As a kid, like many of my friends, I would sometimes tag along with my father when he went to work. But no one else I knew was lucky enough to pass through a giant red castle when they did that. That's because my dad worked at Green-Wood, cleaning and repointing historic monuments. From the moment I first passed under the looming arched entryway and looked out on Green-Wood's 478 magical acres, the place had me wrapped in its spell.

Little did I know then that I'd never leave the place—professionally speaking.

When I began my Green-Wood career as a grasscutter while working my way through law school, I could never have predicted where the journey would take me. Over the past fifty years, I have served as assistant

Rudolph Cronau (1855–1939), *View from Greenwood Cemetery*, 1881, a romanticized view depicting the classical Anderson mausoleum in the left foreground, the Gothic Arch in the middle, and the sunset illuminating New York Harbor. (Watercolor and black ink, collection of Brooklyn Museum.)

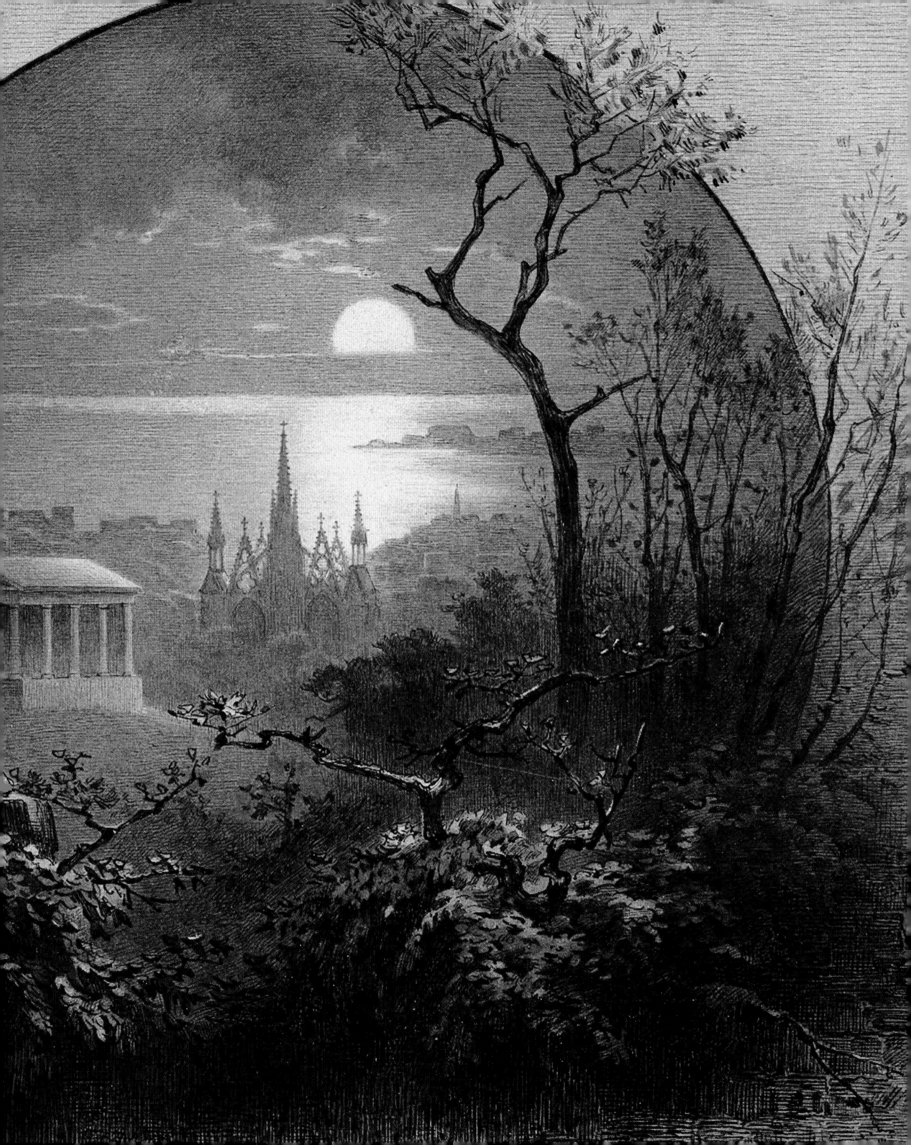

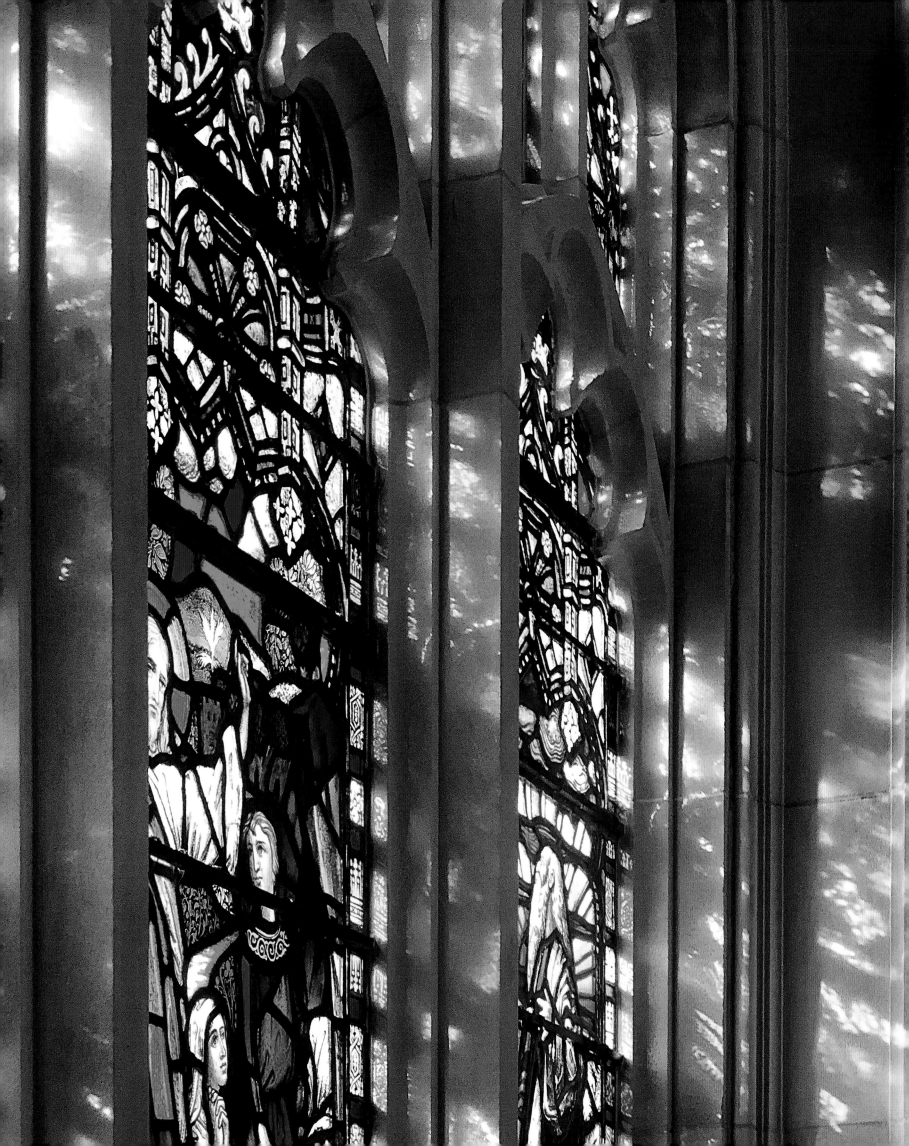

to the surveyor; administrative assistant; grounds maintenance supervisor; and assistant corporate secretary, along the way learning every aspect of cemetery operations.

Since 1986, I've had the privilege to serve as president of this National Historic Landmark where every day I see thousands of visitors strolling Green-Wood's grounds, enjoying the beauty of the landscape. But this wasn't always the case.

Not very long ago Green-Wood was a closed, dark place. The public was not welcomed. Our landscape was neglected. In many ways, we paralleled the downward spiral in which New York City found itself in the 1960s, 70s, and 80s. We lost sight of our venerable history and in doing so almost jeopardized our future.

Early in my tenure as president it became clear to me that Green-Wood needed to dramatically shift its outlook for the future. Land available for traditional in-ground burials, once the mainstay of cemetery operations, would decrease over time. Of course, Green-Wood's sacred duty would always be to memorialize the dead. We would continue to offer cremation, memorial niches, crypts, and more recently, scattering gardens and natural burials. But we also knew we had an incredible opportunity to share this historic cemetery in entirely new ways.

Green-Wood is a rich repository of history, art, architecture, and natural beauty. Drawing on all those attributes, and with a board and staff committed to change, we charted a new plan forward and created The Green-Wood Historic Fund. Its mission was simple: to preserve and honor our past, to perpetuate all that makes this place special, and to make sure that the world knew of and appreciated Green-Wood's significance.

Today, Green-Wood's gates are open 365 days a year. Last year, we welcomed over 450,000 people to our grounds. Our trolley and walking tours, concerts in the catacombs, art installations, bird-watching programs, and nature walks attract tens of thousands annually. Researchers access our historic collections and archival records, which date back to the Cemetery's founding in 1838. Our education department leads over 300 school programs, serving just under 10,000 students every year. And our cutting-edge environmental initiatives are contributing to the health of our local ecosystem and garnering national attention at the same time.

Like New York City, Green-Wood is evolving while still honoring its past. (Actually, I would say Green-Wood has done a much better job with that second part.) Every day, we uphold our solemn obligation to the families we serve. At the same time, we embrace our role as a center for the arts, the environment, history, and education.

One other thing is for sure. I still get the same thrill I had when I was a boy every time I drive up 25th Street under the Gothic Arch. And I know I'm not alone. That's why I am proud to be part of Green-Wood's story.

Detail of bright, jewel-like light streaming into the Historic Chapel, one of forty-one windows created by the Willet Studio in Philadelphia in 1912. This window illustrates scenes from the life of Christ and was restored in 2020.

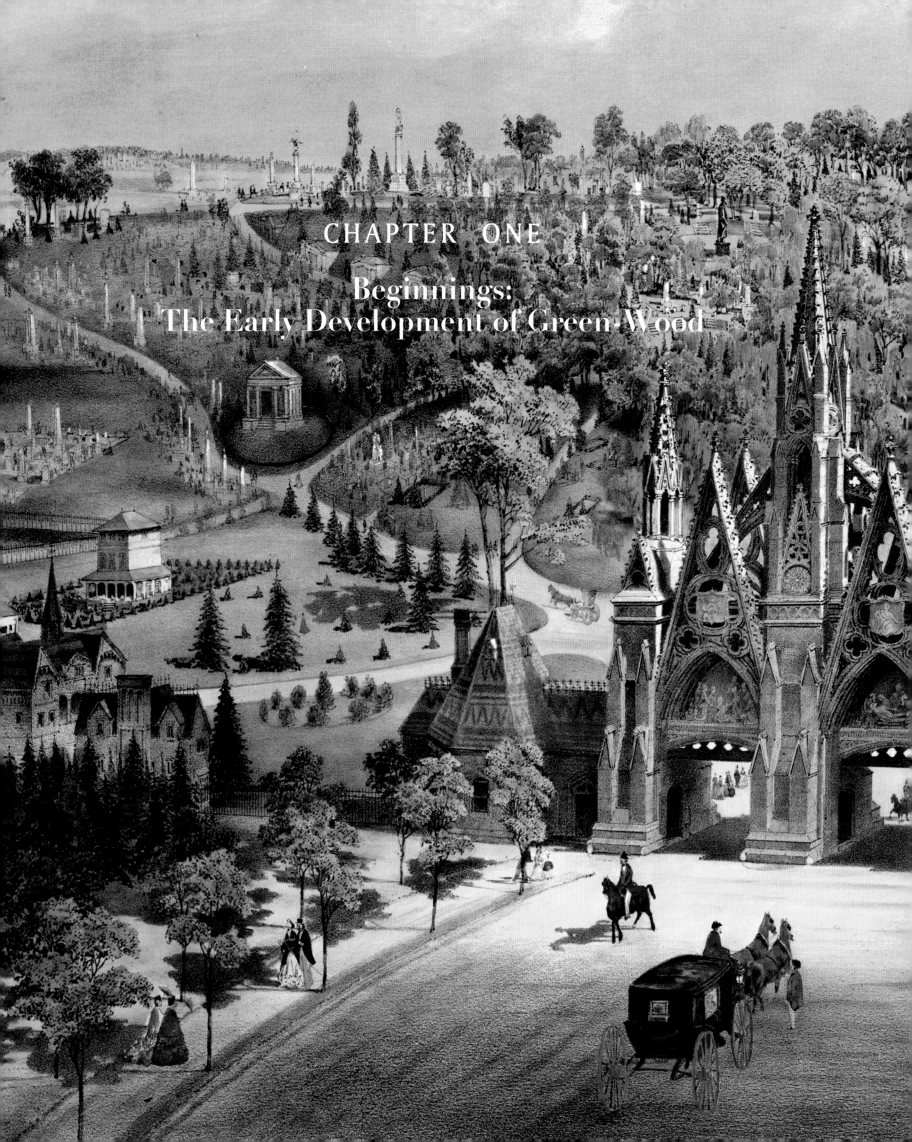

CHAPTER ONE

Beginnings:
The Early Development of Green-Wood

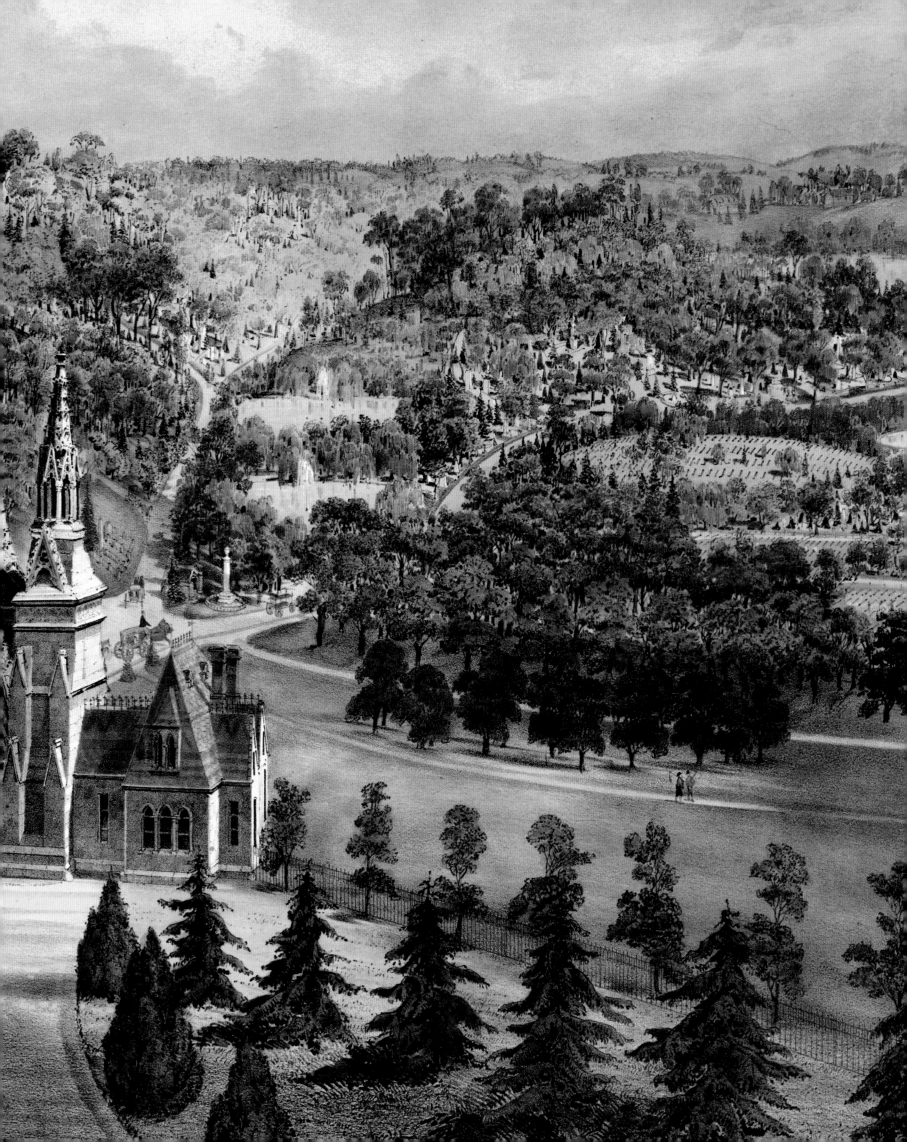

Precursor of Parks

Thomas J. Campanella

Brooklyn in the middle years of the nineteenth century was a subaltern charged—churning with ambition, fueled by industry, eager to match wits with mighty Manahatta. Much of this was boosterism and the bombast of developers, but it spawned a wealth of institutions—precursors of BAM, the Brooklyn Museum, the Brooklyn Public Library. It also gave us some of the finest open spaces in any American city. After New York built Central Park in 1858, Brooklyn retained its designers, Frederick Law Olmsted and Calvert Vaux, to do it one better across the river. Here, on a rolling tract atop the terminal moraine, Olmsted and Vaux laid out Prospect Park. It was not only a masterpiece of urban park design—the duo's greatest work—but the kernel of the nation's first metropolitan open space system, from which vinelike "park-ways" were drawn out across the incipient city.

But the first designed landscape of any scale on either side of the East River was The Green-Wood Cemetery, and it came a full generation before Prospect or Central Parks. Sepulture—burial, interment, inhumation—was one of many services Brooklyn provided New York. Brooklyn was a dependent of New York, but an indispensable one. Land-poor and girdled by water, New York (then only Manhattan Island and part of the Bronx) would have choked on itself without a vast hinterland next door. As Olmsted put it, the city "is in the condition of a walled town." (Brooklyn, he added, "is New York outside the walls.")[1] As Gotham grew, Brooklyn became ever more vital to its being. Brooklyn fed New York, took its trash, made its goods, decanted its masses, housed its workforce, and gave the people a place to splash and play. Brighton Beach and Coney Island were *id* to New York's *ego*; all manner of conduct unbecoming—drinking, gambling, whoring—was not just tolerated there but well served, thus safely bleeding off the manifold pressures of the white-hot urban core.

It was Brooklyn, too, that took the city's dead. Perished horses, cats, and curs were shipped off to Barren Island, and rendered there into brushes, glue, and buttons. The expired human elite, however, went to The Green-Wood Cemetery, to sleep in the deep glacial till. Like Prospect Park, Green-Wood was a paragon of its type—a "rural" cemetery where the dead reposed amidst lush natural beauty. Its European antecedent was French: Père Lachaise Cemetery on the eastern edge of Paris. Named after the father confessor of Louis XIV, Père Lachaise opened in 1804 as an alternative to the packed and ghastly graveyards of the city. Unconsecrated by the church and far from town, it languished at first. But a clever marketing move—"seeding" the cemetery with the exhumed remains of two exalted Frenchmen, Molière and Jean de la Fontaine—caught the attention of Parisian society. Soon, Père Lachaise was *the* place to go when you went. Its grave roll is a catalogue of French history—Balzac, Chopin, Proust, and Edith Piaf are all buried there; so too Oscar Wilde, Maria Callas, and Doors frontman Jim Morrison. The cemetery was equally popular with the living, a treasured place for picnics and strolls.

In America, the idea of burial in a landscaped garden first took root in Cambridge, Massachusetts. Mount Auburn Cemetery was the brainchild of Boston physician-botanist Jacob Bigelow, a vocal advocate of modern sepulture after an 1820s made churchyard burials popular again. Medical theory at the time blamed a variety of dread diseases on poisonous exhalations or "miasmas" thought to emanate from congested urban graveyards. A rural cemetery not only solved this public health menace, but indulged Bigelow's interest in trees and plants. It also reflected changing perceptions of death, less burdened now by Calvinist notions of damnation and worms and charged instead with a redemptive yearning to celebrate the lives and deeds of the deceased. Why, asked Washington Irving in *The Sketch Book of Geoffrey Crayon*, "should we thus seek … to

Previous pages: Lithograph by John Bachmann dating to 1867 titled *Greenwood Cemetery, New York*, of a horse-drawn hearse entering the great Gothic gates. David Bates Douglas (the architect of the High Bridge aqueduct, which spans the Harlem River between the Bronx and Washington Heights and who is interred in Green-Wood) was hired to design the landscape. Douglas fought for the future cemetery to be named "Green-Wood" rather than "Necropolis," which was the choice of Henry Pierrepont and the other founders. (The Green-Wood Historic Fund Collections)

Opposite: One of the earliest known maps of Green-Wood, surveyed by Edward Boyle in 1850, and printed by the studio of Napoleon Sarony (also a photographer, who is interred at Green-Wood). The map showed the original footprint of the Cemetery, but as it gained popularity as a place for final rest in the mid-1860s, it expanded with more land acquisitions. (The Green-Wood Historic Fund Collections)

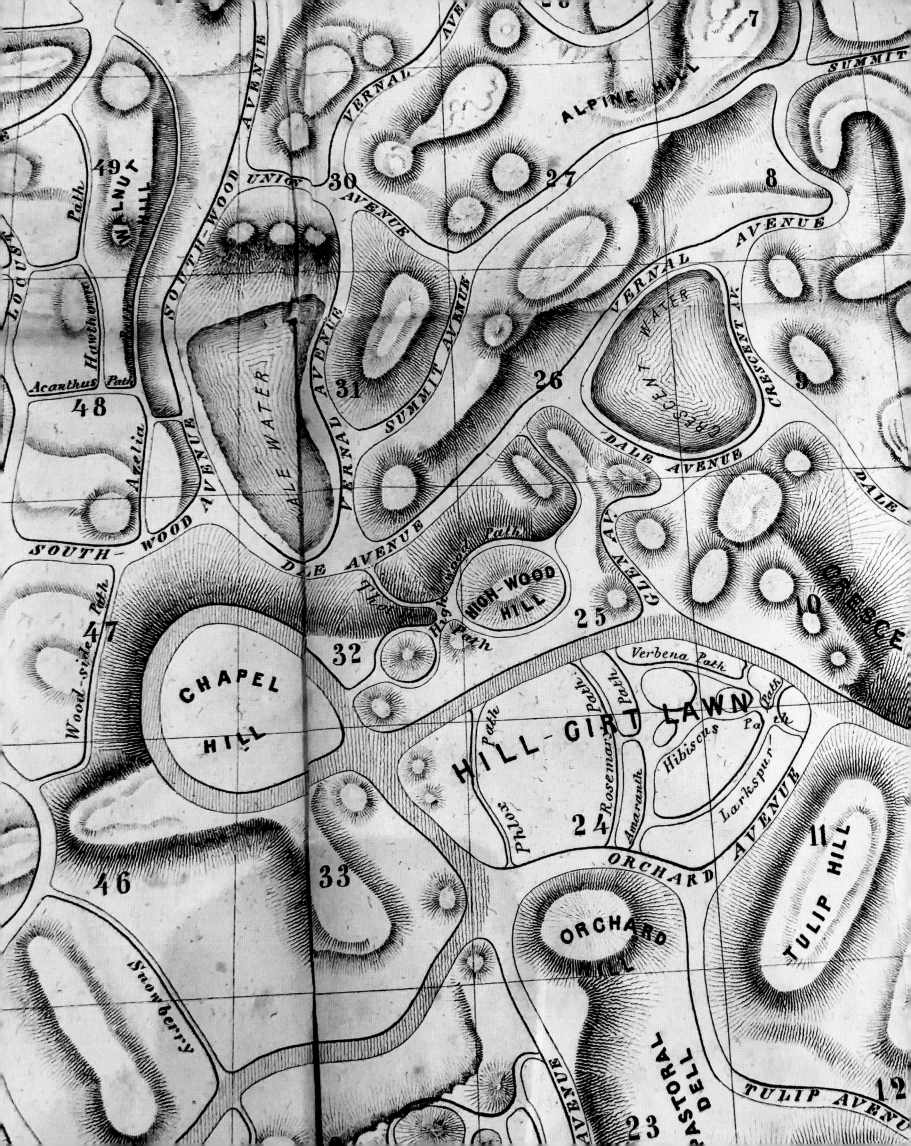

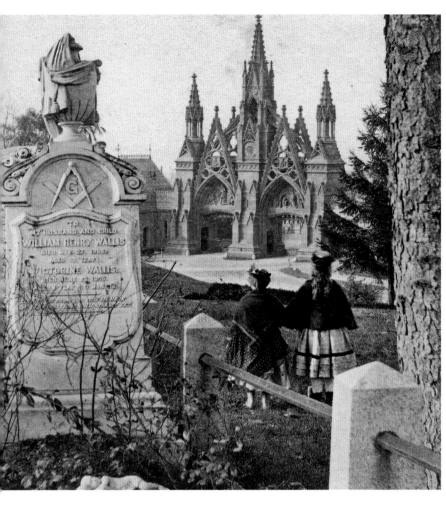

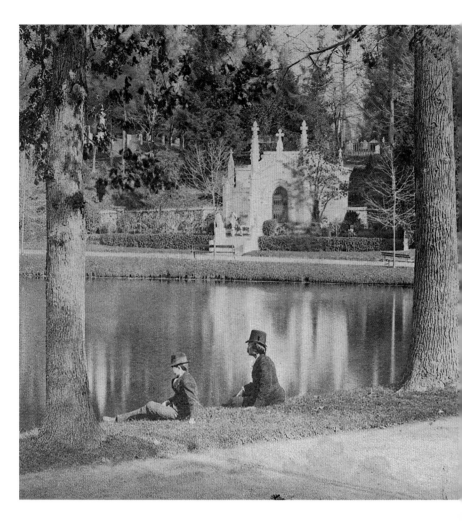

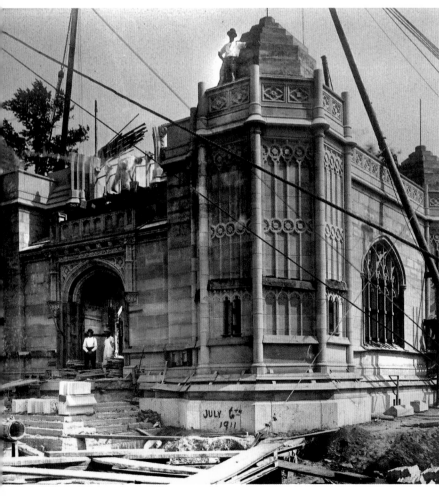

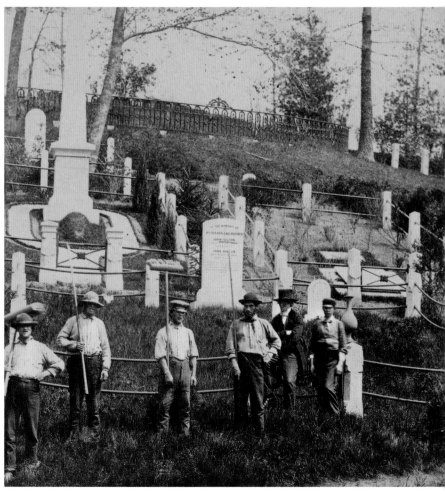

spread horrors round the tomb of those we love? The grave should be surrounded by every thing that might inspire tenderness and veneration for the dead; or that might win the living to virtue."[2]

Backed by the Massachusetts Horticulture Society, Bigelow arranged the purchase of a seventy-two-acre wooded tract above the Charles River—"Sweet Auburn"—where he and engineer Alexander Wadsworth laid out an "ornamented rural cemetery." There, natural beauty might "relieve from their repulsive features the tenements of the deceased," wrote Bigelow, while offering "some consolation to survivors." Mount Auburn was consecrated in September 1831.

It was Brooklynite Henry E. Pierrepont who brought the rural cemetery to New York. Son of Hezekiah Pierrepont, creator of Brooklyn Heights, he visited Mount Auburn in 1832, returning with the desire that New York and Brooklyn should have a similar establishment ". . . not unworthy of their greatness." Pierrepont spent the next year in Europe visiting old cemeteries in France and Italy. He was later placed in charge of laying out streets for the newly established City of Brooklyn. It was in this capacity that Pierrepont could spare land for his cemetery from the hungry grid—a sprawling tract on the terminal moraine known as the Heights of Guana. Capped by Brooklyn's highest hill, it offered "a variety and beauty of picturesque scenery . . . seldom to be met with in so small a compass." The Heights was already hallowed ground, for much of the Battle of Brooklyn—a watershed in the American Revolution—had been fought there.[3]

Pierrepont and a group of prominent Brooklynites chartered the Cemetery as a joint-stock corporation in April 1838, spending the next ten months securing the 175-acre site piecemeal from a greedy gaggle of landowners. The grounds were very nearly called Necropolis. But the name was deemed too classical for a Romantic landscape, and much too urban. "Necropolis," it was decided, "*savours* of *art* and *classic refinement*, rather than of *feeling*, and herein is our objection. A Necropolis should be an architectural establishment, not a shady forest. Besides, a Necropolis is a mere depository for *dead bodies*—ours is a *Cemetery . . . a place of repose*." And so it was named Green-Wood instead, whose "visible associations," wrote trustee David B. Douglas, "are intended to be exactly what its name implies—*verdure*, *shade*, *ruralness*, *natural beauty*; every thing, in short, in contrast with the *glare*, *set form*, *fixed rule* and *fashion* of the city."[4] A civil engineer who cut his teeth on the Croton Aqueduct and Brooklyn-Jamaica railroad, it was Douglas who took charge of crafting a pastoral landscape out of this rough and frazzled tract. Like Père Lachaise and Mount Auburn—and later Central and Prospect Parks—Green-Wood was arranged in the style of the English landscape garden, with an emphasis on smooth, flowing lines, irregular plantings, and scenes artfully crafted to mimic nature. There, the dead would sleep "beneath the verdant and flowery sod," wrote Green-Wood's first historian Nehemiah Cleaveland, "beneath green and waving foliage—amid tranquil shades, where Nature weeps in all her dews, and sighs in every breeze, and chants a requiem by each warbling bird."[5]

The first improvements at Green-Wood—a simple rail-fence around the perimeter and an access road "passing through its most interesting portions"—were made in the summer of 1839. The first interment, of a man named John Hanna, came that fall. A decade later he had 26,000 very quiet neighbors, a congress of souls nearly equal to the population of the Bronx and Queens at the time. Landscape theorist Andrew Jackson Downing predicted that Green-Wood would eclipse Mount Auburn as America's greatest garden cemetery. "In size it is much larger," he observed in 1841, "and if possible exceeds it in the diversity of surface, and especially in the grandeur of the views. Every advantage has been taken of the undulation of surface, and the fine groups, masses, and thickets of trees, in arranging the walks; and there can be no doubt, when this cemetery is completed, it will be one of the most unique in the world."[6]

Moreover, Downing offered, America's rural cemeteries were "the first really elegant public gardens or promenades formed in this country."[7] Thronged from the start by people yearning for fresh air, trees, and open space, Mount Auburn, Green-Wood, and Philadelphia's Laurel Hill were effectively our first urban parks. When Green-Wood's main road opened on July 4, 1839, word got out that a place of great natural beauty "had been added to the scanty privileges of New York and Brooklyn." Overnight the Cemetery became "a place of considerable resort," Cleaveland noted, and by the 1860s only Niagara Falls was drawing more visitors.

The popularity of these cemeteries underscored the need for open space in America's increasingly congested cities. "Judging from the crowds of people in carriages, and on foot, which I find constantly thronging Green-wood," Downing reported in *The Horticulturalist*, "I think it is plain enough how much our citizens, of all classes, would enjoy public parks on a similar scale." Green-Wood and its kin thus helped launch the urban parks movement of the later nineteenth century, changing the very form and character of the American metropolis.[8]

Clockwise from Upper Left: Stereoview card view of two children looking down from Bay Side Avenue toward the Arch, next to the gravestone of William Henry Wallis and family, circa 1875; view of two gentlemen in repose on the shores of Crescent Waters, the Niblo vault in the background; Green-Wood's ground crew circa 1870, before the days of power tools—the crew used scythes to cut the grass and push brooms to clear the paths and roadways (the foreman in a dark suit on the right, watches over the men); construction workers pause during work on the Historic Chapel on July 6, 1911. (The Green-Wood Historic Fund Collections)

NOTES:

[1] Frederick Law Olmsted and Calvert Vaux, *Observations on the Progress of Improvements in Street Plans* (Brooklyn: Van Anden's Print, 1868), 22–24.

[2] John Gorham Coffin (attributed), *Remarks on the Dangers and Duties of Sepulture* (Boston: Phelps and Farnham, 1823), 5, 11; Washington Irving, *The Sketch Book of Geoffrey Crayon, Gent.* (Chicago and New York: Belford, Clarke and Company, [1819] 1885), 177.

[3] Jacob Bigelow, *History of Mount Auburn Cemetery* (Boston and Cambridge: James Munroe and Company, 1860), 1, 11; Nehemiah Cleaveland, *Green-Wood Cemetery: A History of the Institution from 1838 to 1864* (New York: Anderson and Archer, 1866), 31; David B. Douglas, Exposition of the Plan and *Objects of the Green-Wood Cemetery* (New York: Narine and Company, 1839), 11.

[4] Douglas, *Exposition of the Plan and Objects of the Green-Wood Cemetery*, 11–12.

[5] Cleaveland, *Green-Wood Cemetery*, 28; Nehemiah Cleaveland, *Rules and Regulations of the Green-Wood Cemetery* (Brooklyn: Green-Wood Cemetery, 1831), 24.

[6] Cleaveland, *Green-Wood Cemetery*, 23, 31; Andrew J. Downing, "Additional Notes on the Progress of Gardening in the United States," *The Gardener's Magazine* (March 1841), 146–147; Andrew J. Downing, "A Talk About Public Parks and Gardens," *The Horticulturalist* 3:4 (October 1848), 157.

[7] Cleaveland, *Green-Wood Cemetery*, 23, 31; Andrew J. Downing, "Additional Notes on the Progress of Gardening in the United States," 146-147; Downing, "A Talk About Public Parks and Gardens."

[8] Cleaveland, *Green-Wood Cemetery*, 23–24; Downing, "A Talk About Public Parks and Gardens."

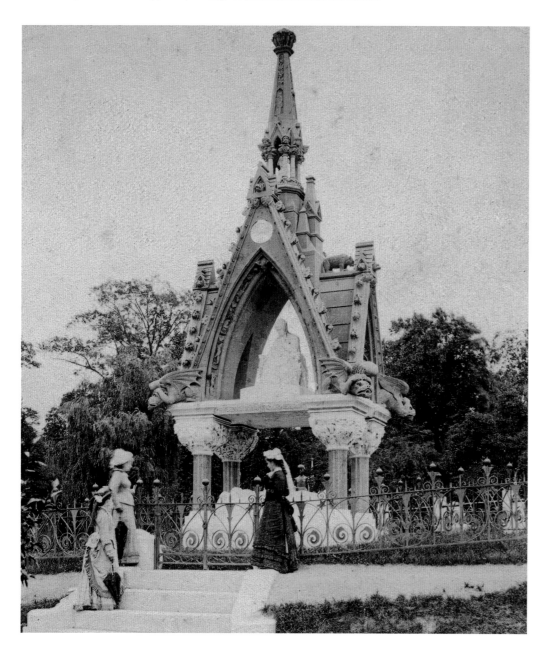

An image of finely attired visitors at the Matthews monument circa 1880. Designed by Karl Müller and completed in 1873, the monument memorializes the "Soda Fountain King," John Matthews. At right: Horse-drawn hearses exiting the Cemetery, from an unattributed woodcut from a German language edition of *Frank Leslie's Illustrated Newspaper*. The original heavy wooden gates are visible inside the Arch, which would pull down at night, and have since been removed. (The Green-Wood Historic Fund Collections)

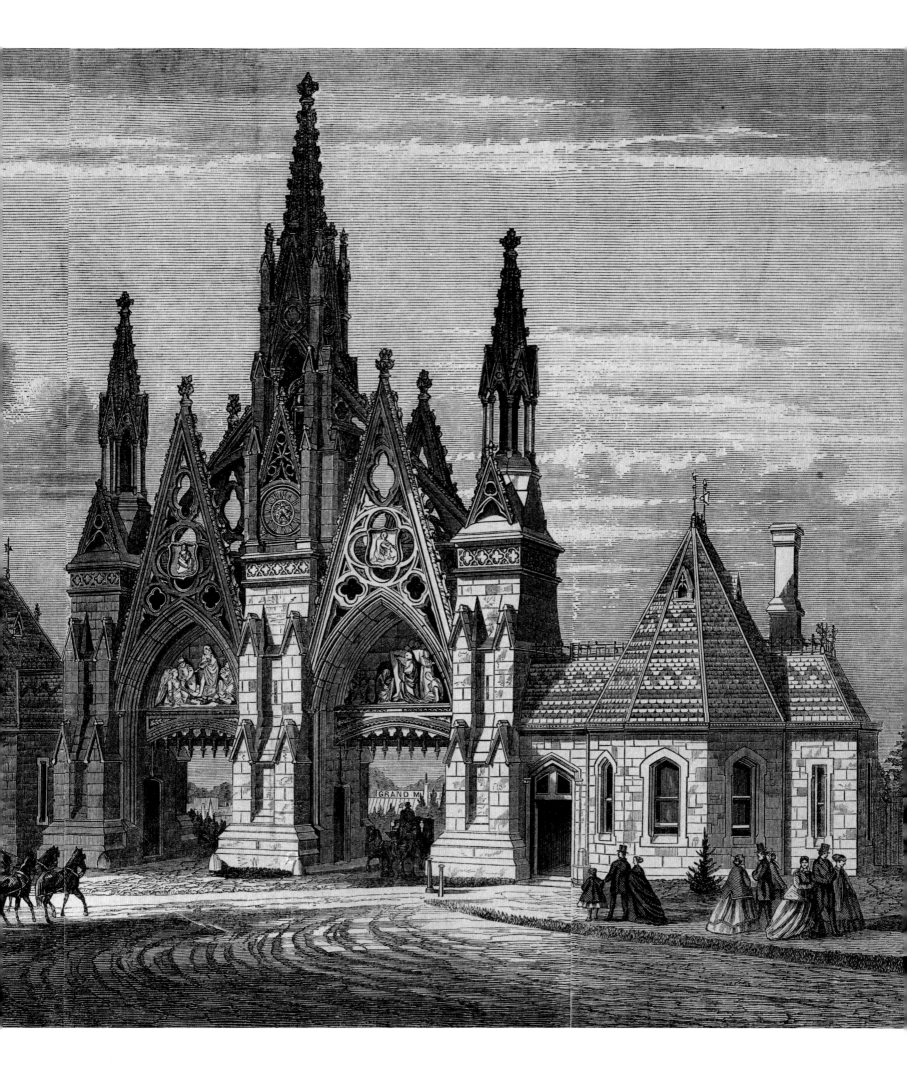

GRAND M[

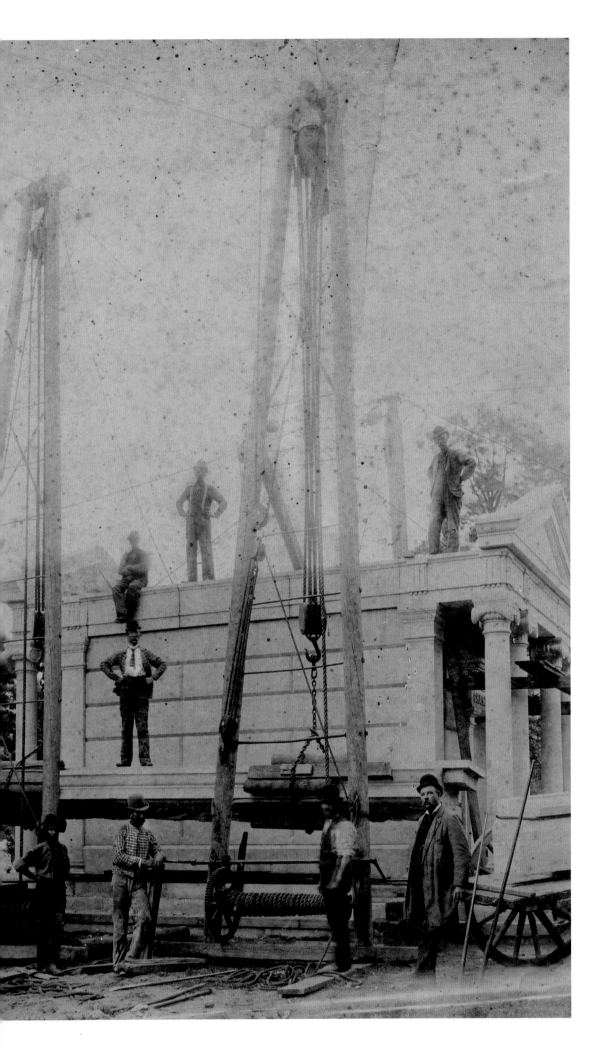

During the construction of the Yerkes mausoleum, workers pose on a hoist, which is lifting stone panels to the roof. (The Green-Wood Historic Fund Collections)

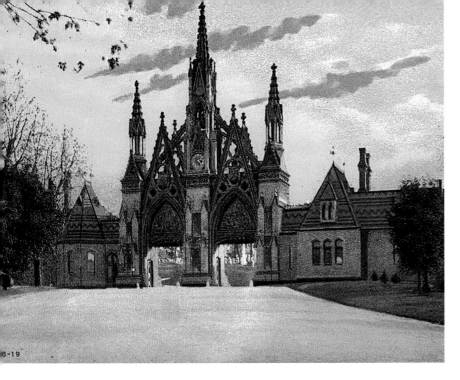

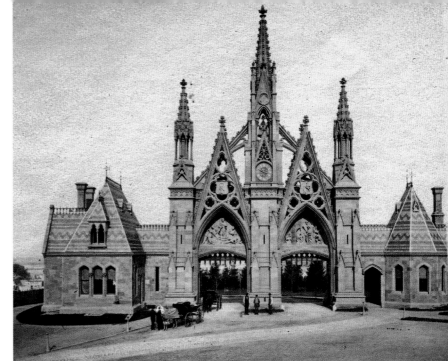

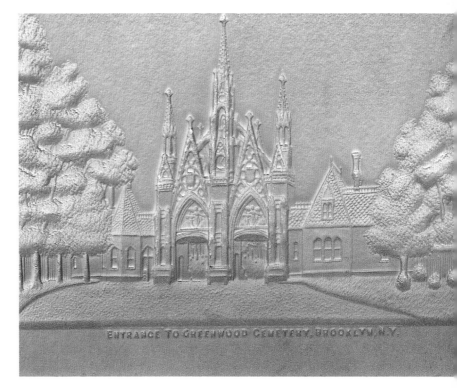

Various depictions of the Main Entrance Arch of Green-Wood.

Upper left: Lithographic postcard (possibly German) circa 1905. (The Green-Wood Historic Fund Collections)

Middle left: Detail of the embossed cover of *Green-Wood Cemetery: A History of the Institution* by Nehemiah Cleaveland. (The Green-Wood Historic Fund Collections)

Lower left: Colored embossed postcard asking the recipient "Did you ever see this place?" dated May 25,1909. (Collection Andrew Garn)

Upper right: Stereoview card showing three men standing against the front gates as two horse-drawn hearses enter. Date and source unknown.

Middle right: Embossed postcard from 1916.

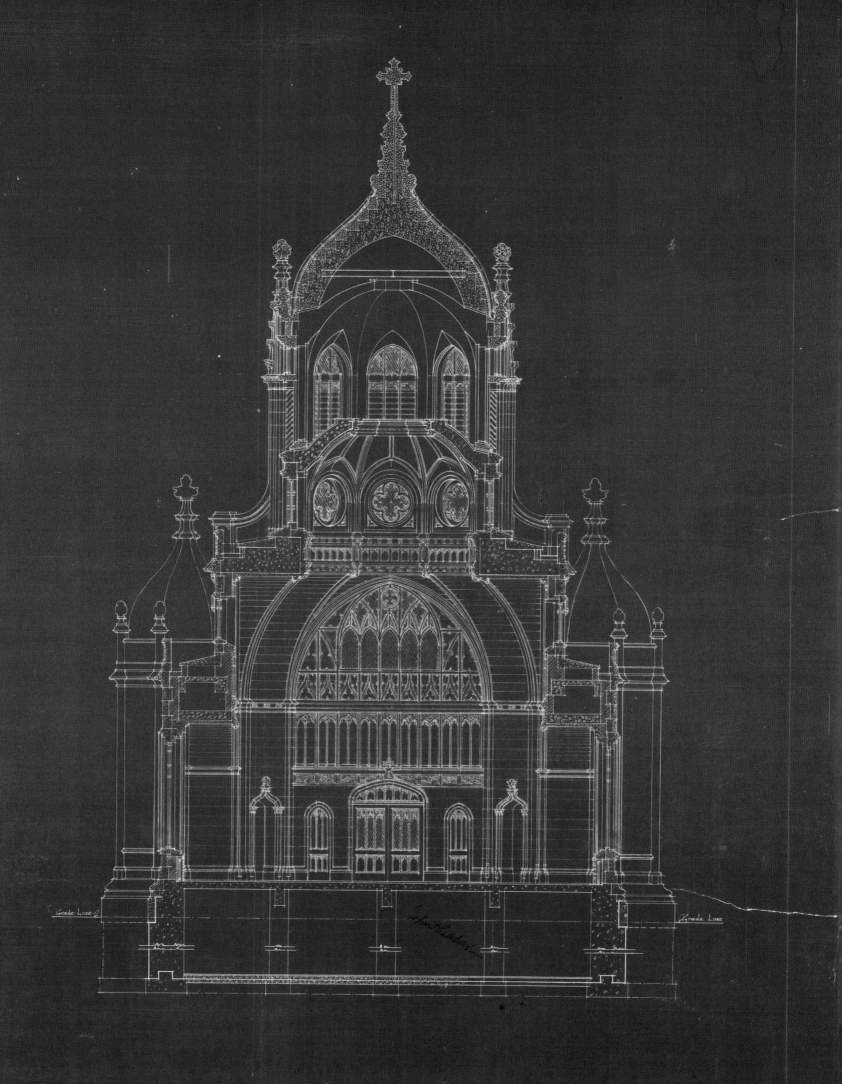

CROSS SECTION
SCALE, 1/4 INCH = 1 FOOT.

CHAPTER TWO

Planning:
Blueprints and Architectural Drawings

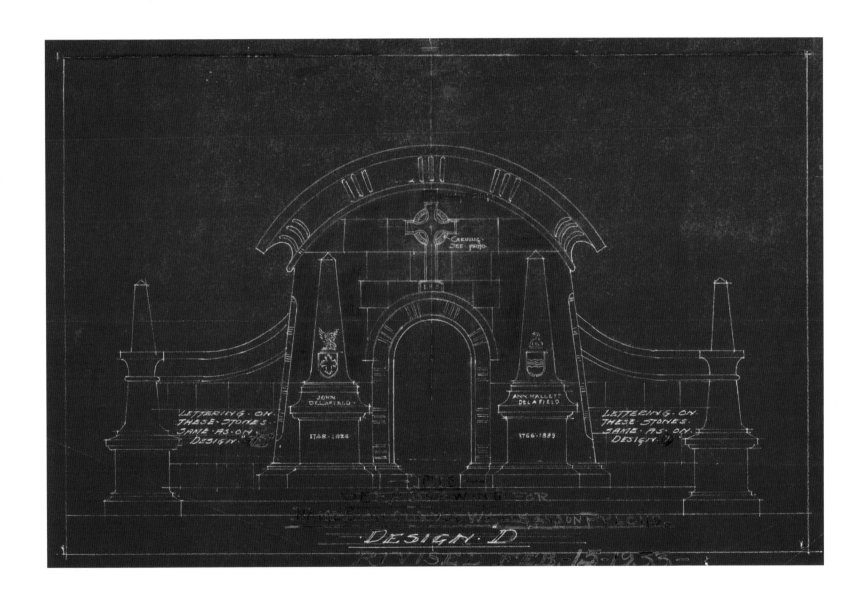

Opposite: Architectural drawing showing a front elevation of the Historic Chapel, designed by Warren and Wetmore in 1910 and completed in 1913. The new structure allowed for larger funeral services and other formal ceremonies (see p. 42). Above: Delafield family vault (see p. 53). (The Green-Wood Cemetery Archives)

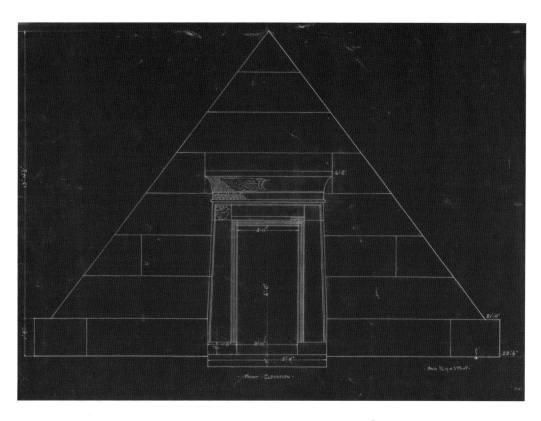

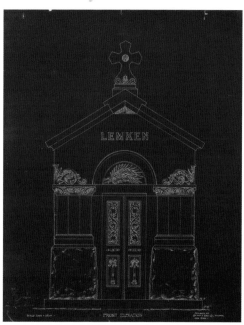

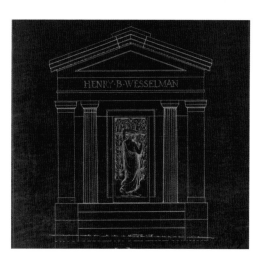

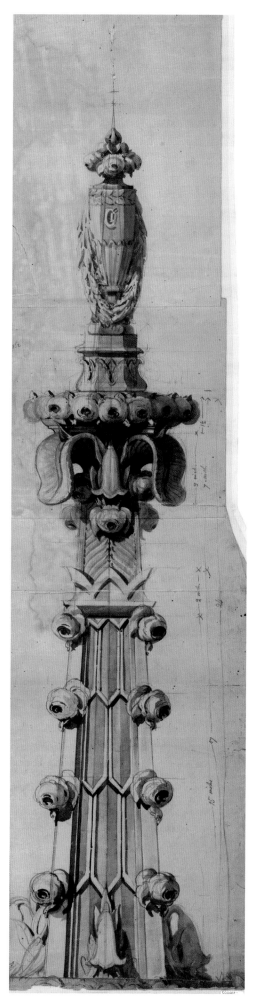

Upper left: Van Ness-Parsons Egyptian Revival vault—a pyramid with Egyptian-style pilasters and a cornice with a carving of Osiris covered with a flat pediment. When erected, the design caused a bit of a stir for traditionalists, and two Biblical statues were added to the front entry.

Middle left: Lemker mausoleum, designed by Leland & Hall Co in 1902, the mausoleum has two ornately carved metal doors. Rusticated walls at the bottom appear to support the outlines of three columns on each side of the door. The triangular roof supports a stone cross.

Lower left: Henry B. Wesselman mausoleum, with two fluted Tuscan columns and a cast metal door of a draped female, was designed in the Greek chapel style by John Feiter in 1926.

Right: Canda monument spire topped with a wreath-wrapped urn being held up by leaves detail (1848 in pencil and watercolor on yellow paper; see pp. 89, 246). (The Green-Wood Cemetery Archives)

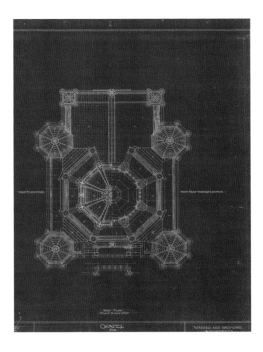

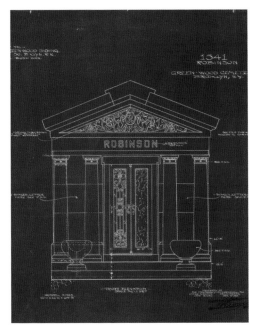

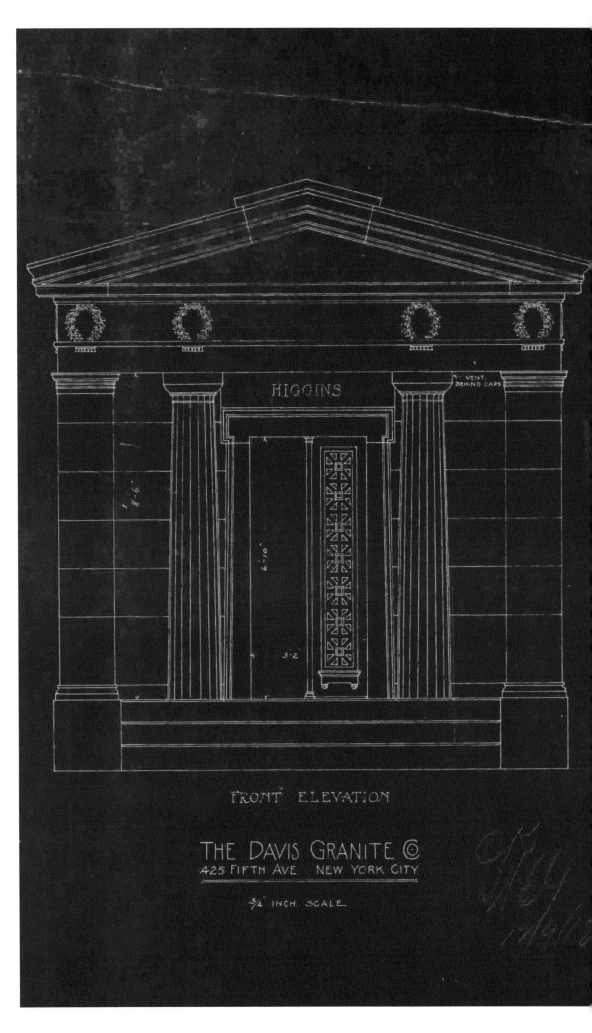

Top left: Roof plan of the Historic Chapel.
Middle left: Robinson mausoleum, designed by Presbrey-Coykendall. The plan calls for columns, vases, carvings, and a window supplied by the mausoleum owner.
Right: The Higgins mausoleum, built by the Davis Granite Co. in 1918, is flanked by two tapering Doric columns, features four carved wreaths in the frieze, and has an important position on Battle Hill facing New York Harbor. The Higgins lot is also the site of the famous Minerva and the "Altar to Liberty" (see p. 97), which was commissioned by Charles Higgins.

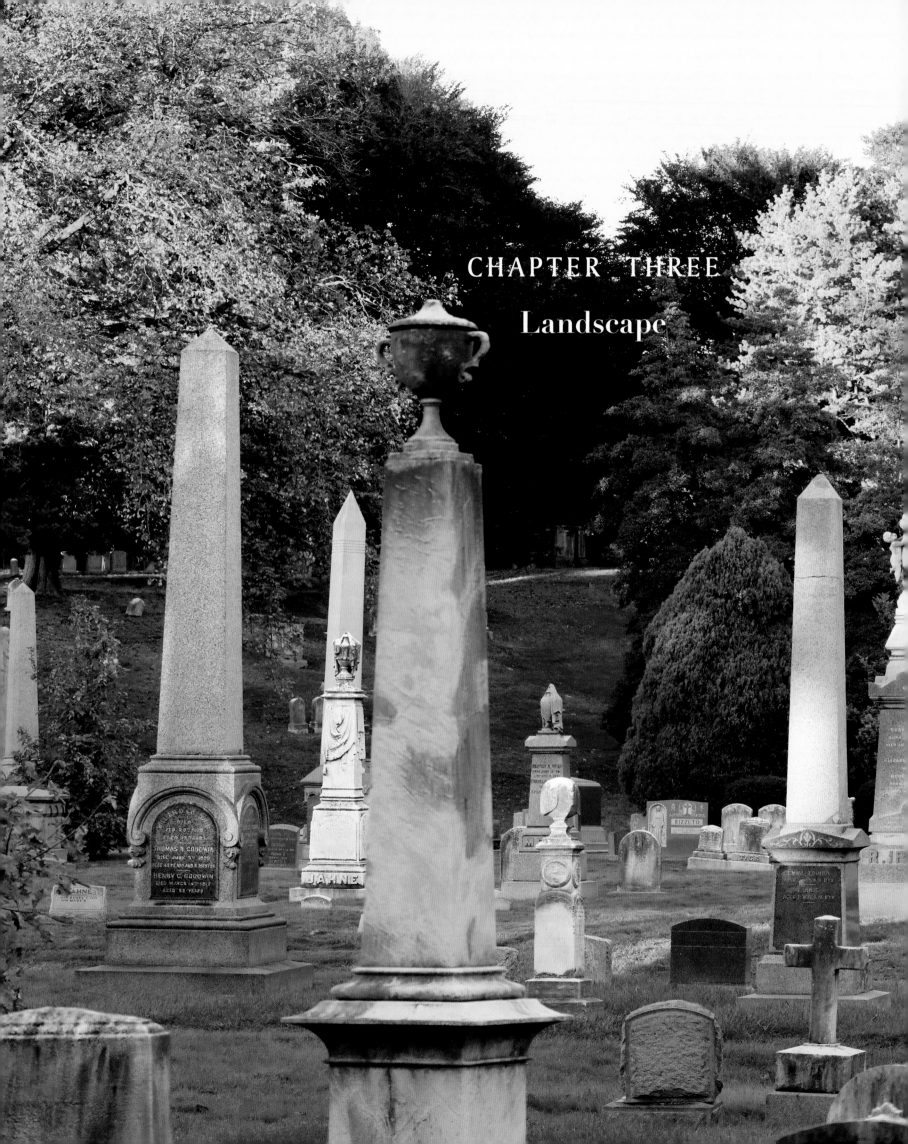

CHAPTER THREE

Landscape

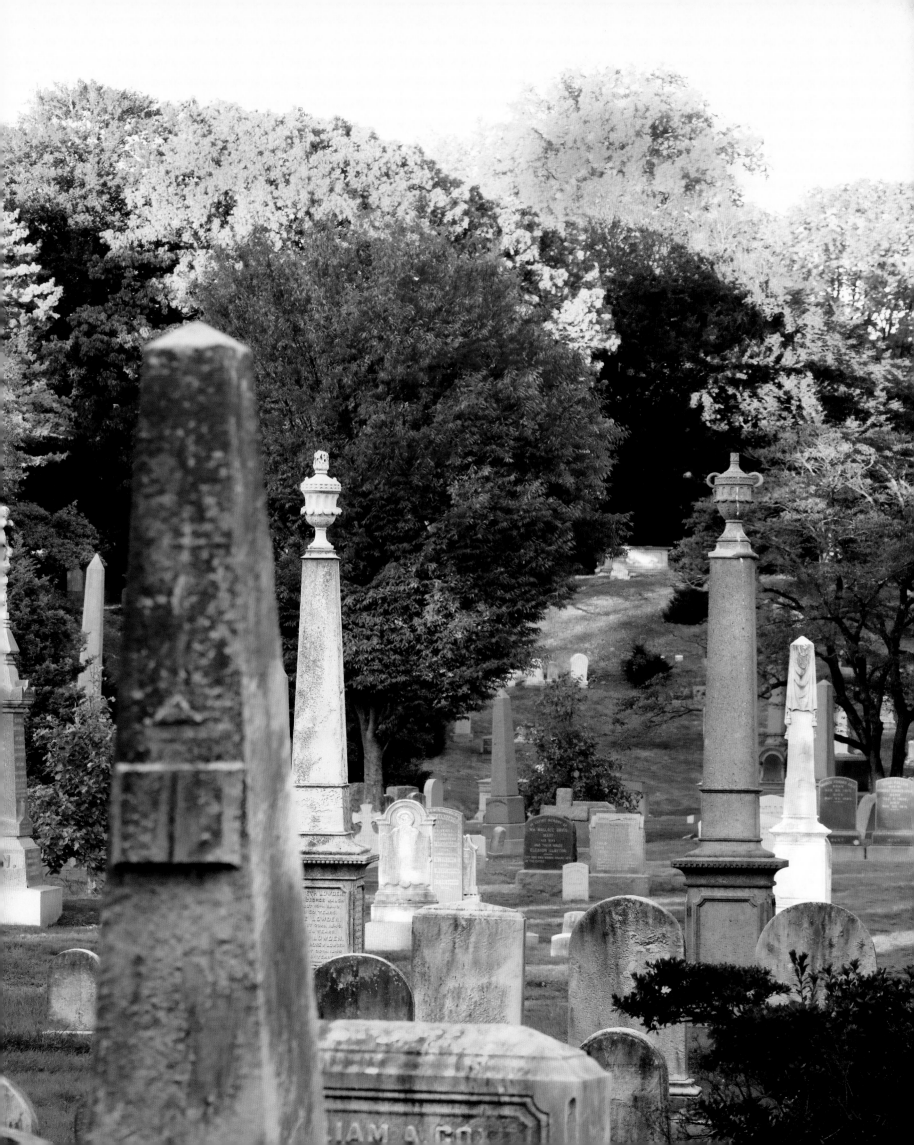

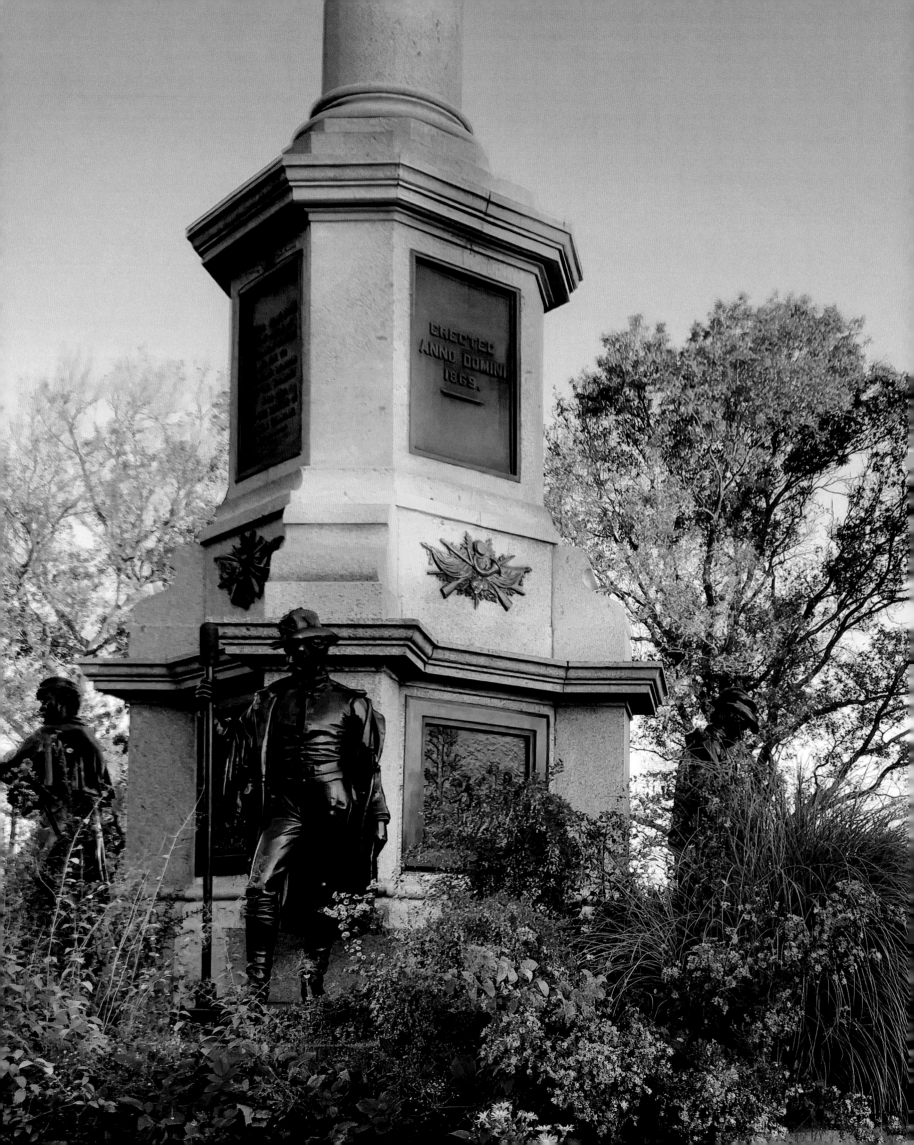

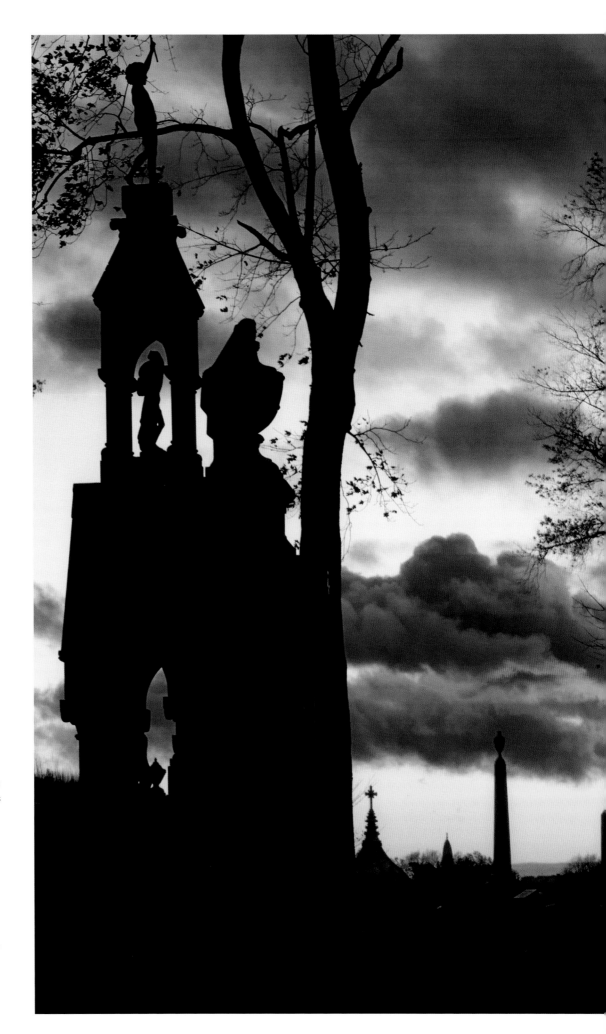

Previous spread: A view looking east over monuments near Locust Avenue, showing the early signs of autumn. As a Level III accredited arboretum, Green-Wood is home to over 8,000 trees and shrubs and 500 different species. Today, new plantings are selected for climate adaptability, wildlife value, enhancement of the landscape, and resilience to changes in future weather patterns.

Opposite: Green-Wood's Soldiers' Monument, located atop Battle Hill, the highest natural point in Brooklyn, honors the 148,000 New York men who served during the Civil War. Dedicated in 1876, construction of the monument began just four years after the end of the war. It features four life-sized statues of soldiers, representing the four branches of the Army: engineers, infantry, artillery, and cavalry. Originally cast in zinc, the sculptures deteriorated badly over the years and were replaced in 2002 with reproduction bronze statuary.

Right: Looking west toward a winter sunset from Battle Hill.

Planting Trees,
A Generous Act of Faith

Art Presson

"A society grows great when old men plant trees
in whose shade they will never sit."

—Anonymous Greek proverb

In the early twentieth century, stewards of The Green-Wood Cemetery planted nearly one hundred European beech trees on its grounds. Now, more than 120 years later, these tributes to the future provide shade so deep that little else grows under them. I would like to believe the motive for the planting was enthusiasm for the future. A beautiful design gesture on Landscape Avenue paired copper beech trees to form an enormous, dark—nearly black—canopy over the road. There is evidence suggesting two more of these copper beech pairs were intended to create a procession down Tulip Avenue, but the other two trees of the same vintage and spacing have no twin on the opposite side of the road. 'Tis a pity; but squint and you can see in your mind's eye the two copper beech that failed to make it to maturity. Fortunately, there are other allées throughout Green-Wood that were the result of other strong design gestures that include linden, cherry, sweet gum, maple, and beech trees. They are largely intact, compelling, and no squinting or imagining is required of the viewer.

Commemorating tragedy can be a powerful occasion to express grief through tree planting. A memorial grove of quaking aspens was planted in 2010 to commemorate the fiftieth anniversary of the harrowing mid-air collision of two commercial flights on December 17, 1960, which killed all 120 passengers on the planes as well as six people on the ground in Brooklyn. The unidentified human remains were collected in three caskets and buried in an unmarked grave, Lot 38325, Grave 980. Atop a short set of stairs, a new monument memorializes the crash with engraved names of the deceased and a description of the tragedy. The grove of aspens, provided by Million Trees NYC, was planted along the adjacent bank and tremble in the slightest breeze, as a tribute to heartbreak.

As an arboretum Green-Wood is most focused on succession planting to sustain its Living Collection, fill in gaps in the canopy, and increase diversity, while seeking to provide the most food and shelter for wildlife. To rapidly restore canopy, Green-Wood has been installing hundreds of bare-root trees (trees harvested from nurseries where soil has been removed from their roots, which are then kept moist in transit by being dipped in silica gel and then bagged). A tree harvested in this manner ships with more roots intact than a tree dug with soil, at a fraction of the weight and cost. The most recent effort was made possible by funding from the New York State Department of Environmental Conservation.

Our sincere hope is that one fine sunny day in the distant future, people not yet born will appreciate the shade of the trees we are planting today. Planting trees is a generous act of faith in, and a gift to, future generations. Those alive now should come to Green-Wood to enjoy and be comforted by the work of forward-thinking individuals past. Taking in art and history within a transcendent landscape is a powerful and moving experience for the living.

Right: Graves back-lit by early morning autumn light from Lawn Avenue.

Following pages:
40: Lanier family vault on Vine Path, built for James Franklin Doughty Lanier (1800–1881) and his wife and children. The vault is constructed from brownstone in the Gothic Revival style.

41: A Japanese maple with elegantly twisted branches on Fir Avenue.

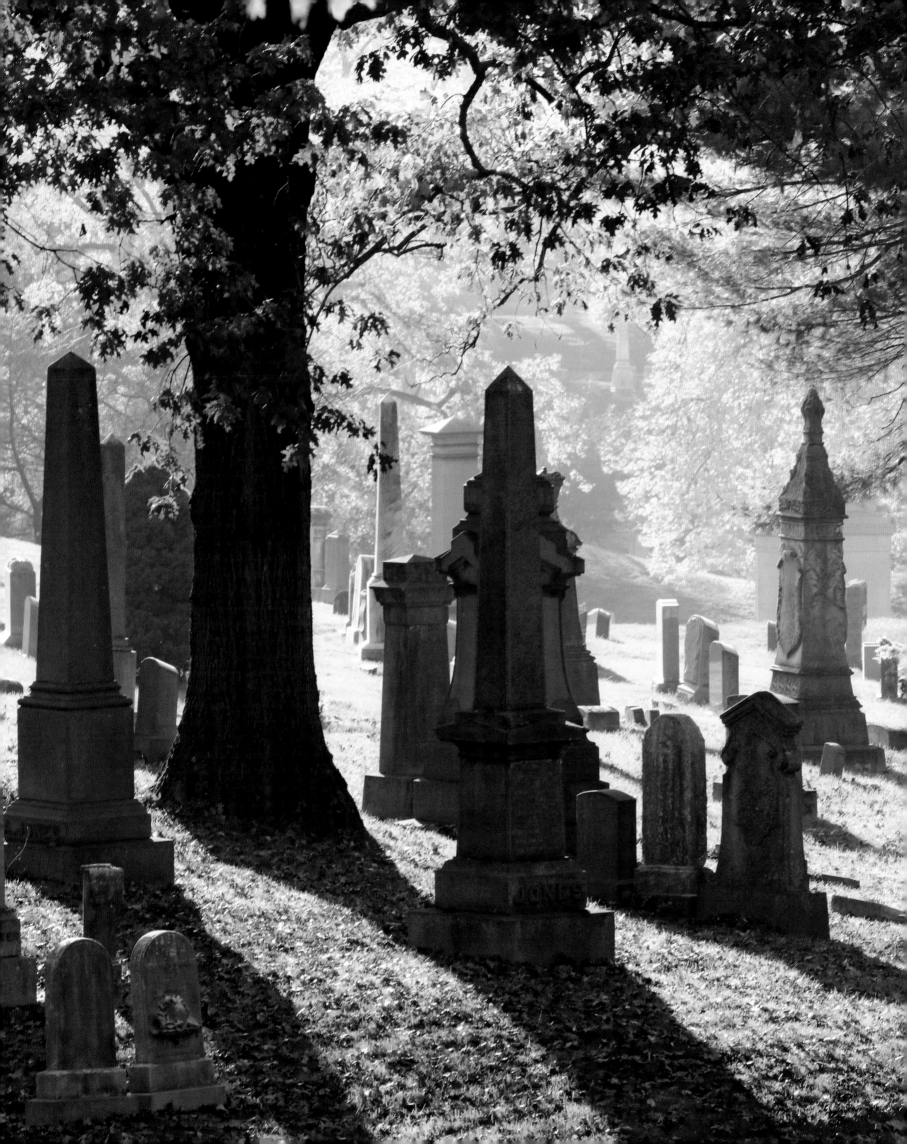

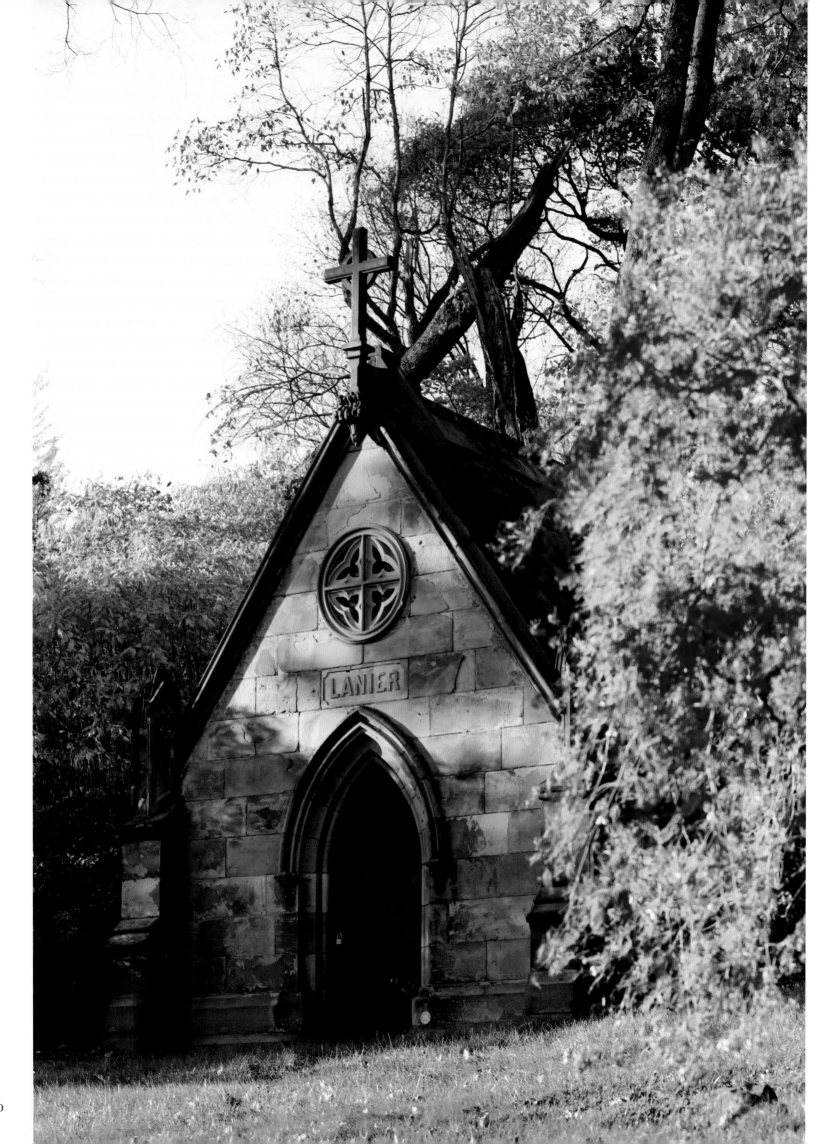

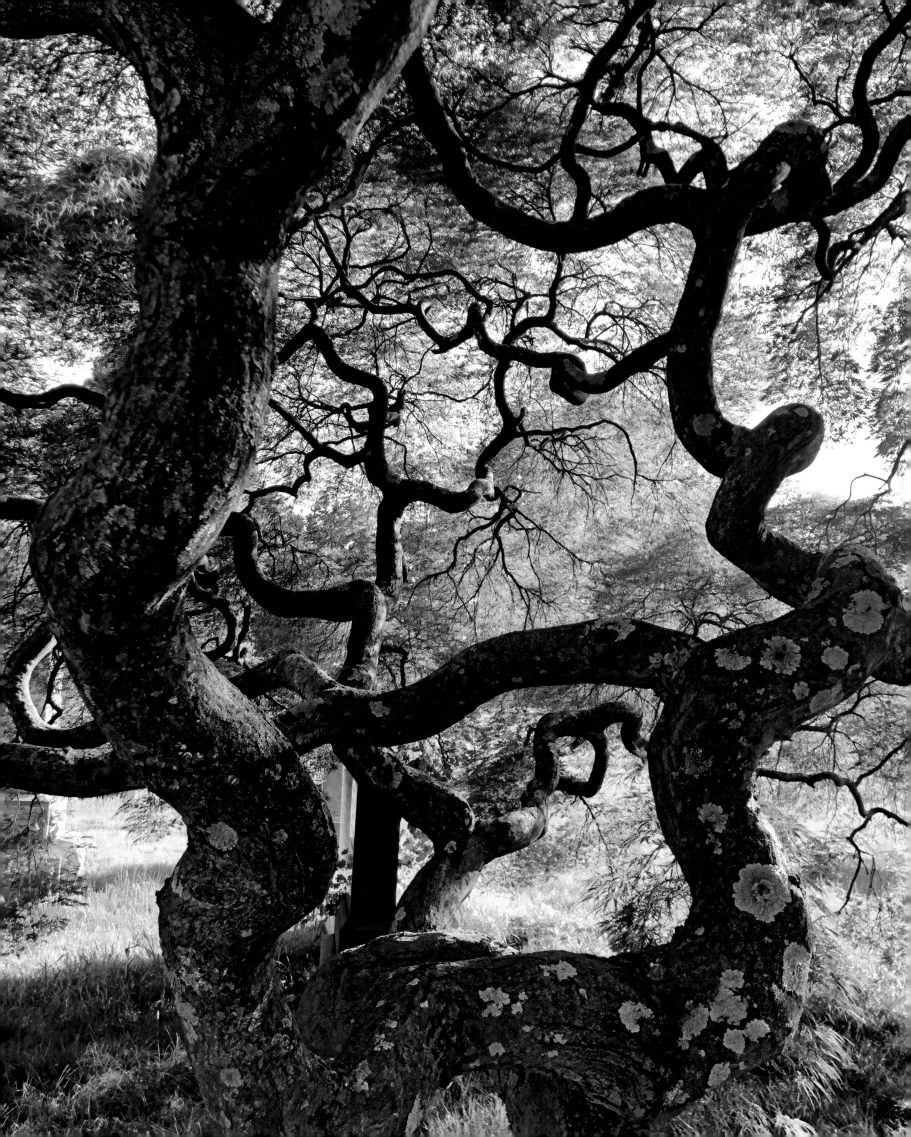

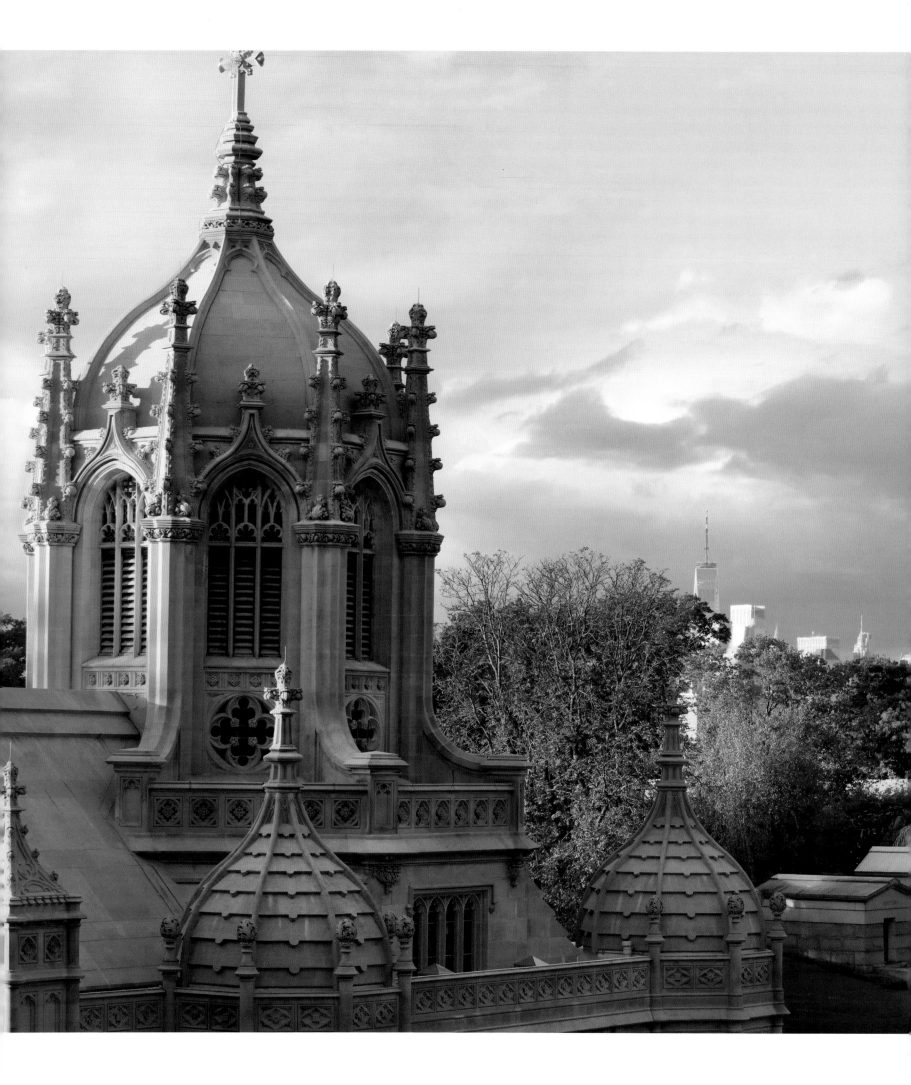

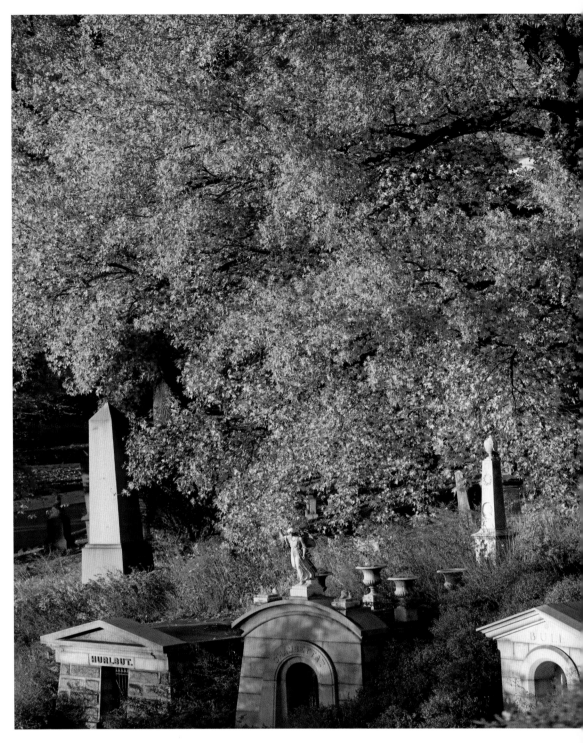

Left: The Historic Chapel stands in late afternoon fall light with the lower Manhattan skyline in the distance. Designed by Warren and Wetmore and completed in 1913, the Chapel is an example of late Gothic Revival (with a sprinkling of Byzantine) architecture, and traditional Beaux Arts–influenced massing. The chapel's structure was inspired by Christopher Wren's Thomas Tower ("Tom Tower") at Christ Church College, Oxford, England (1682).

Above: Fall light dapples the Hurlbut, Chambettaz, and Bull family vaults along Sycamore Avenue.

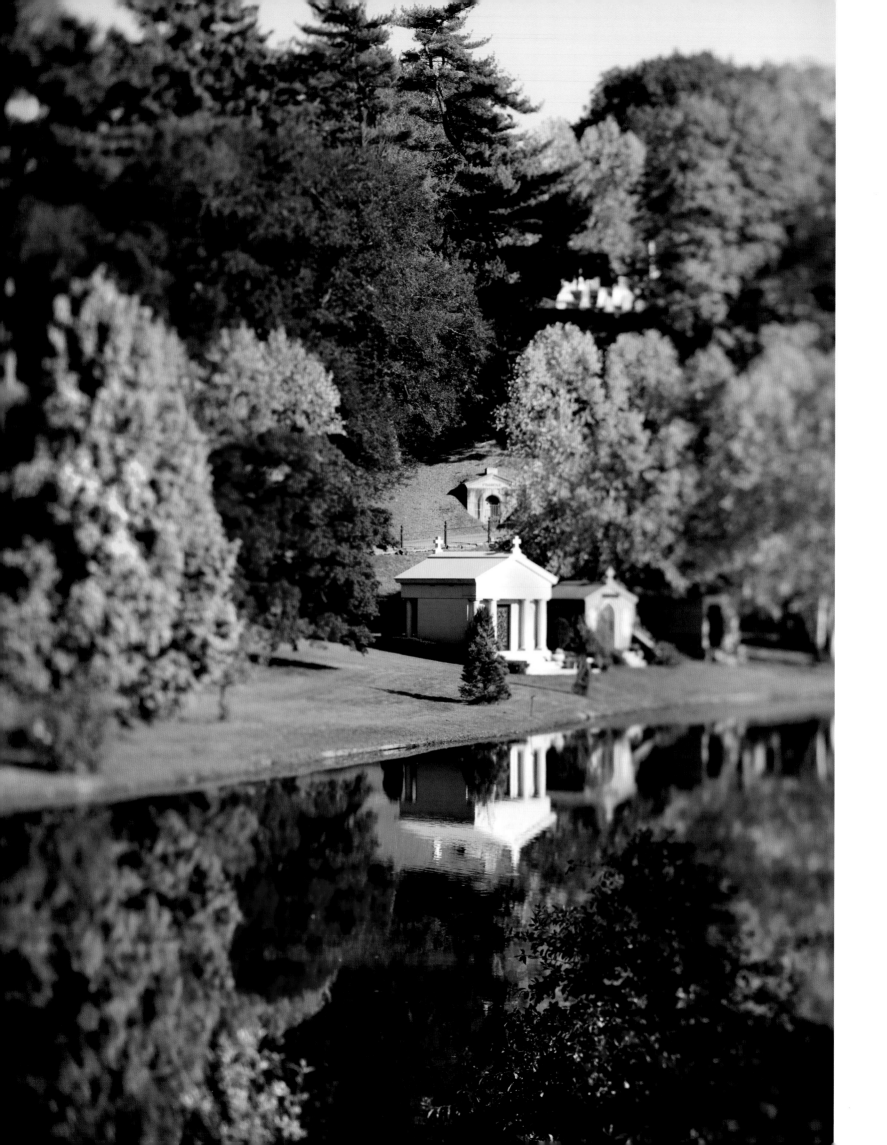

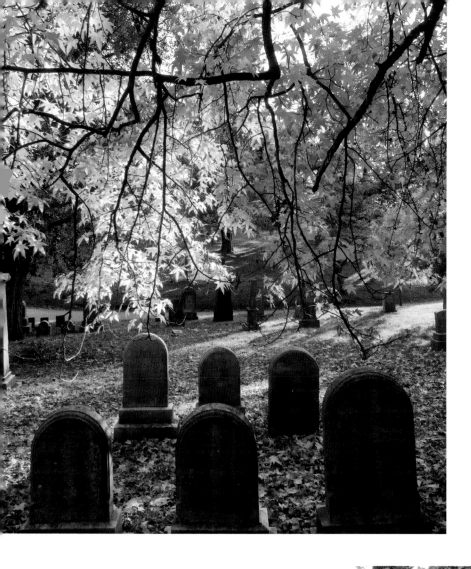

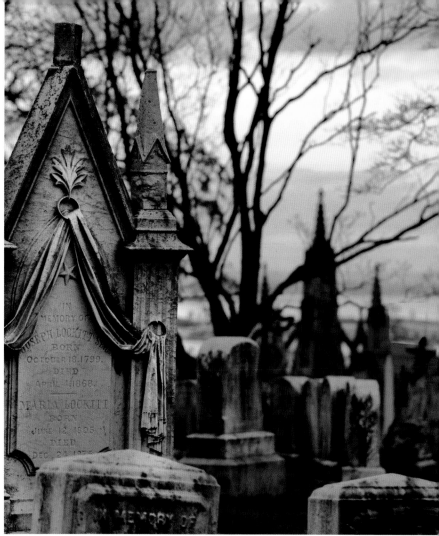

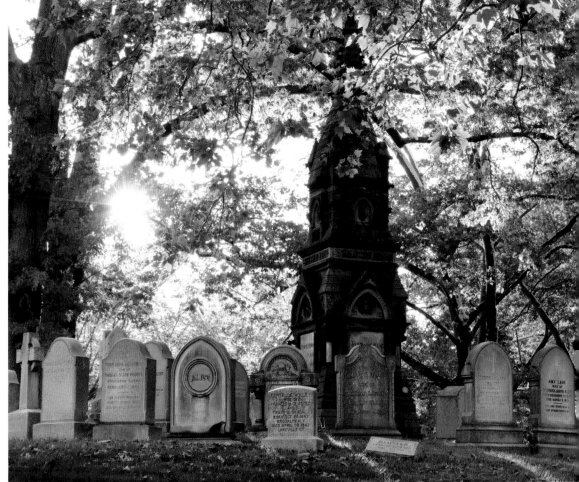

Opposite: Contemporary mausoleums reflected in Sylvan Water in early fall.

Upper left: A family lot under a sweetgum tree.

Upper right: Lockitt family monument overlooking the Arch.

Lower right: Slade family monument and graves.

A common layout at Green-Wood, with a large central monument displaying the family name(s), and a verse or quote, surrounded by smaller head and foot stones for the individual family members buried in the lot. The inscription around the monument, quoting Revelation, reads: "Blessed are the dead which die in the Lord."

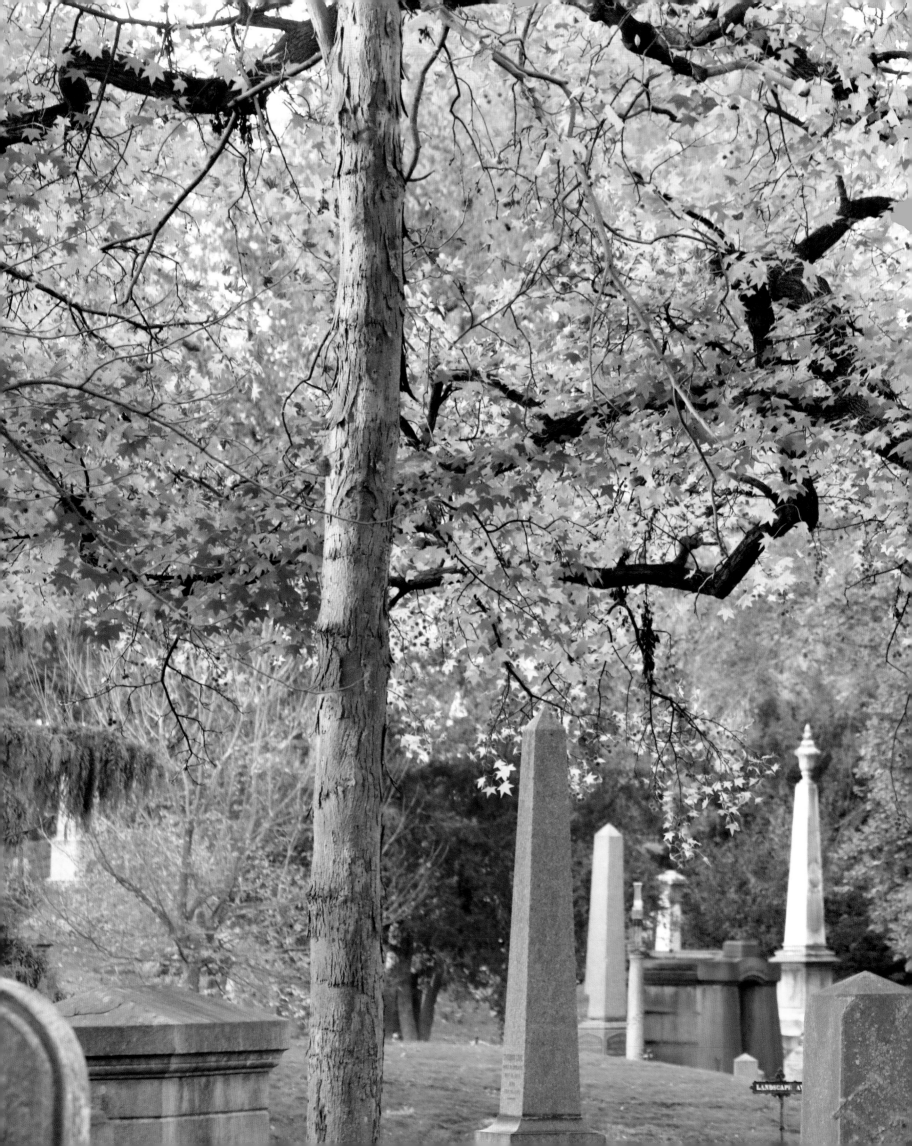

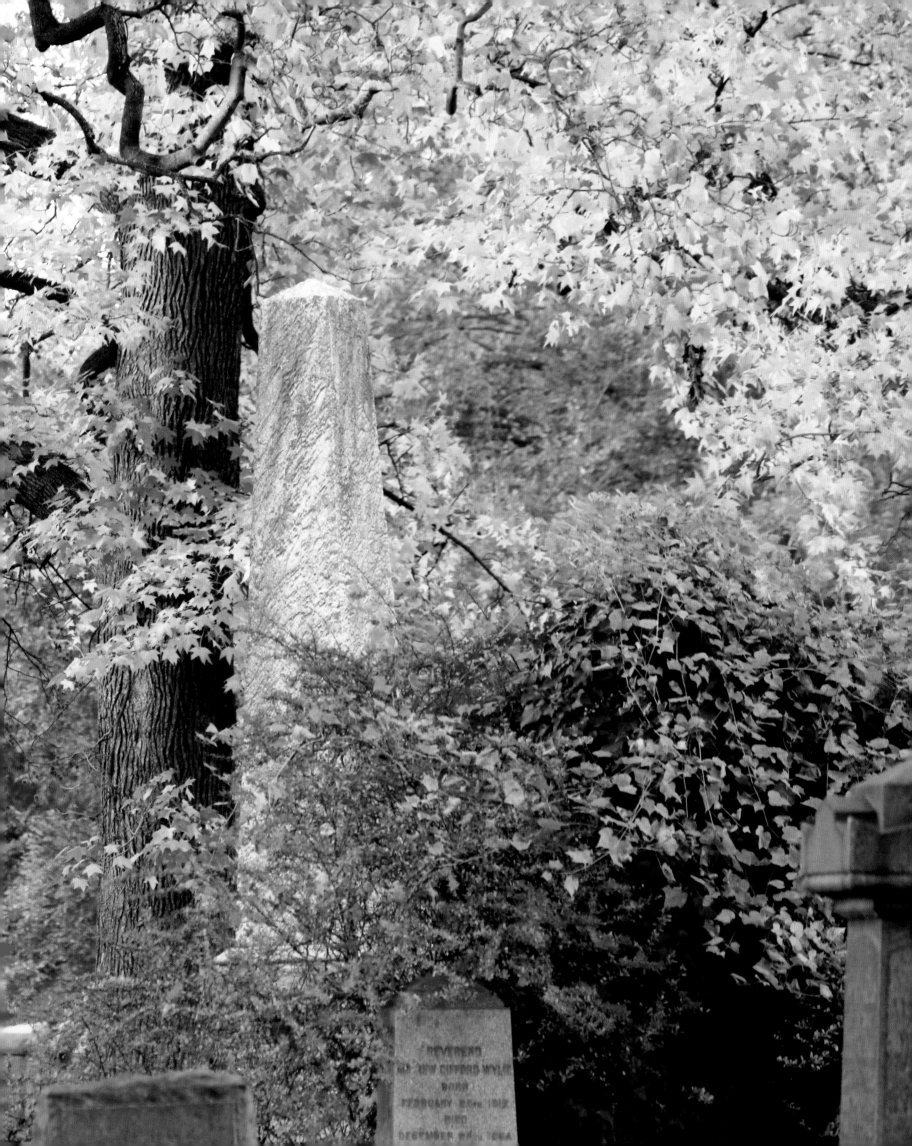

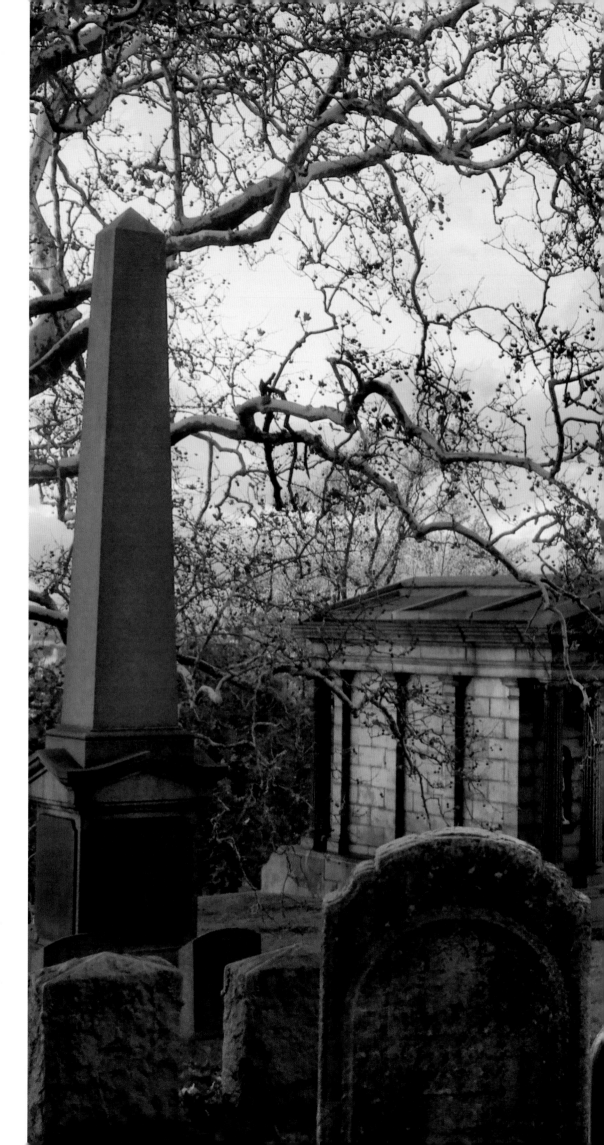

"The boundaries which divide Life from Death are at best shadowy and vague. Who shall say where the one ends, and where the other begins?"—Edgar Allan Poe

Previous pages: Looking from Lawn Avenue toward Landscape Avenue through a group of sweetgum, Himalayan pine, and red oak trees.

Right: View from Greenbank Path, past a London plane tree and the Anderson mausoleum, with the sunset over Lower Manhattan in the background.

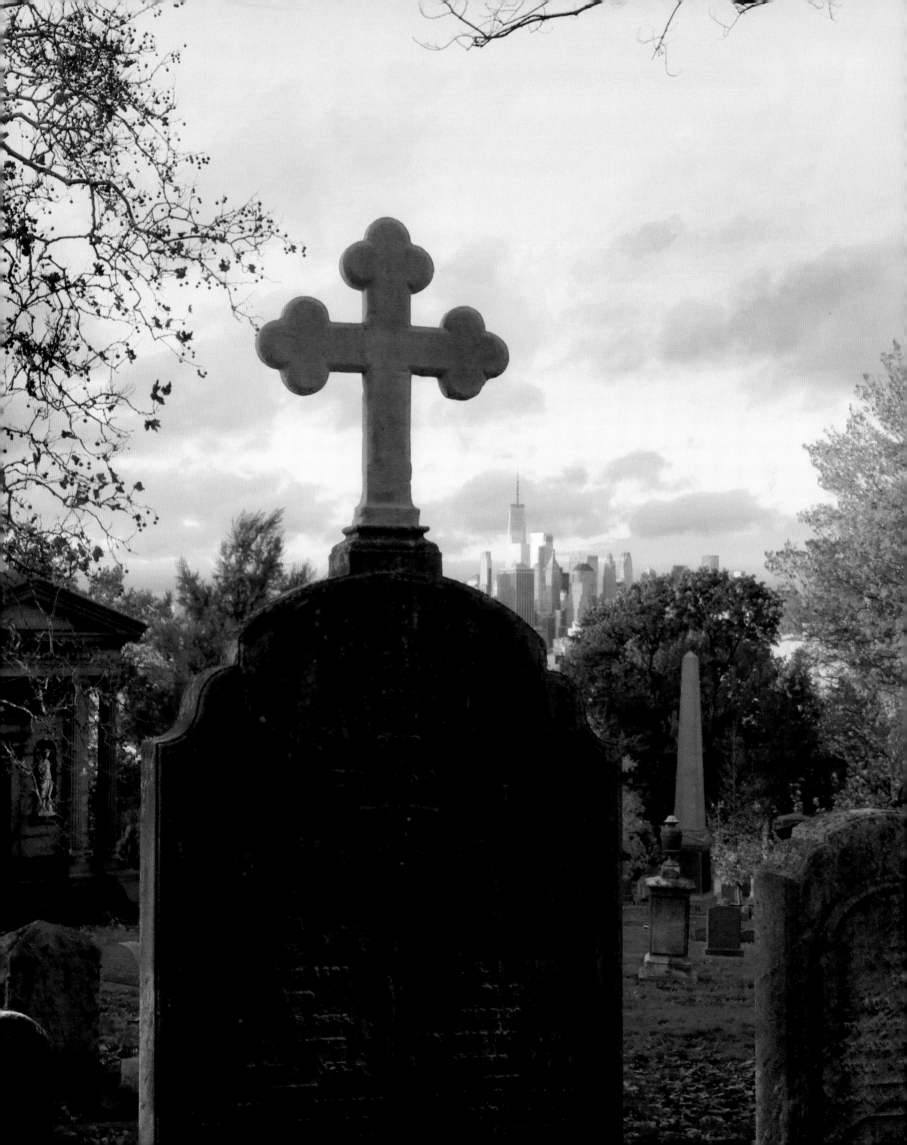

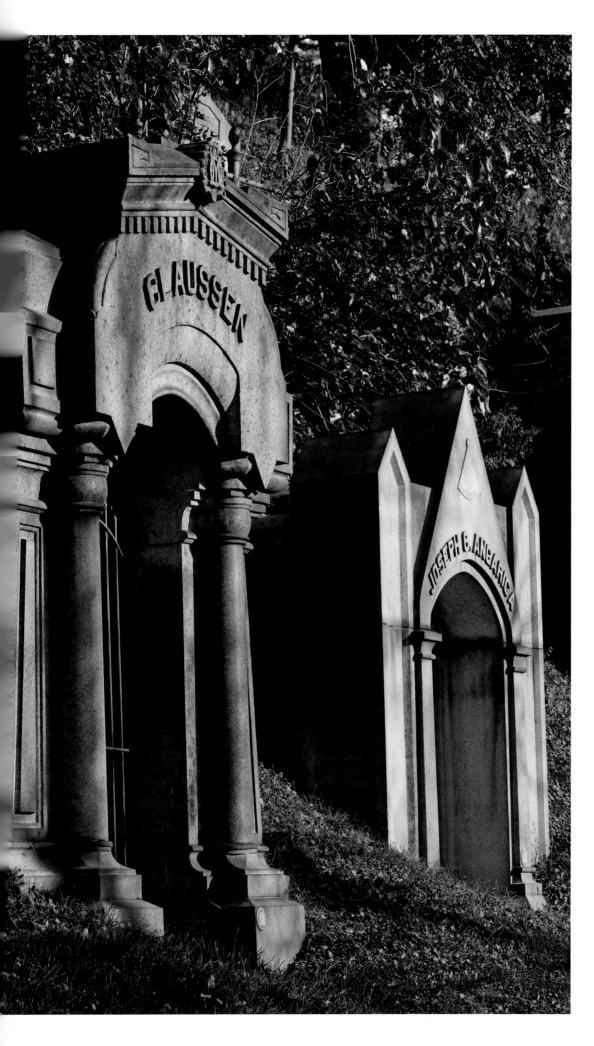

"Death comes to all, but great achievements build a monument which shall endure until the sun grows cold."—Ralph Waldo

Emerson. Left: Claussen and Angarica vaults overlooking Sylvan Water. Opposite: A full moon sets over the crown of the Mason mausoleum on Vine Avenue.

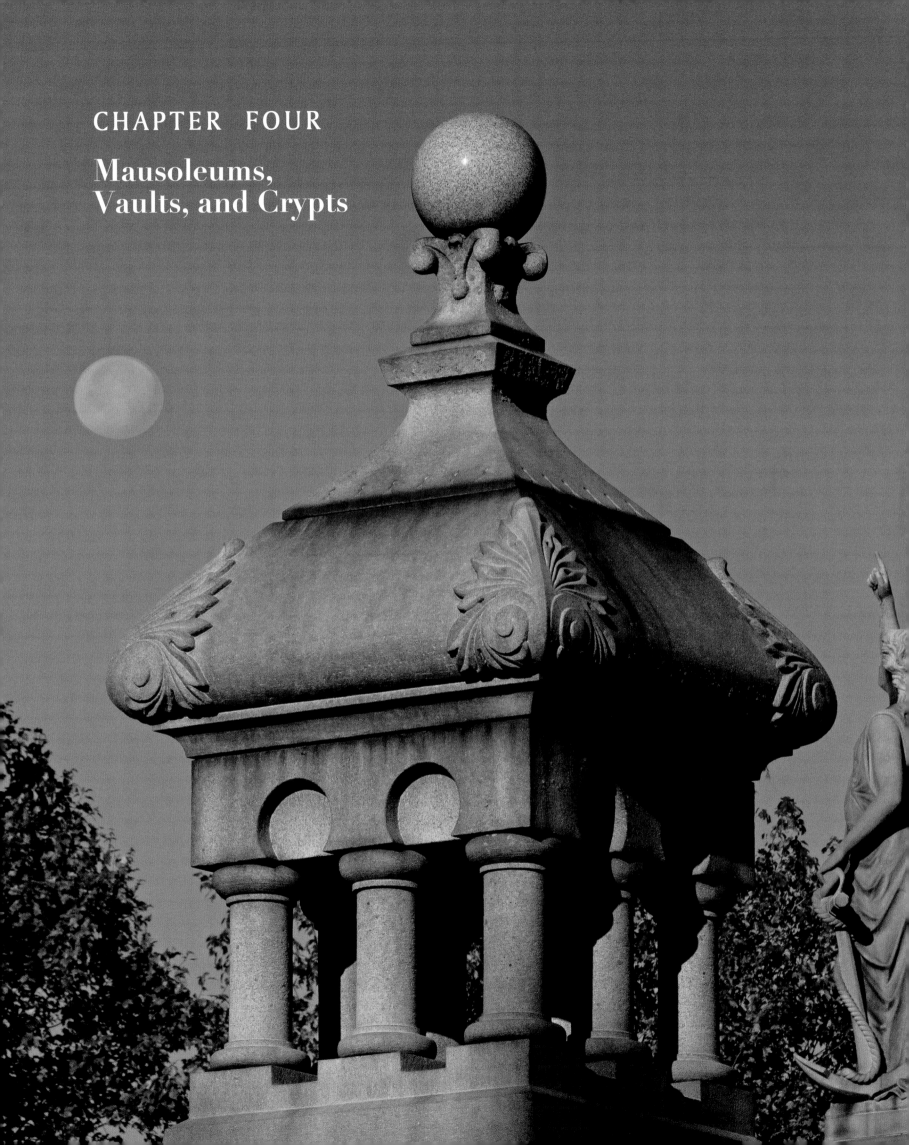

CHAPTER FOUR

Mausoleums,
Vaults, and Crypts

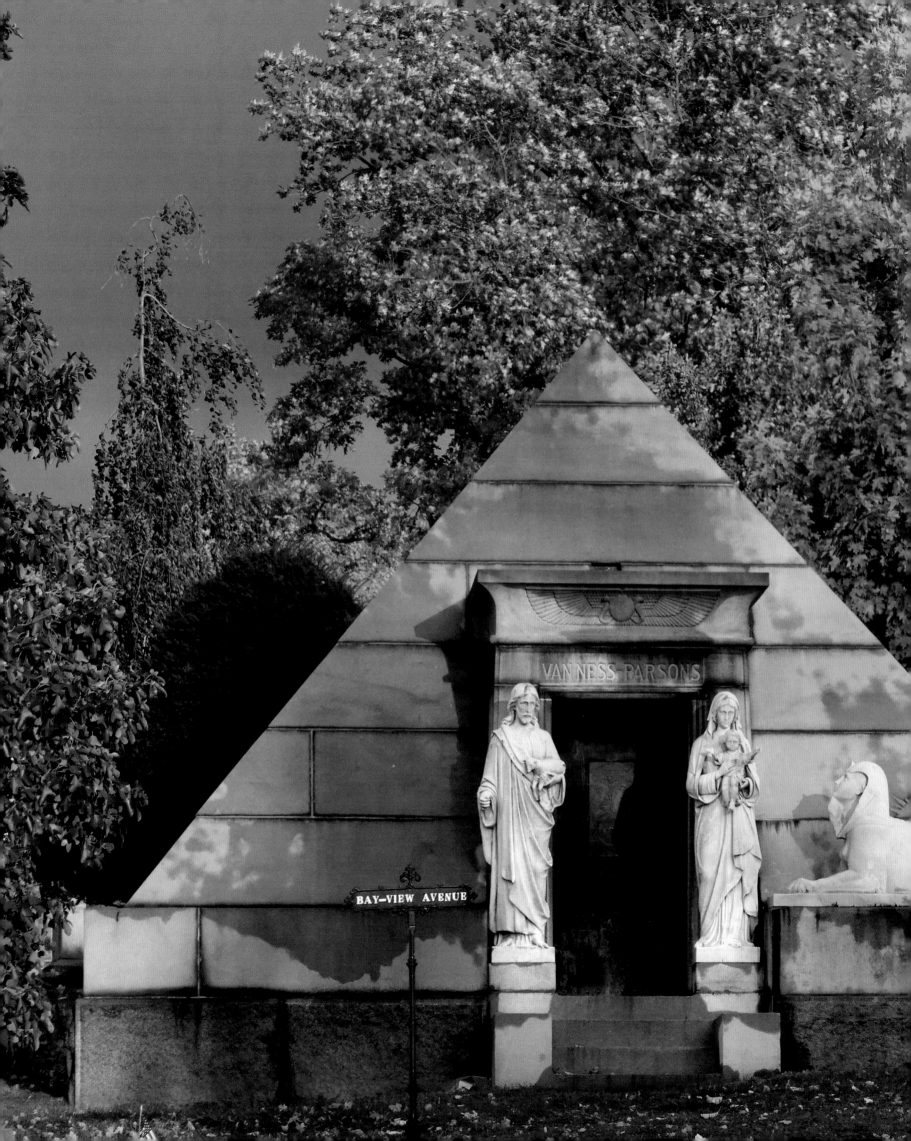

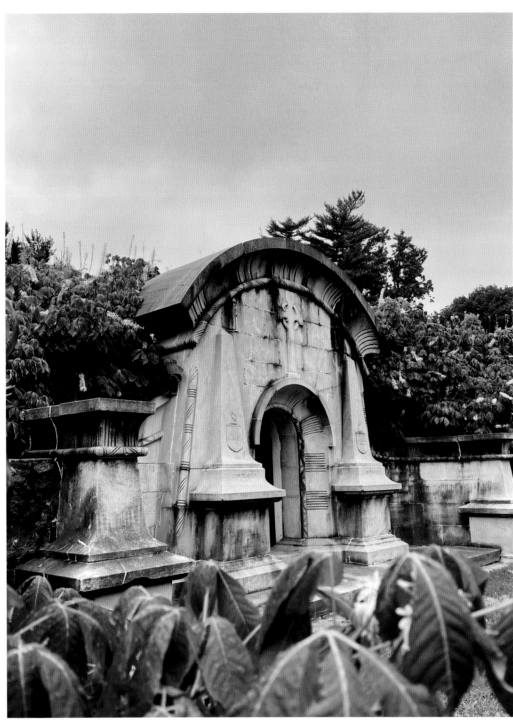

Left: One of several Egyptian Revival pyramid mausoleums at Green-Wood, the Van Ness-Parsons stands alone as the most lavish and eccentric. It was built for the pianist, Egyptologist, astrologer, and philosopher Alfred Ross Parsons, who also wrote *New Light from the Great Pyramid*. The book details the connection between the zodiac and Christianity. The mausoleum is an intriguing mash-up of Eyptian and Christian symbolism, featuring Jesus Christ as the Good Shepard holding a lamb and a sphinx staring up at Jochebed holding her son Moses, while the door features a Christian cross, an orb engraved with a sign of the zodiac, vulture wings, and the Egyptian symbol of the sun.

Above: Bottlebrush buckeye leaves surrounding the Delafield vault. Richard Delafield (1798–1873) served his country as war general, a U.S. Military Academy superintendent, and Chief of the Corps of Engineers of the United States Army. He formed the "Delafield Commission" in 1855 and was sent by then-Secretary of War Jefferson Davis to Europe to observe the European military. Later Delafield was in charge of New York Harbor defenses during the Civil War.

53

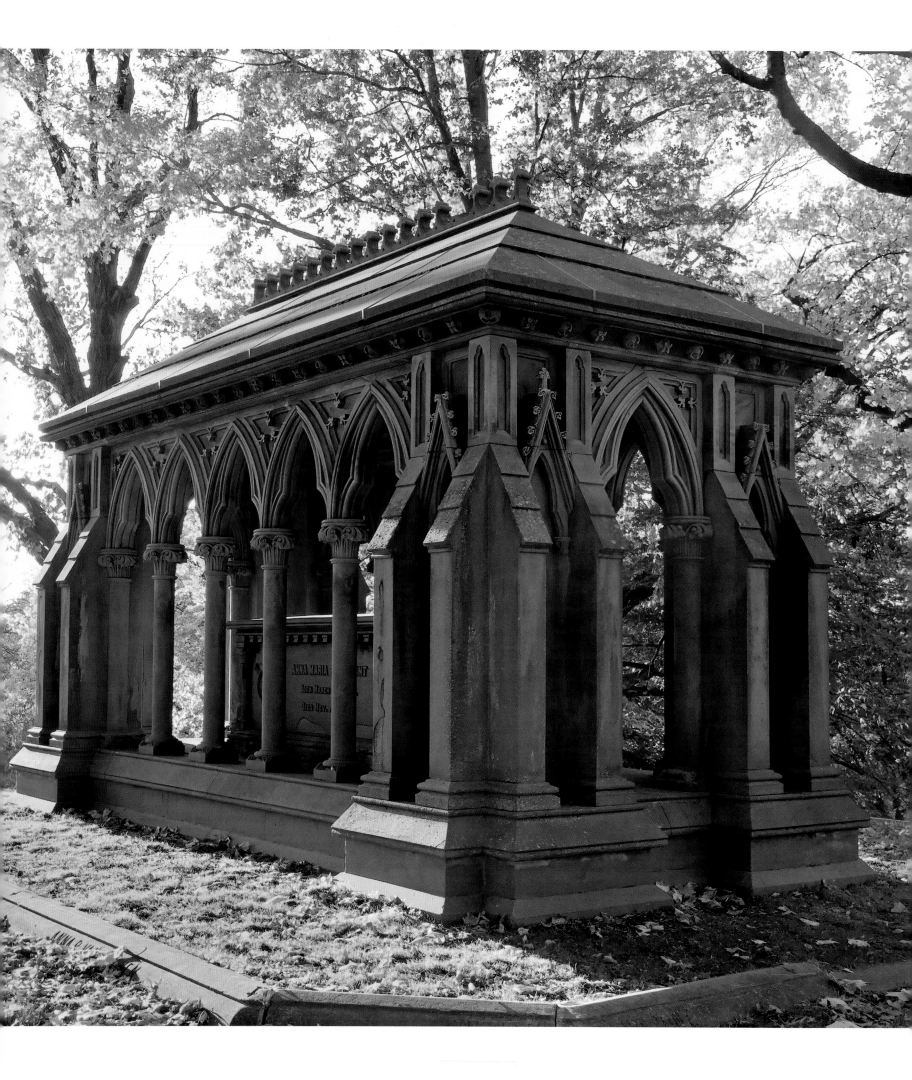

Mausoleums: Architecture for the Afterlife

Andrew Garn

Brooklyn is home to a self-contained and majestic metropolis made of rolling hills and stately trees, dotted with temples and shrines in a variety of forms. The Green-Wood Cemetery's alfresco archive of diverse architectural styles reveals a story of changing cultural tastes and a desire to leave a mark on the world for others to experience.

Its mausoleums freely mix influences from across time and around the world, such as Victorian, Gothic Revival, Neoclassical, Greek Revival, Romanesque Revival, ancient Egyptian, and Islamic design, with a sprinkling of Art Nouveau, Art Deco, and Modernism. These dignified compositions in stone rest on hummocks and nestle into hillsides and in ravines. From a distance, they appear massive, but as one approaches, some are merely small-scale versions of the temples they aspire to be. Instead of honoring kings, pharaohs, or ancient gods, these representations of the grand tombs of the past offer tributes to a railway baron, a silver miner, a banker, a builder of canals, an inventor of great machines, and many other elites of modern New York City.

About 800 mausoleums and vaults are scattered within the gates of Green-Wood. Mausoleums are free-standing aboveground tombs, whereas a vault is built into a hillside. Both may have underground chambers for additional entombment of the dearly departed.

Funerary architecture serves a basic functional purpose similar to the design of a home: to shelter people from the elements. Yet for people of means, it further conveys prestige as to the occupants' status and prosperity. Many wealthy families used the same designers they hired for their houses in life as for their eternal homes. Green-Wood features the works of leading architects and designers like Richard Upjohn, McKim, Mead & White, Warren and Wetmore, Augustus Saint-Gaudens, Ernest Flagg, and Louis Comfort Tiffany.

The tradition of erecting structures to contain the dead dates back millennia. Perhaps the most epic is the Great Pyramid of Giza, towering over the Egyptian desert sand, which was built by the labor of thousands of people. The most iconic mausoleum in history may be the Taj Mahal, constructed by the Mughal emperor Shah Jahan for his favorite wife, Mumtaz Mahal. This exalted masterpiece of white marble and precious stones in India still astonishes visitors today.

There are more modest methods to hold the deceased, including columbaria, which are sepulchral structures, sometimes open to the elements, containing numerous niches for urns. The name columbarium comes from the Latin *columba,* which means pigeon or dove and refers to pigeon houses or dovecotes. It was common for ancient Romans, particularly the middle and lower classes, to be cremated; their ashes were placed into urns that were kept in a communal columbarium. Columbaria have been constructed across Green-Wood in the last century as cremation has become more prevalent in the United States.

Catafalques are ornate, usually movable structures that can be mounted on a stage for a person of importance to lay in state for public viewing. Permanent versions have been erected in cemeteries with a few adorning Green-Wood's hills.

To be celebrated in death in a way that perpetuates and symbolizes the importance of life unites cultures across the world. In Green-Wood, these traditions of belief reverberate in every memorial and in how it was designed to remember the dead.

The Pierrepont Gothic Revival pavilion, designed by Richard Upjohn, stands almost in the center of the old boundary of the Cemetery, on a hill once called Lawn Girt, between Lawn and Central Avenues. It serves as a memorial to the family of Green-Wood's founder, Henry Evelyn Pierrepont (1808–1888). Pierrepont also played a significant role in the planning of Brooklyn—beginning its ferry services to New York—as well as in the establishment of The Green-Wood Cemetery itself. Within the pavilion is a monument in the form of a sarcophagus, which bears the family's names and birth dates.

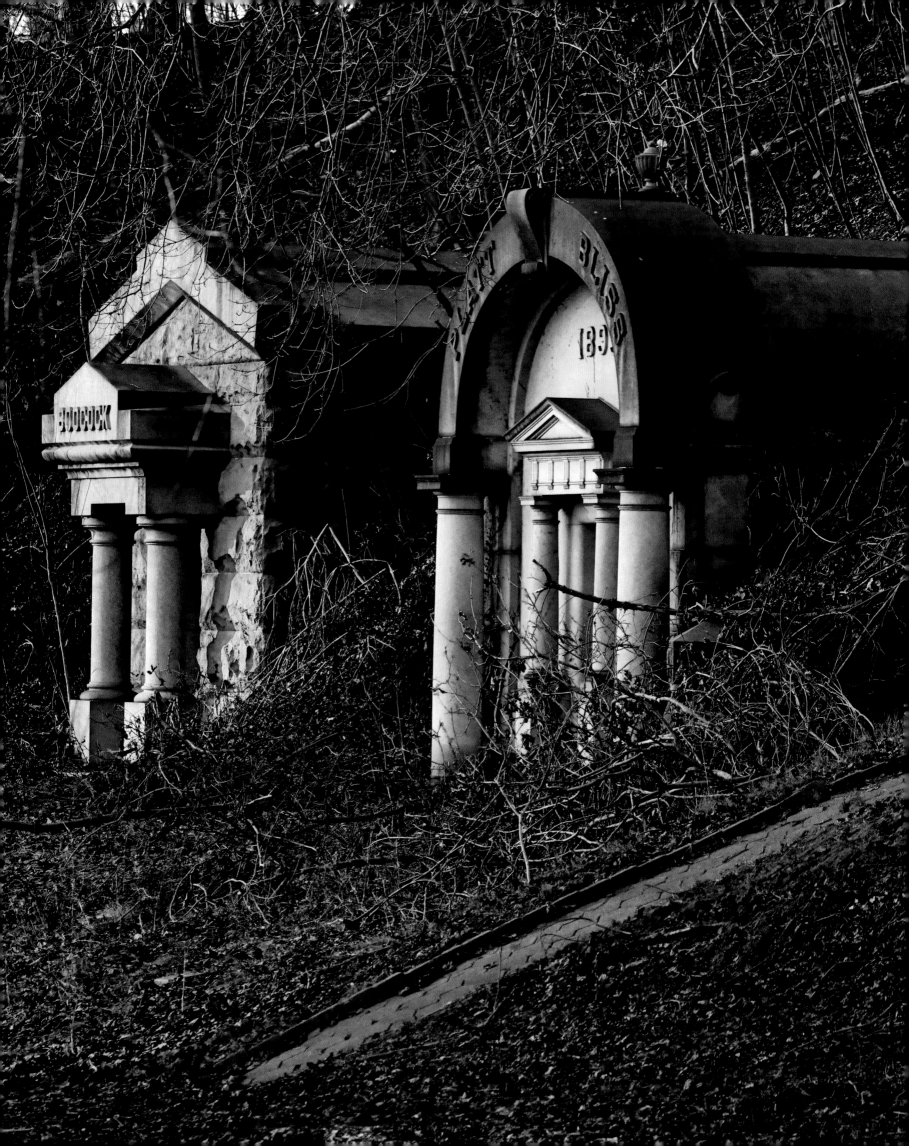

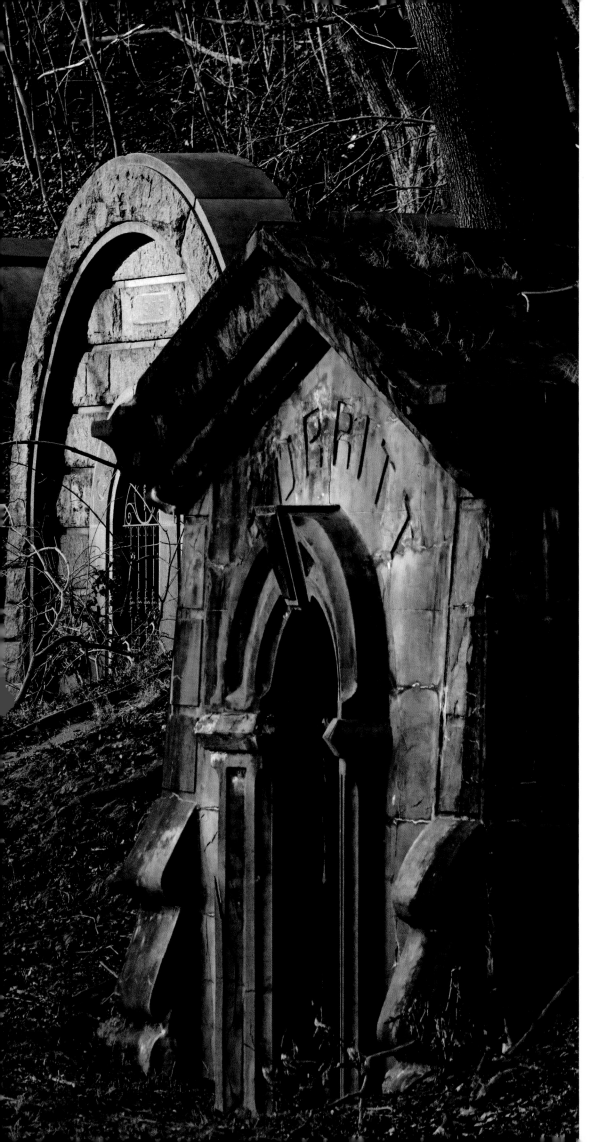

"No human dwelling is within view, if we except the still mansions of the dead. Neither sight nor sound is here to remind us of the noisy, living world."—Nehemiah Cleaveland

Left: (Green-Wood's first historian) in *Green-Wood Illustrated* (1847). Vaults stand solemnly facing Dell Water, including those of the Platt-Bliss, Boocock, Murray, and Burritt families. Somewhat overgrown and sheltered in a quiet ravine, Dell Water is a birder's paradise.

Following spread:
58: The John Anderson mausoleum sits on a prominent hill as one enters the Cemetery. A stately Greek Temple in miniature, the structure memorialized Anderson and his family. Anderson was a tobacco magnate suspected of killing Mary Rogers, known as "the beautiful cigar girl," whom he had hired to attract male customers to his shop in Lower Manhattan. The shop was frequented by writers Washington Irving, James Fenimore Cooper, and Edgar Allan Poe. Poe wrote a poem in homage to Mary, whose lifeless body was discovered floating in the Hudson River in 1841. Although there were numerous suspects, including Mary's boyfriend, Anderson, and even Poe, no one was ever charged with the crime.

59: The Cornelius Kingston Garrison (1809–1885) mausoleum, is a Moorish Revival gem with touches of Byzantine and Islamic motifs, designed by architect Griffith Thomas. Thomas also designed the original New York Life building in Manhattan. Garrison made his fortune from owning ships and setting up a bank near the Panama Canal during the California gold rush. The mausoleum features marble, granite, and a copper dome. It was restored in 2021 by the Green-Wood restoration staff, and participants in The Bridge to Crafts Careers Program, a paid training program in masonry restoration presented in partnership with World Monuments Fund and Opportunities for a Better Tomorrow.

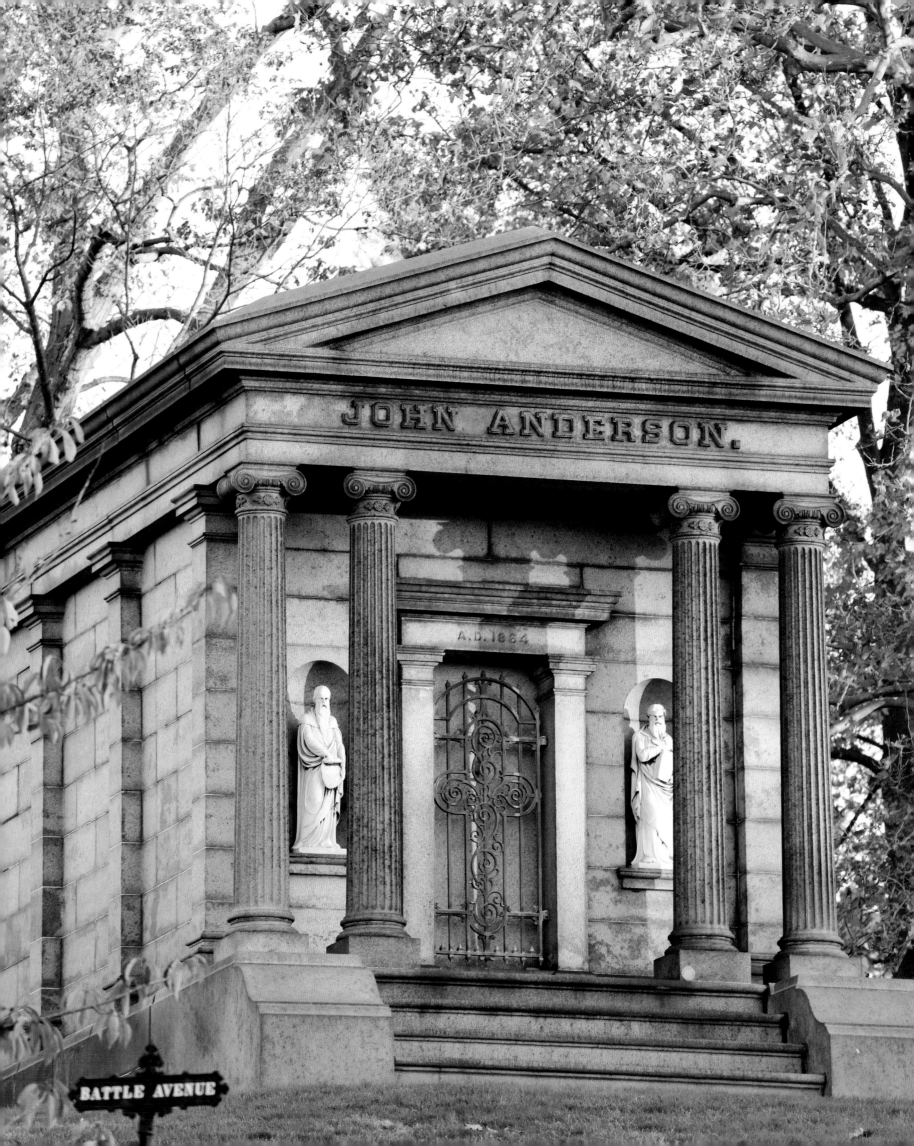

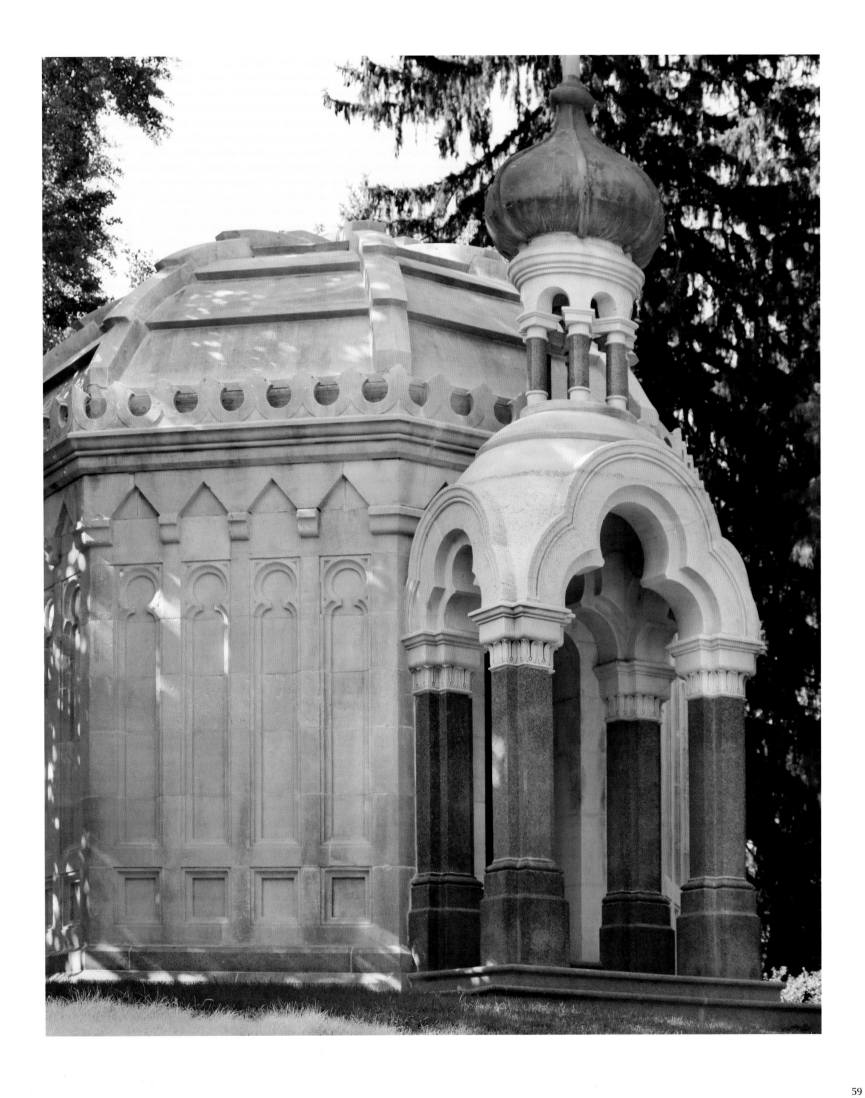

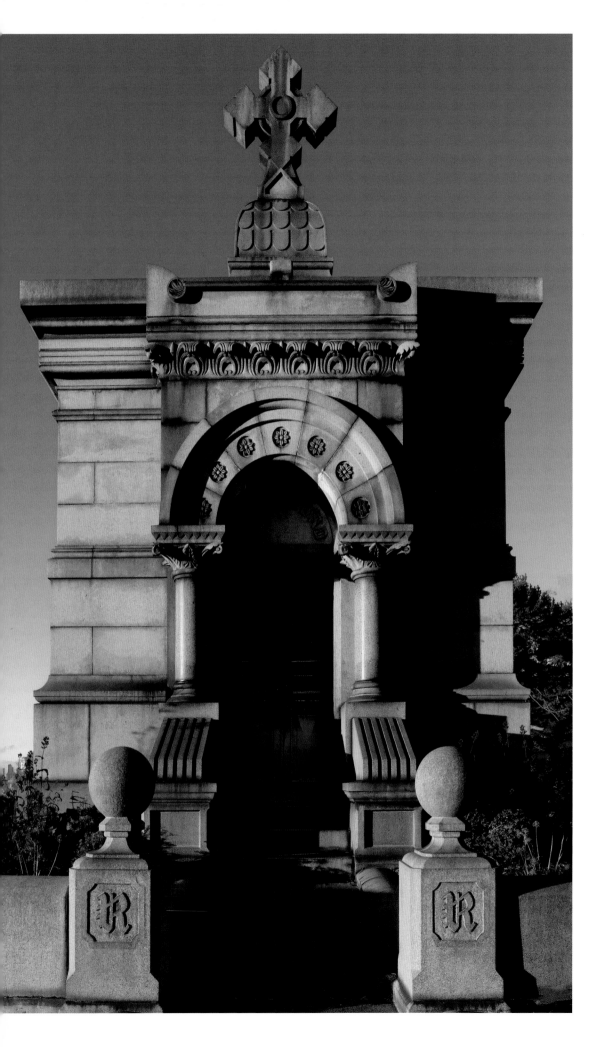

Left: The stately Rutherford mausoleum facing Oak Avenue on Hilly Ridge.
Opposite: Multiple Gothic spires surround this octagona-shaped mausoleum of William Chauncey, a wealthy shipping merchant. Recently restored, the stone used was rumored to be quarried by prisoners in Sing Sing prison, thirty miles up the Hudson River.

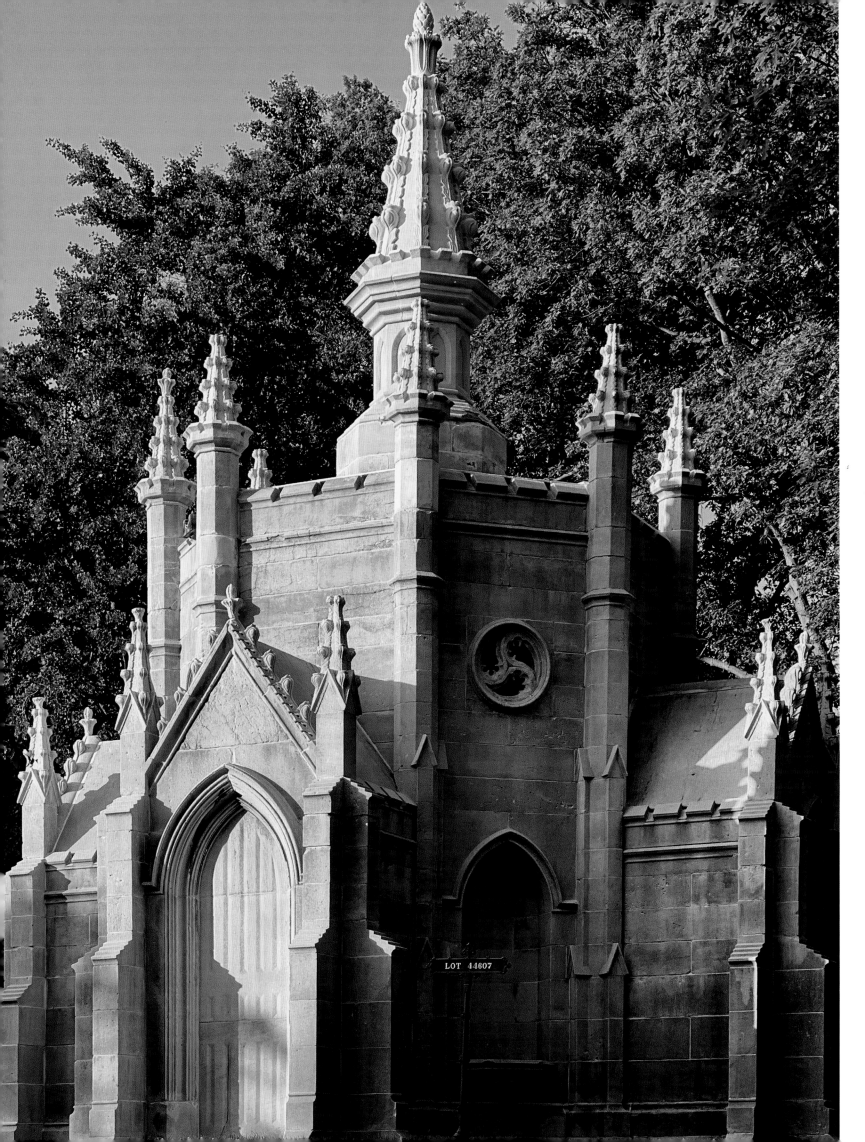

LOT 44607

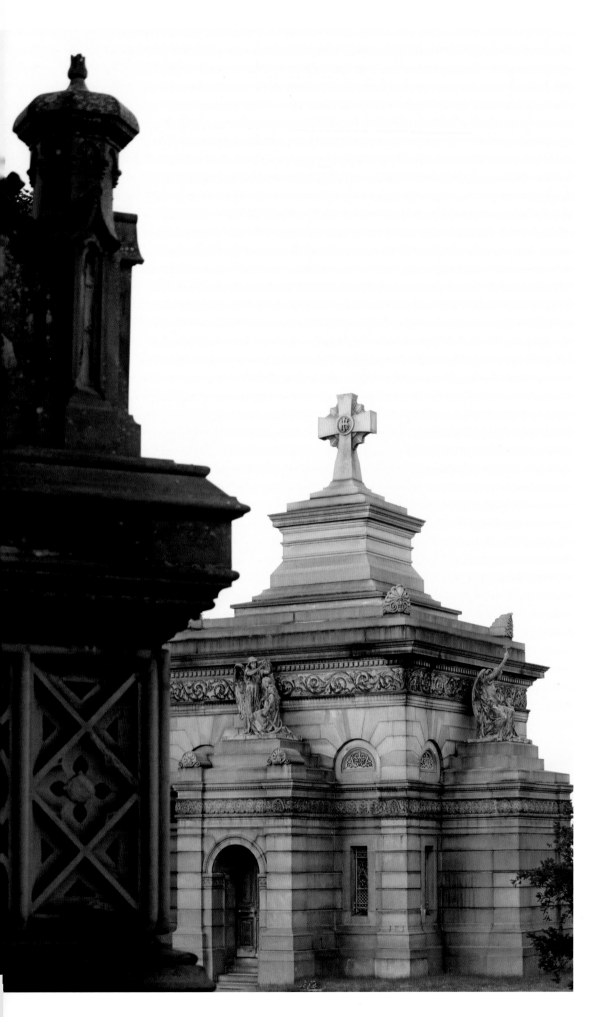

Left: The Mackay mausoleum, one of the largest and most costly structures in Green-Wood, was built by John Mackay in 1895 in the Italian Renaissance Revival style. The four statues surrounding the structure depict Sorrow, Faith, Death, and Life. The roof panel, at 26.5 feet square and 14 inches thick, is thought to be the largest piece of stone ever quarried in the United States. Mackay had become one of the wealthiest men in America through silver mining at the Comstock lode in Virginia City, Nevada. The mausoleum is the only one in the country wired for heat and electricity, as Mackay thought a warm and bright mausoleum would entice clergymen to be more apt to visit and pray for the souls interred. A fund was set aside allowing priests to continue to say Mass inside until 1954. Opposite, clockwise from upper left: Hurlbut, Thompson, Tucker, and Dewey vaults in various locations.

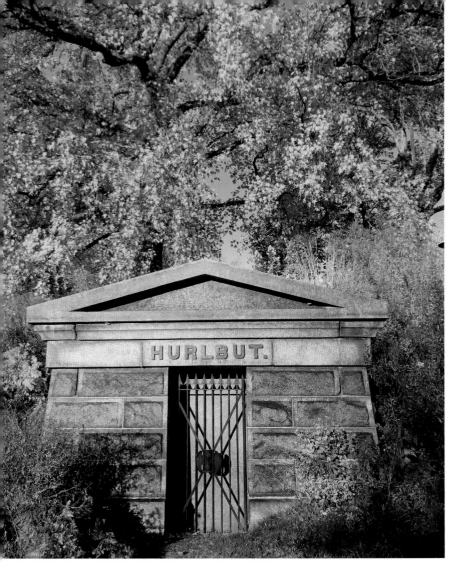

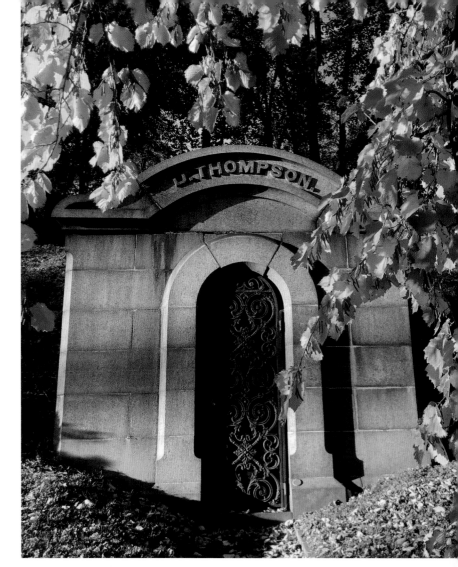

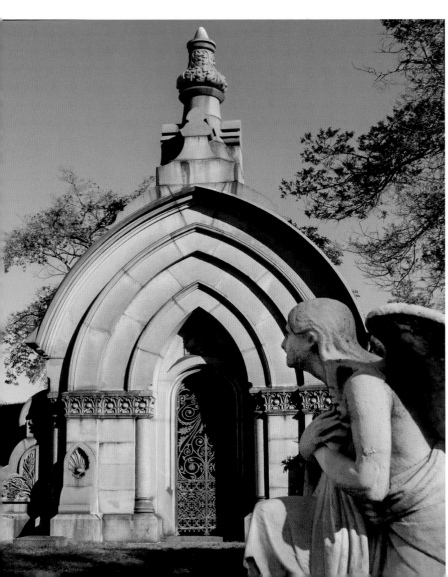

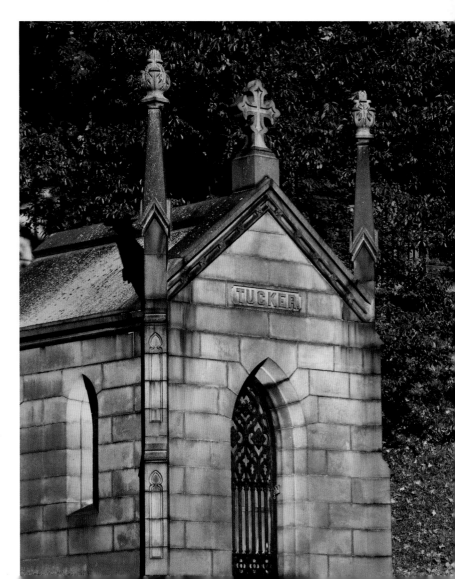

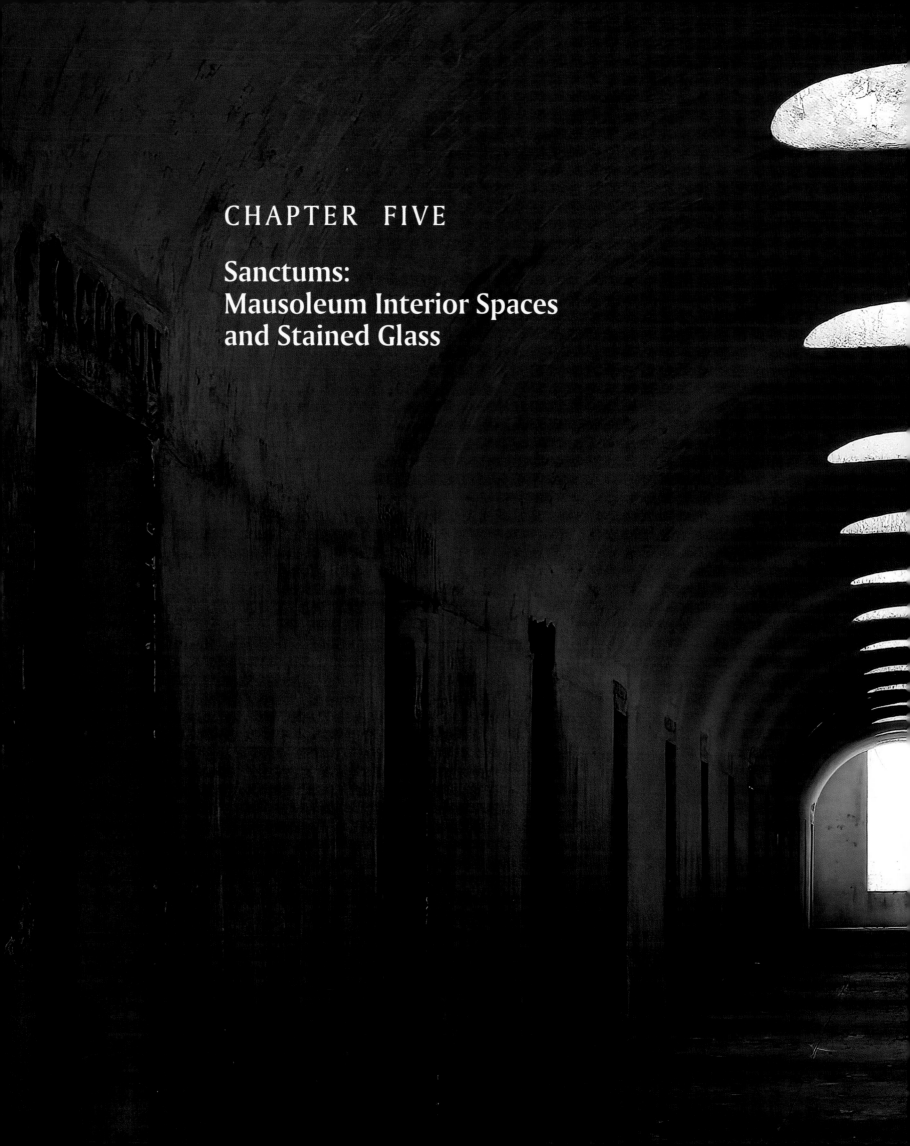

CHAPTER FIVE

Sanctums:
Mausoleum Interior Spaces
and Stained Glass

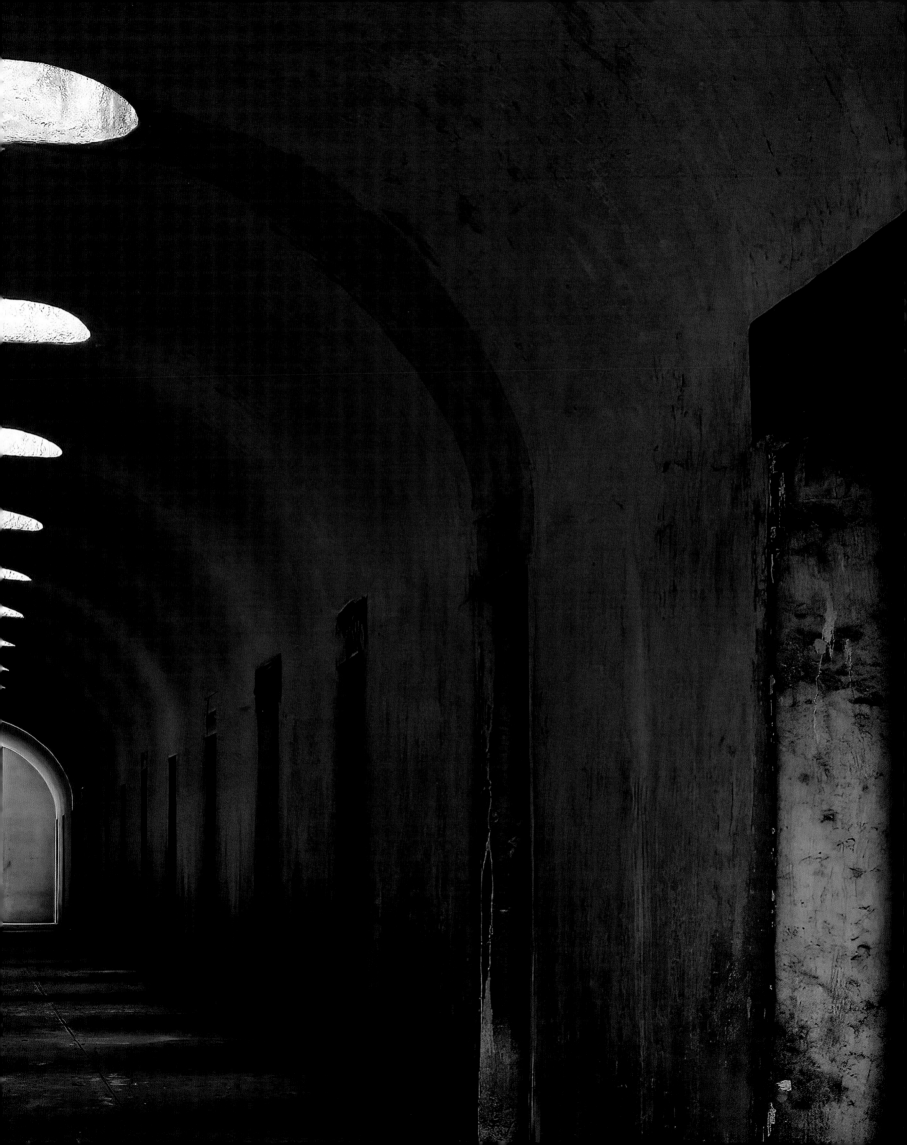

"Death is no more than passing from one room into another. But there's a difference for me you know. Because in that other room I shall be able to see."—Helen Keller

Previous spread: When opened in the 1850s, the Catacombs were an innovative burial system, a sort of apartment house for a middle-class clientele. It also appealed to those wanting to be buried aboveground (for fear of being buried alive, a common notion in those days) but who could not afford a free-standing single-family mausoleum or vault. Within the main barrel-vaulted chamber, thirty individual family vaults share access. Among the permanent residents is Ward McAllister, a tastemaker during the Gilded Age who coined the praise "The 400," referring to the top New York families in high-society standing.

Above: The setting sun illuminates the interior of the Bryce vault.
Opposite: Ranken Family vault.

Next spread:
68: A view inside the Dewey vault.
69: Steinway mausoleum interior.

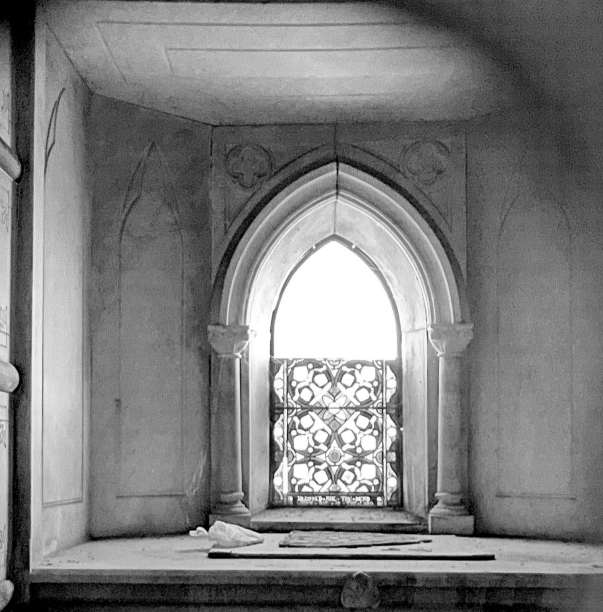

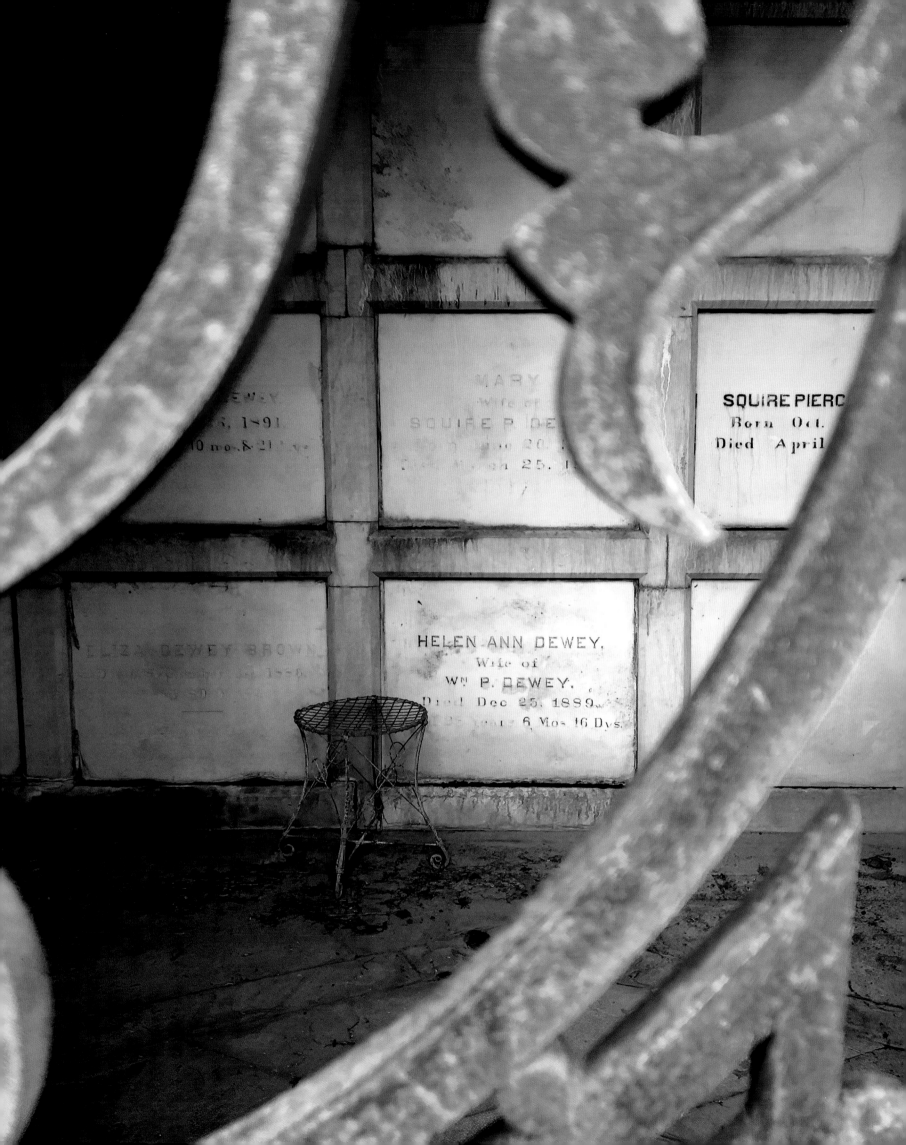

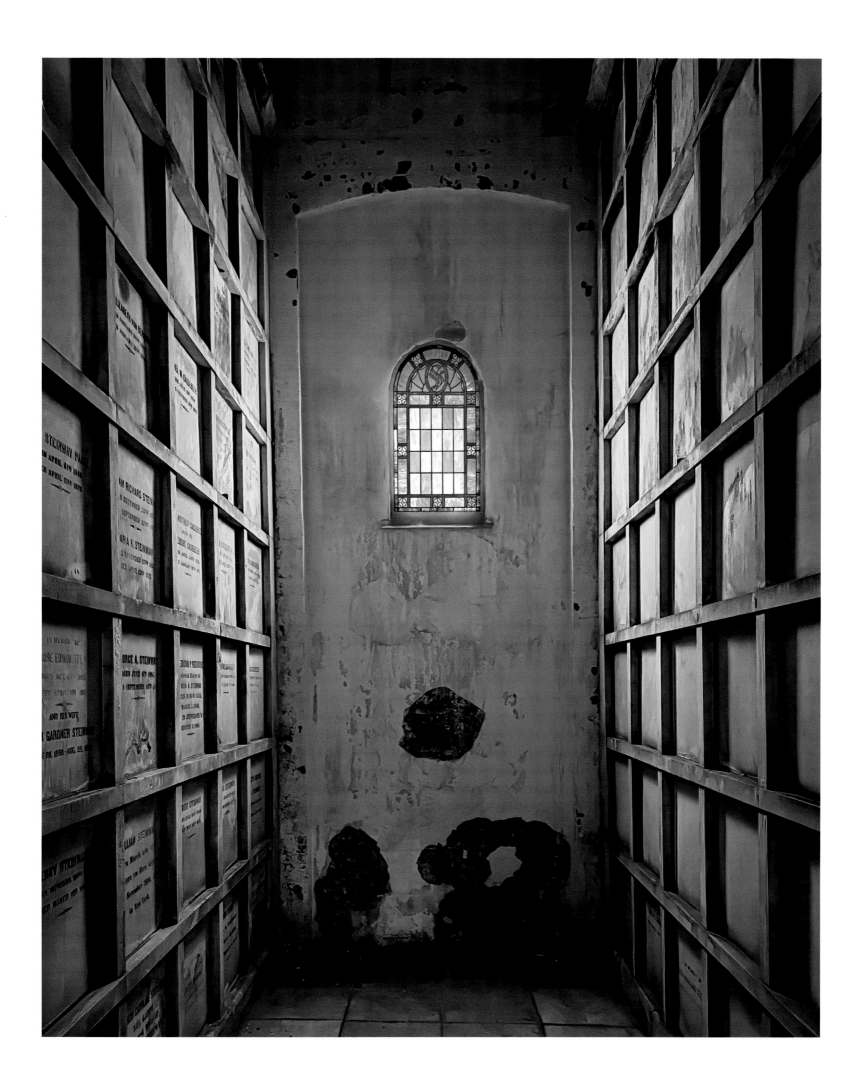

HARRIET A. HARTMANN

BORN AUG. 25, 1842.

DIED MAY 7, 1919.

JANE C. JACKSON

BORN MAY 27, 1836

DIED DEC. 22, 1921

OUR MOTHER

CATHERINE A. CROSSMAN,

DIED MAY 26, 1898.

OUR FATHER

JAMES W. CROSSMAN,

DIED MAY 20, 1875.

GEORGE W. CROSSMAN

BORN SEPT. 14, 1844,

DIED JAN. 15, 1913.

WILLIAM H. CROSSMAN

BORN DEC. 20, 1831.

DIED JUNE 18, 1895.

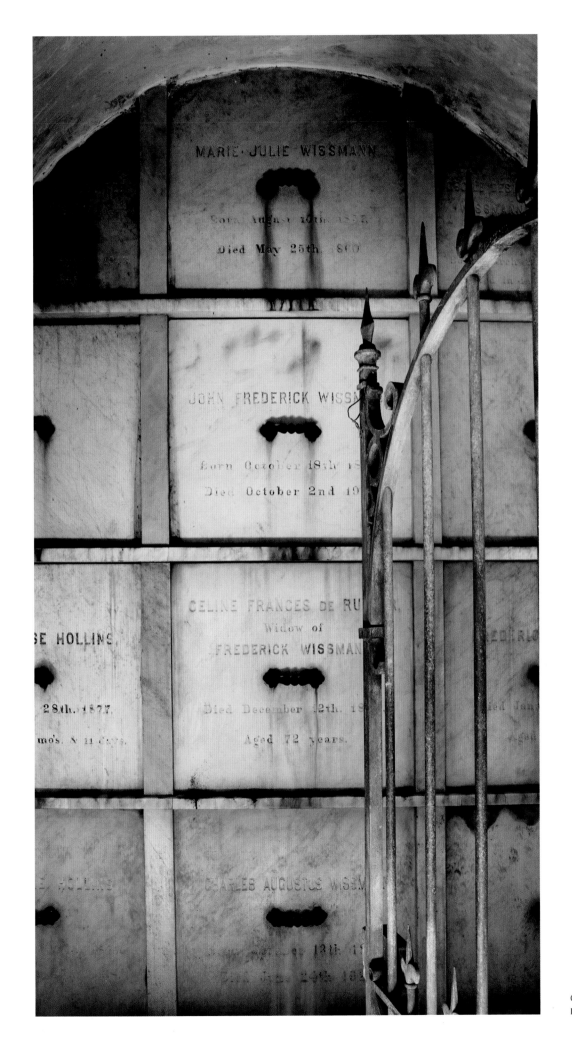

MARIE JULIE WISSMANN

Born August 19th, 1833.

Died May 25th, 1890

JOHN FREDERICK WISSMAN

Born October 18th, 18

Died October 2nd, 19

SE HOLLINS.

CELINE FRANCES DE RU
Widow of
FREDERICK WISSMAN

28th, 1877.

Died December 12th, 18

mo's. & 11 days.

Aged 72 years.

CHARLES AUGUSTUS WISSM

Opposite: Crossman vault interior.
Left: Wissman vault inside the Catacombs

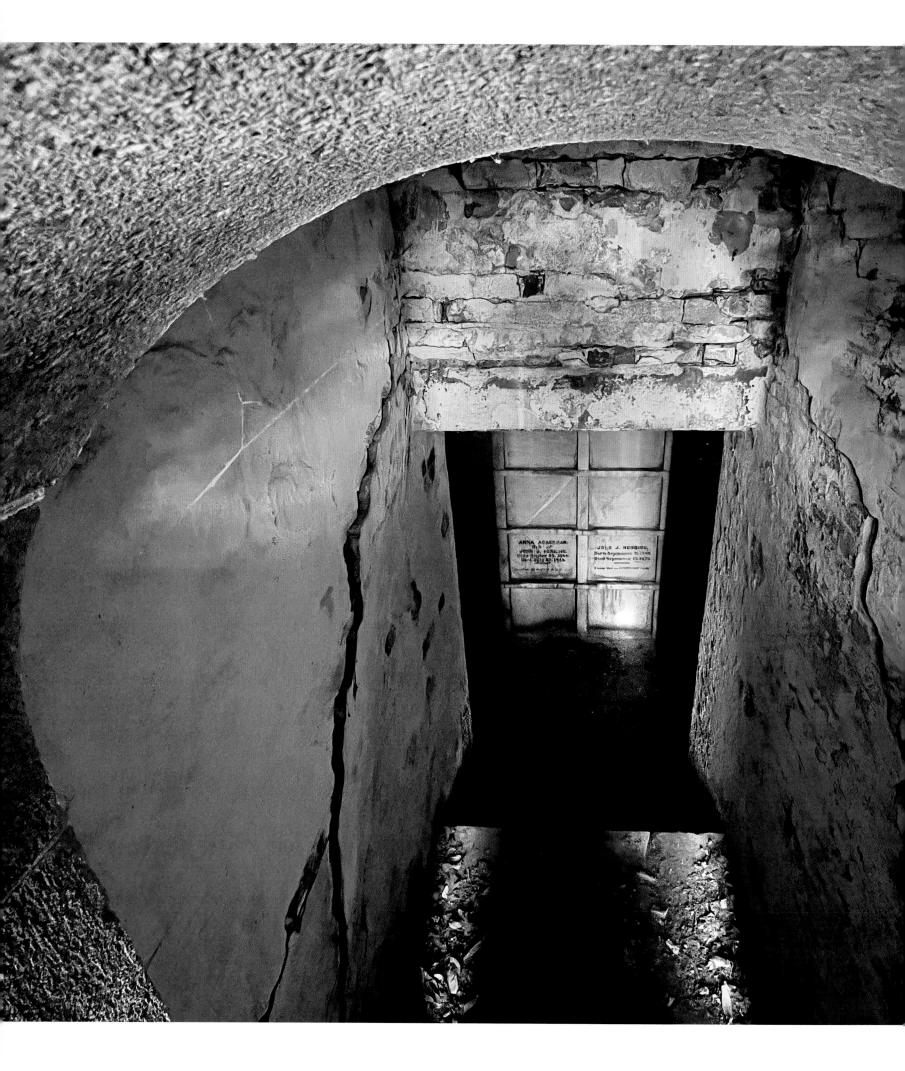

"I hope it is true that a man can die and yet not only live in others but give them life, and not only life, but that great consciousness of life."—Jack Kerouac

Left: Poillon vault looking down into an underground chamber.
Above: Keys for the Delafield vault.

Stained Glass at Green-Wood

Julie L. Sloan

With the growth of enormous fortunes during the Gilded Age, elaborate mansions were built to express one's wealth during life. Likewise, elaborate single-family mausoleums came into popularity in rural cemeteries and were also built to impress. Some were as large as chapels, while others were small Greek or Egyptian Revival temples. Many had at least one window opening to let in light, along with a bronze door with some manner of grille to allow a view inside. Typically the window opening was filled with stained glass, usually to commemorate the paterfamilias or as an artistic expression of grief. But it was also a welcoming spot lit with sunlight in an otherwise somber surrounding. The Green-Wood Cemetery is home to many interesting and artistic stained-glass windows by both known and unknown artists. It is also the resting place of many stained-glass artists. Interestingly, the two most famous American stained-glass artists—Louis Comfort Tiffany and John La Farge—are both buried at Green-Wood, but neither burial site has stained glass.

Cemetery windows run the gamut of designs, from religious figures to decorative flowers to fraternal symbolism. At Green-Wood, the Daly Mausoleum illustrates Christ standing in a field of lilies, symbolizing purity, welcoming us into the eternal garden. Resurrection angels light the Bedford and Reisenweber mausoleums, with lilies and irises, comforting with the belief of the resurrection of the dead. Mourning angels adore a jeweled cross in D. Maitland Armstrong's window in the Somers mausoleum. An angel kneels before a broken column adorned with a laurel wreath, a classical symbol of mourning, in the Sullivan mausoleum, while the laurel wreath and flaming braziers of classical art adorn the Hungerford tomb. A more obvious scene of resurrection is *Noli Me Tangere* in the Schmadeke tomb, where Christ warns Mary Magdalene not to touch him because he has not yet ascended, but rather to tell the disciples that she has seen him (John 20:17). In the Ludlum tomb is a rendering in glass of William Holman Hunt's famous painting, *The Light of the World* (also known as *Christ Knocking at the Door*) (1854), one of the most copied works of religious art in the late nineteenth century.

Floral and landscape imagery is less overtly religious but no less poignant. Tiffany Studios popularized the image of the River of Life, as in the Wesselman mausoleum, where the autumn foliage and the verse from "The Hour of Death" by Felicia Dorothea Hemans suggest a long and full life. The Heins mausoleum places the River of Life behind a field of white lilies. A vase and border of lilies illumines the Sager tomb. A brilliant sunrise in the Ahlstrom mausoleum, rising behind cypress trees, refers to the resurrection and the hope of life everlasting. In the Ulmer and Durham mausoleums, poppies represent death and remembrance.

A more personal and at the same time mysterious use of symbolism appears in the Mathisen tomb. The scimitar and crescent decorated with the head of an Egyptian sphinx is the symbol of the Shriners, a branch of the Freemasons. The sword represents the backbone, or membership, of the order. The crescent is made up of two claws, symbolizing philanthropy. The double-headed eagle and the number "32" in a triangle represents the Scottish Rite. Both symbols are some of the most common and recognized in Freemasonry.

Other buildings in The Green-Wood Cemetery are lit with stained glass, most notably the Historic Chapel. The small building is bejeweled with forty-one colorful windows by the Willet Studio of Philadelphia, made in 1912. The main window illustrates the Resurrection of Christ. On either side of the chapel are scenes from the life of Christ. Above them are the archangels. At the Fort Hamilton Parkway entrance to the Cemetery is a gatehouse, built in the 1870s. It is decorated with Aesthetic Movement windows by Charles Booth, an English stained-glass artist working in New York. The windows are mainly decorative, grouped around a large, flat bowl of flowers like dahlias or zinnias, rising joyfully against a ruby-red background. The scene is bordered by sunflowers and white-and-yellow decorative squares. This small sanctum of bright light and color provides a moment's respite from as one enters the Cemetery's gates.

The interior of the Hungerford family mausoleum.

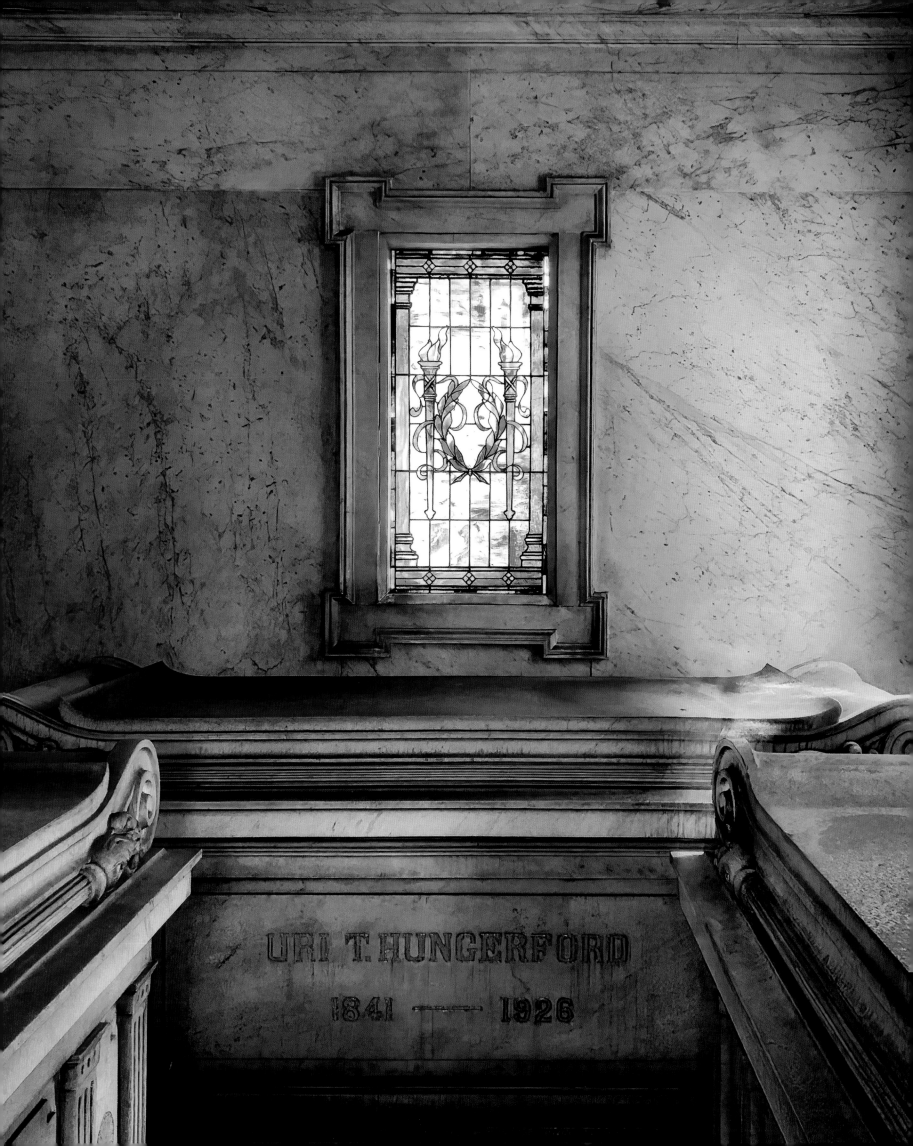

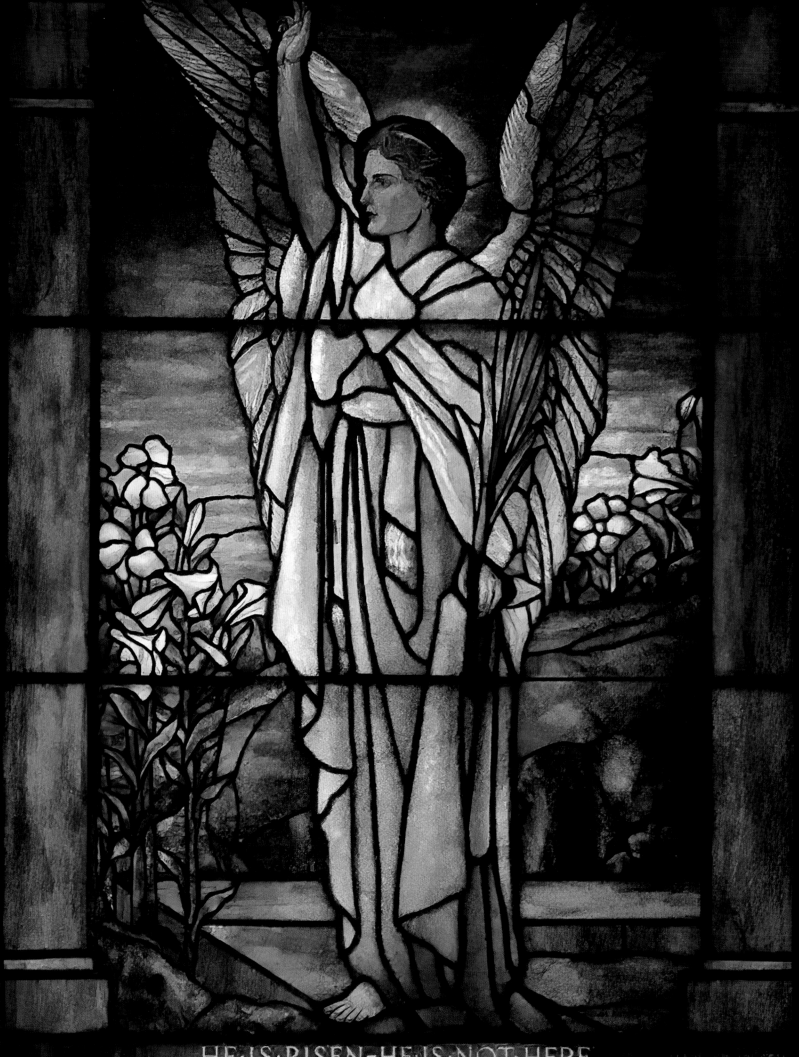

HE·IS·RISEN—HE·IS·NOT·HERE

IN·LOVING·REMEMBRANCE·OF
ALFRED·COTTON·BEDFORD

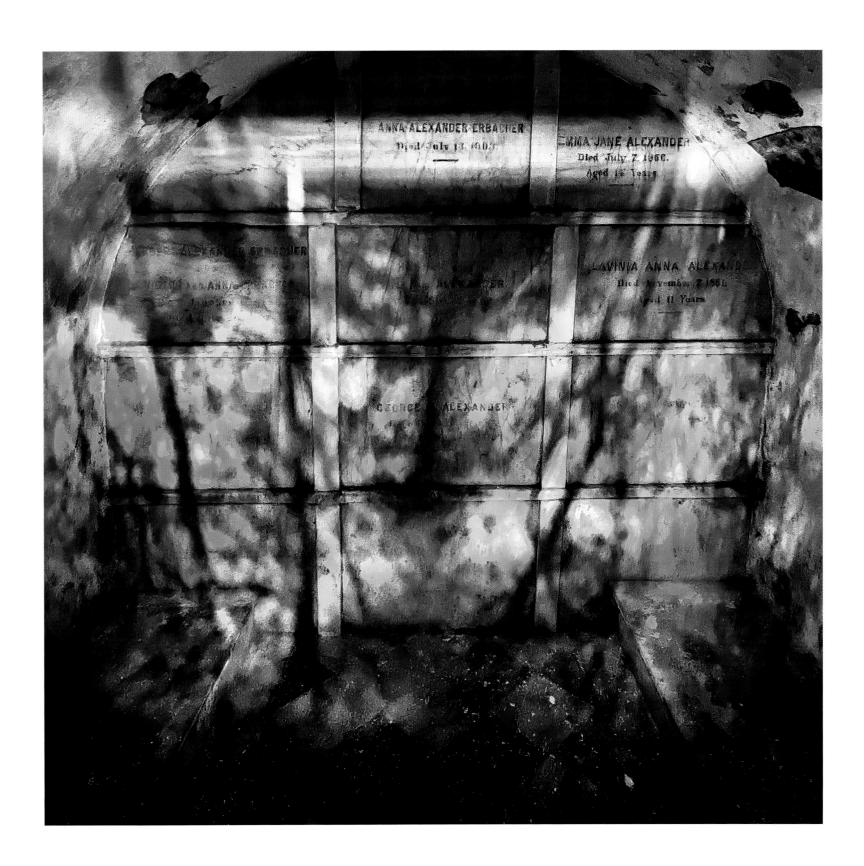

ANNA ALEXANDER ERBACHER
Died July 13, 1903

EMMA JANE ALEXANDER
Died July 7, 1860.
Aged 14 Years

LAVINIA ANNA ALEXANDER
Died November 2, 1860
Aged 11 Years

GEORGE ALEXANDER

Opposite: Stained glass in the Bedford mausoleum.
Above: Camera obscura effect of outside trees rendered upside down inside the Alexander vault.

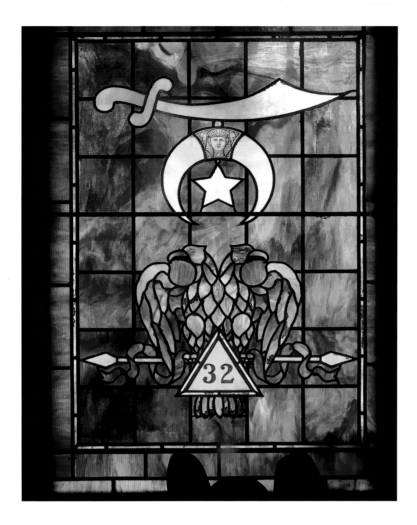

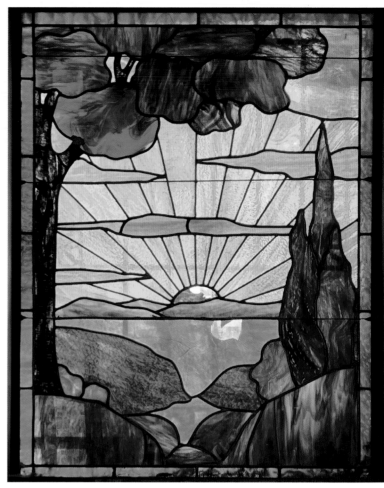

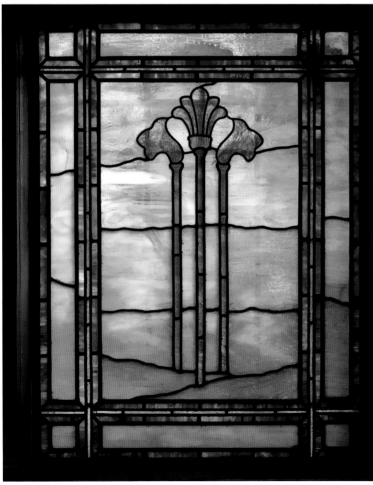

Left, clockwise from upper left: Masonic symbols in Captain Mathiesen's mausoleum, a landscape scene in Ahlstrom mausoleum, and the Durham mausoleum's amaryllis stained glass. Opposite: Reflection of Durant vault and Battle Hill looking into the Daly mausoleum with its Tiffany stained-glass window.

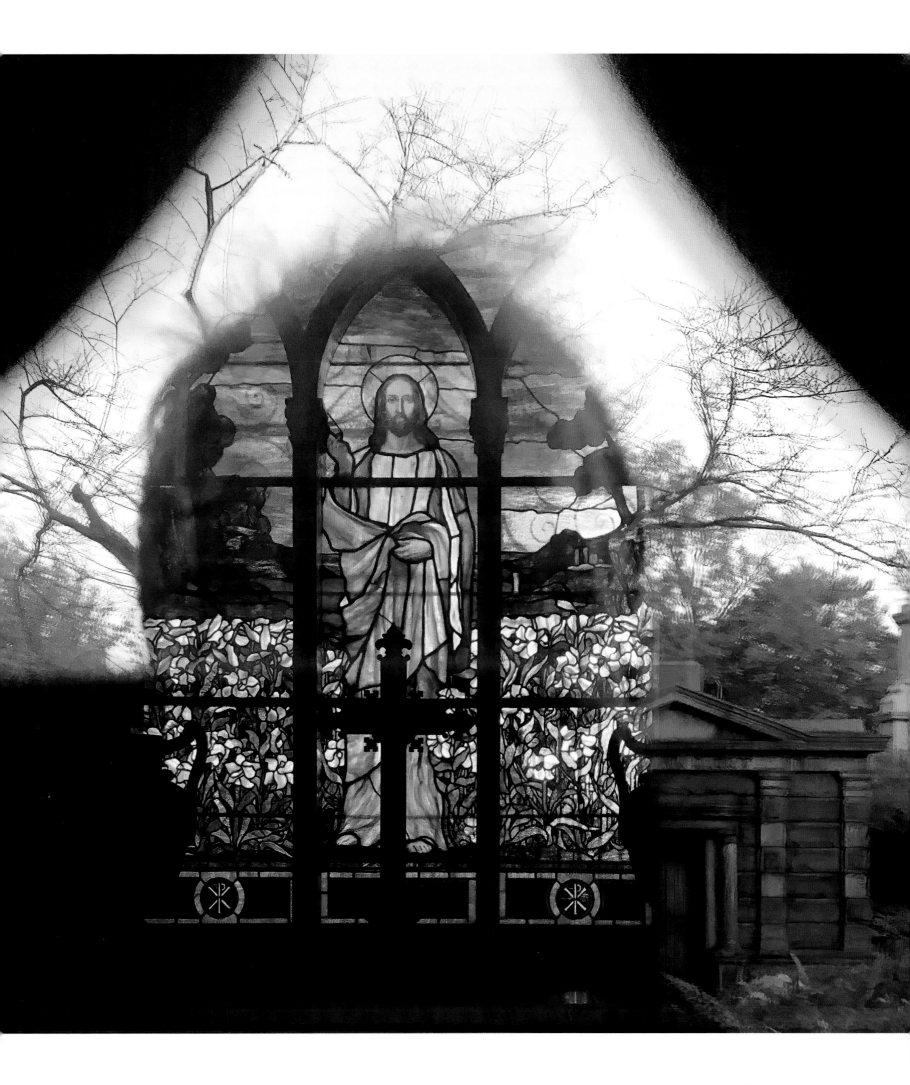

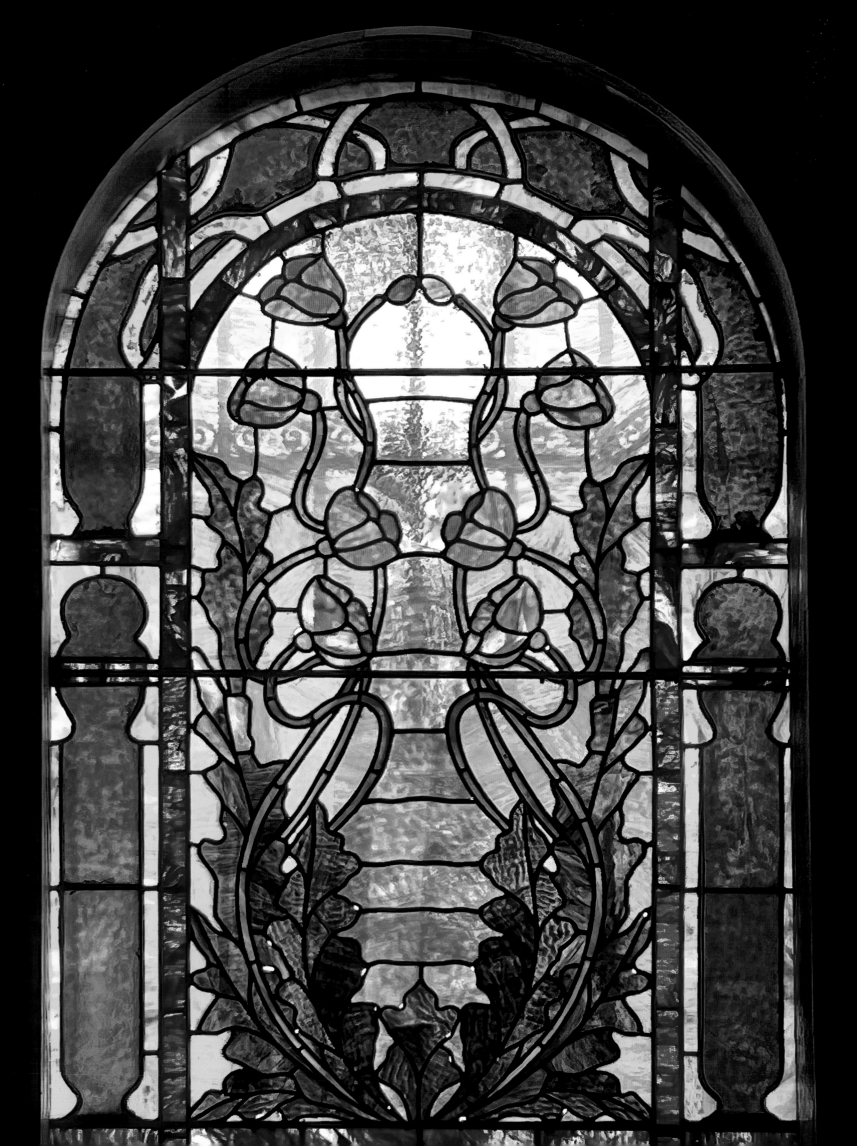

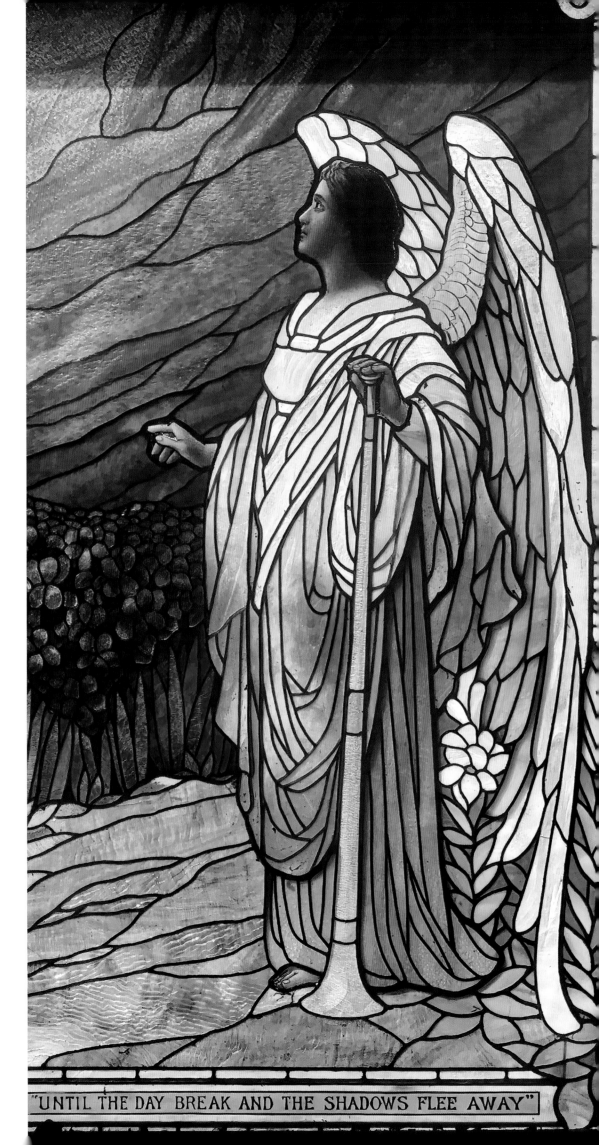

"UNTIL THE DAY BREAK AND THE SHADOWS FLEE AWAY"

Opposite: Ulmer mausoleum with stained-glass poppies.
Right: Reisenweber mausoleum with stained-glass angel

Following spread:
Mausoleums of Sager (at left) and Heins (at right) with depictions
of lilies in stained glass.

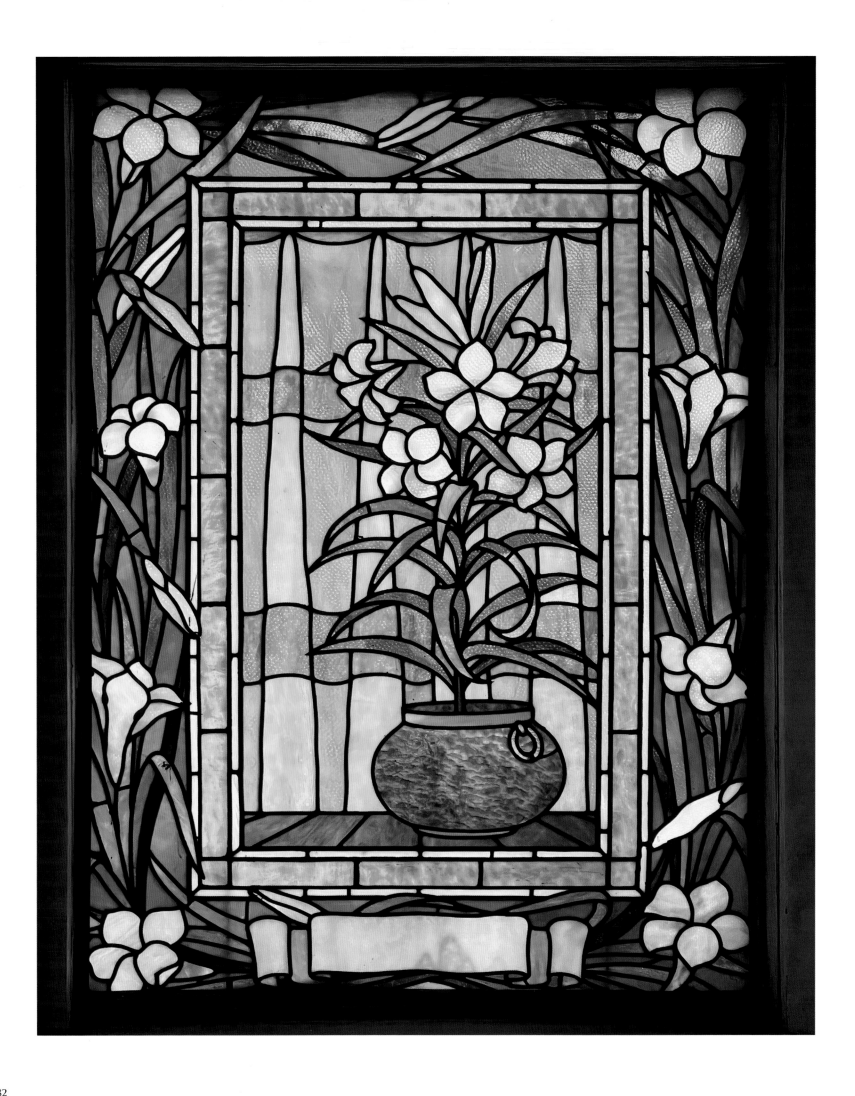

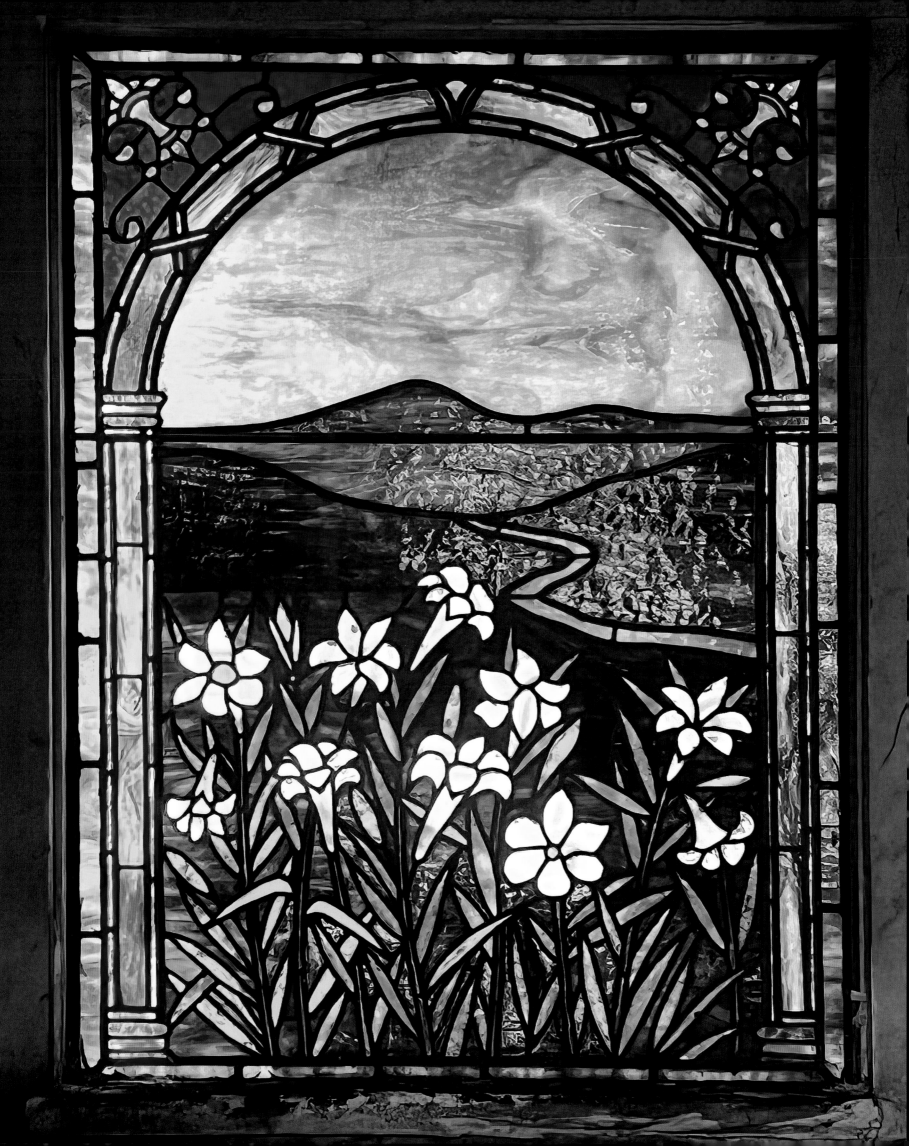

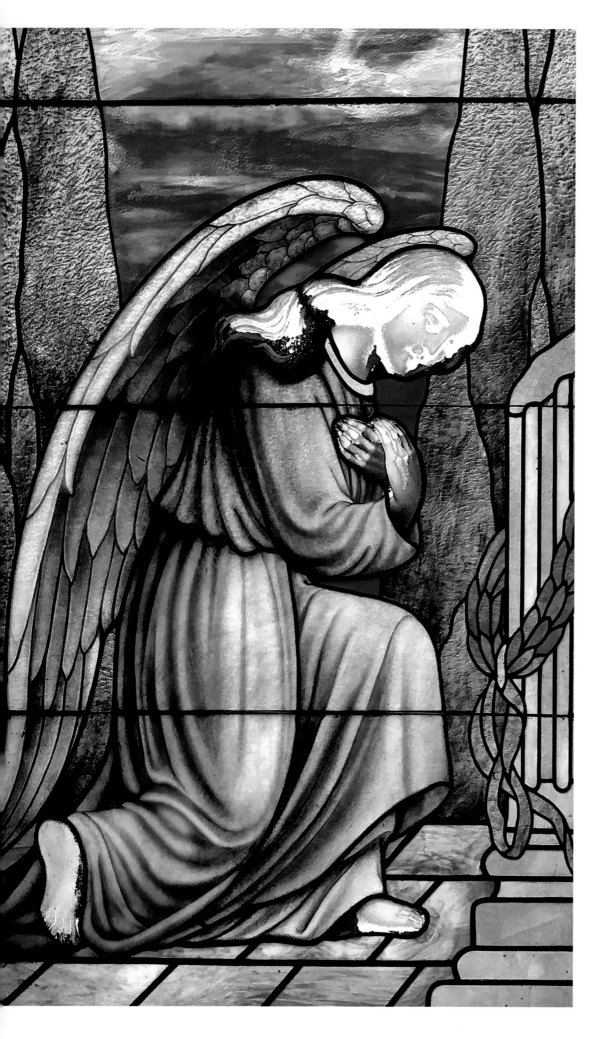

Left: Sullivan mausoleum with a kneeling angel in stained glass.
Opposite: Wesselman mausoleum, stained-glass inscription,
"Leaves have their time to fall, and flowers to wither at the north
winds breath, thou hast all seasons for thine own o death."

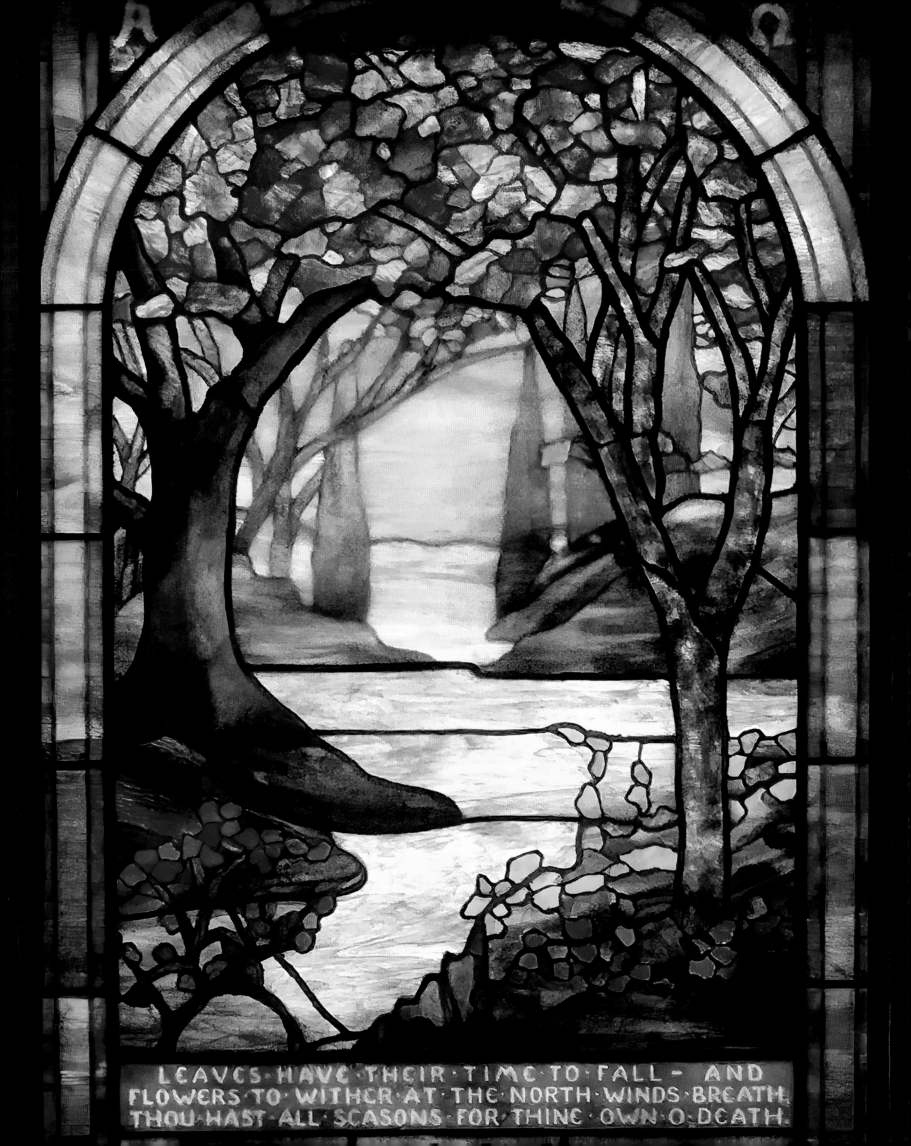

LEAVES·HAVE·THEIR·TIME·TO·FALL — AND
FLOWERS·TO·WITHER·AT·THE·NORTH·WINDS·BREATH·
THOU·HAST·ALL·SEASONS·FOR·THINE·OWN·O·DEATH·

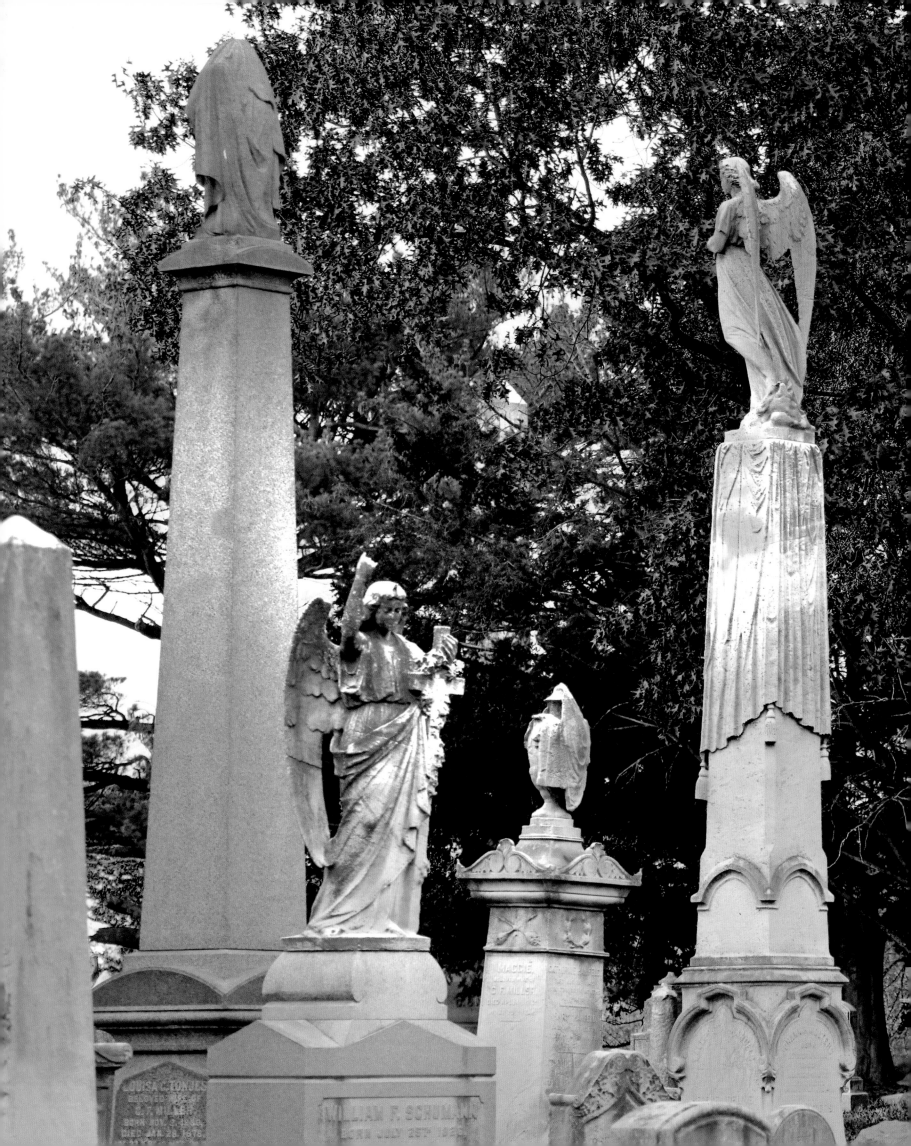

CHAPTER SIX

Statuary and Sculpture

Symbols of Souls: Statuary at Green-Wood

Andrew Garn

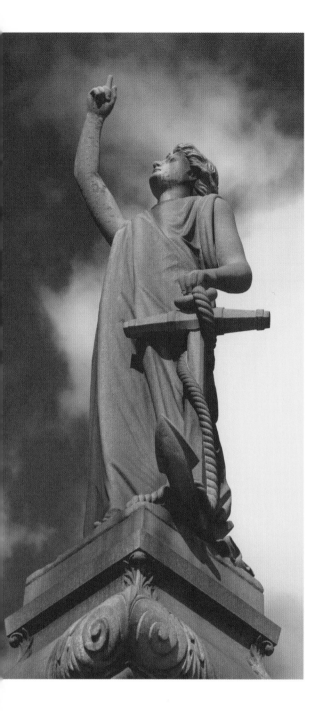

"We die only once, and for such a long time."—Moliere

Previous spread: A grouping of Obelisks, angels, urns, and crosses.

This spread:
Left: Woman atop a column holds an anchor and points skyward. The anchor signifies hope and steadfastness.
Opposite, left: One of the most visited monuments at Green-Wood, the Canda memorial honors the tragic death of the seventeen-year-old debutante Charlotte Canda, who died in her father's arms aon the evening of her birthday. She was thrown from her carriage when her horses were startled by a sudden thunderstorm. Before her death, Canda had been designing a memorial for her deceased aunt. Those designs were repurposed for Charlotte's memorial and executed by the sculptors Robert Launitz and John Frazee.
Upper right: One of the few male angels in the Cemetery, honoring Adam Weber and his family.
Bottom right: Rear view of the Valentine angel by Adolfo Apolloni.

"Our memory is a more perfect world than the universe: it gives back life to those who no longer exist."

—Guy de Maupassant (1850–1893)

The Green-Wood Cemetery holds tens of thousands of gravestones and statuary to interpret, tales to unravel, and countless symbols and designs to decode. There are monuments in granite, marble, limestone, sandstone, bronze, zinc, and terra-cotta. Craftsmen have created soaring Egyptian obelisks, which represent shafts of sunlight descending to the dead, columns supporting draped urns, and winged angels, some reaching for the sky while others placidly sit in repose. There are stone figures in flowing robes, flora, and fauna of exquisite detail, all carved from stones that can stand for centuries.

Cemetery statues tell the stories of lives departed and express the grief of those left behind. Angels, sobbing women, sleeping children, and brave soldiers all suggest something of who is remembered beneath the earth, connecting us to strangers through their carved faces and forms.

Sometimes, these stories are visual representations of the successful lives of the interred. Other times, horrific events are memorialized so they will never be forgotten—as for the Brooklyn Theatre Fire, which killed 278 people in 1876. Below a tall memorial obelisk honoring the tragedy, 130 bodies are buried in a circular mass grave.

The tale of a life can also be told with words and symbols. Even a simple stone marker, easily stepped over, is worth a pause to witness its engraving of "Mother," "Father," "Our Sunshine," or merely initials.

Most of the funerary sculptures are quite serious, a somber honoring of the dead using classical architecture elements. Others are joyous follies, like the monument to John Matthews, the "Soda Fountain King," which is a cornucopia of animals, flora, and figures. William Niblo's vault is likewise a theatrical showpiece, fitting for a tycoon of nineteenth-century entertainment who is said to have hosted parties on his mausoleum's lawn long before his eternal rest within its walls. A memorial can also be an ageless representation of wealth and pride, a lavish spectacle that still acts as a memento mori, recalling that there are no pockets in shrouds to bring material gains into the afterlife.

Queen Victoria may have been the seed of cemetery fascination. When her husband, Prince Albert, died in 1861, it began a forty-year cycle of mourning that stretched from England to the United States, inspiring New Yorkers to wear black and build countless monuments. (The memorial for Green-Wood's "Soda Fountain King" even resembles the Albert Memorial in London with its spire and Gothic canopy.) Yet the will to remember those ancestors who came before us is such a strong human desire that people have long used any material to create a monument to a loved one. In Green-Wood, there are the public lots where numerous graves are unmarked and the memorials are humble, yet the act of care in consigning a loved one to a peaceful place makes them as meaningful as the grandest tomb.

There are bas-relief portraits of the dead and scenes from life, like the Griffith monument, which depicts in white marble a husband going off to work, bidding goodbye to his wife for the last time, as she would die later that day. The monument for the Brown family has a ship being swallowed out at sea rendered in stone, evoking their loss in the sinking of the *SS Arctic* in September 1854. The memorial to Oscar and Maggie Dietzel, who died in a Brooklyn train collision on August 26, 1893, while returning from Manhattan Beach, is executed with carved models of the street cars crashed together.

A flourishing cemetery is constituted from several parts: landscapes, planted trees and flowers that attract other living things, and beautiful markers of the dead. Together, they offer respite for the living, history for the curious, and a moving sense of the human belief in some experience existing beyond death.

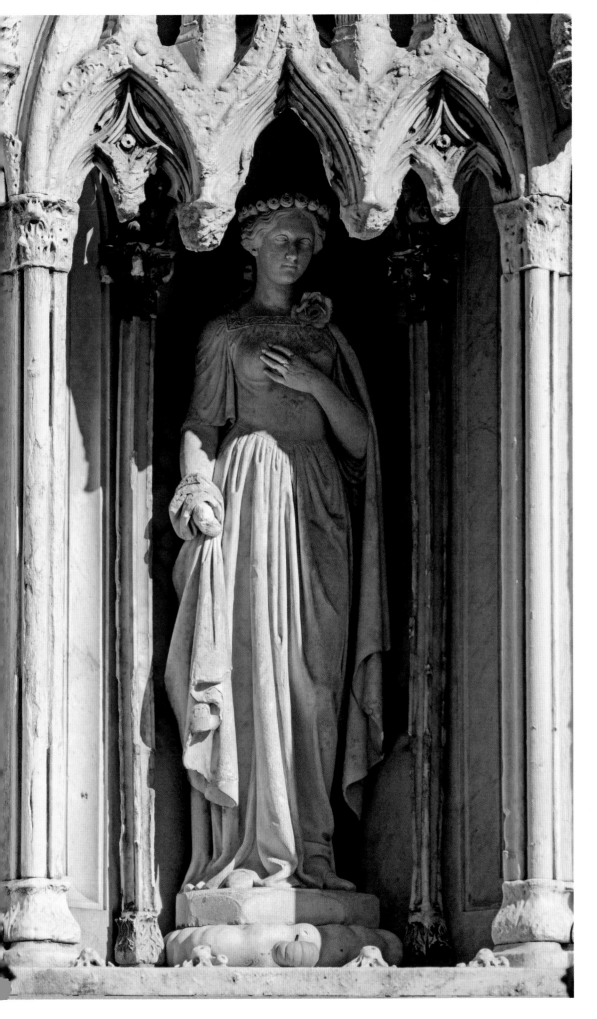

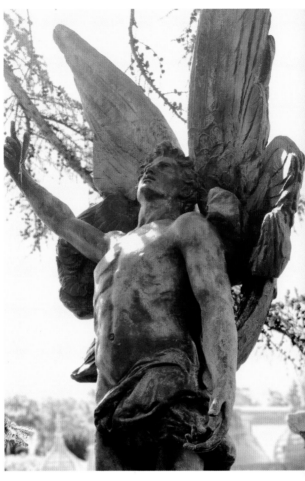

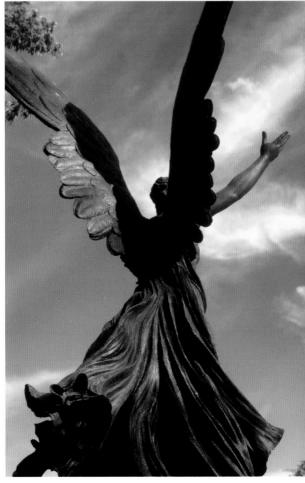

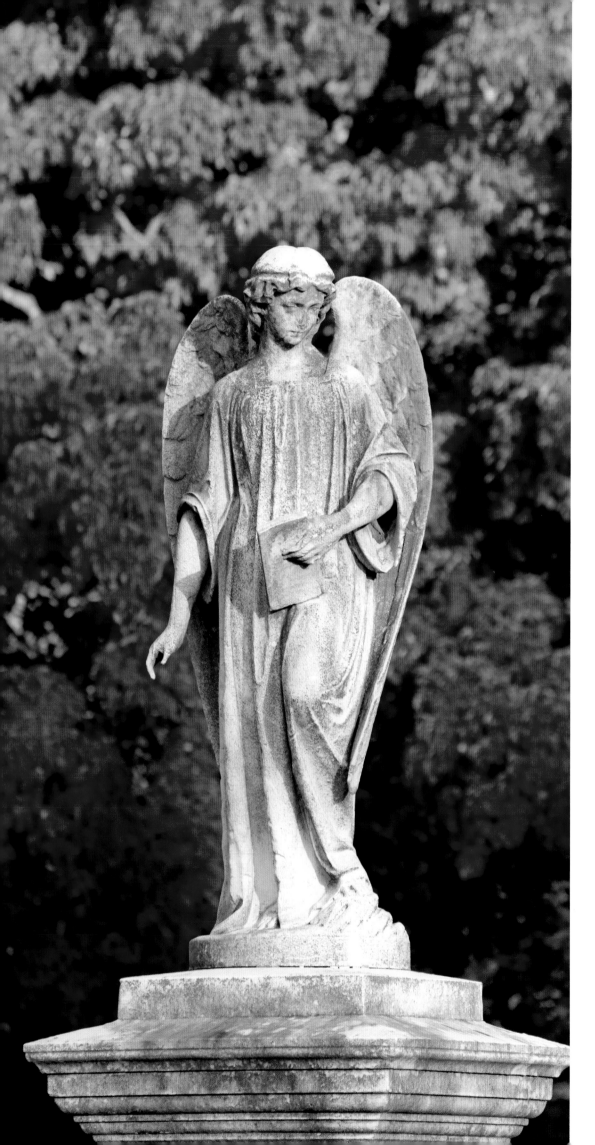

Left: An angel stands atop the Payne memorial with fall dogwood leaves in the background.
Above: Brownstone finial from the Dr. Valentine Mott vault.

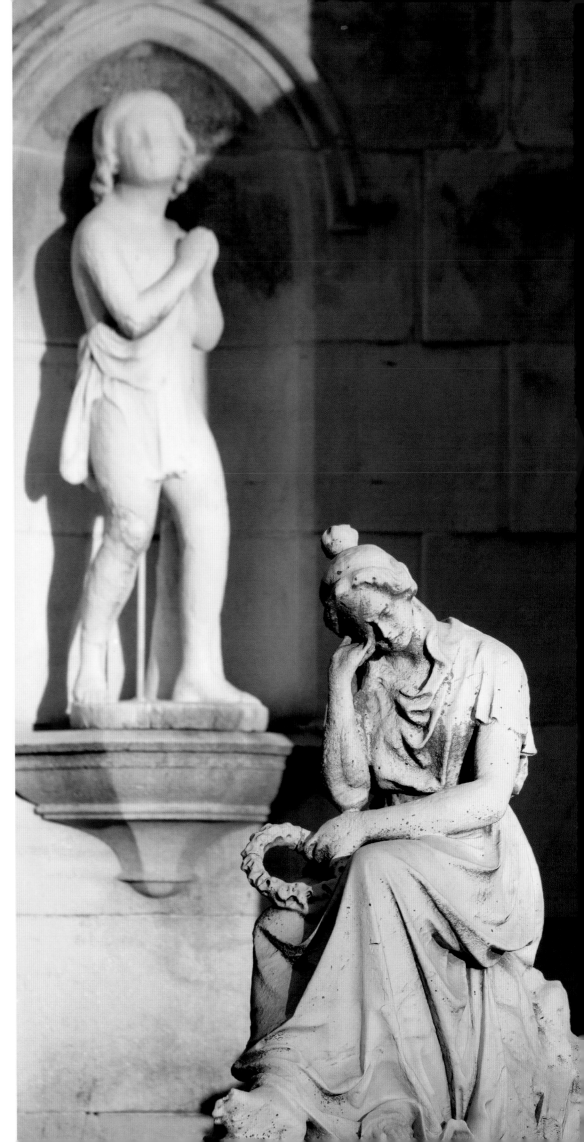

Right: A marble sculpture of a remorseful woman sits holding a wreath, the symbol of victory over death, as a boy prays behind her at the Niblo vault.

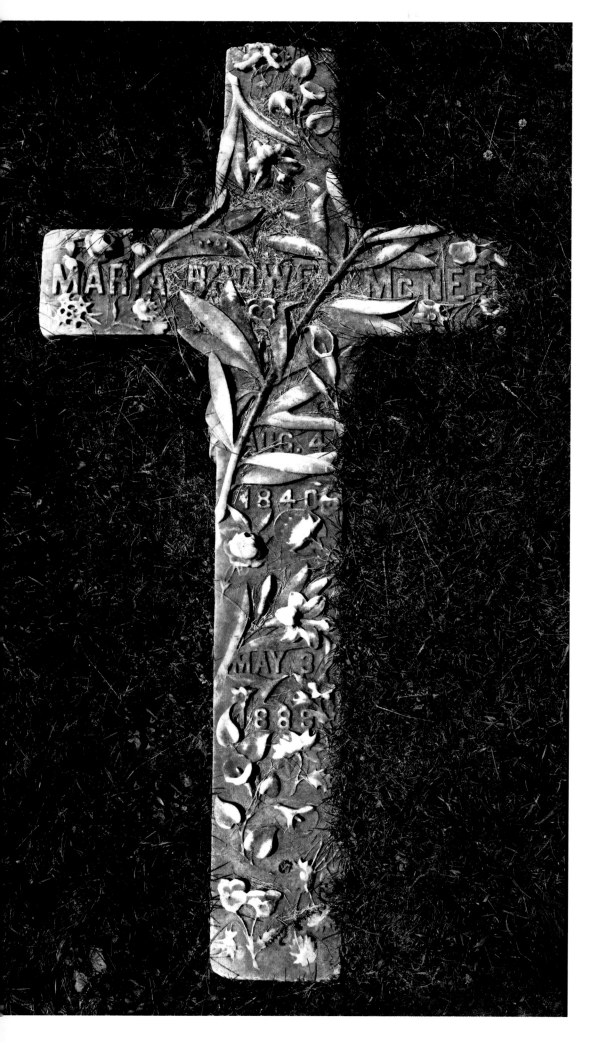

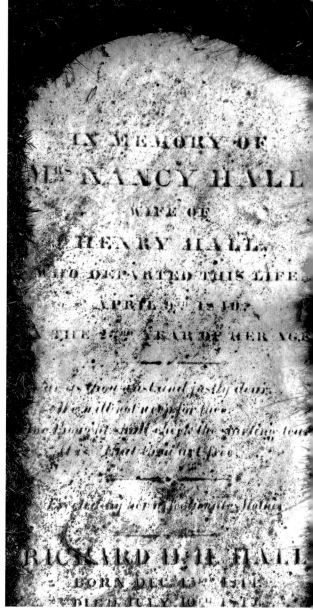

Left and above: Two well-worn flat tablet grave markers offer different approaches to nineteenth-century memorialization. The McNeel cross (at left) is symbolic, with lilies and pansies scattered over a cross, whereas the Hall marker is carved with a long epitaph that remembers the deceased in florid words. Opposite: An angel strides between two doves in the Acea mausoleum while clutching a bouquet from which she is dropping flowers. Like the doves poised to fly away, the cut blooms represent the fleetingness of life. Cuban-born Nicolas Acea (1828–1904) made his fortune refining sugar in Cuba. The mausoleum was designed by Farrington, Gould and Hoagland.

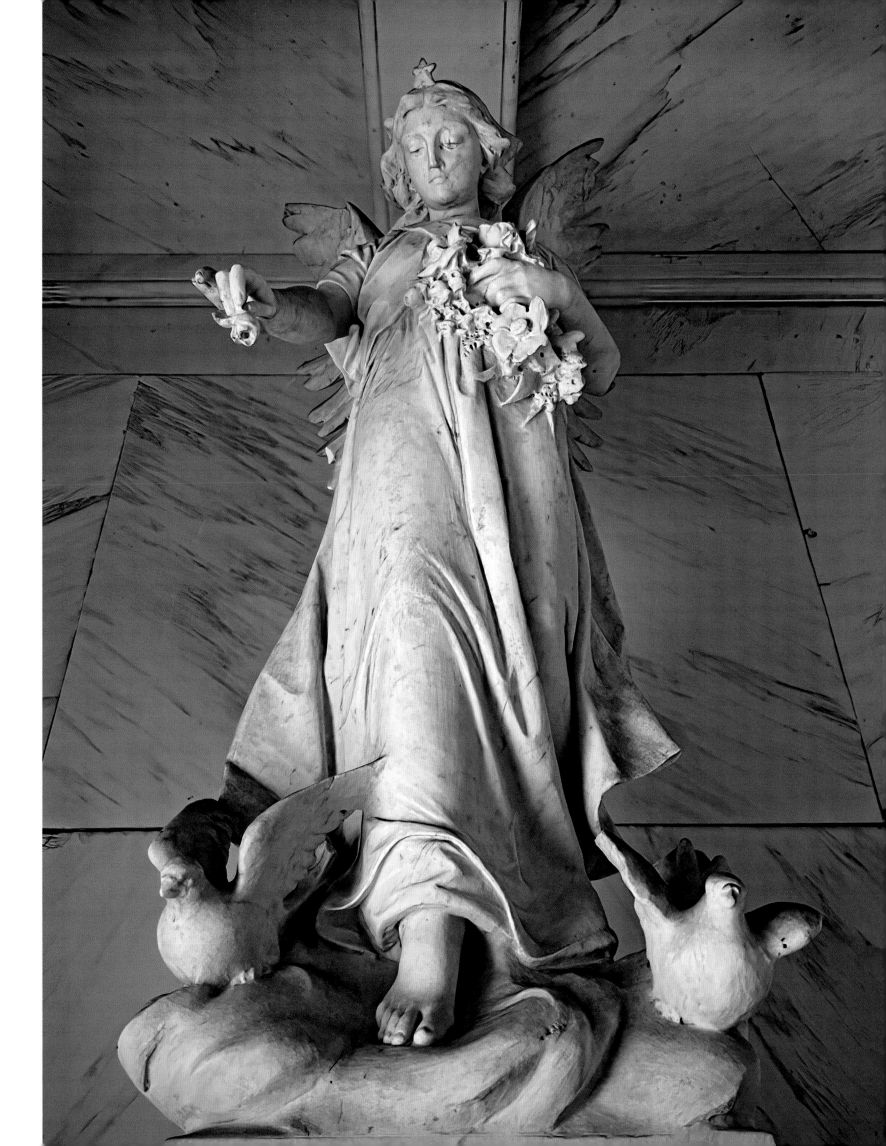

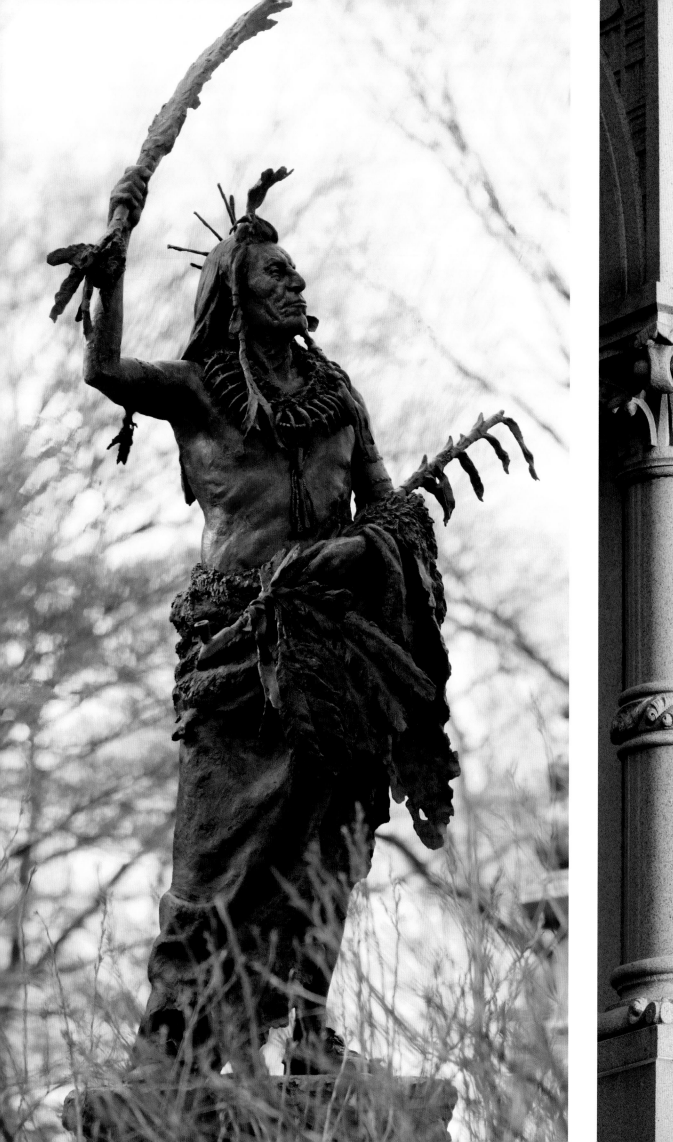

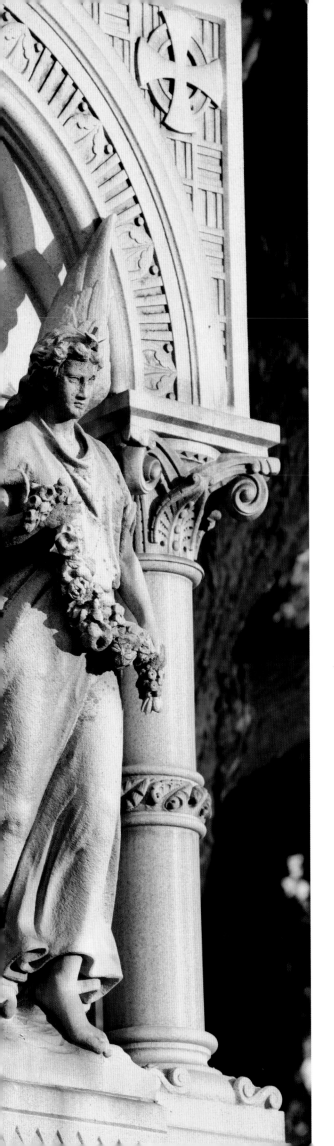
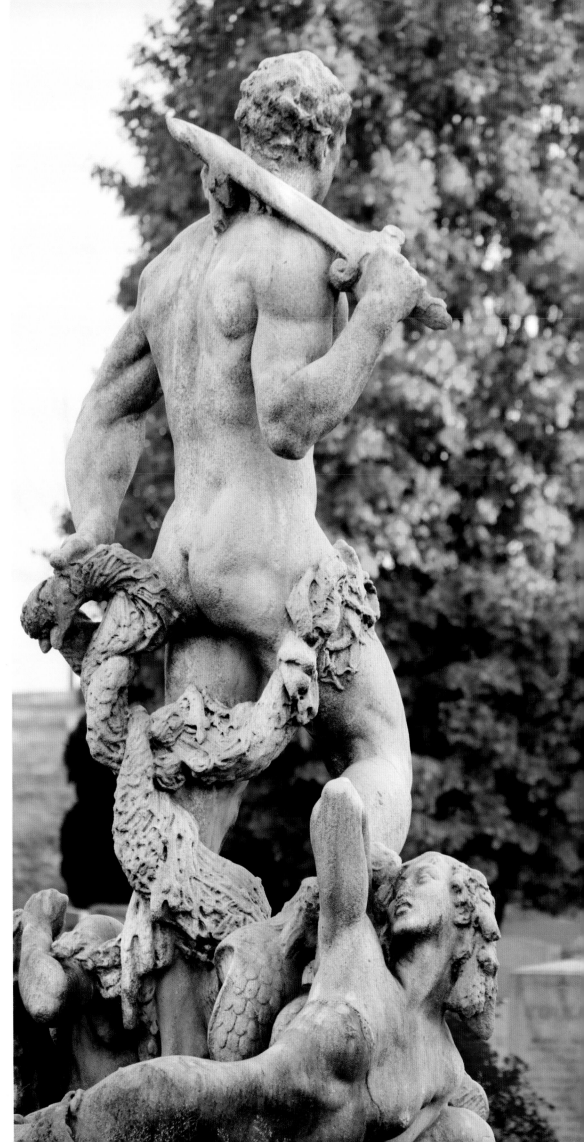

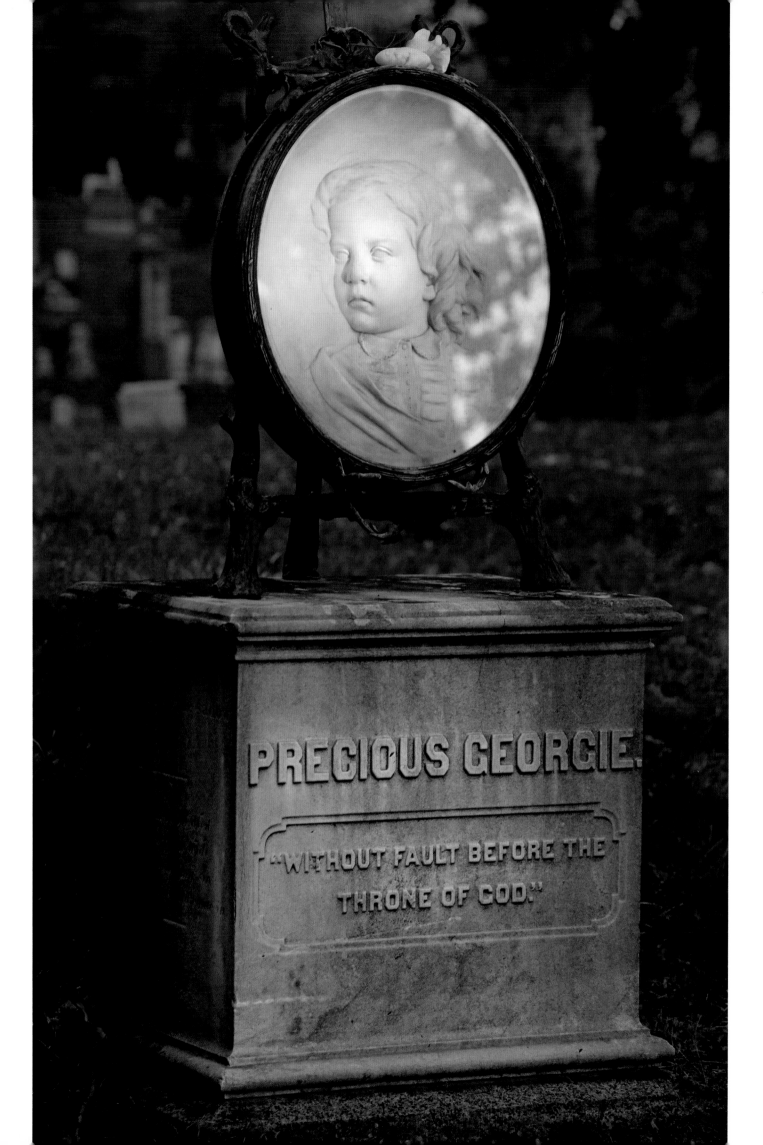

"Some things are more precious because they don't last long."
—Oscar Wilde

*"To pretend angels do not exist because they are invisible is to believe
we never sleep because we don't see ourselves sleeping."*
—Thomas Aquinas

Previous spread:
Left: *The Greeter*, a 2012 tribute to the artist George Catlin
(1796–1872) by the sculptor John Coleman (b. 1949). The
bronze figure is of Black Moccasin, a Hidasta chief who famously
greeted Lewis and Clark in 1805. Catlin befriended the chief
in1838 and painted his portrait. It became his mission to
preserve the images and customs of Native Americans.
Center: Siefke Trexler monument with standing angel holding a
garland of flowers.
Right: A posterior view of the statue *Civic Virtue* by Frederick
MacMonnies. Once part of a monumental fountain, it was
intended as an allegorical representation of Virtue triumphing
over Treachery and Corruption. It was immediately met with
controversy shortly after it was unveiled in 1922 in City Hall
Park. Feminists considered the imagery of a male (representing
virtue) standing over female mermaids (representing vice) as
oppressive. Public outcry and Fiorello LaGuardia's distain for
looking at the statue's rear-end from his office in City Hall forced
a move to Queens in 1941. It continued to spark outrage in
Queens; finally it was brought to a quiet corner of Green-Wood.

This spread:
Opposite: The cameo portrait of "Precious Georgie" cast in a
warm dusk glow. Georgie died at age five of scarlet fever and
was the son of Reverend Theodore Cuyler of the Lafayette
Avenue Presbyterian church in Brooklyn.
Top right: The sculpture of the goddess Minerva and the "Altar
to Liberty" on Battle Hill salutes the Statue of Liberty in the New
York Harbor. Minerva was the Roman goddess of wisdom and
stands as a tribute to the first major battle of the Revolutionary
War. She was unveiled in 1920 on the 144th anniversary of the
Battle of Brooklyn.
Bottom right: The memorial to "Little Gussie," who lays
in eternal rest.

Next spread:
Peace, faith, protection, and beauty are all symbols of the angels
found across Green-Wood in a variety of styles and poses. Each
winged figure is designed to convey emotion or meaning. As
eternal guardians, angels stand sentinel to protect those in
perpetual slumber.

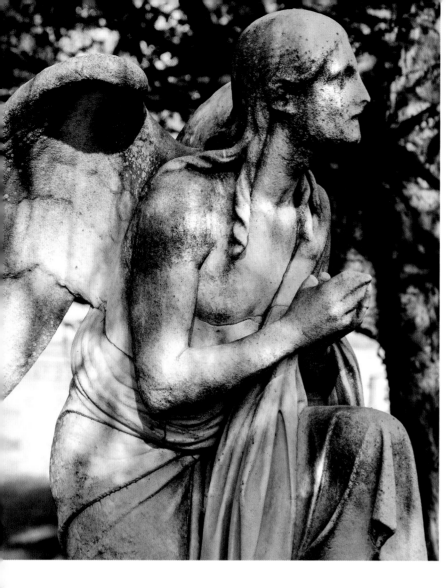

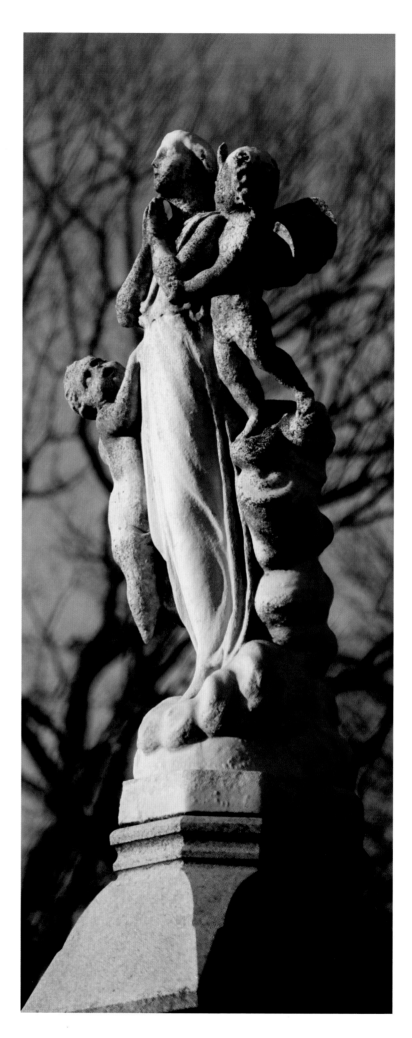

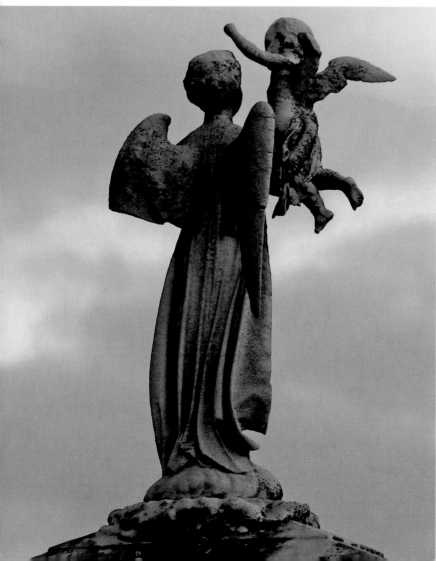

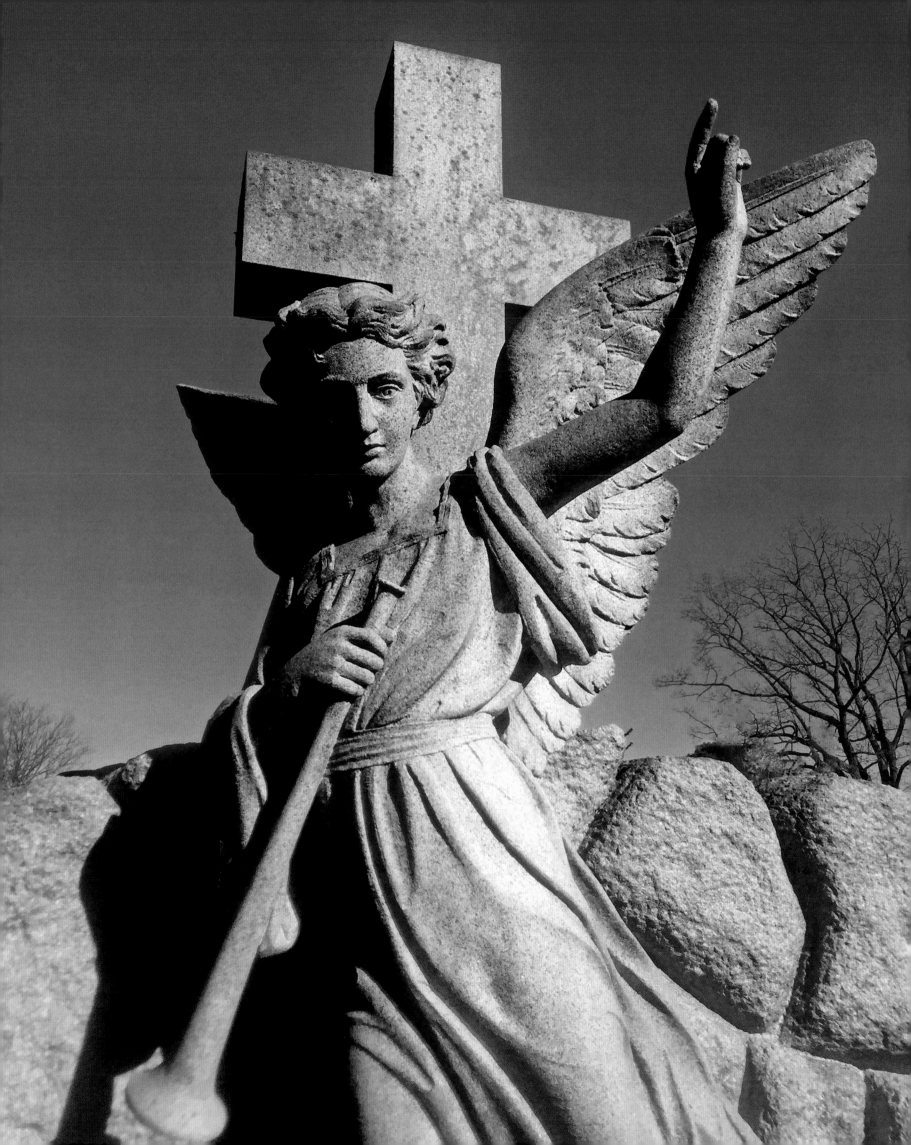

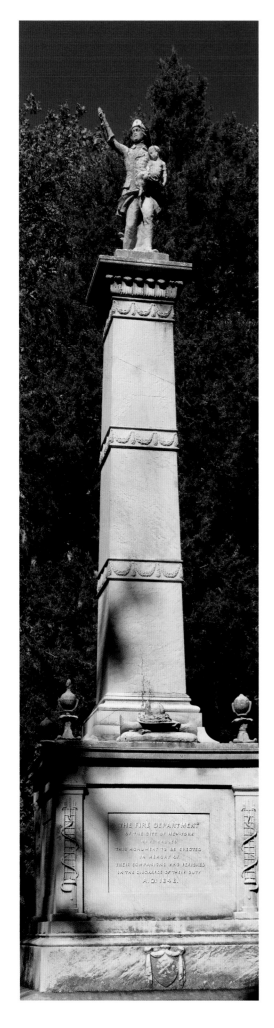

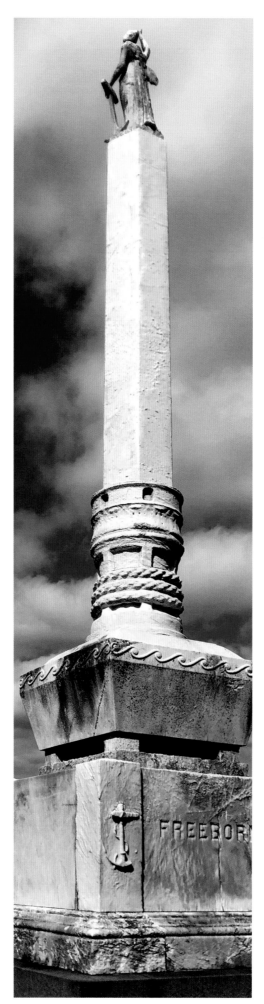

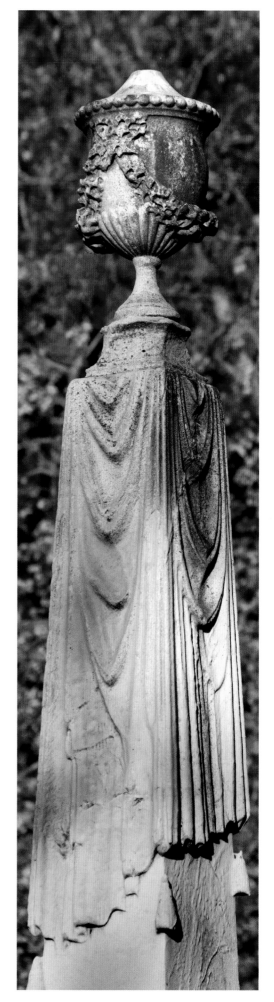

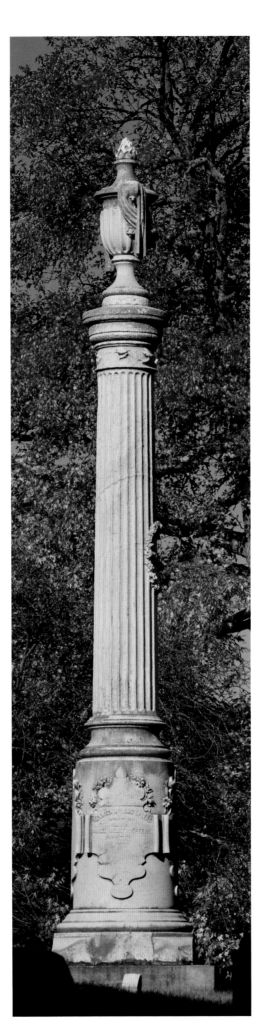

Opposite left: The marble monument was erected to commemorate the volunteer firefighters of New York City who died in the line of duty. A tall and majestic tower that is generously covered with fire-related symbols, at top is a statue of a fireman saving a child. Adorning his hat is a wreath of oak leaves, the traditional reward given to a lifesaving hero. Hydrants, hooks, ladders, hoses, and downturned firemen's torches decorate the monument sculpted by Robert Launitz.

Opposite center: The heroic actions of Thomas Freeborn are memorialized in this depiction of a notorious 1846 disaster at sea off the coast of Mantoloking, New Jersey. Despite his gallant attempts, Freeborn and all 51 passengers were lost in the violent and icy storm. The obelisk is known as the Pilot's Monument and honors all who worked in that dangerous profession, including Freeborn. Harbor pilots still sail out to greet incoming ships to guide them into port.

Opposite right: A draped square column holds an urn with hanging wreaths.

Right: Speer family memorial column.

Far right: Abraham Vosburgh was one of the earliest casualties of the Civil War, dying of consumption in 1861. He was commander of the 71st New York State National Guard. Members of his regiment erected this monument in his honor, which was sculpted by Patrizzio Piatti.

Next spread: Two details of the Dewey vault.

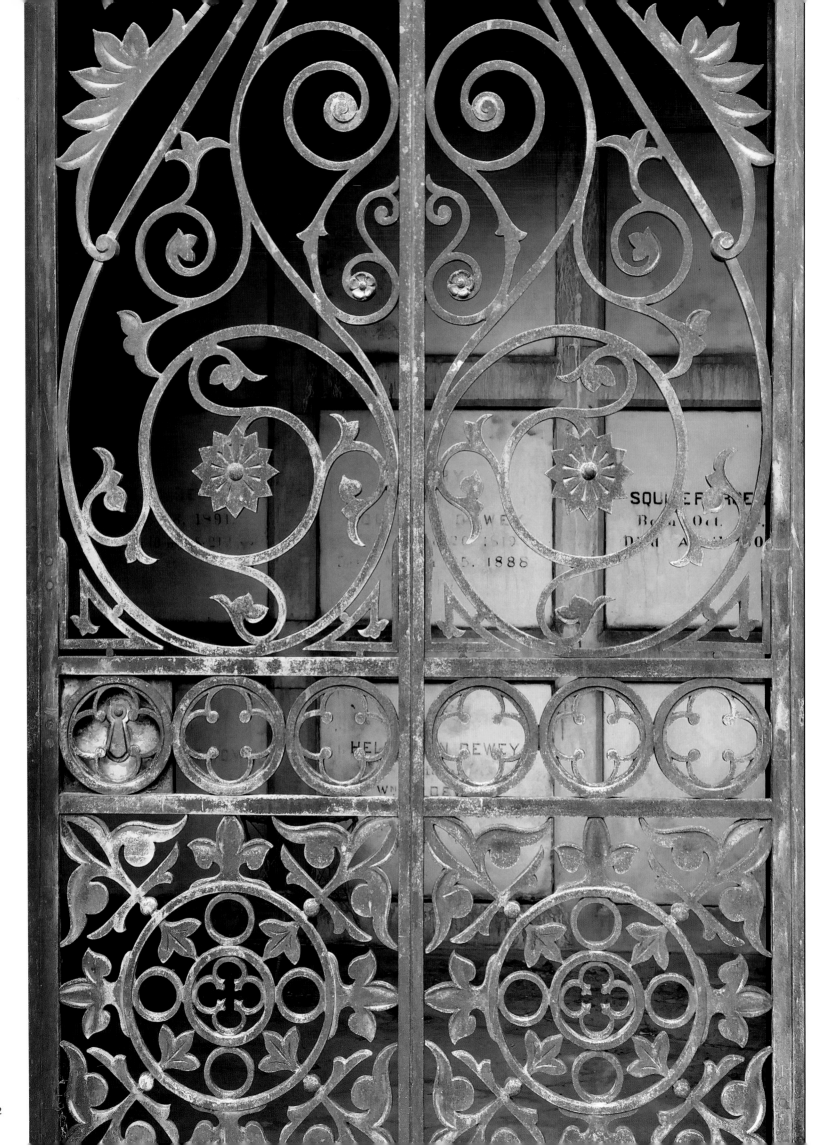

CHAPTER SEVEN

Metalwork and Stone Carving

A Garden of Meaning in Stone

Allison C. Meier

However beautiful a flower is when it opens, the bloom will soon wither and fade. That inevitable decay has linked flowers to death for centuries, with fallen petals and slumped stems frequently appearing in seventeenth-century European vanitas paintings that reminded viewers of their own life's transience. They also have a long history as grave offerings, with evidence of their use dating back 14,000 years to a burial site carefully lined with flowers in present-day Israel. Today even cemeteries in the harshest climates, where little green can grow, will have plastic blooms placed on graves to show that the deceased are remembered.

By the time The Green-Wood Cemetery was established in 1838, floriography—the language of flowers—was surging in popularity. Many of the families choosing the Brooklyn burial ground as their final resting place likely had a floral dictionary at home that drew on traditional symbolism associated with flowers. One of the most successful of these books was *Flora's Dictionary* by Elizabeth Washington Gamble Wirt of Virginia, published in 1829. Wirt's book joined literary quotes with notes on symbolism for over two hundred flowers and other plants, from acacia for "friendship" to zinnia for "absence." Many other books followed, such as Lucy Hooper's 1841 *The Lady's Book of Flowers and Poetry* and Kate Greenaway's illustrated 1884 *The Language of Flowers*. The books were being an opportunity for women to write about botanical discoveries for a popular audience at the time when scientific publications were still considered a male realm. Their work reinforced the practice of using flowers to convey feelings.

And when it came to the cemetery, there was much to express about life, loss, and the hope for some future reunion beyond the veil. One small headstone for a girl named Isabelle, located in the family plot of Tammany Hall's infamous William Magear "Boss" Tweed, reads: "The bud is nipped on Earth to bloom in Heaven." A snapped rosebud is carved in the marble, a symbol that this life did not have the chance to begin before it ended. All across Green-Wood are these somber indications of a life cut short, recalling the high childhood mortality that often claimed multiple members of a family. For the two children that Carsten and Mathilde Riecks lost in the mid-nineteenth century, a dual headstone with two broken rosebuds emerging from a rose mourns them both, their respective epitaphs tallying, to the day, the brief time their family had with them. Sometimes daisies, which Henry Phillips noted in his 1825 *Floral Emblems* as "one of the earliest floral amusements of infancy," also adorn these small tombs.

The relationship between mortality and a broken flower can easily be interpreted today, but other symbols are more obscure. The pinwheel of sepals on the passionflower can often be found bordering headstones, referencing how each element of the perennial vine was connected to symbolism for the Passion of Christ, from its five stamens for the five holy wounds to its three stigma for the nails on the cross. Tulips continue to bloom even after they are cut, and as perennial flowers that return every spring, they are symbols of eternal life and love. The thistle can be found on graves of people from Scotland, where the flower is the national emblem; with its spiny stems and leaves, it's also a symbol of protection.

Several flowers have multiple meanings as they have been reinterpreted over time, such as the poppy, whose blooms and pods appear on monuments in Green-Wood. Victorians would have been familiar with the narcotic effects of opium, from its availability in the medicinal laudanum to the opium dens where many sought oblivion. In a Cemetery, the sleep symbolized by the poppy is everlasting. After World War I, the poppy took on another role. A plant that thrives on disturbed ground, its bright red blossoms dotted the ravaged battlefields of Europe. Canadian military doctor John McCrae in 1915 was moved to write his poem "In Flanders Fields" about those landscapes where ". . . the poppies blow / Between the crosses, row on row." The poppy is now a symbol to remember the losses of war.

Previous spread: An abstraction of a tree bud carved in granite.

Opposite: Daisies are carved on the granite monument for Constance Ward, who died in childhood. The flowers evoke innocence and youthful play like tying daisy chains or playing "he loves me, he loves me not," as well as the brief bloom of life, like a blossom that soon wilts and fades. Constance was one of six children born to Rear Admiral Aaron Ward and his wife Annie. The nineteenth-century had high childhood mortality rates and the diminutive monuments in Green-Wood, with symbolism like daisies, lilies, lambs, and sleeping babies memorialize their short lives with love.

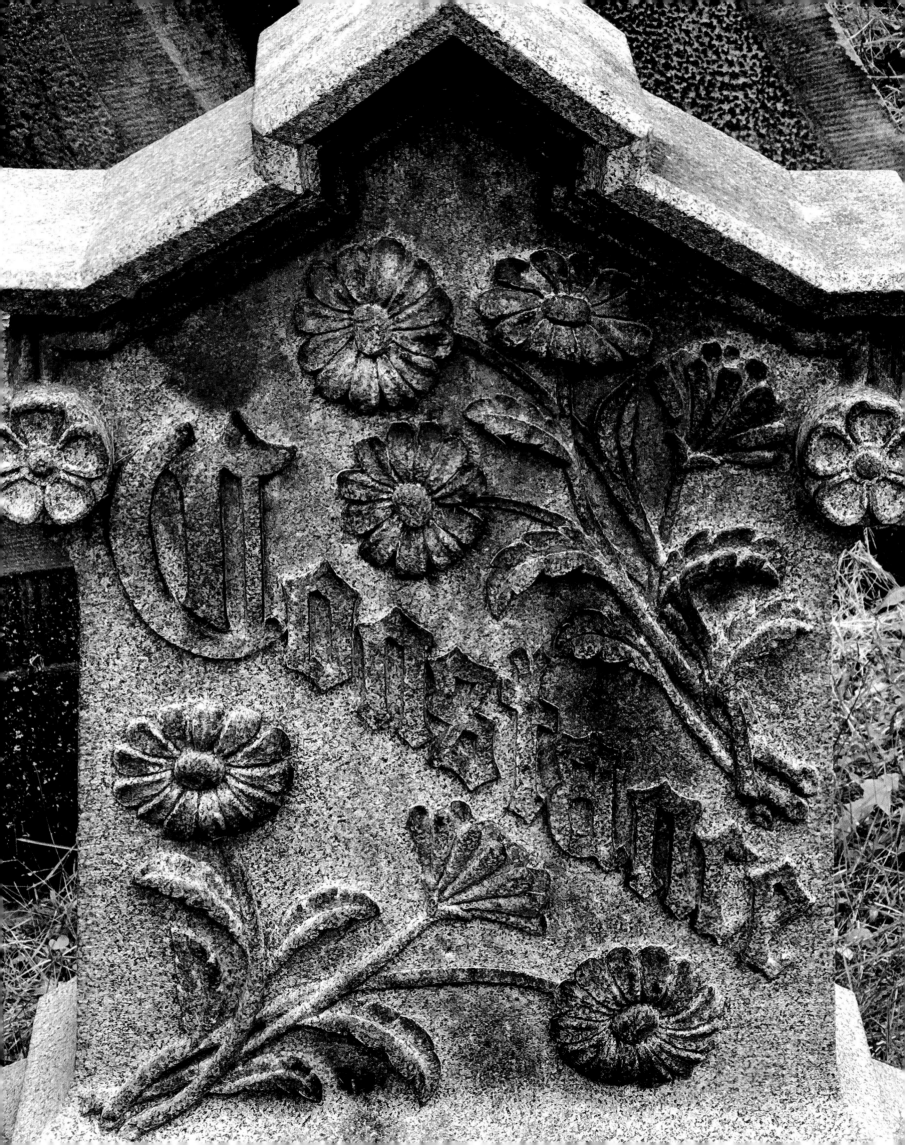

Other flowers had links to nineteenth-century funerary rituals beyond the graveyard. Pansies can be spied on memorials evoking remembrance, as their name is derived from the French *pensée*, or "thought." They were common at the time on mourning brooches, which sometimes contained pansies delicately shaped from hair cut from the deceased as a tactile way to keep their memory close. Carnations similarly had a broader meaning in memorialization. In addition to their layered petals appearing on tombs, they were popular in funerary arrangements as a long-lasting, fragrant choice that comes in a variety of colors.

Lilies, too, were abundantly present in the nineteenth-century funeral parlor; Queen Victoria was laid out on a deathbed brimming with white calla lilies when she died in 1901, as immortalized in a painting by Hubert von Herkomer. As one of the first flowers to emerge after the long dormancy of winter, lilies are a symbol of rebirth. In Green-Wood you can find lily of the valley with its bell-shaped blooms cast on zinc markers. On a vibrant stained-glass window in the mausoleum of Marcus Daly, a nineteenth-century copper tycoon, which depicts Jesus walking through a field of white lilies, signifying resurrection.

Still, the most common flower in Green-Wood, carved in marble, granite, and brownstone, is the rose, a symbol of love. Some, like those rosebuds, have their stems broken—a sign of a flourishing life ended—while others are arranged in garlands that join monuments for couples whose bond was not severed by death. Looking closely at these floral symbols reveals something about who a person was, what they believed, and how they wanted to be remembered. Although the meaning ascribed to flowers has waned over time, we can pause to consider how these small statements of grief and love connect us to people who died more than a century ago. Like the seeds of a fading flower that are collected to plant again, these symbols endure as reminders of the cyclical nature of life and death and ask us to savor our own moments of blooming.

Below: Three types of carved flora adorning monuments in Green-Wood. While the popularity of nineteenth-century floriography, or the language of flowers, encouraged the symbolic choice of specific blooms, others were used decoratively and reflected different stylistic movements, like Art Nouveau or Art Deco, in the early twentieth century. Even made of stone, these plants give the monuments a vivid sense of life going on after death.

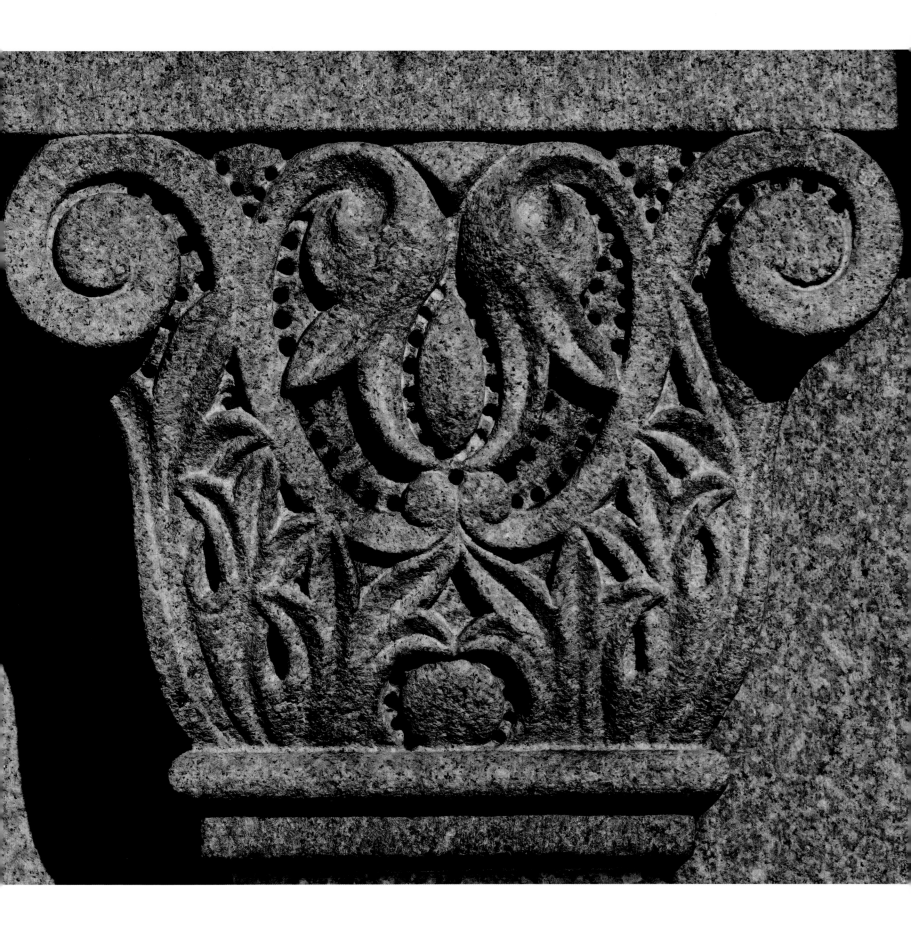

The mottled texture of the granite adds to the detailed surface of this ornate memorial. The shape of the foliage is reminiscent of how acanthus leaves were carved in antiquity, with the ancient Greeks and Romans frequently covering capitals and friezes on temples with the spiny plant.

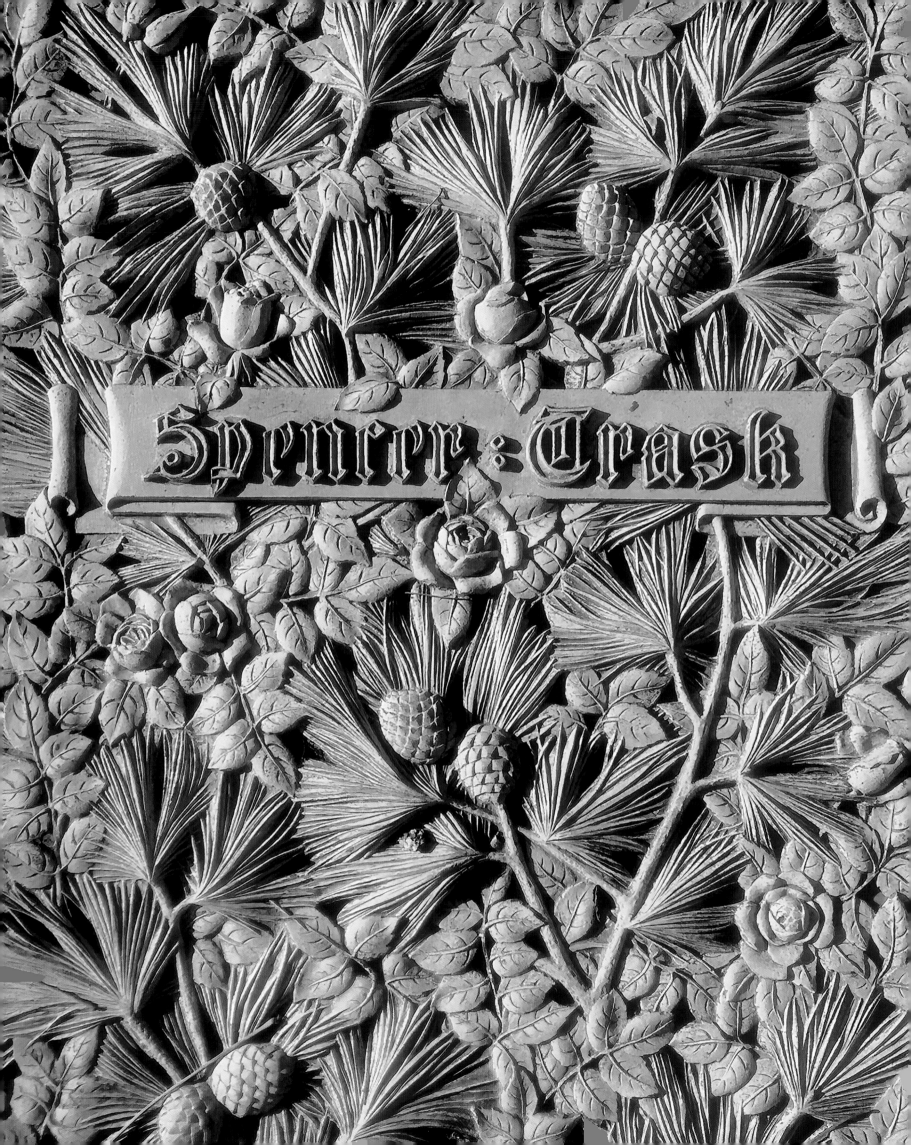

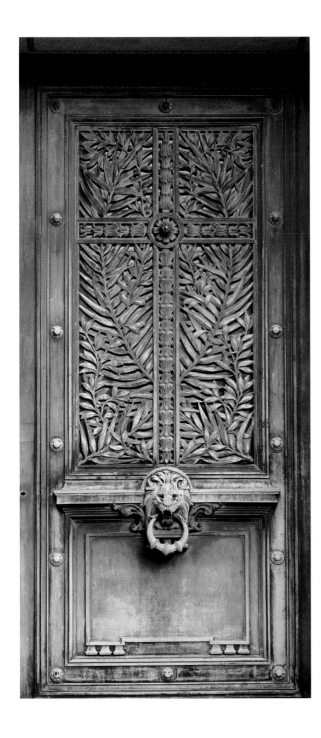

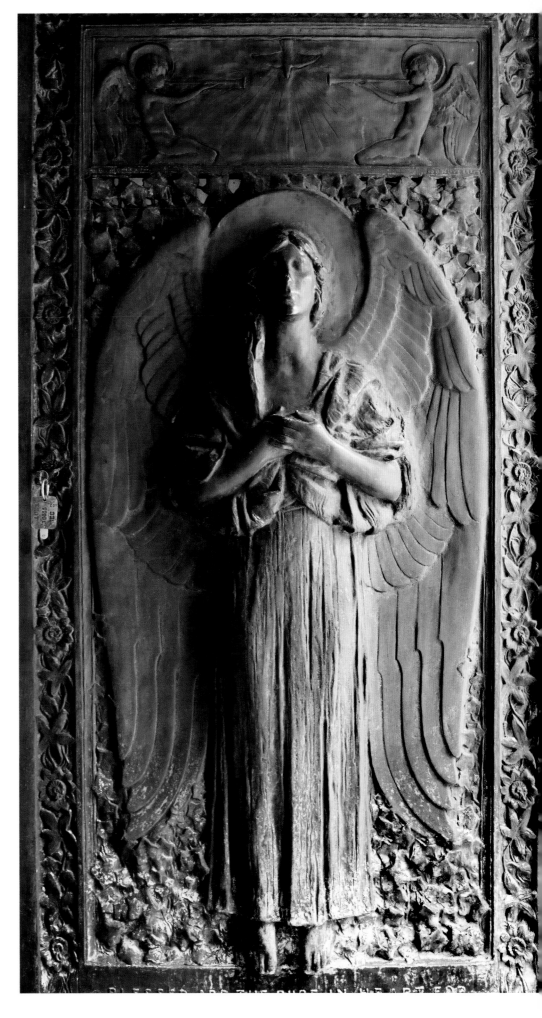

Opposite: A rose and pinecone motif on the flat tablet grave marker of Spencer Trask. A renowned financier, Trask made a tremendous contribution to the field of literature with the creation of Yaddo in upstate New York. John Cheever once wrote that Yaddo has "seen more distinguished activity in the arts than any other piece of ground in the English-speaking community and perhaps the world." Yaddo artists have won 74 Pulitzer Prizes, 29 MacArthur Fellowships, 68 National Book Awards, and a Nobel Prize.

Above: Bourne mausoleum door with a cross embedded with leaves and a lion head holding a thick ring.

Right: The Acea mausoleum door with three angels.

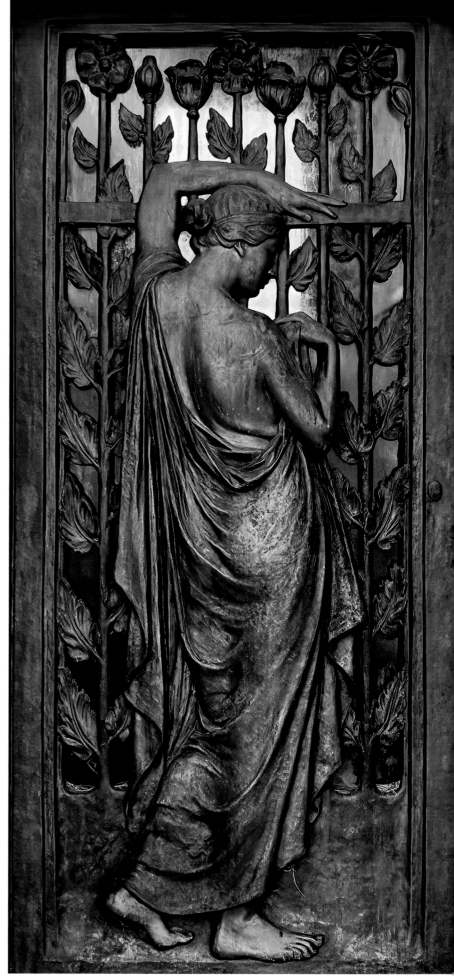

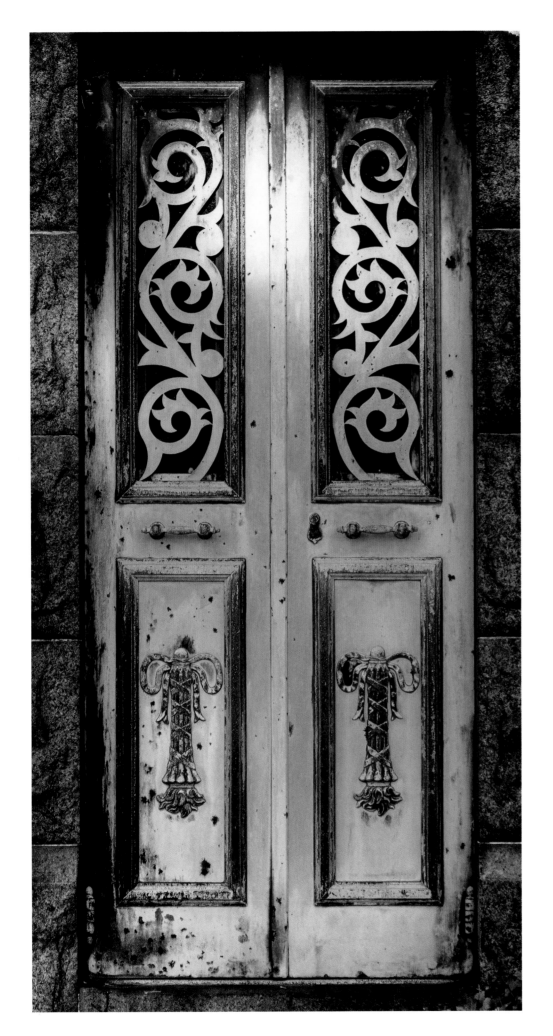

Opposite left: Horn mausoleum door.
Opposite right: Rosencrans mausoleum door.
Left: Doors to the Theo Wood vault.

Next spread:
The fanciful monument for the "Soda Fountain King" John Matthews (1808–1870), who made his fortune on carbonated beverages. Designed by sculptor Karl Müller, who must have been pleased when his work was honored as "Mortuary Monument of the Year" soon after it was unveiled. The memorial is a fantastical conglomeration, featuring winged gargoyles; a menagerie of animals, including lions, bears, a wolf, turtles, lizards, and a ram; florets; and leaves, as well as portraits of religious figures and Matthews family members.

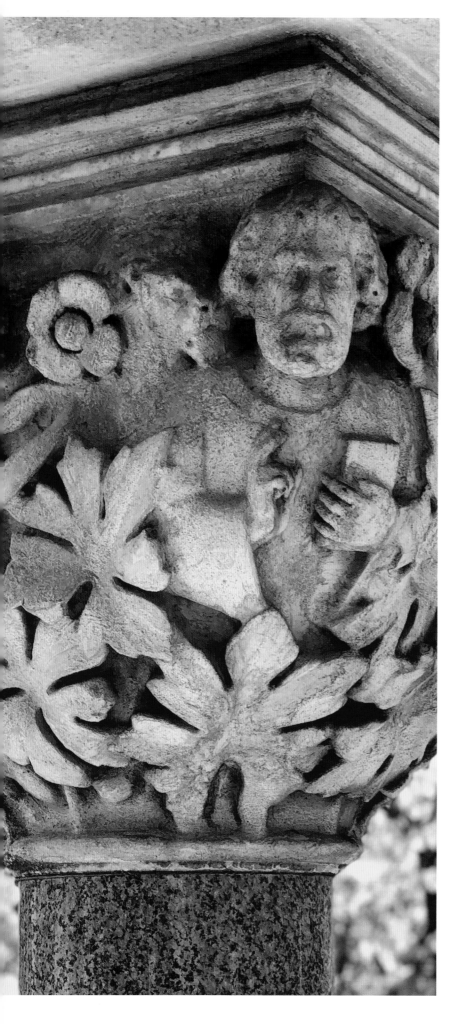

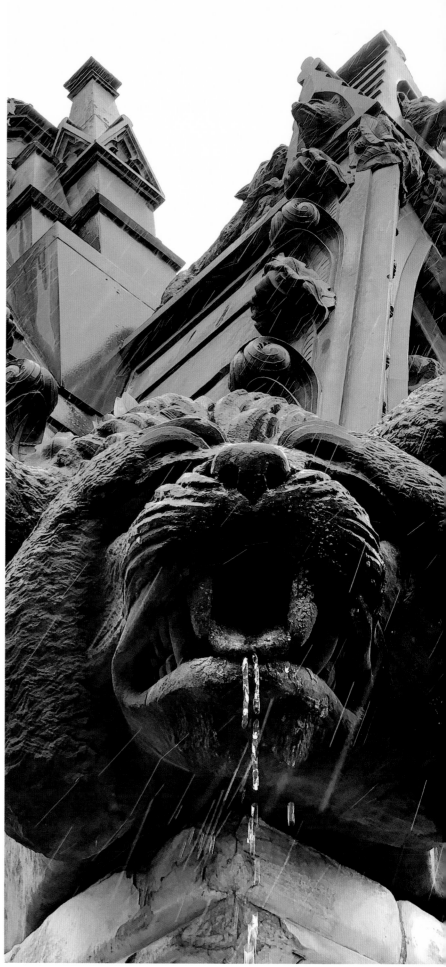

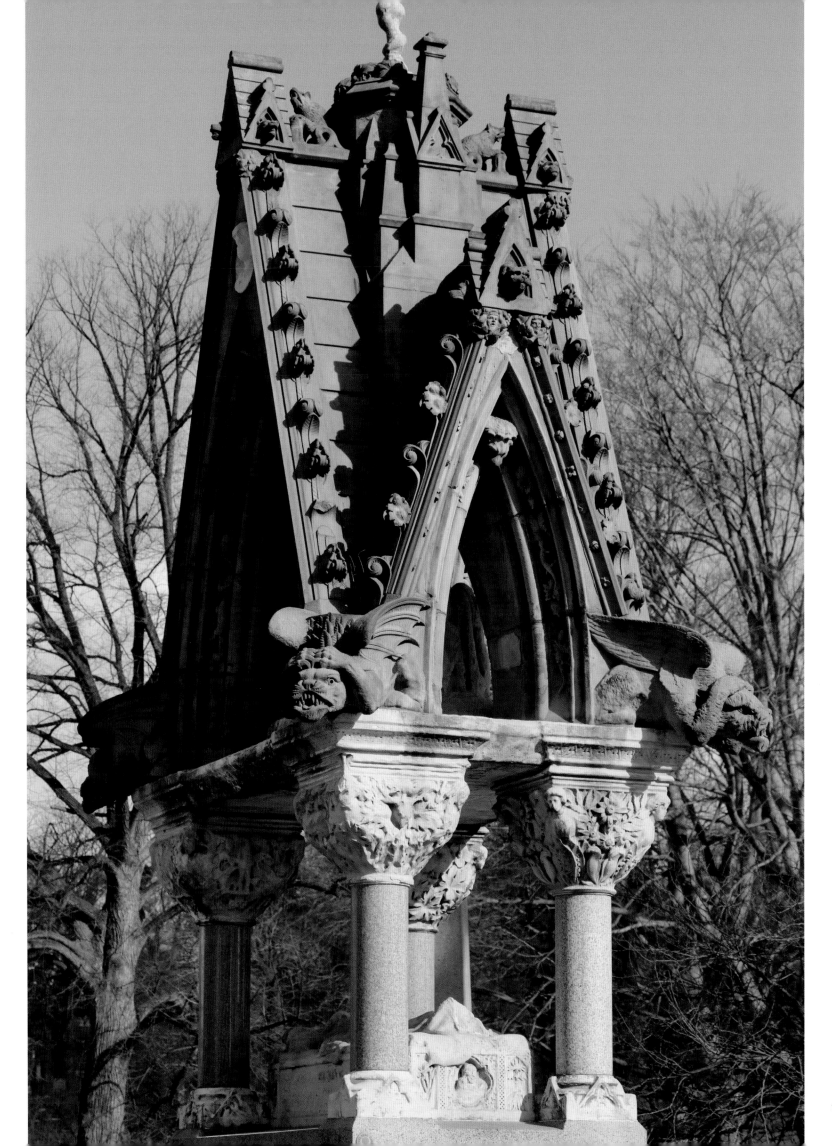

115

Left: The Moller vault gate. Rain, oxygen, and time set off a chemical reaction that gives bronze the green hue that so well complements stone mausoleums and monuments.

Opposite: Detail of bronze panel by Augustus Saint-Gaudens on the Stewart vault. This panel depicts an angel holding a banner or scroll, symbolizing the taking of life's inventory. When it was unveiled, it was considered controversial for the faces of angels depicting death as something other than a mournful experience. When the architect Sanford White saw the plans, he urged Saint-Gaudens to write to the Stewarts to explain. "Some people are such God-damned asses they always think of death as a gloomy performance instead of resurrection." The angels that Saint-Gaudens sculpted were purposely meant to be not gloomy.

116

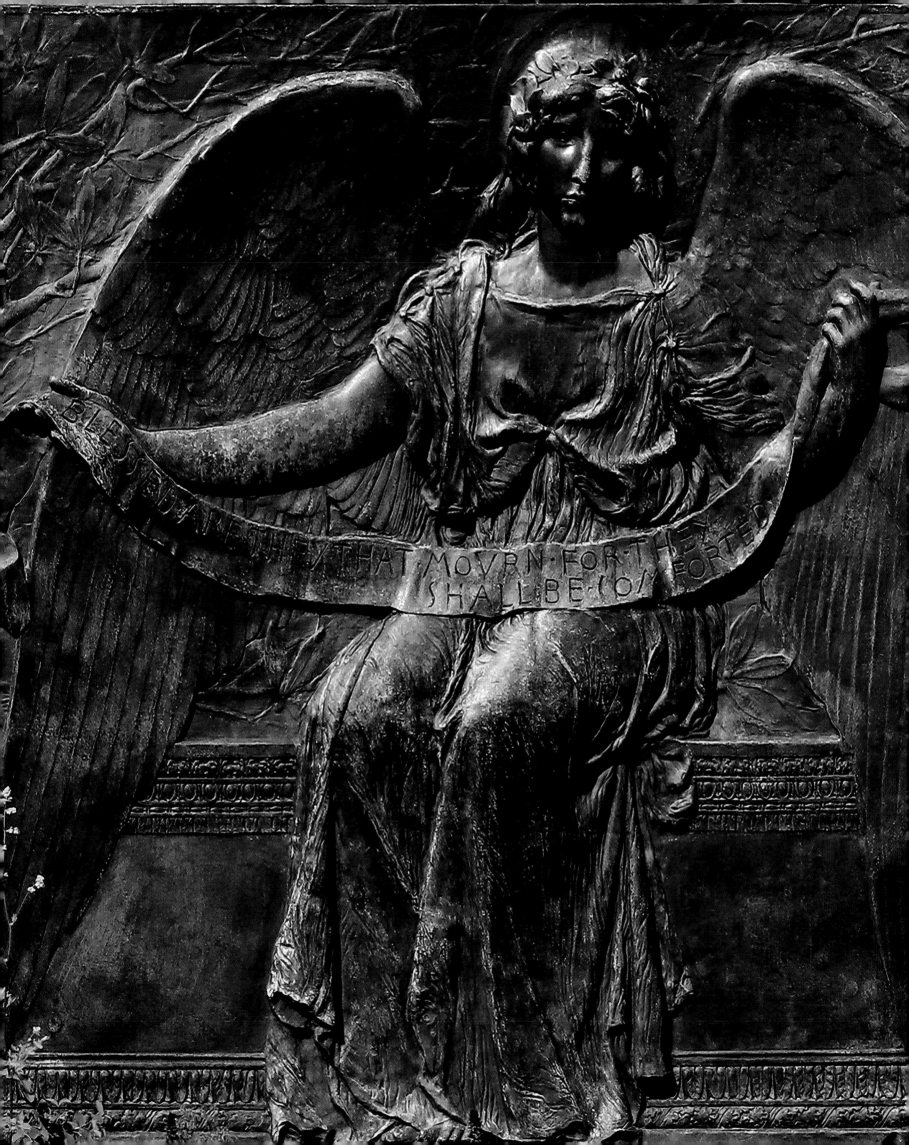

"Unable are the loved to die, for love is immortality."
—Emily Dickinson

Opposite: Detail of an hourglass with wings, *Tempus Fugit*,
at the Tucker vault.
Above: A downturned torch, symbolizing "life extinguished,"
at the Napier mausoleum.

Following spread:
Left: Oxidized floriated metalwork.
Middle: Door detail of the Smallman mausoleum.
Right: Lion head on the Bourne family Beaux Arts mausoleum
designed by Ernest Flagg, Frederick Bourne's architect of choice.
Bourne made his fortune as head of the Singer Sewing machine
company and commissioned Flagg to design not only this family
mausoleum, but also the headquarters for his company (the
Singer Building in New York City), the Bournes' estate in Suffolk
County, and a mansion on an island in Lake Ontario.

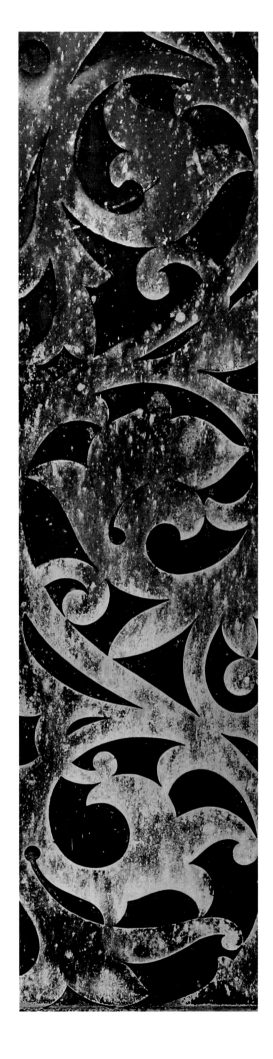
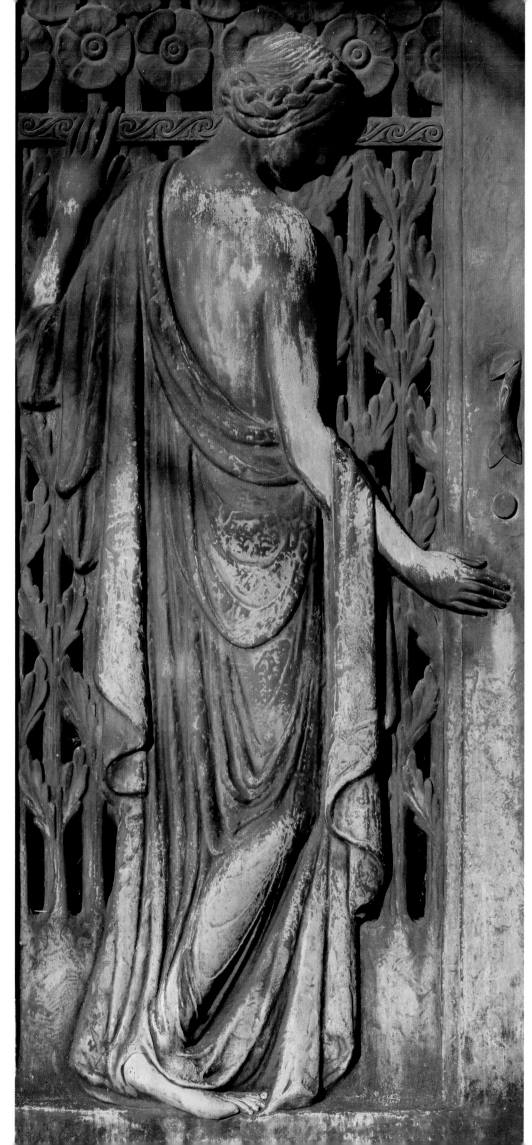

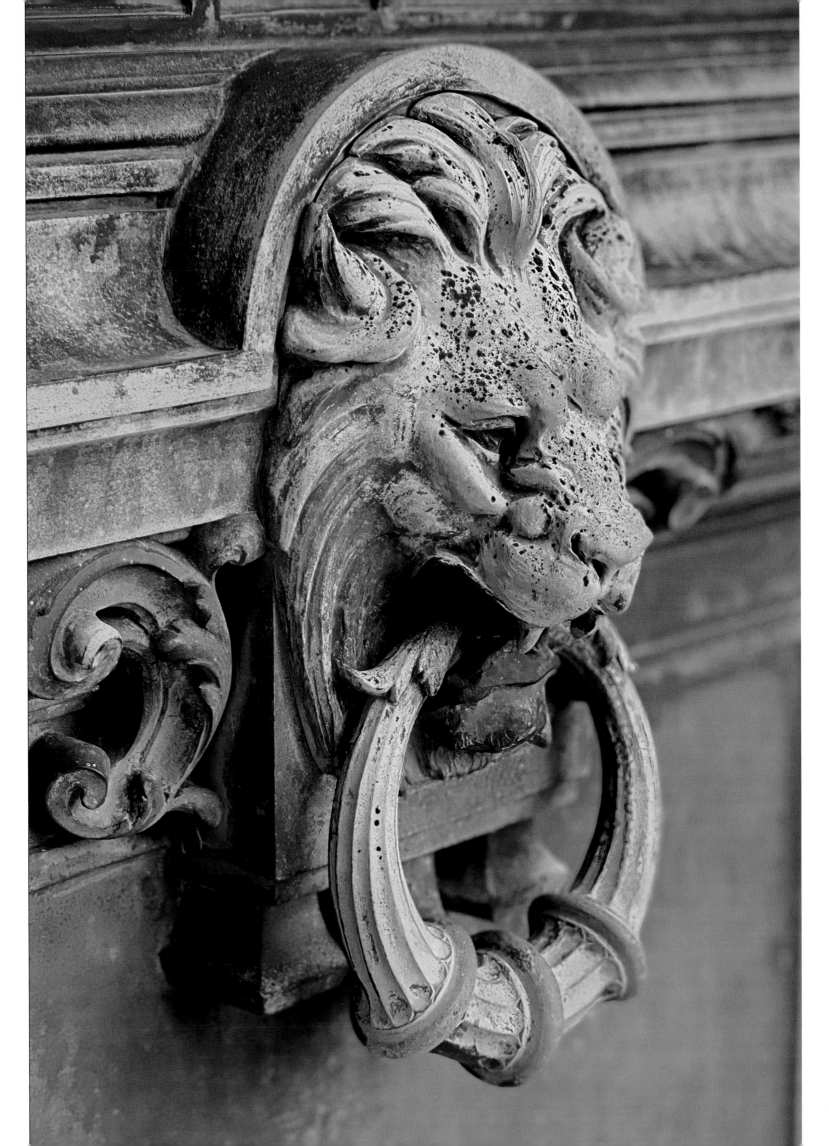

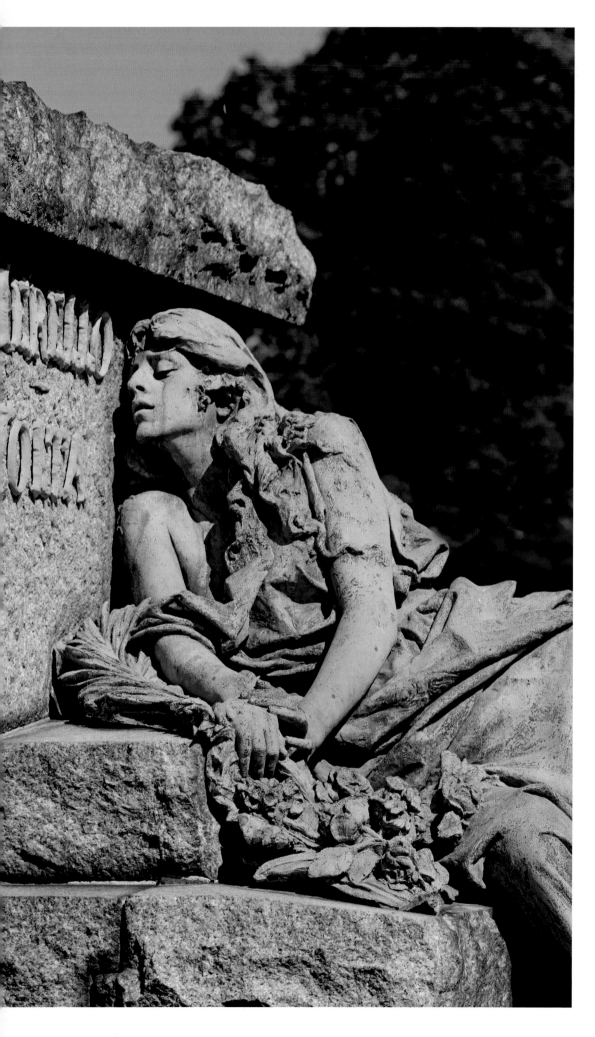

Left: The figure adorning the Merello-Volta monument is sometimes called the "Mafia Bride," rumored to depict a woman murdered on her wedding day. In fact, Rose Merello Gaurino stepped in front of the shotgun of an enraged family servant who was attempting to kill another servant. The monument features a door behind it that steps down to an underground vault.

Right: *Azarel, the Angel of Death* by artist Solon Borglum. The shrouded angel marks the graves of Charles Schieren (1845–1915), former Brooklyn mayor, and his wife. The figure's outstreched arms touch upon two large closed books, symbolizing lives fully lived.

Following spread:
Faces surround visitors to Green-Wood, whether carved in marble or cast in metal, sometimes representing the people interred below, other times allegorical virtues, angels, or other beings. Left: Sphinx head at the VanNess-Parsons mausoleum. Right, clockwise from upper left: Shade and moisture have caused the face of Hiram Fogg to deteriorate over the years. (The Foggs founded the eponymous first museum at Harvard University.) The face of Mary Powers. A relief portrat of Mrs. Wilby. William Wheatley, an American stage actor and theater producer of the nineteenth century, who produced what is believed to be "the first great American musical" at Niblo's garden.

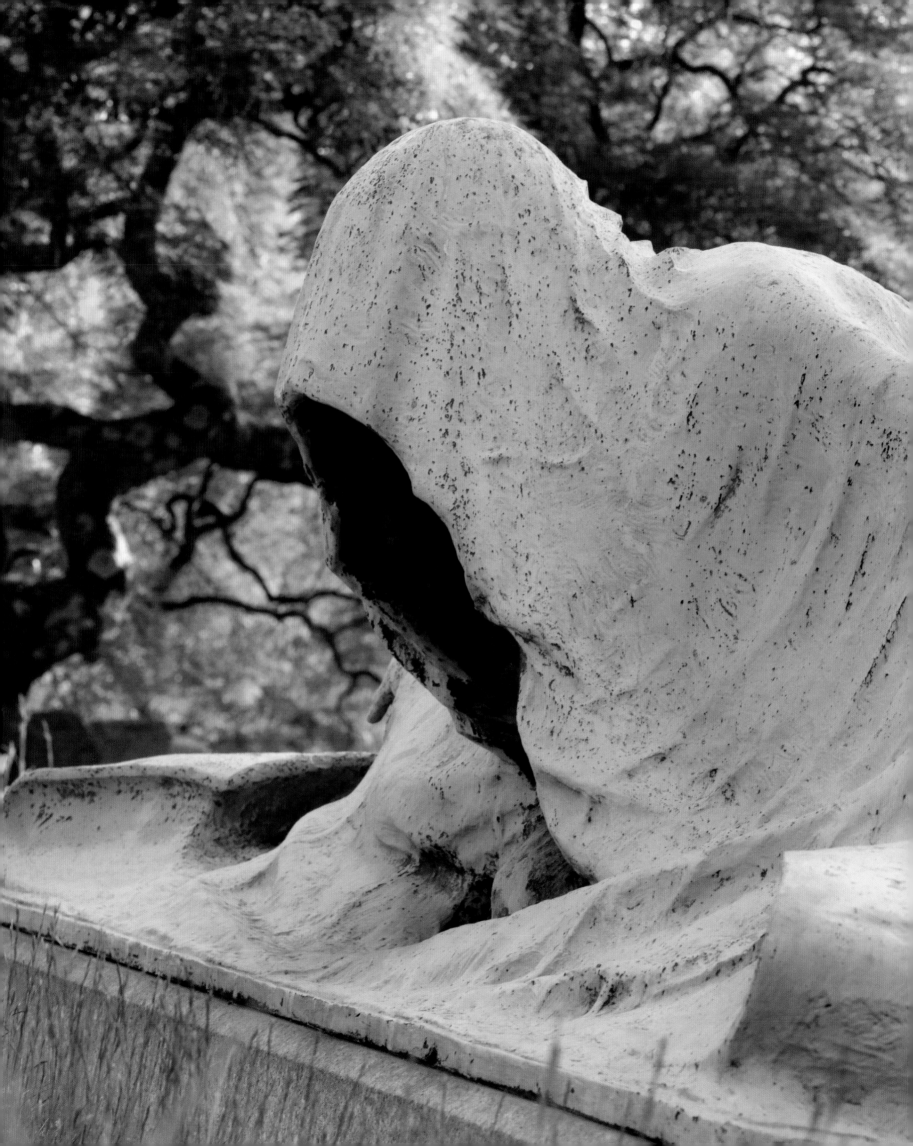

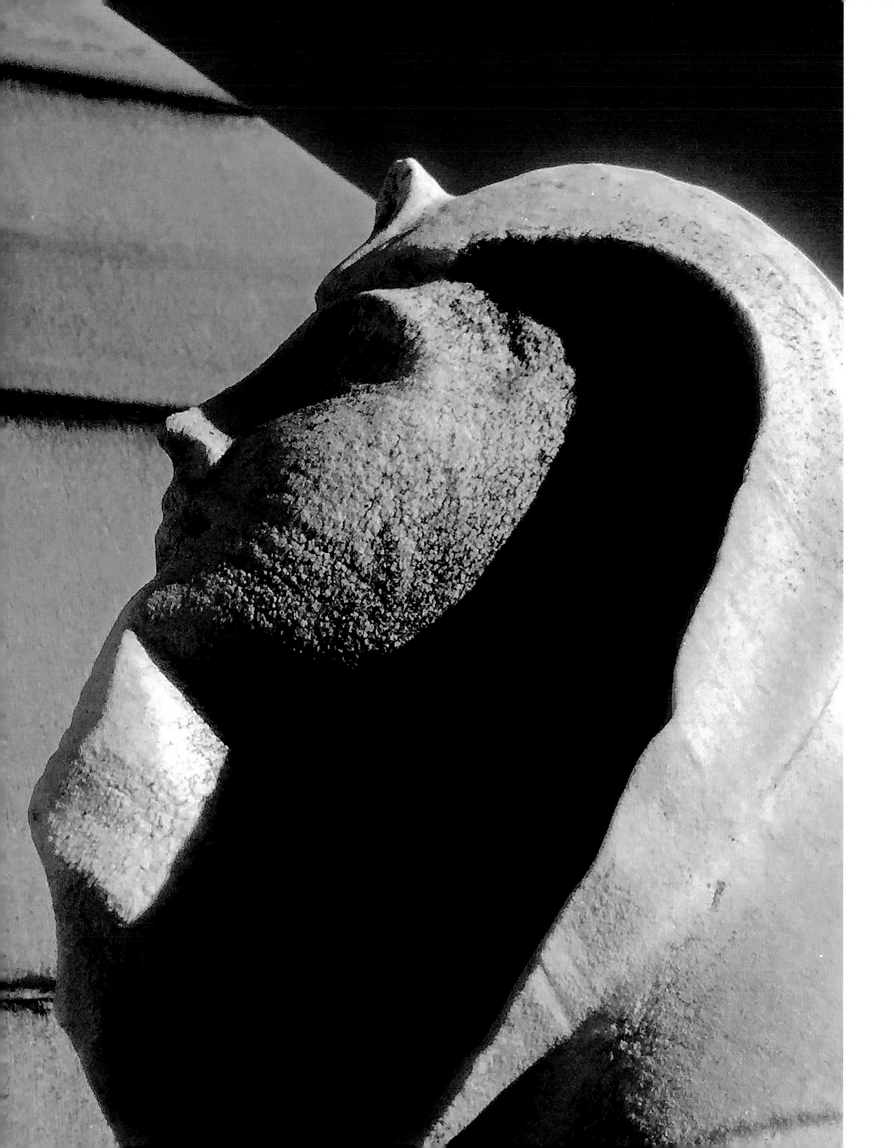

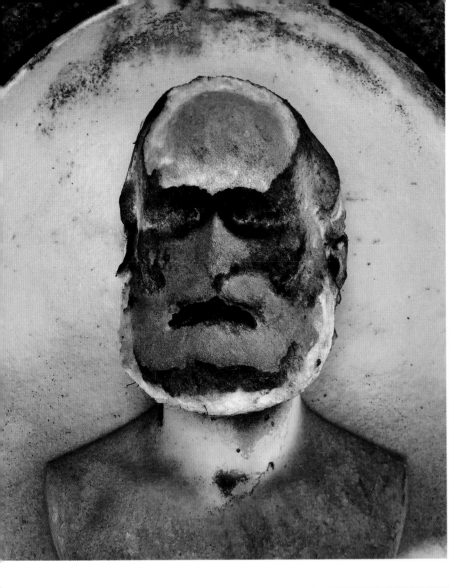
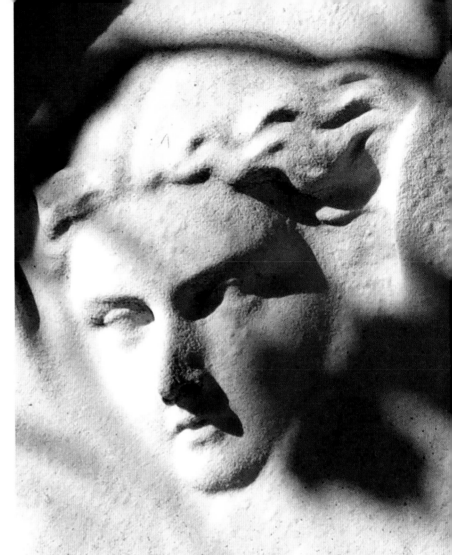
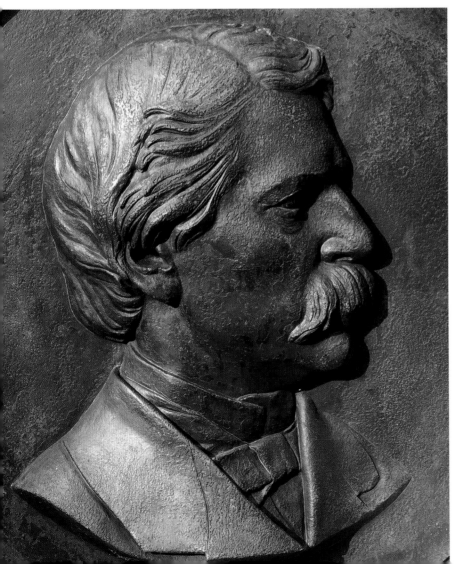
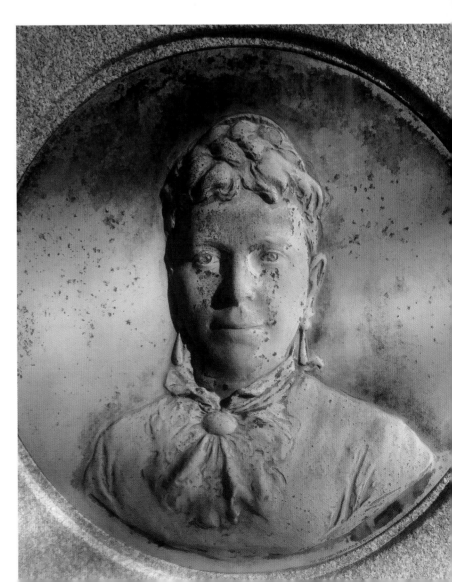

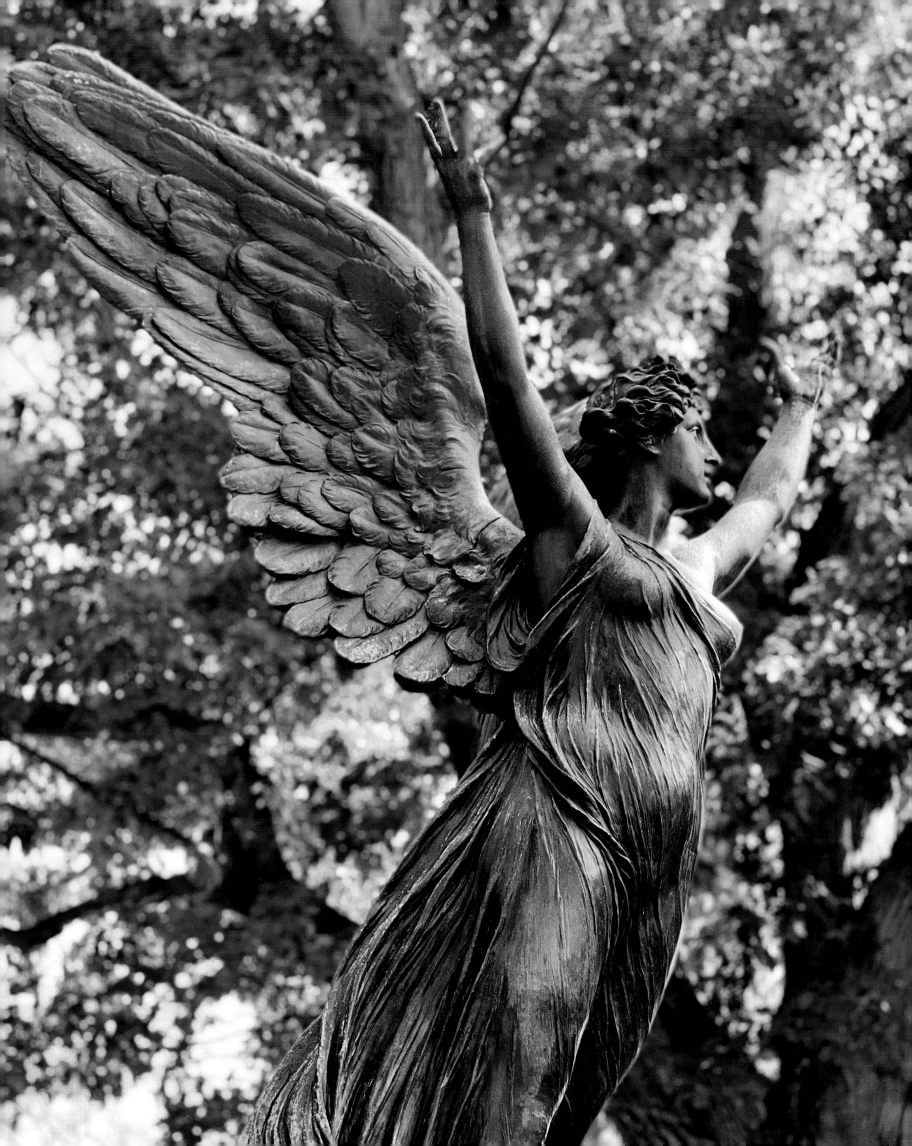

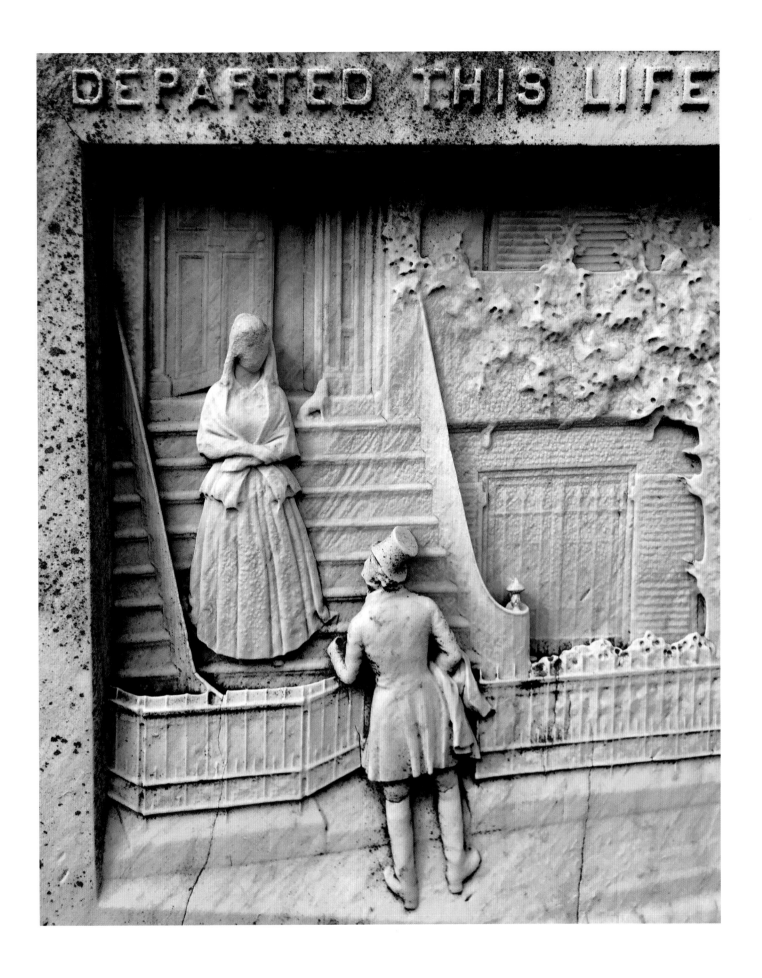

DEPARTED THIS LIFE

Opposite: The sculpture, known as the "Valentine Angel," by sculptor Adolfo Apolloni, is among the most dynamic memorials in the Cemetery. The angel, covered in flowing drapery, raises her arms triumphantly, suggesting an ascension to heaven.

Above: Charles Griffith bids farewell to his wife Jane on the steps of their Manhattan townhouse, their small dog waiting by the open door. The memorial freezes a memory in marble of the last time Charles saw Jane alive before her sudden death of a heart attack that afternoon.

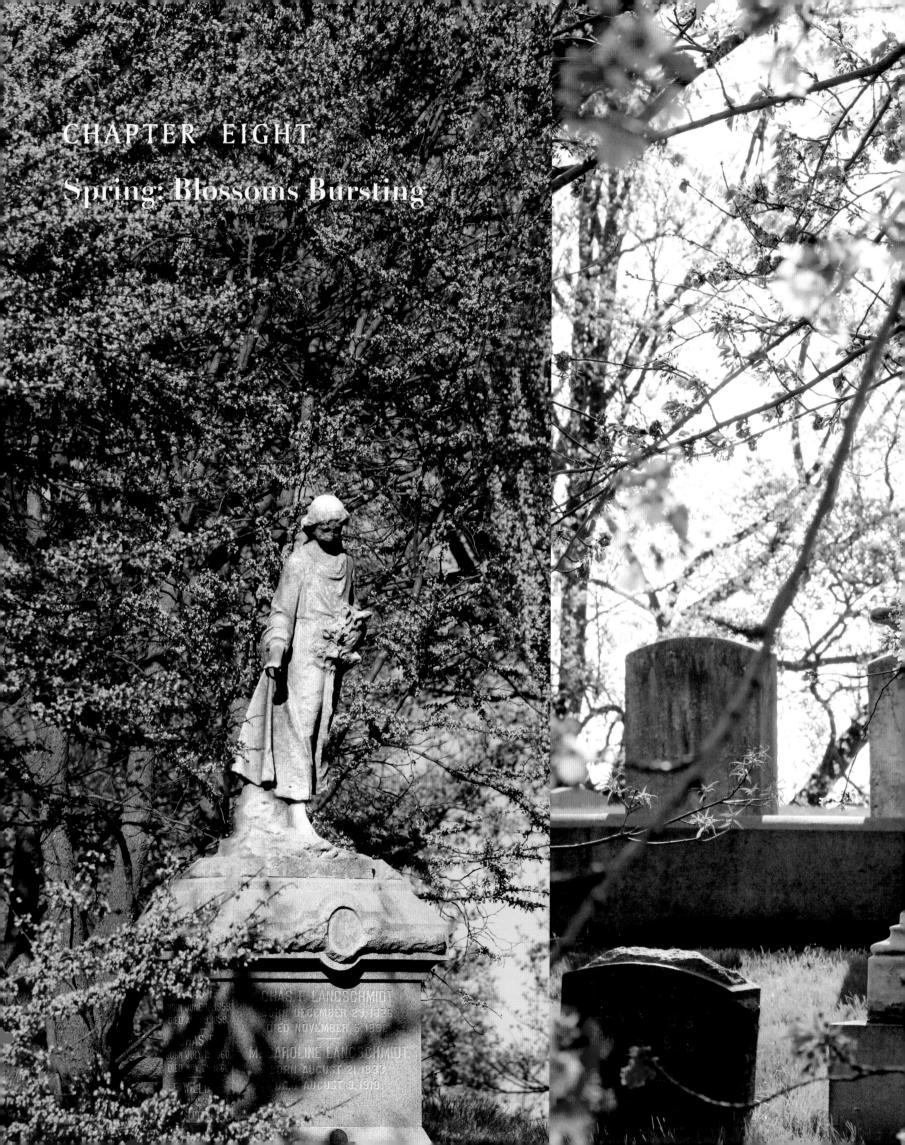

CHAPTER EIGHT

Spring: Blossoms Bursting

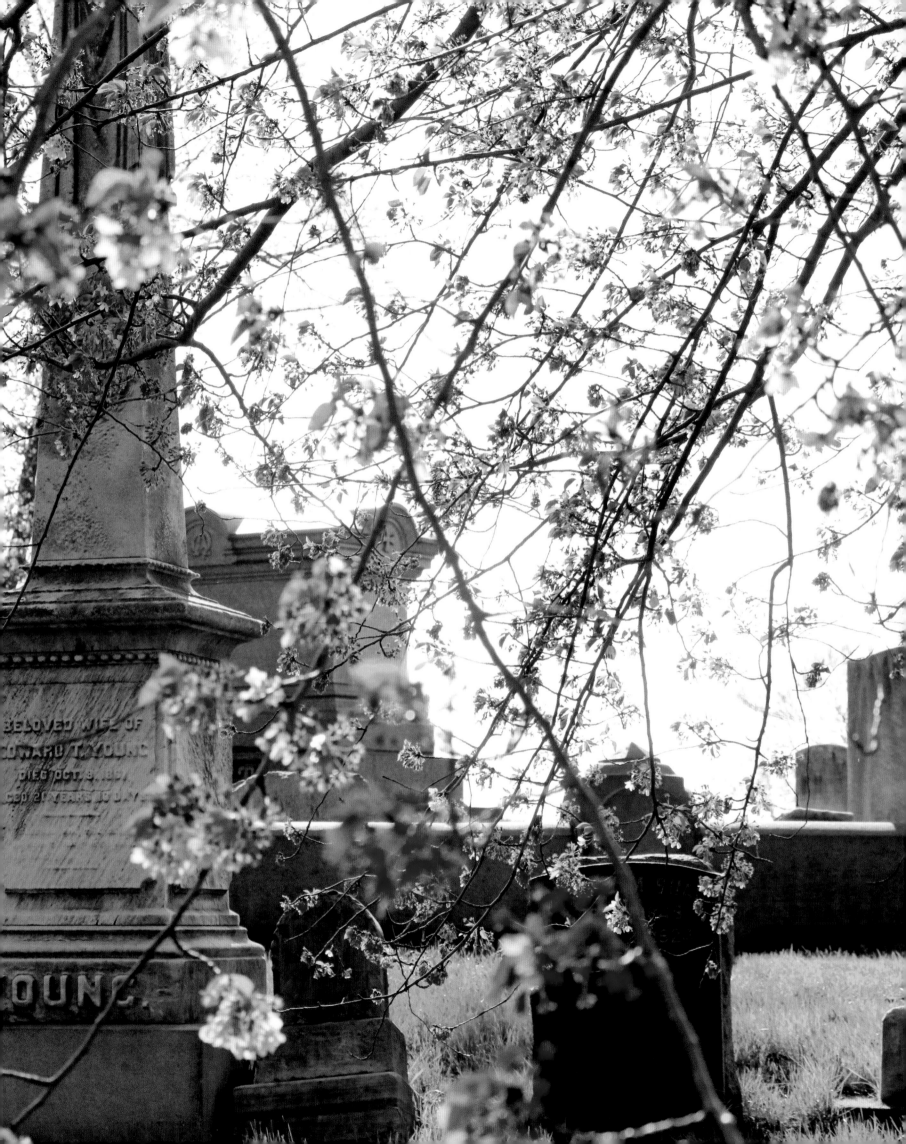

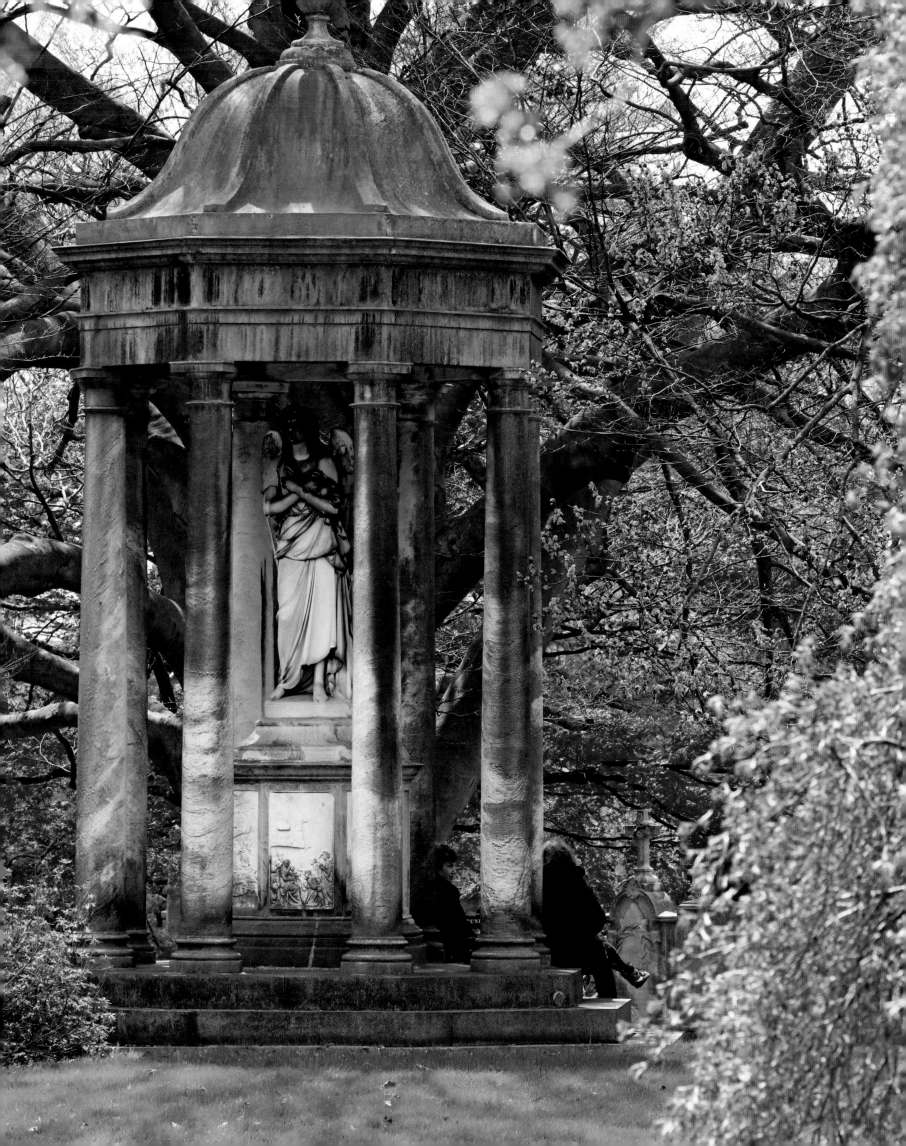

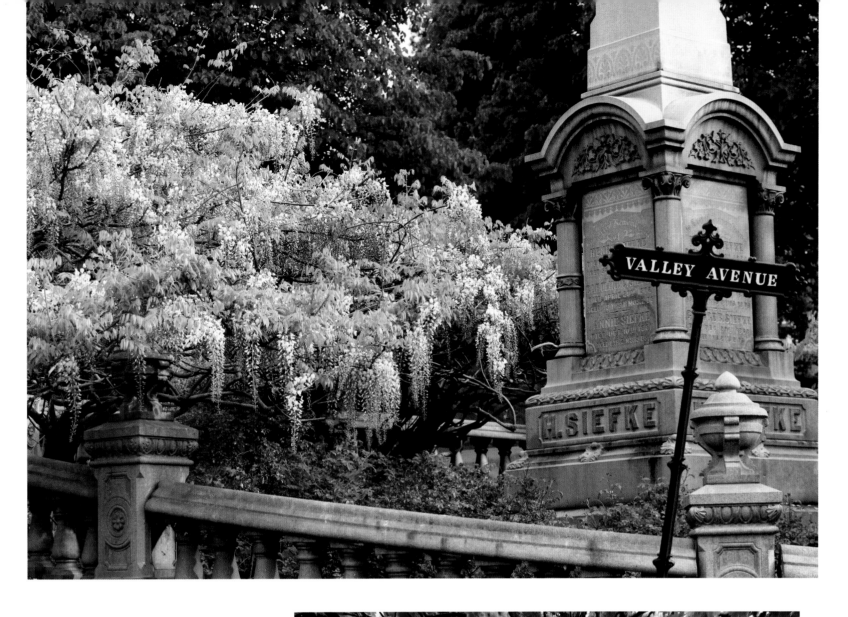

Previous spread:
Left: Langschmidt monument surrounded by resplendent red bud blossoms, near Ocean and Vine Avenues.
Right: Lacy cherry blossoms looking west from Bayside Avenue.

Opposite: The baldachino monument to Abraham Scribner (d. 1862) once included a marble stairway, posts with urns, and a fence, all of which have all been lost to time.
Above: Glorious purple wisteria blossoms surround the Siefke monument near Valley Water. The lot is one of the few in Green-Wood with the original stone fence around it. Most were removed over the years because they fell into disrepair or made tending the lawns very difficult.
Right: Positively bursting with bright pink flowers at water's edge stands this Kwanzan cherry tree.

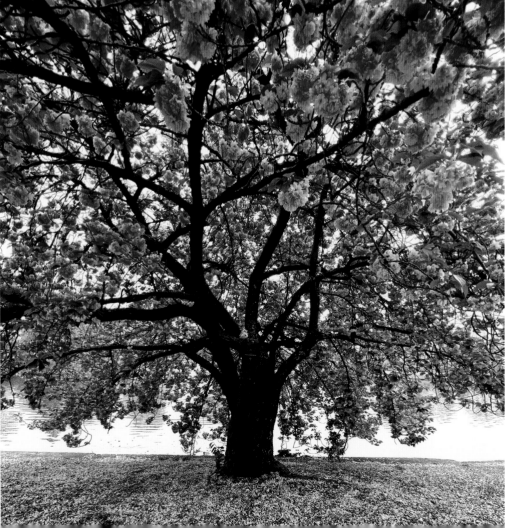

Watching Spring

Andrew Garn

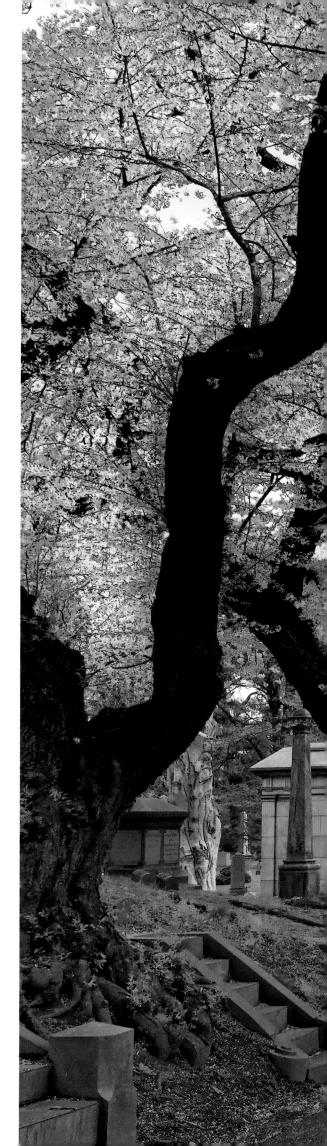

S pring is a dazzling spectacle at Green-Wood as contours of the landscape subtly flash minute dots of color, then suddenly, as if overnight, the world erupts into gaudy bloom. As the earth warms, we witness the awakening of nature in this urban sanctuary, made especially remarkable at Green-Wood, with thousands of trees, shrubs, and multitudes of flowers.

Jolting yellow forsythia shrubs burst forth, followed by showy saucer magnolias, then the distinctive flowering red-bud trees, their leafless branches covered in clinging, light purple florets, signaling rebirth.

Revisiting the constantly changing, landscapes through continuous years and observing multiple springs was a particular reward of this long-term project. Photographing the same trees, hillsides, lawns, and flowers again and again afforded me a unique opportunity to witness the subtle patterns and utter capriciousness of nature.

An unusual warm spell in January 2019 caused the weeping cherry trees to bloom about 3 months early. Because of the pandemic, 2021 was a spring awakening with mixed emotional responses—hopefulness, but with the continued dread we had all experienced for a year. The weather, however, provided a particularly strong start for early blooming magnolias, with temperatures above freezing in early spring, encouraging the long, graceful pastel petals to bloom in luminous lemon and coral, set against bare branches.

In spring 2022, a late frost in March quickly rendered many of the glorious magnolia petals a limp brown, slippery as banana peels on the ground. A few weeks later, the sustained cool (but above freezing) overnight temperatures continued into April, functioning like a florist's cooler—very agreeable to other spring trees. Kwanzan cherry trees, with their multitude of frilly pink blossoms, seemed to bloom for a month, their petals finally letting go and creating magical carpets of blushing paths and waterways.

Look anywhere in Green-Wood and you will see a confection of nature exploding. Among stone monuments erupt the naturalized spring ephemerals, candy-cane striped Carolina spring beauties, delicate white Star-of-Bethlehem, and yellow, nodding trout lilies growing inside cradle graves. By June, all these early spring bloomers will have totally vanished until the following spring.

Lavish white or pale-yellow blossoms of dogwoods demand your attention as well as the aforementioned, showy Kwanzan cherries; their extending branches create delicate archways over walking paths and roadways. Not to be outdone, the crabapples flowering around Crescent Water pulsate with pink and white blossoms, sometimes punctuated by bright yellow warblers.

Maples proffer surprisingly large yellow, orange, and red flowers. The tall, straight, and grand tulip poplars provide bright yellow, fist-size blossoms, which resemble their spring bulb namesakes. Horse chestnuts yield large conical clusters of pink-tinged creamy flowers.

Even the mighty oak trees contribute to the spring extravaganza with bright yellow-green tassels called catkins. The male catkins produce pollen that fertilizes the female ovaries, which turn into acorns come fall.

The shrubs also contribute to the show. Gaudy pink, orange, and red azaleas pop up throughout the hillocks and valleys. Giant rhododendrons offer their large pink clusters, set against dark green, leathery evergreen leaves—some so large that you can walk amongst them and feel like you are inside a house.

An inquisitive botanist will also discover some rarities at Green-Wood. The Franklinia tree (in the tea family, and now extinct in the wild) presents bright daffodil-like flowers, centered with intense yellow stamens. Camelia trees (also in the tea family) exhibit small, intense red flowers with long golden stamens. The trifoliate orange, hidden behind a thicket of spruce trees, is a riot of softly scented white blooms protected by ferocious two-inch thorns.

The colors of spring at Green-Wood offer beauty and pageantry for all who visit.

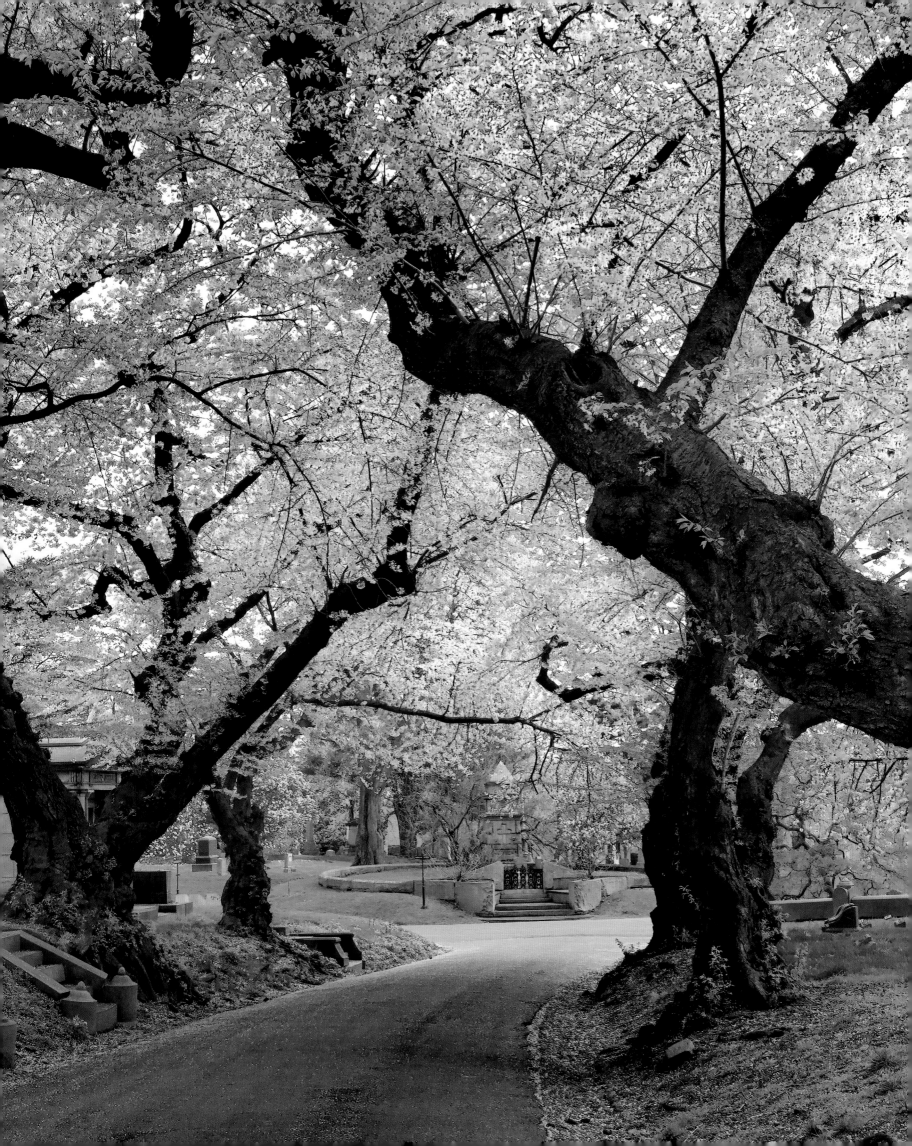

Previous spread:
The Yoshino cherry allée on Battle Avenue. Green-Wood is home to twenty-five unique cultivars of cherry trees.

Right: Kwanzan cherry blossoms floating on Valley Water.
Opposite: Azalea blooms fronting the Phelps mausoleum (renovated in 2022) by Crescent Water. The structure, a fine example of Gothic Revival funerary architecture, sports six "crockets," spires with carvings of buds, flowers, and leaves.

Next spread:
Looking across Valley Water through Kwanzan cherry blossoms to the Historic Chapel. Valley Water was one of eight original bodies of water in the Cemetery carved out by glaciers about 18,000 years ago. Today there are only four left, as they were filled for various projects, including the building of the Chapel.

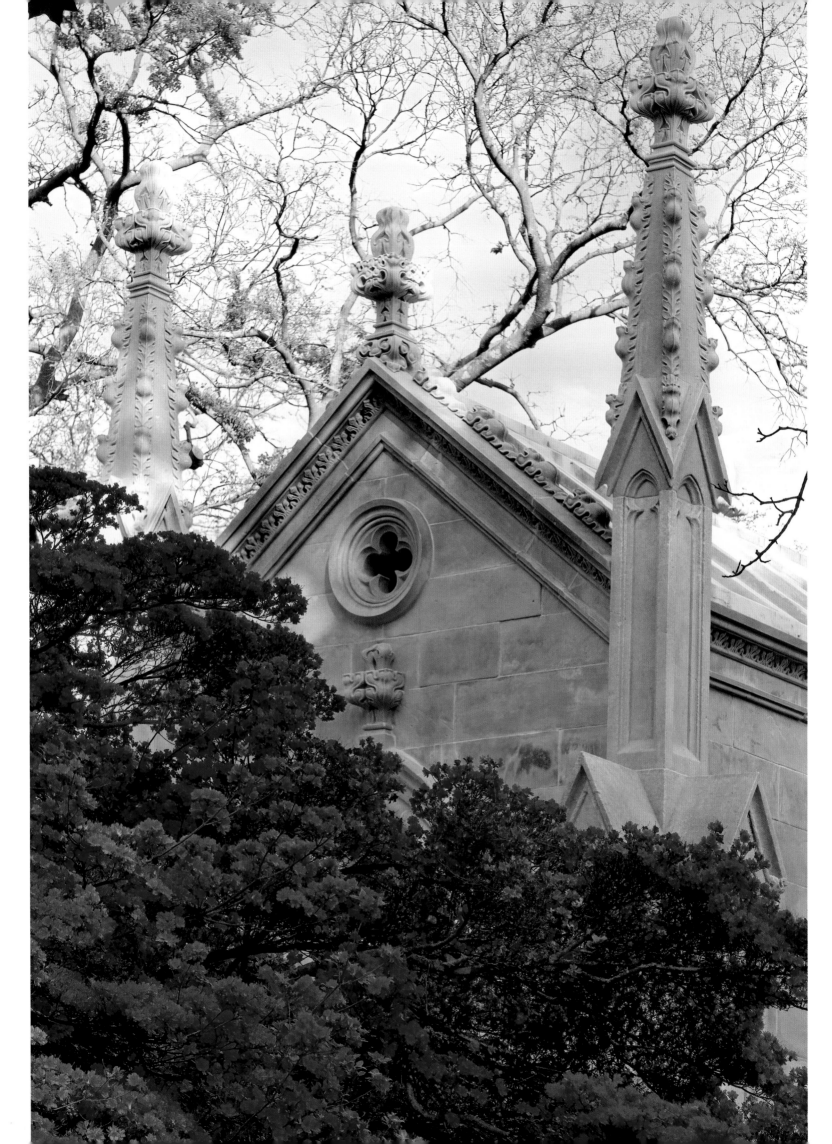

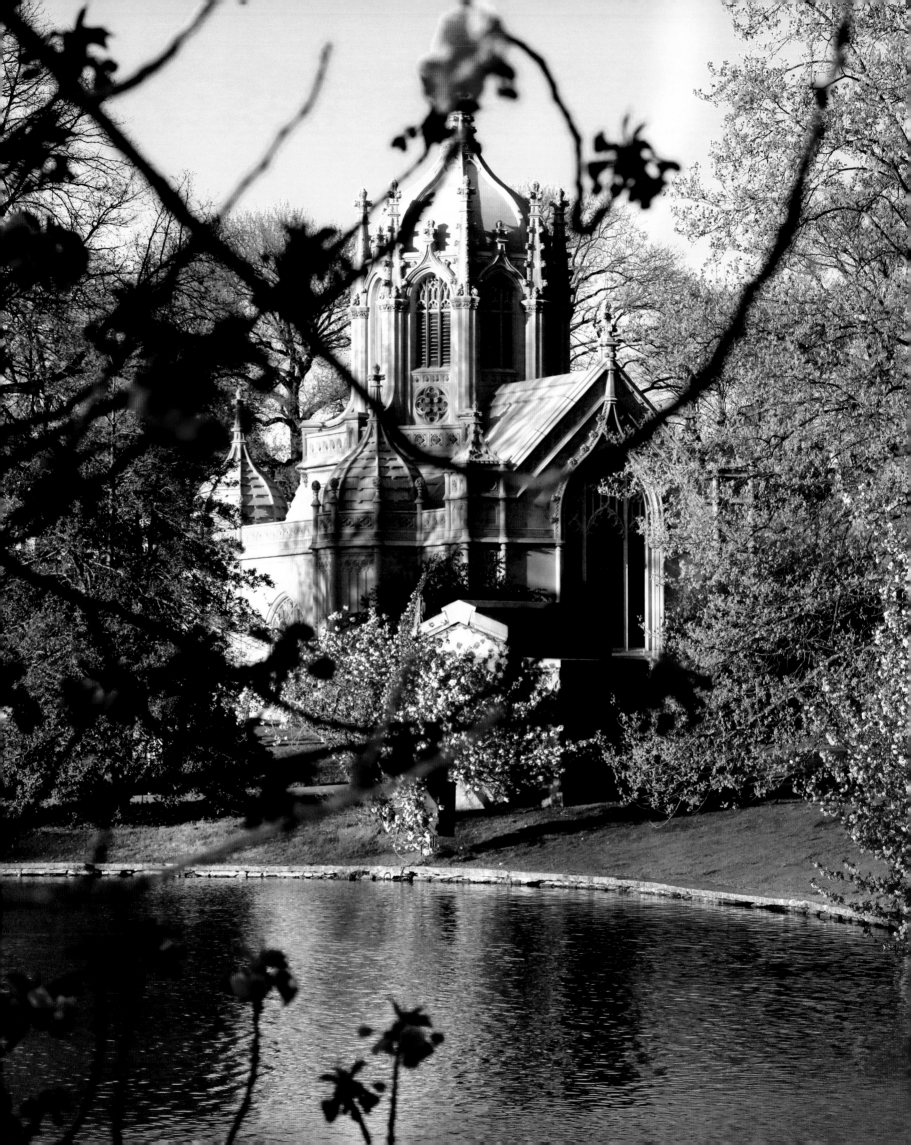

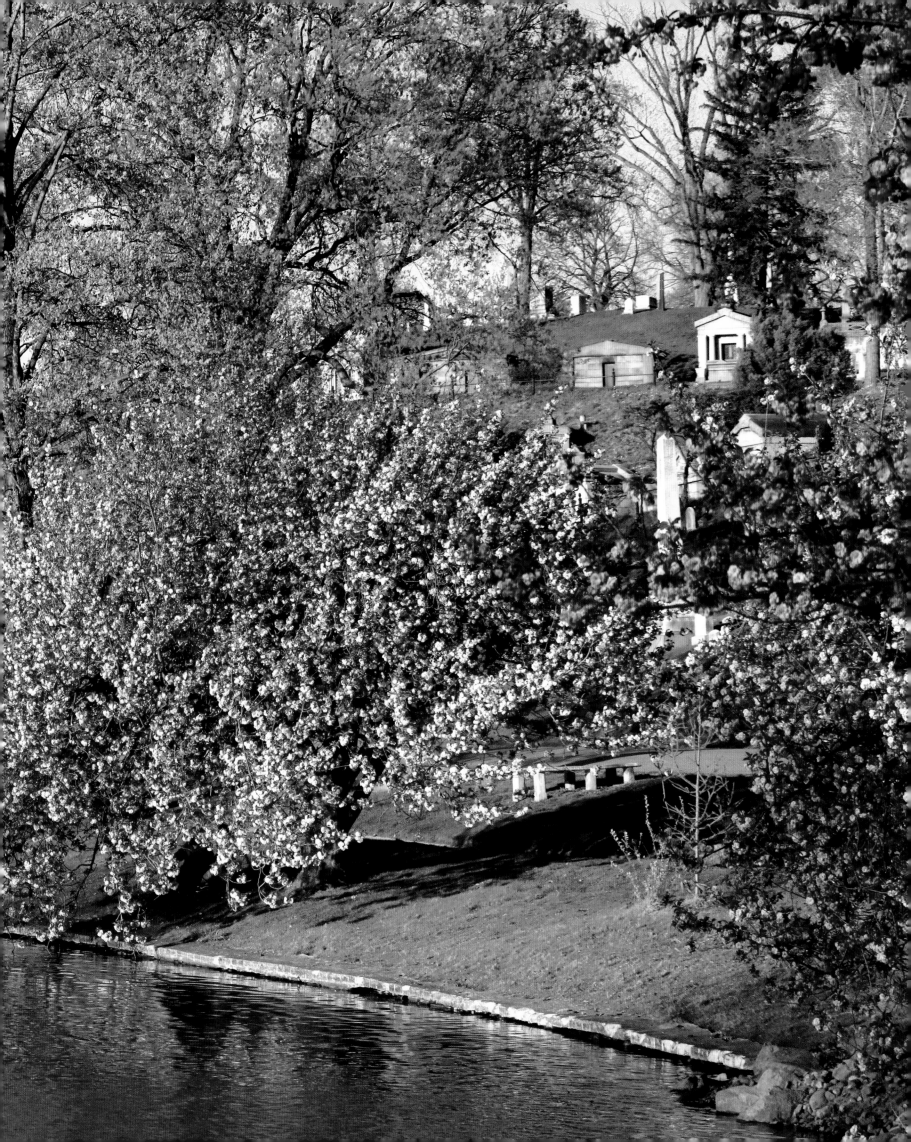

Opposite: Japanese maples and obelisks between Fir and Sassafras Avenues. There are countless obelisks built in Green-Wood, which came into vogue as cemetery monuments during two periods of "Egyptomania"—in the early 1800s, during Napolean's invasion, and again in 1922 with the discovery of the tomb of Tutankhamun.

Right: The Ravesteyn monument and blooming azalea and cherry blossoms. Azaleas originate from China and Japan, their vibrant five-petal flowers ranging in color from white to fuchsia. In both Eastern and Western cultures, they symbolize self-care, love, and respect.

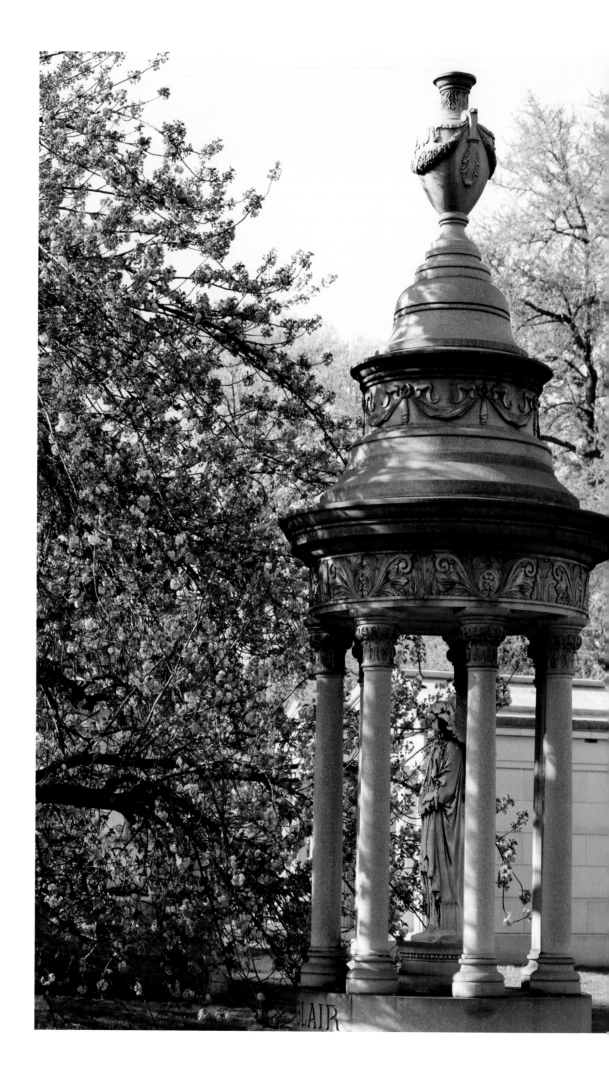

Right: The Blair monument framed by cherry blossoms off Vine Avenue.
Opposite: Joseph H. Terry vault with forsythia in early March.

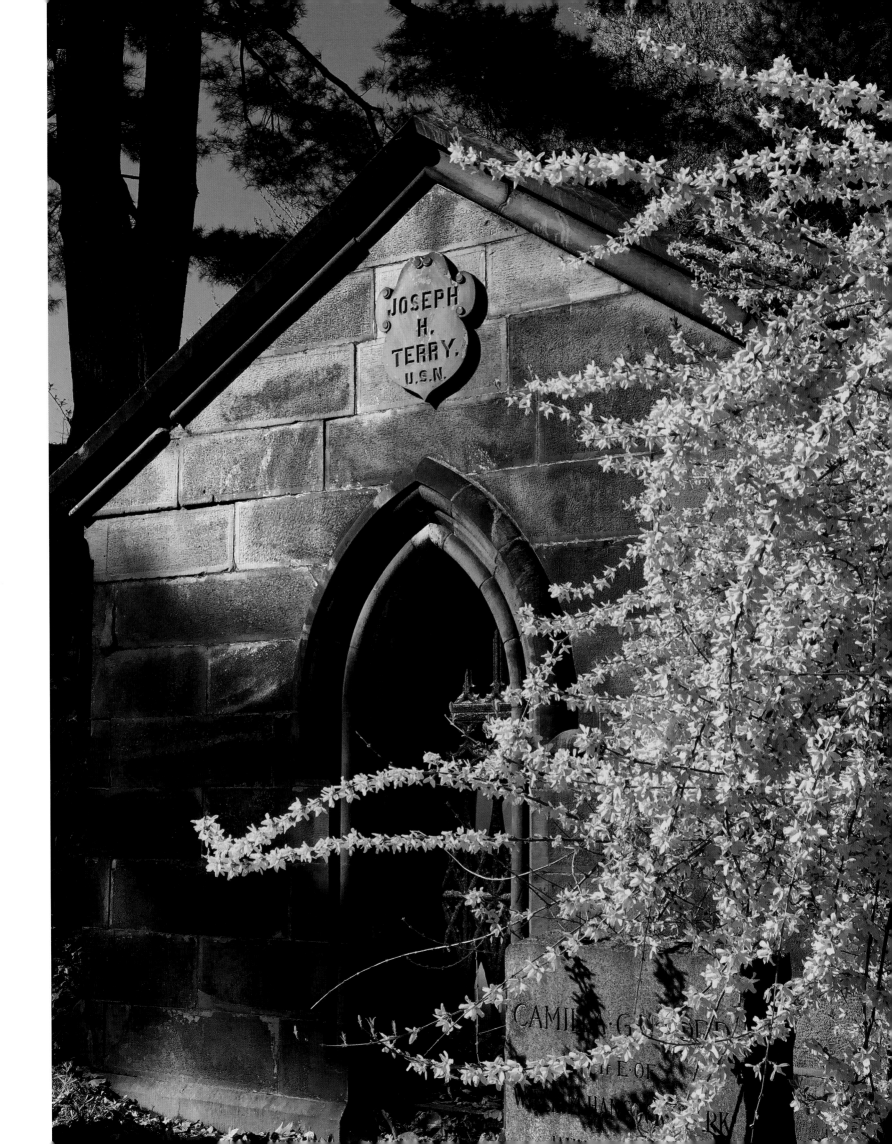

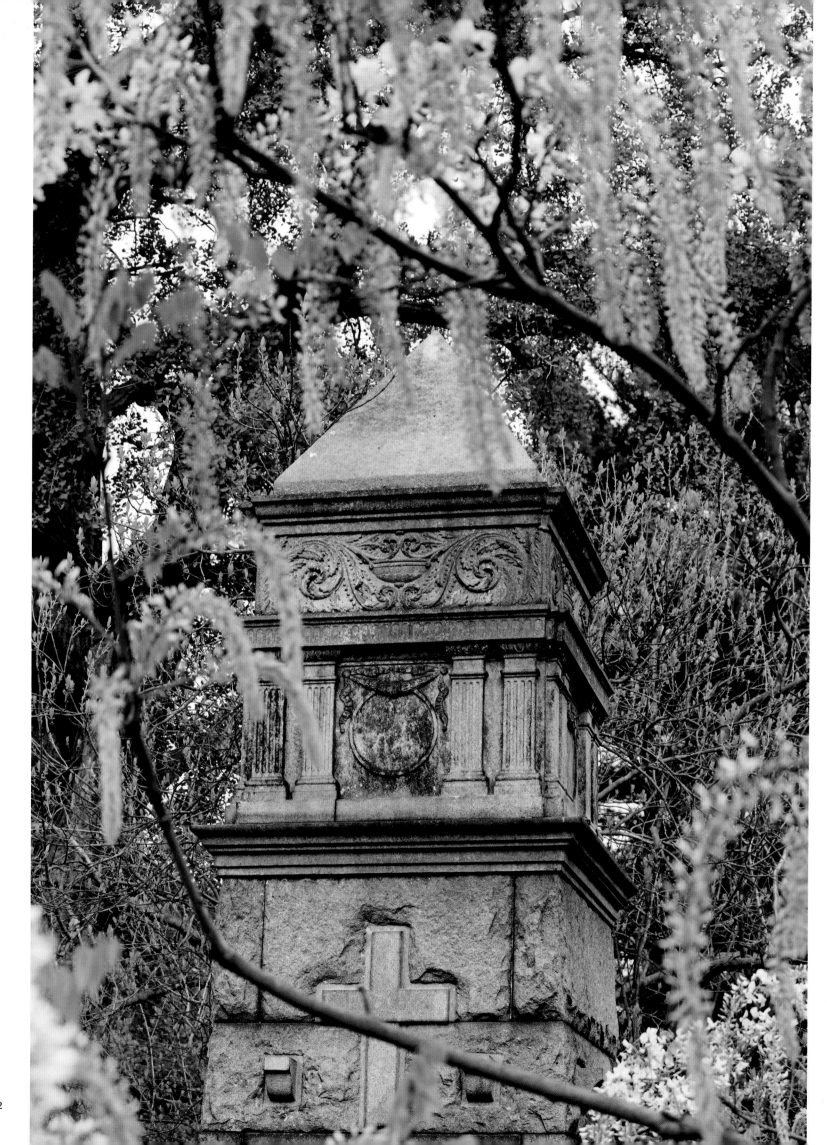

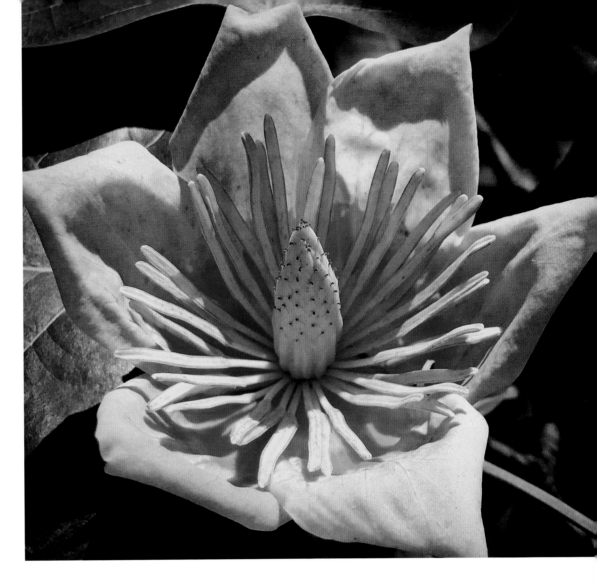

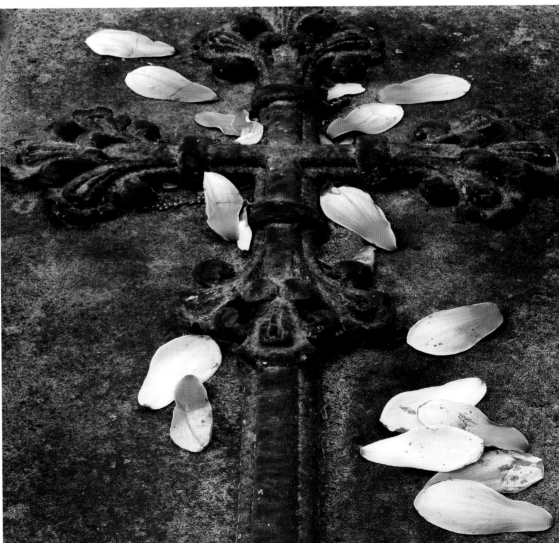

Opposite: White wisteria in bloom around the Matthews family monument on Hemlock Avenue.

Top right: Tulip tree flower. Tulip trees are the tallest (and straightest) standing trees in Green-Wood and the largest deciduous tree of the eastern North American forest. While its name relates to the strong resemblance of its flowers to the spring blooming tulip, the tulip tree is a member of the Magnolia family. The tree's flowers attract beetles, flies, and bees to their pollen-rich anthers.

Bottom right: Saucer magnolia petals fallen on a tablet grave embossed with a Gothic cross.

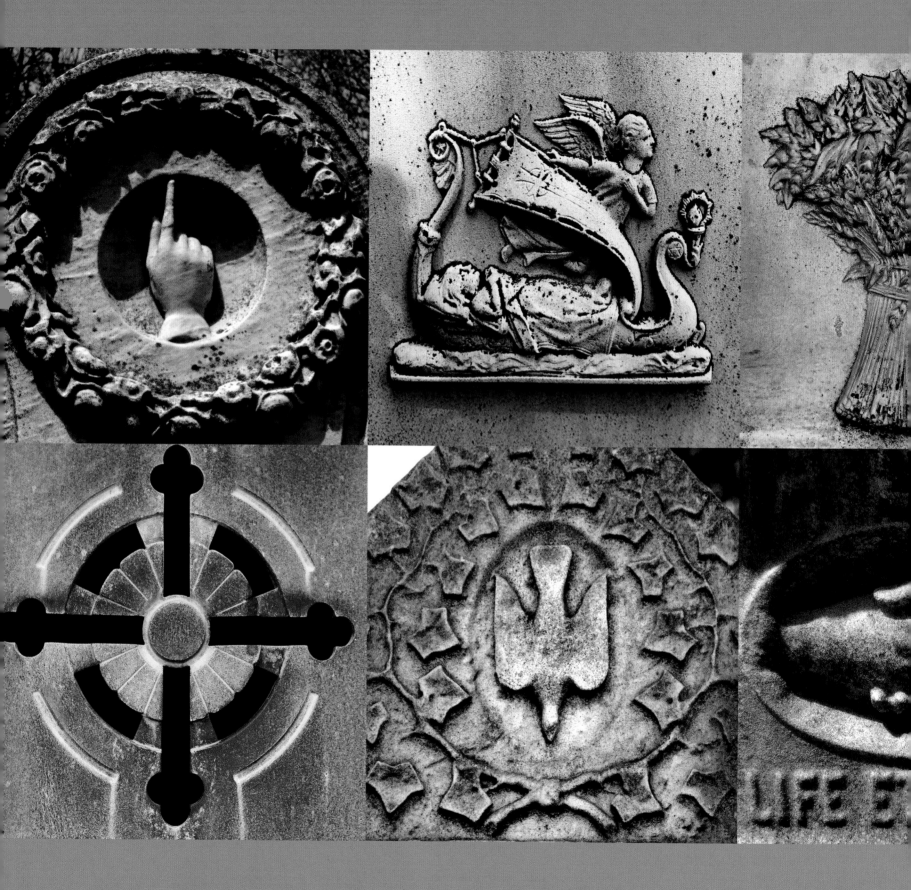

144

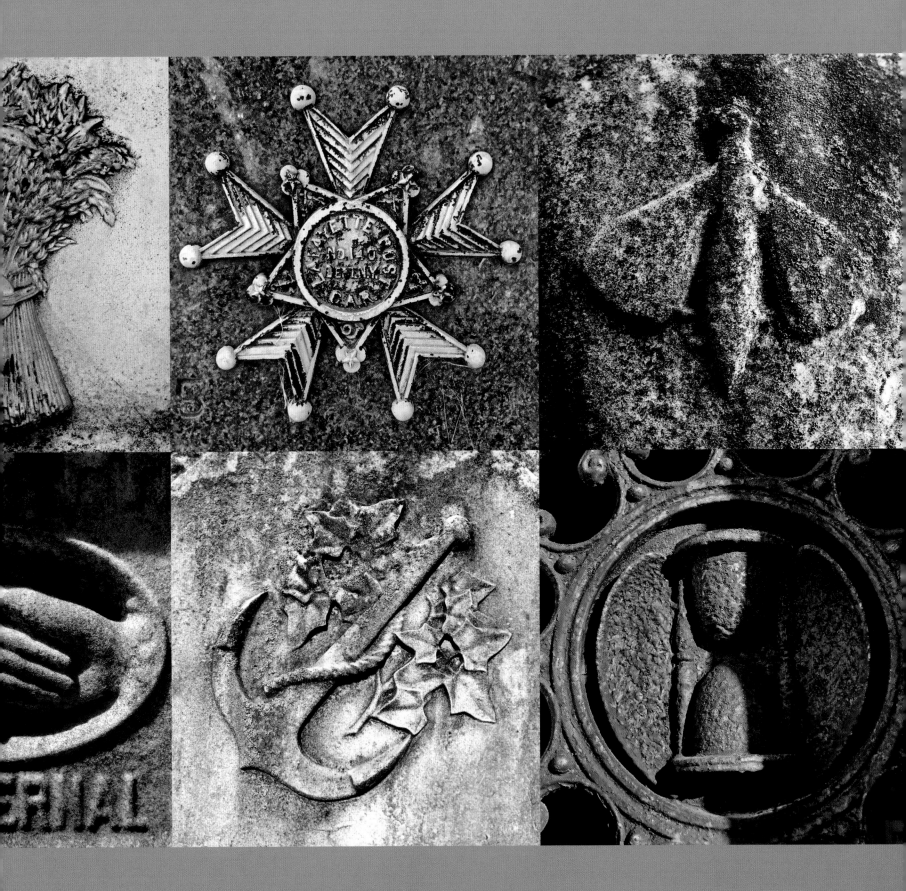

Words and Symbols: Typography and Ornamentation

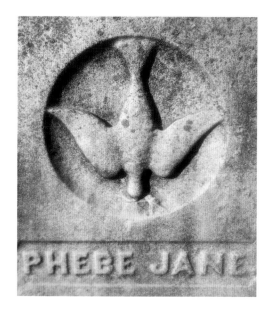

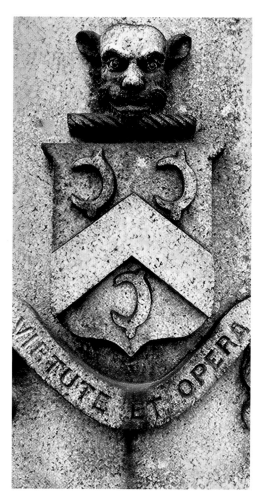

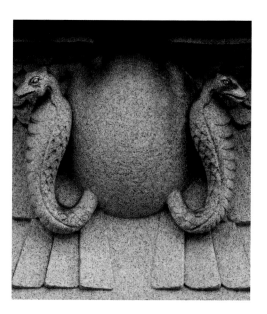

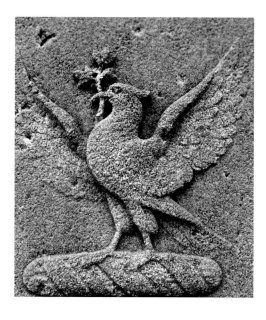

Previous spread:
From clasped hands linking loved ones beyond the veil of death to a rose broken while it was in bloom, a great wealth of symbolic imagery is evident at Green-Wood. Many of these symbols derive from Christian tradition, such as descending doves, which represent the Holy Spirit, or butterflies, which reference the cycle of life, death, and, finally, resurrection.

This spread:
Other symbols are indicative of cultural heritage, like thistles, commonly on tombstones of those with Scottish heritage, or the heraldic piece here paired with the text *virtute et opera* (by virtue and energy). Some, like the hourglass, have been used for centuries to signify the inevitable passage of time. Although many of the cemetery symbols have become obscure, pausing to decipher them can lead to a deeper understanding of whom they remember.

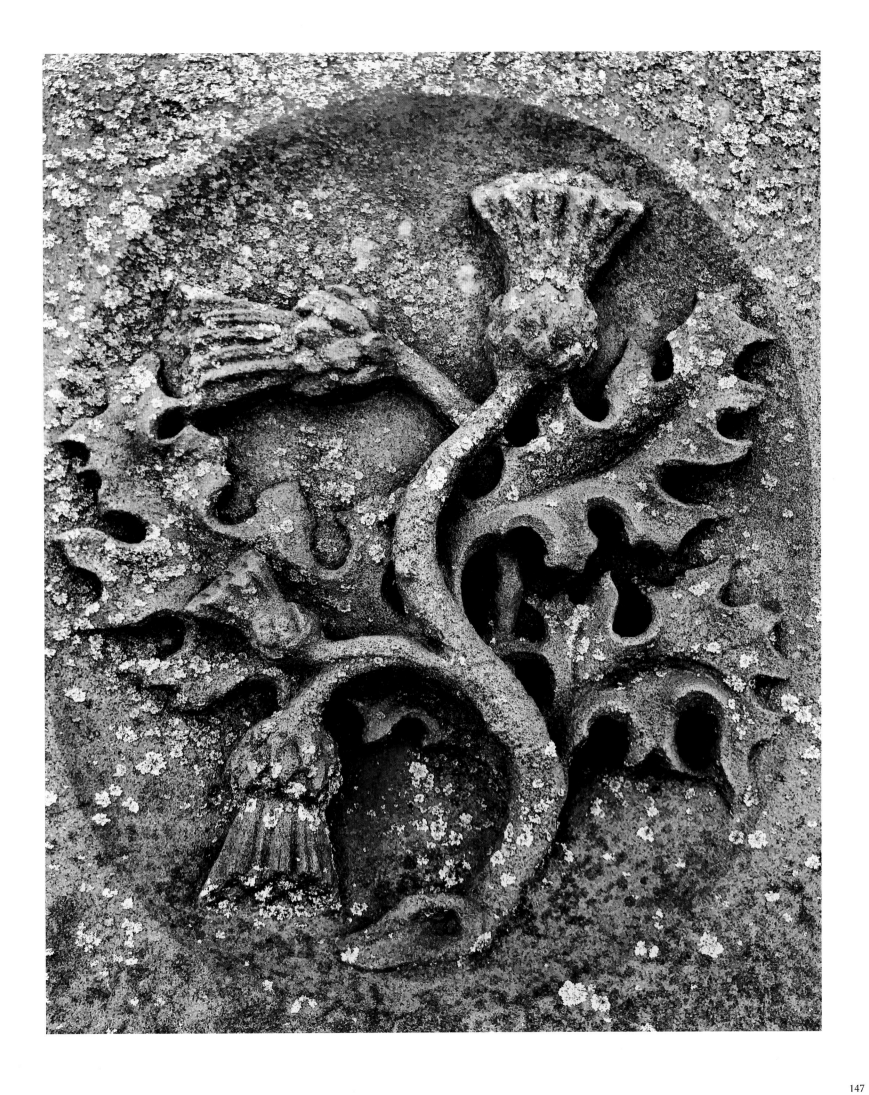

Lettering and Inscriptions

Angela Voulangas

*The only really permanent tribute is the one in which
the touch of the artist persists long after the personal interest has faded.*
—Lettering in marble, Vermont Marble Company, 1923

Almost all structures and gravestones in The Green-Wood Cemetery display lettering; hand-drawn or traced, the words are then cut into stone. The oldest inscriptions are those in the Cemetery's Cedar Dell. These eighteenth-century stones, which were moved to Green-Wood, are about sixty years older than the Cemetery itself. Among these markers are idiosyncrasies of spelling and abbreviation that are unlike what can be found in the rest of Green-Wood. Created with hammer and chisel, often by itinerant or local unskilled carvers, these stones are especially expressive and poignant. On several you can see "scribe lines," the faint guides carvers made for themselves in order to keep a straight line.

By the time of Green-Wood's founding in 1838, memorial carving was fast becoming an industry and designs were moving away from sandstone and slate markers to marble and, later, granite. Each material change brought with it different tools and lettering styles. Carvers often had models they referred to and their lettering reflected larger stylistic trends. Models might include English bronze memorial plaques, type specimens, books, or popular prints.

Some common lettering styles in Green-Wood:

Sans Serif

Other names for this ubiquitous and simple letterform are Gothic, Egyptian, Commercial, Grotesque, and Block Letter. Sans serifs at Green-Wood were created with both raised letters and incised, or "sunk," letters. Raised letters were more difficult to carve correctly as all the surrounding stone had to be cut away. The stonecutter needed skill to judge the weight and spacing of each letter artistically, and it was easy to break off the corners.

As trade journals and manuals became common, artisans were taught to be mindful of the depth and angle of the incision when cutting a letter. Skilled stonecutters were aware of how shadow and light affected the strength of the letter—its color and weight—and took into account the final position of the stone and the conditions in which it would be seen.

Gothic Revival

As an aesthetic style in architecture and furniture design, Gothic Revival had a long history and went through many iterations. Similarly, in lettering there are very different forms under that umbrella term, each using different medieval scripts as reference. From angular, pointed faces such as Black Letter or Fraktur to more rounded medieval-looking letters such as Lombardic, all are under the rubric of Gothic Revival. The Arts and Crafts movement of the late nineteenth century popularized a heavier, darker version of the letterform— what we think of as "Old English," or the style of the *New York Times* masthead.

Rustic

Some of the most unusual and charming letters found at Green-Wood are Rustics. Featuring words composed of depictions of bark, twigs, or vines interweaving the letters, Rustics are an original letterform development from the nineteenth century. The style was wildly popular on sheet music, book covers, and

sentimental "ladies" prints earlier in the 1800s—but it had staying power on monuments, lasting well into the twentieth century. For a nice correlation with the Rustics of Green-Wood see Walt Whitman's 1855 cover design for his own *Leaves of Grass*, where the foliage-dense letters nearly fall apart.

Most Rustics are carved in relief, with those carved into marble often "sugaring"—wearing away into the elements. It is a wonderful surprise then to come upon one of the "white bronze" (cast zinc) monuments of the 1870s and 80s where the twig and bark Rustics are as crisp as the day they were installed.

While much lettering in Green-Wood is beautiful and "correct," and carvers were exhorted to have high aspirations, there are many instances where they fell short. Sometimes it's in the awkward spacing, curious ornament, and odd mismatched styles that we get a true feeling of the hand behind the letter.

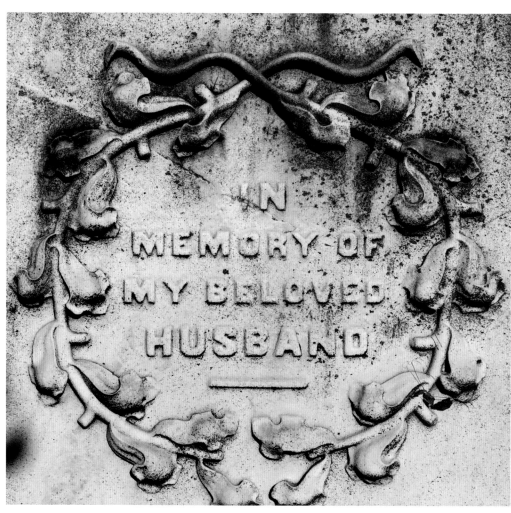

Previous spread:
In the Victorian era, *floriography* was a sensation with bouquets and arrangements often carrying cryptic meanings. Those with a deep curiosity carried a flora dictionary to decipher them.

This and following spreads:
A sampling of typography from 1820–1940 showing a broad range of styles.

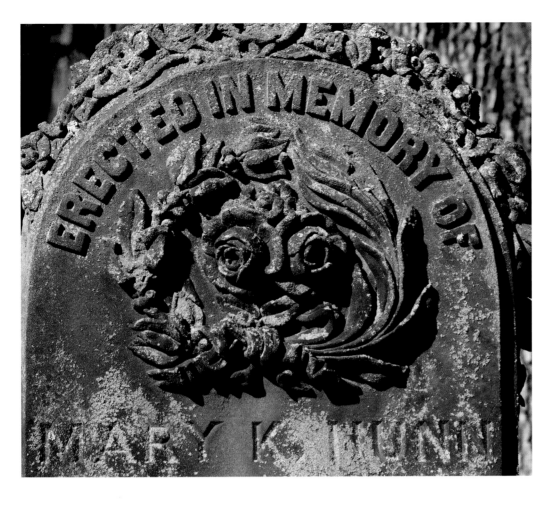

ERECTED IN MEMORY OF
MARY K. NUNN

OUR
MOTHER
AND
FATHER

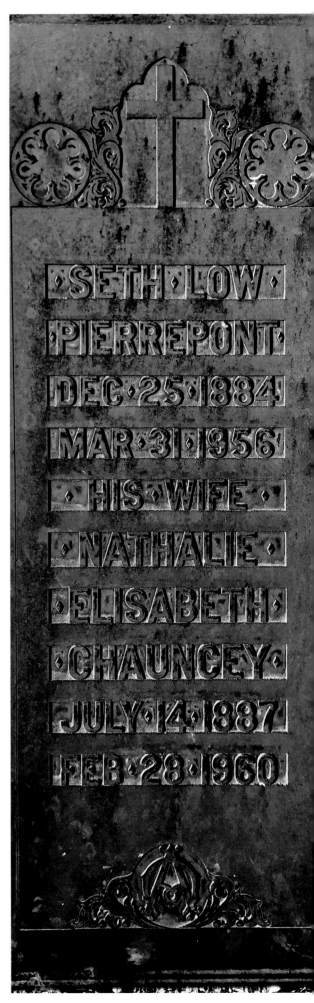

SETH LOW
PIERREPONT
DEC·25·1884
MAR·31·1956
·HIS·WIFE·
·NATHALIE·
·ELISABETH·
·CHAUNCEY·
·JULY·14·1887
·FEB·28·1960

The Grave of
SIMEON
EDGERTON Jun
of Pawlet Vt.
Who
died at Brookly
Aug 4 1845. Æ 2

AMEL

Spencer : Trask

HUSBAN

BRODH

MASON

MARA BROWE MCM

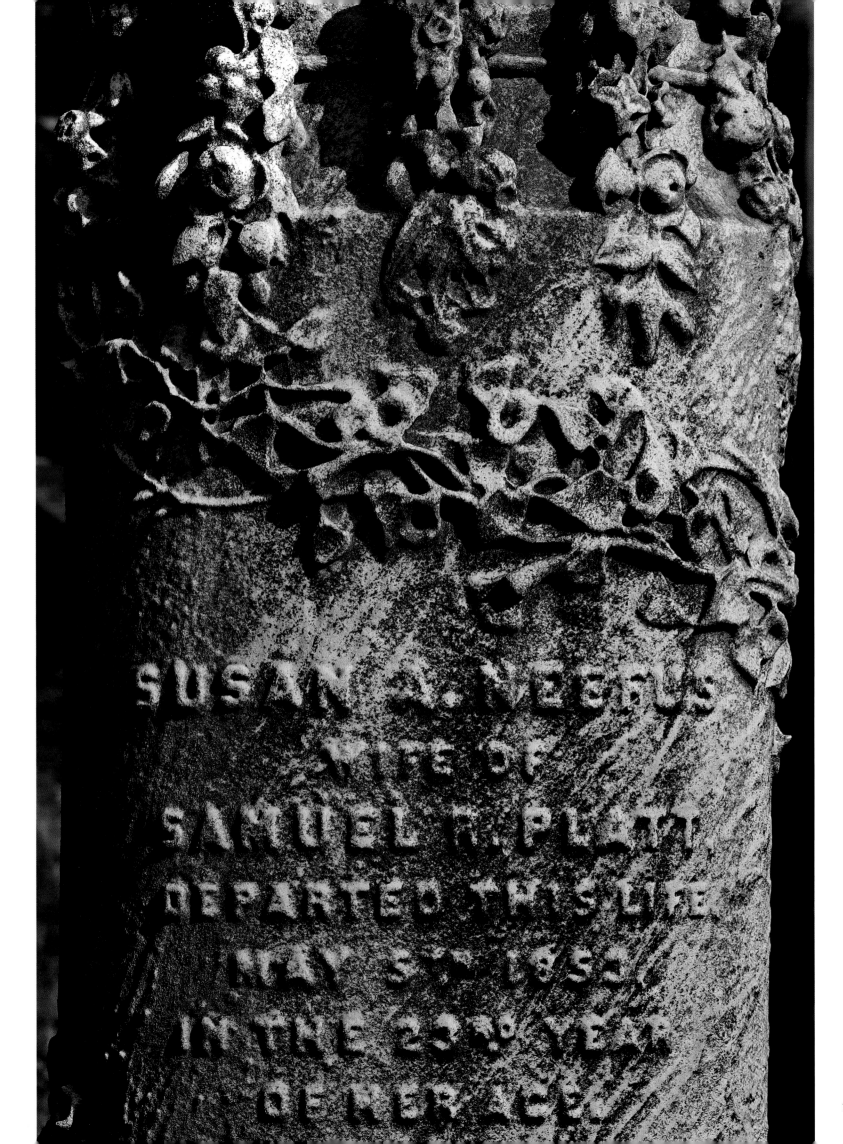

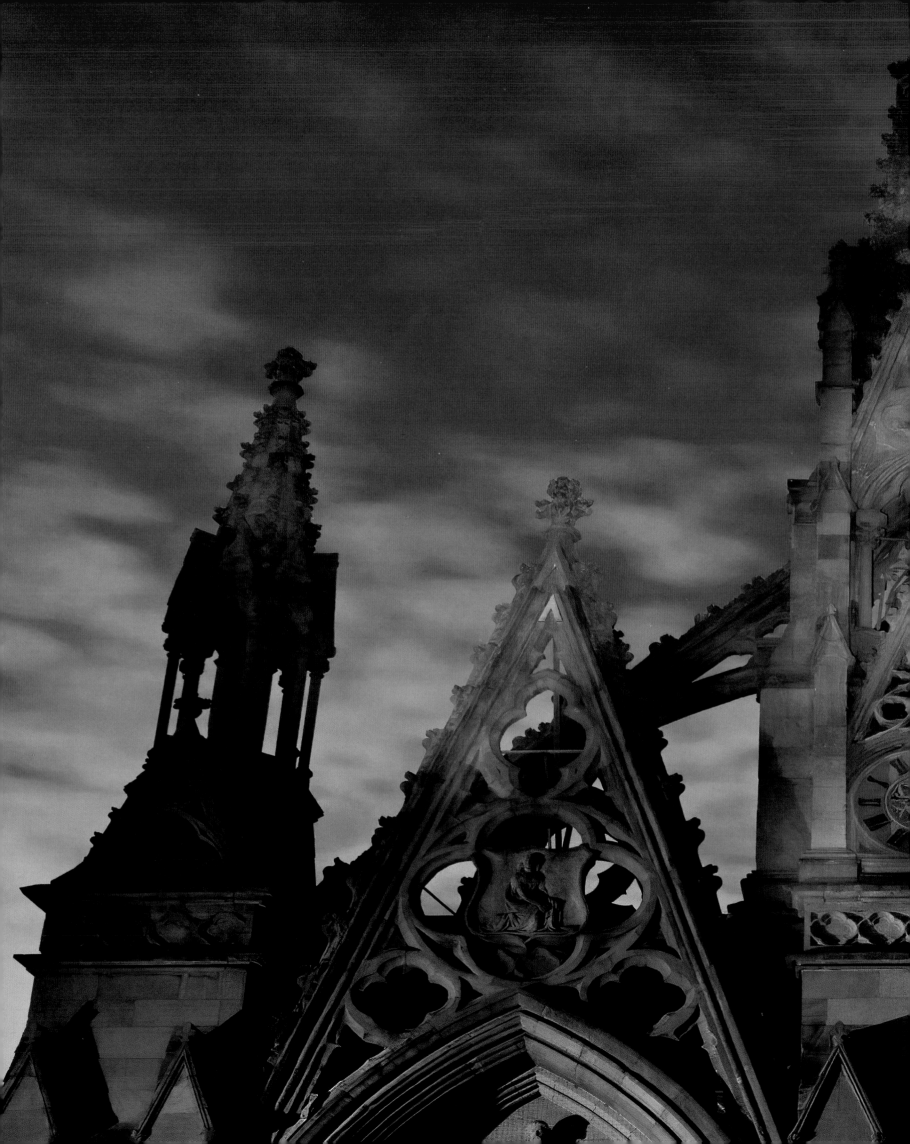

CHAPTER TEN

Night: Darkness Envelops

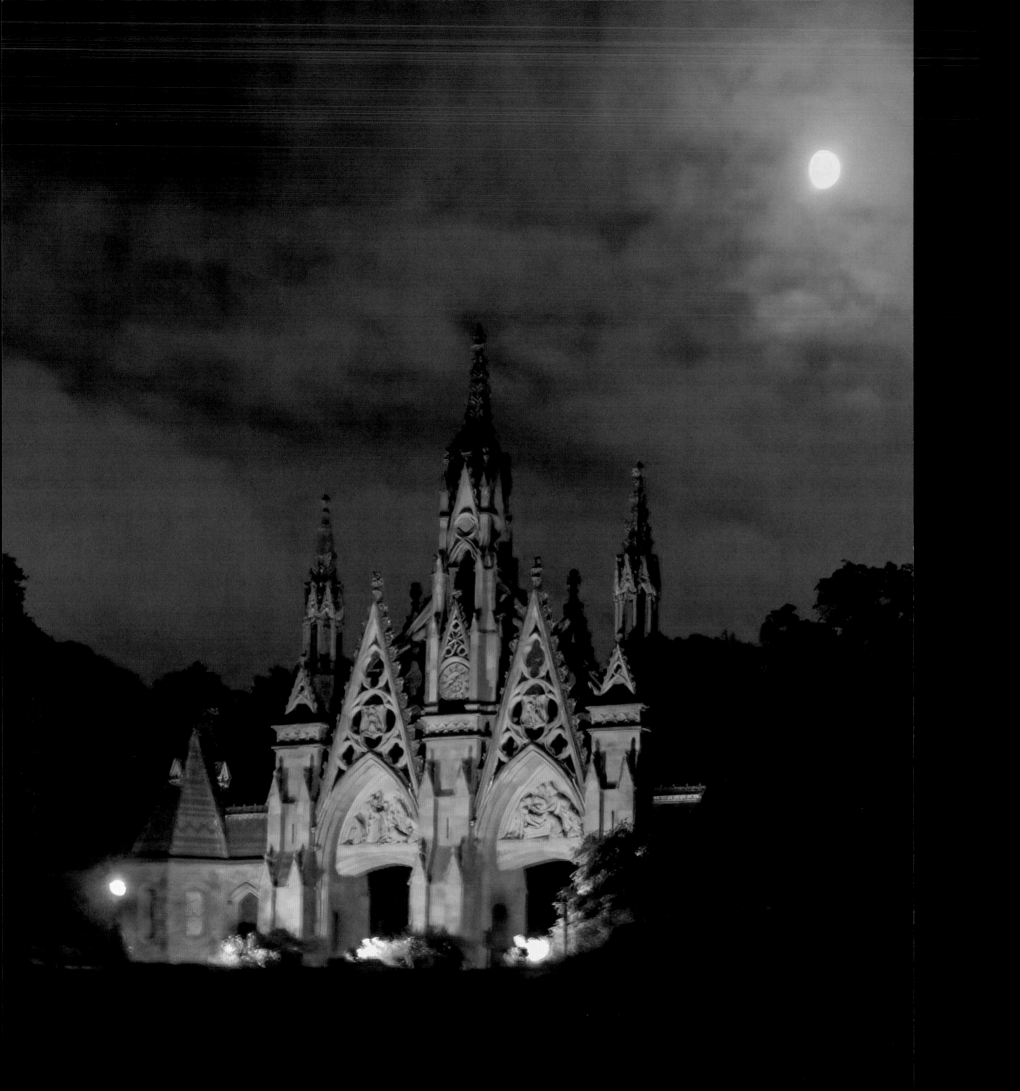

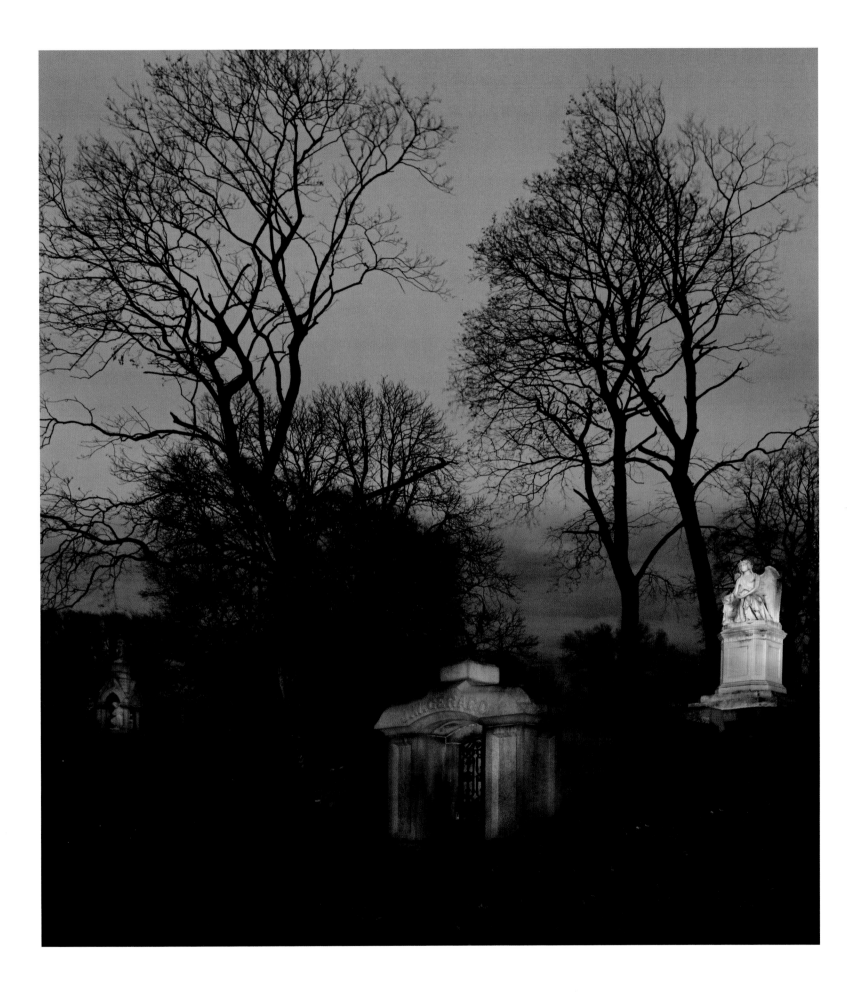

"Darkness had no effect upon my fancy, and a churchyard was to me merely the receptacle of bodies deprived of life, which, from being the seat of beauty and strength, had become food for the worm."
—Mary Shelley

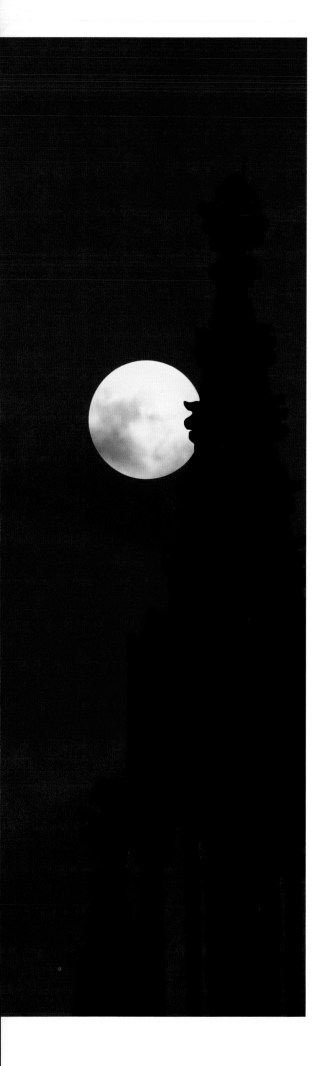

The Cemetery After Sunset

Allison C. Meier

The first time I was in The Green-Wood Cemetery after the gates were locked and the sun was setting, casting lengthy shadows from the tombs, I noticed the stillness. To have acres of open space around me with no direct artificial light and no other people—living, that is—was something I had not experienced in New York City. Over the subsequent years, on after-hours tours, at concerts, at gatherings at candlelit mausoleums, and at film screenings, I've found that a cemetery at night is not spooky, despite its popularity as a setting for horror. It is instead a respite, where, in a dense urban area, crowded with lights and noise, there is calm.

On the highest points of Green-Wood's topography, such as Battle Hill, the Manhattan skyline is radiantly visible, especially in winter when the trees are thinned of foliage. The Statue of Liberty gleams in the harbor among the passing ferries. Further into the Cemetery, in its valleys between hills and on its tree-lined pathways, there is deeper darkness. Although it is a welcome pause for those people lucky enough to stay after nightfall, it is also active with nocturnal life thanks to the animals that have in the Cemetery a natural haven.

The tranquil nights reveal fauna rarely observed elsewhere in the city. One autumn night while leading a tour to the graves of magicians and mediums, I spotted with my flashlight a tiny red-backed salamander on a granite headstone. At dusk, chimney swifts flit through the waning light to catch insects and great horned owls softly hoot their stuttering calls. Eastern red bats that hang on tree branches during the day, their rusty fur blending in with the leaves, take flight to feast on mosquitoes, moths, and beetles. On the ground below, possums and raccoons leave their hidden dens to forage for food. Beneath the surface of the glacial ponds, snapping turtles wait patiently to snap up unsuspecting prey.

In summer, the depths of evening are illuminated by the mesmerizing rhythm of blinking fireflies. In autumn and winter, as the sun begins to rise, the Cemetery can be shrouded with fog, giving it a phantasmagoric look in which time seems to fall away and the Green-Wood of 150 years ago feels tantalizingly close.

The years, however, have altered the surrounding area, with light pollution causing a constant glow in the sky and the sounds of cars on the streets and airplanes overhead penetrating the Cemetery's borders. Still, the night here is transportive. The names and dates on the individual memorials are muted; just the silhouettes of the obelisks, angels, columns, and headstones are discernible. Sometimes the full moon shines above as it has since people first set foot on this land, long before it was a cemetery. Each of us is one of many to pass through and experience the serenity of this landscape, which now more than ever is a vital place where there is always night in a sleepless city.

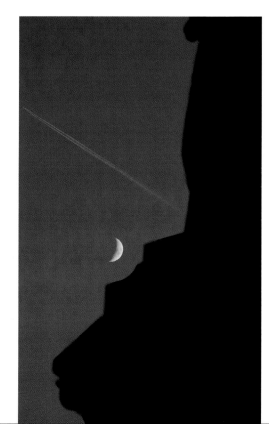

Left: Full moon over Battle Hill.
Right: A crescent moon and jet contrail at dusk.
Opposite: Main Entrance Arch during a rain storm.

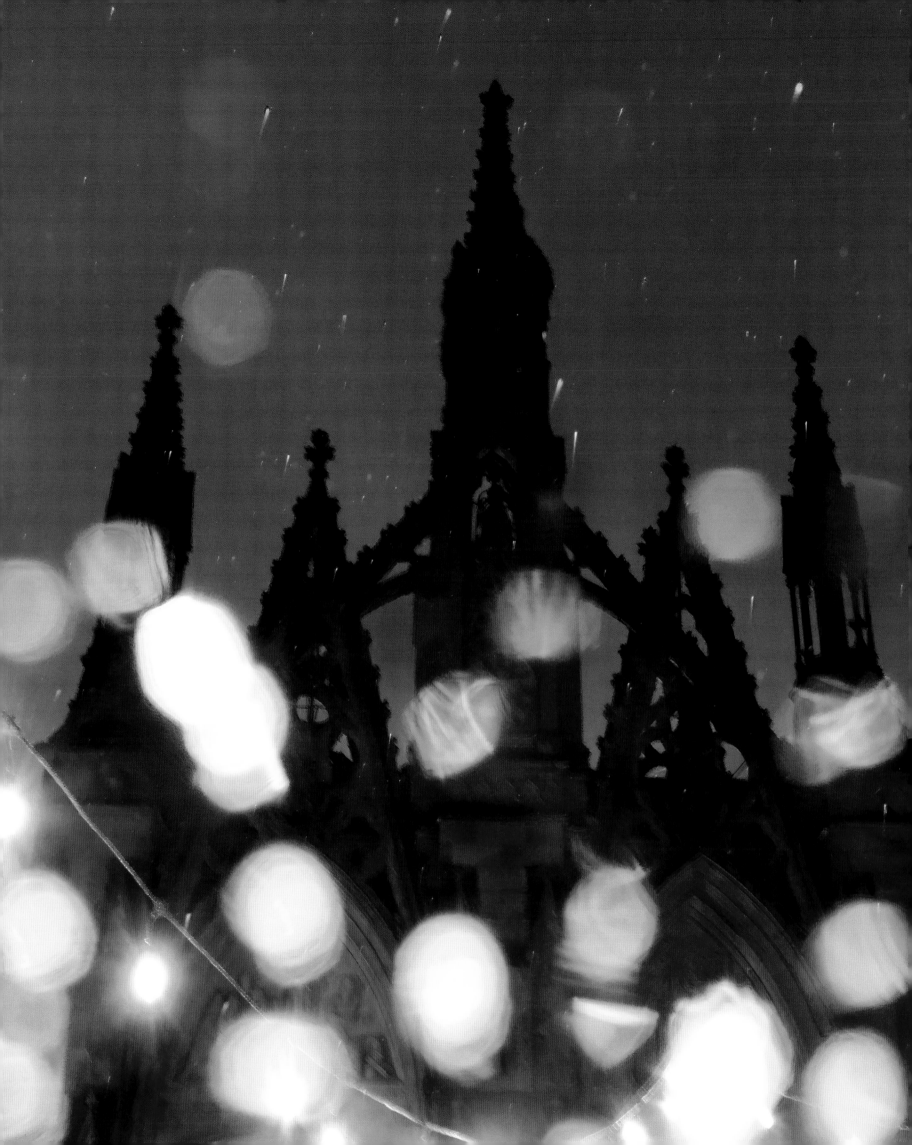

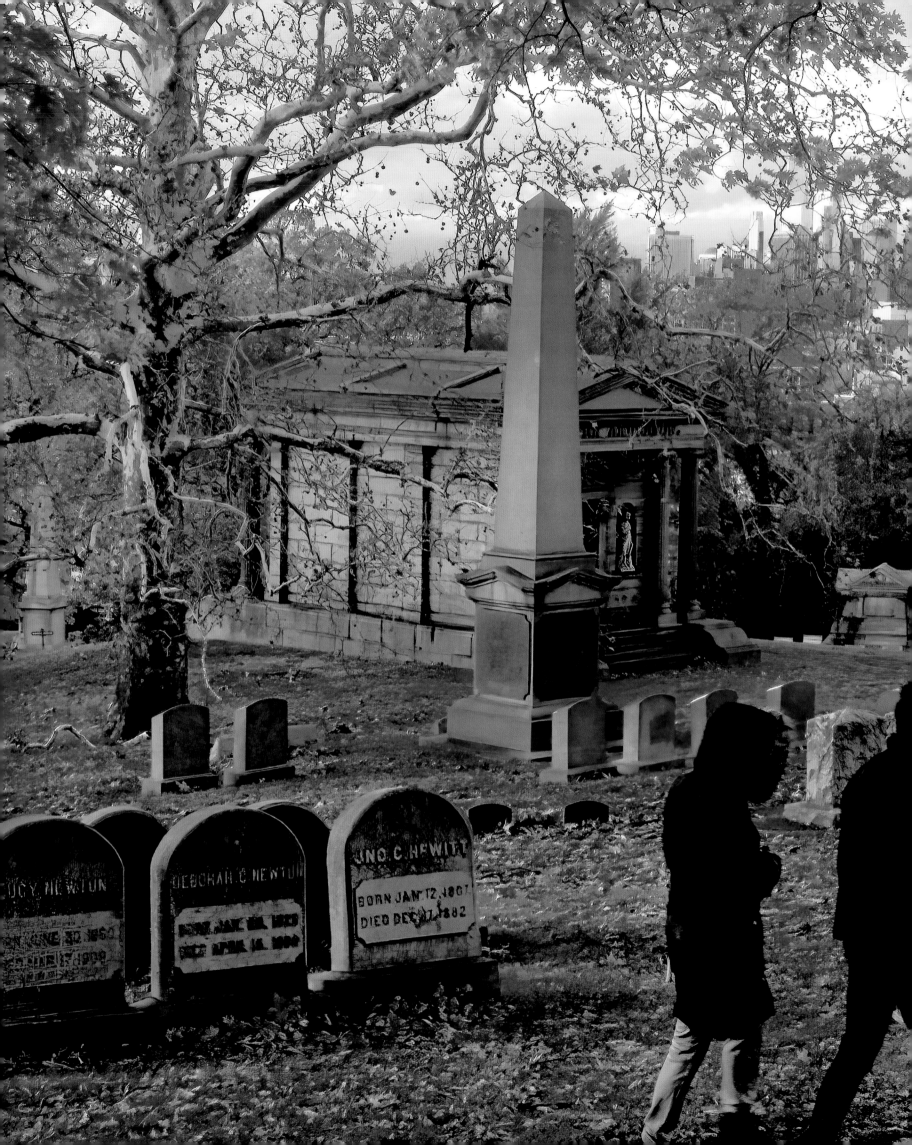

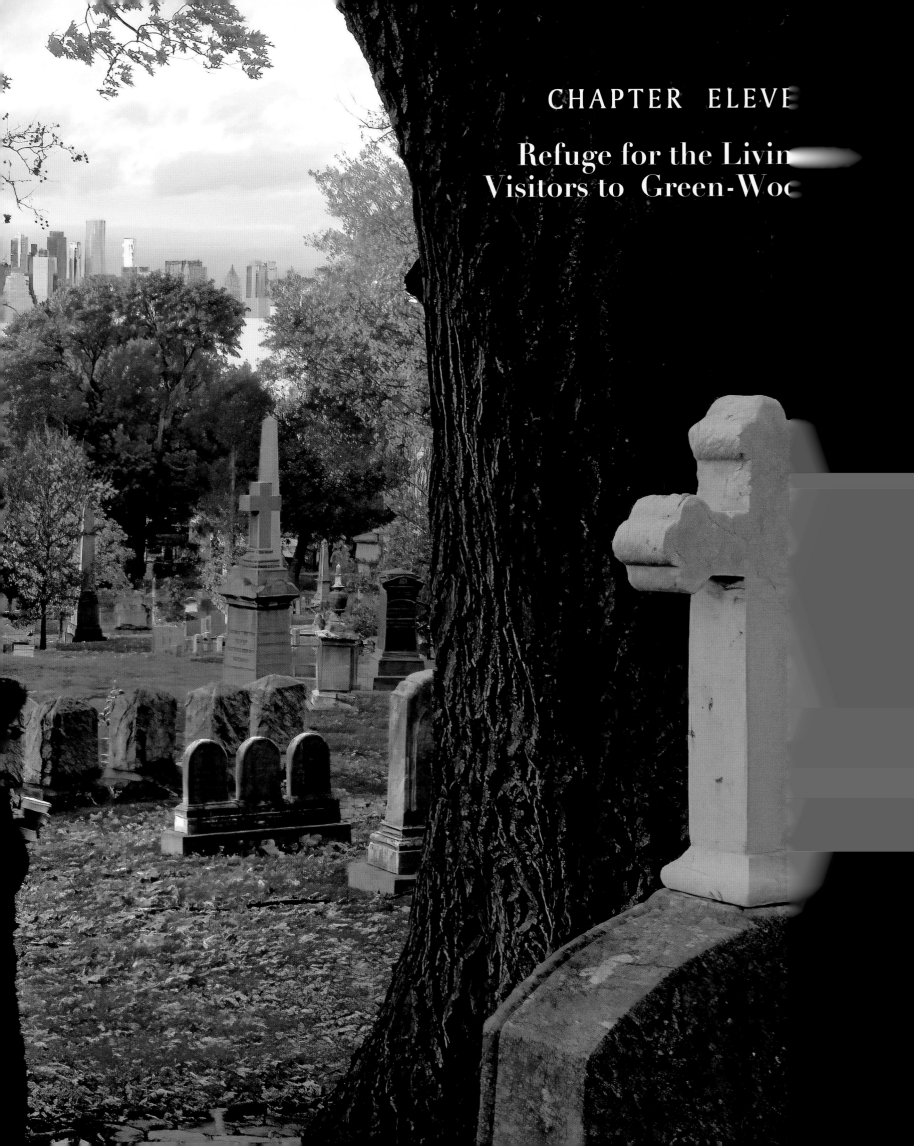

Previous spread:
A late afternoon autumn stroll along Artemisia Path, with Lower Manhattan in the background.

Opposite: Practicing accordions for an evening performance.
Left: A gentleman plays a wooden flute in the shade
of a weeping cherry tree at the edge of Crescent Water.

Green-Wood as Refuge

Andrew Garn

"Life-affirming" might not be the phrase that leaps to mind when visualizing a cemetery. Yet Green-Wood is precisely that to nearly half a million visitors a year. Since 1838, people have been drawn to this bucolic oasis. Set among rolling hills (and boasting the highest point in Brooklyn), the landscape was formed by the advance of the ice-age-era Laurentide glacier. Today, Green-Wood overlooks the great metropolis that was built around it, and for nearly two centuries it has continued to be an ideal refuge for multitudes of New Yorkers seeking respite from the cacophony of the city. From horse-drawn carriage rides and picnics in the mid-nineteenth century to recent jazz concerts in the Catacombs, Green-Wood has always been an attraction for the living, while remaining an active cemetery.

Approaching Green-Wood's 478 acres from the upward slope of industrial 25th Street, and crossing Fifth Avenue, visitors are initially greeted with verdant lawns and Richard Upjohn's soaring and saturnine Victorian spires.

While passing under the Gothic Arch, they might first get an inkling that this is a different sort of resting place for the departed. At certain times of day, pedestrians are startled by joyous squawking overhead. Looking upward, they are greeted by the playful, dive-bombing resident monk parakeets. Nesting in the dense, tangled branches woven into the frilly brownstone crevices of the main spire, their shrieking calls almost mock this somber entry portal.

The spires come alive as these florescent green birds streak through the sky. This is a perfect example of what makes Green-Wood so special: it is a unique sanctuary, a result of this melding of nature and the man-made.

Green-Wood adeptly combines architecture, the arts, and nature in a peaceful setting. Among the imposing mausoleums, vaults, and monuments, thousands of trees and plants are bursting with life. Each tree provides a place to stop and ponder, as branches reach upwards to the sky in celebration. Examine root structures as the tendrils reach down and mingle with the dead. Or simply sit, rest, read a book. It is a haven for all.

What exactly constitutes a compelling destination to seek comfort, solace, enlightenment, or rejuvenation? For some it is a place of worship, an imposing site filled with symbols of divine beings. For others, it might provide an opportunity for a walk amidst the natural world, surrounded by actual divine beings.

Green-Wood offers silent reflective places, yet it is also filled with life. While it might seem paradoxical to celebrate being alive while in a cemetery, it is precisely that juxtaposition that Green-Wood offers: a memorial landscape filled with flora and fauna that serve to remind us to take joy in life—while we still can.

Even on a perfect spring day, when nearby Prospect Park is thronged with city dwellers thrilled to be outside after a long dark winter, each flowering tree surrounded by what can seem to be scores of people, there are always secret corners of Green-Wood where a visitor can be alone.

No matter how often I have visited, I always encounter a new vista, a fresh integration of nature and the built environment. I may discover an unfamiliar tomb inscription, a tree's blossoms I have never noticed, or a red-tailed hawk soaring through the statuary.

I am aware of others' enjoyment as well. Green-Wood offers a much-needed pause from a frenetic city in so many ways: I rejoice in seeing a solitary walker on a rainy day, children laughing and frolicking on a grassy knoll, a barefoot young man softly playing a flute under a willow tree. I can't help thinking that those below-ground would be so pleased at the contented life that continues on directly above.

Skipping under a bloomingsaucer saucer magnolia tree. One of the earliest blooming magnolias at Green-Wood, the saucer magnolia explodes in colorful shades of fuchsia and pink. Its early bloom-time makes the species susceptible to late frosts, exacerbated by a changing environment where weather patterns are becoming increasingly erratic. It is a hybrid of its parent species: the Yulan magnolia and the Mulan magnolia, both native to southwestern China.

Next spread:
166: A woman strolls by Sylvan Water under a backlit red maple tree. True to its name, the red maple displays the most vivid of reds. A much-appreciated tree, nearly all its parts are red at some point during its life cycle (flowers, fruit, petioles, and fall leaves). The red maple is the host plant to the rosy maple moth and a favored larval host to the Cecropia silk moth, which is the largest moth in the North America.
167 (right top): A cemetery tour up Greenbank Path, toward Battle Hill, on a rainy day.
167 (middle left): A couple shares a quiet, contemplative moment near the comfort of a spruce tree.
167 (bottom right): Walking on Verdant Path.

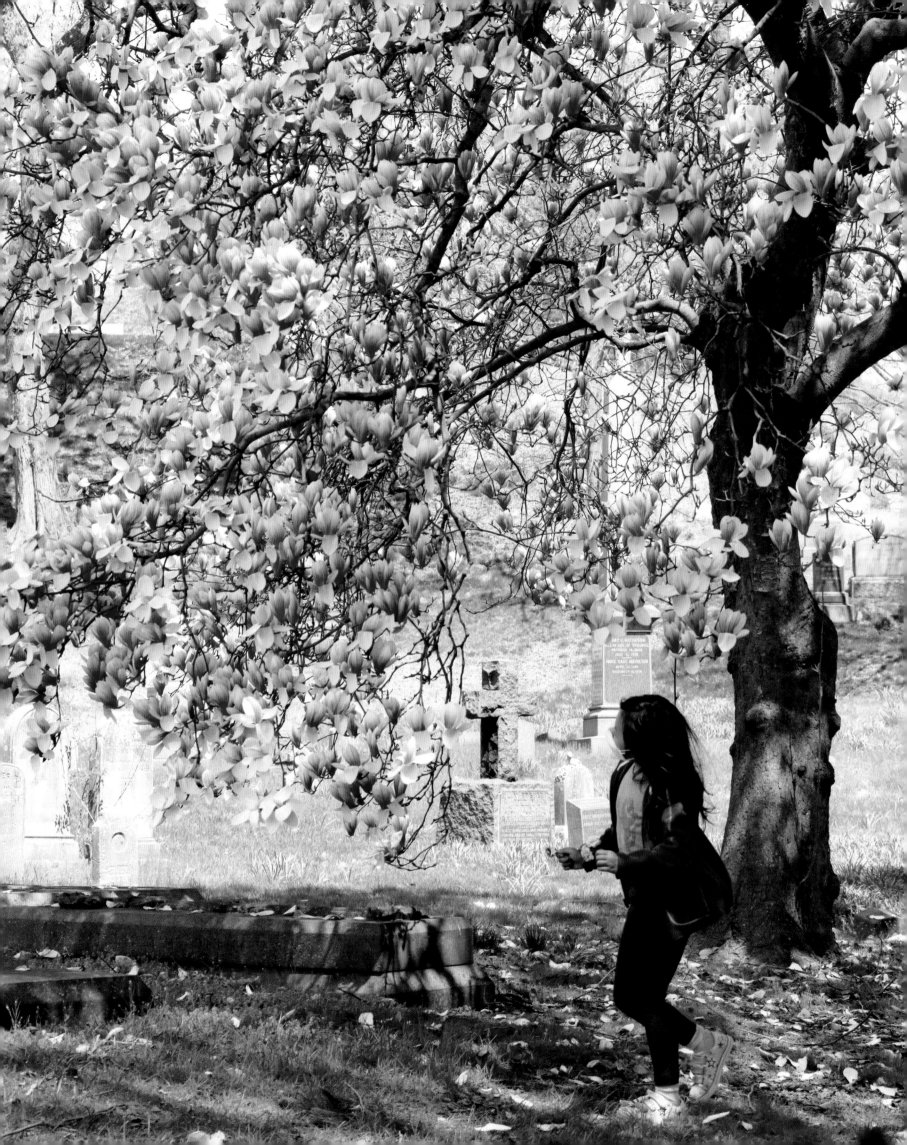

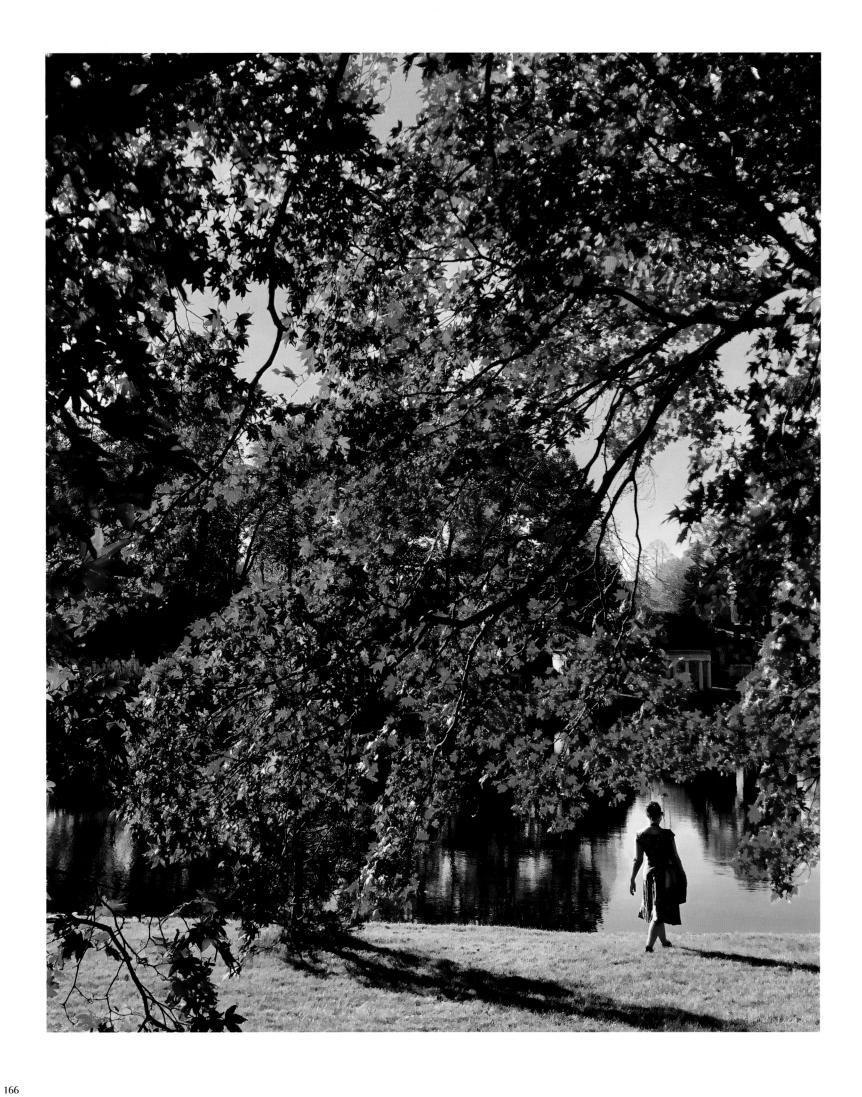

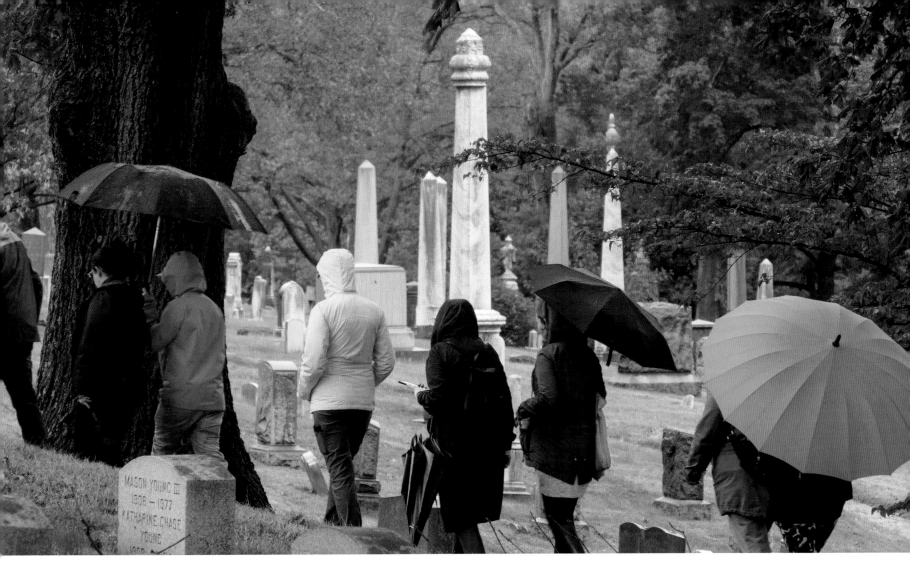

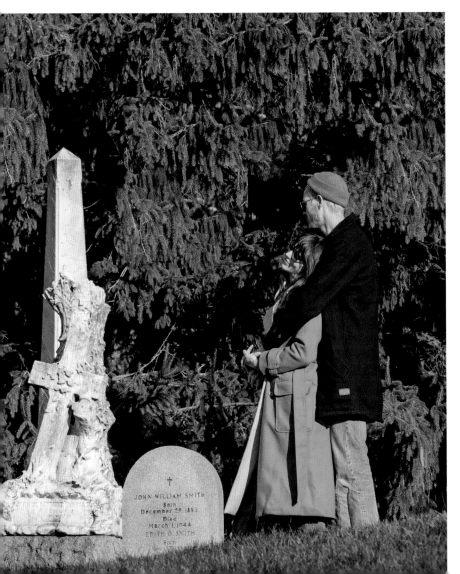

Opposite: An afternoon frolic in early autumn.
Left: A visitor promenades in a red velvet coat past an old beech tree on Sweetgum Path.

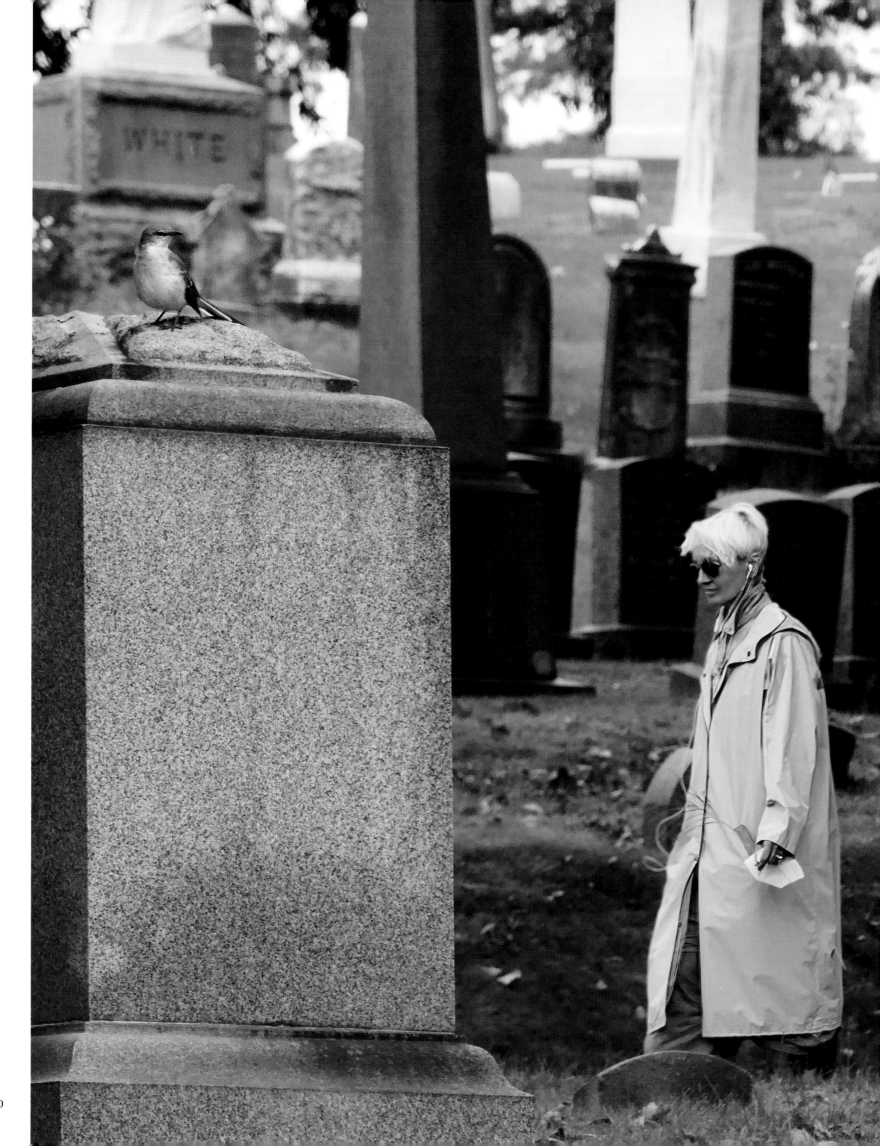

A mockingbird watches a woman in blue on a rainy-day walk on Sumac Path.

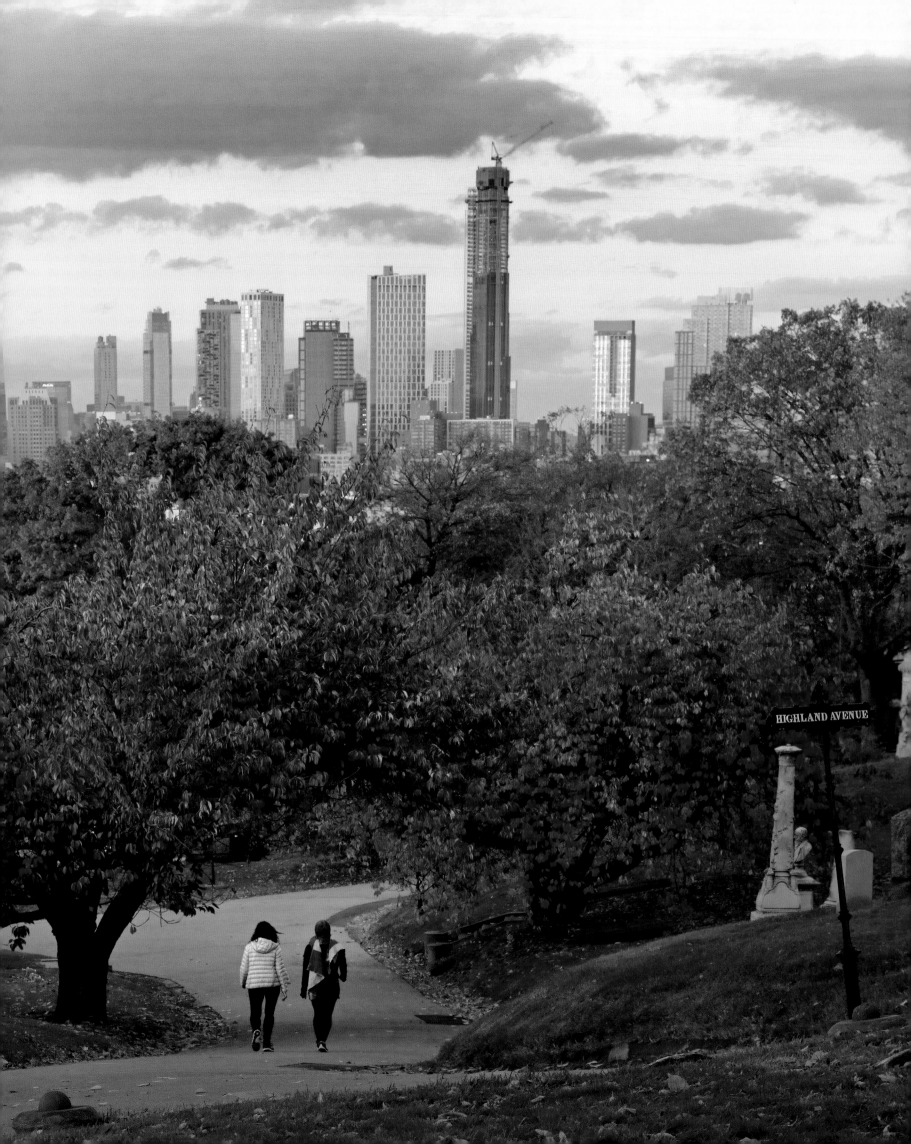

"Softly the evening came with the sunset."
—Henry Wadsworth Longfellow

Opposite: Two woman walk down Highland Avenue, with the Downtown Brooklyn skyline rising in the background.
Left: A solitary walk up Bay Grove Path to take in the sunset.

Following two spreads:
174: A mother and her daughters relax on the grass off Artemisia Path, overlooking the Historic Chapel right after sunset.
175: Music lovers seek cooling shade during a special Memorial Day concert.
176–177: Guest conductor Brian P. Worsdale leads the ISO Symphonic Band at Third Street at Green-Wood's annual Memorial Day concert.

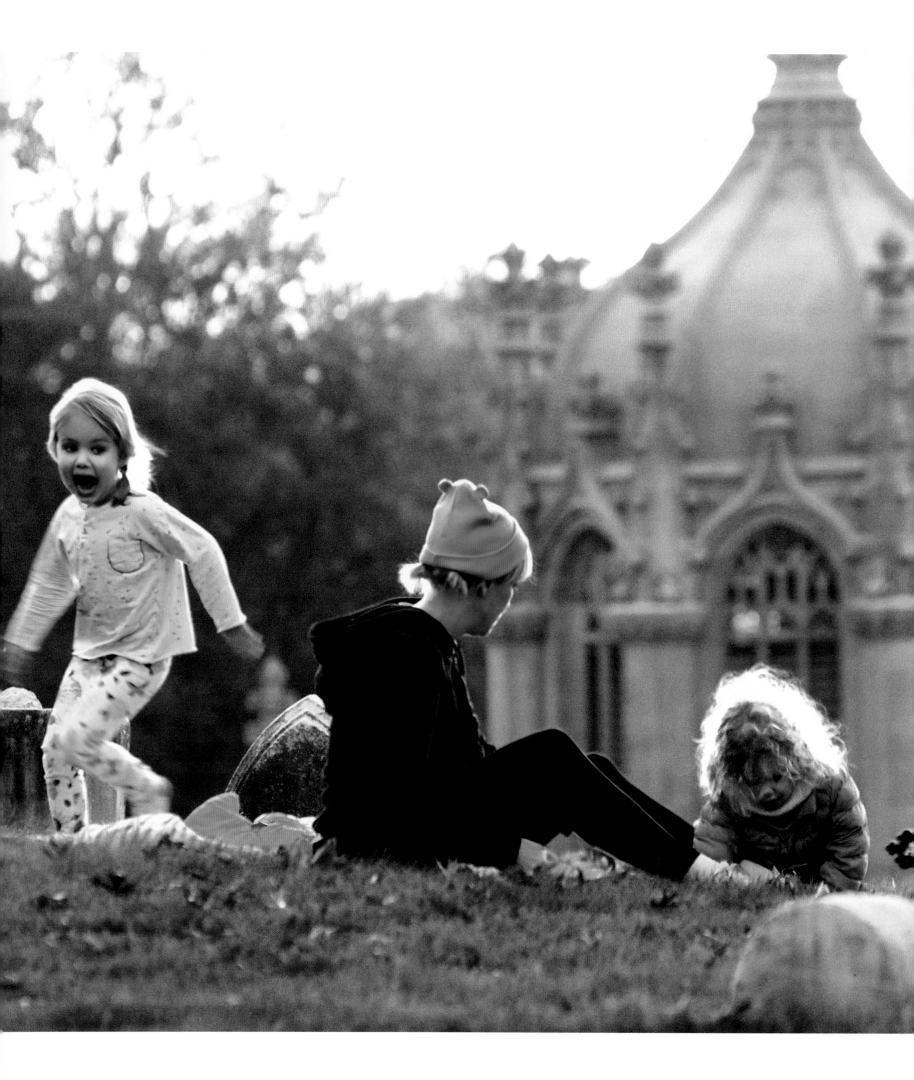

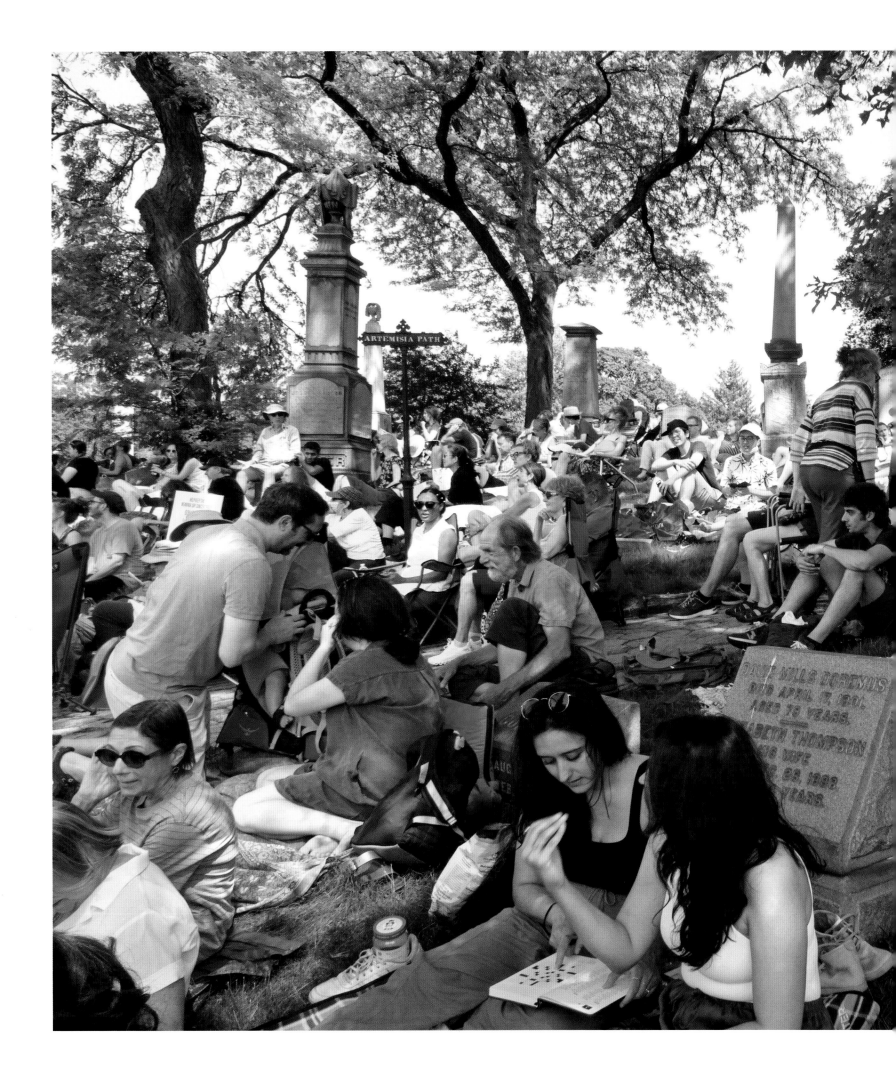

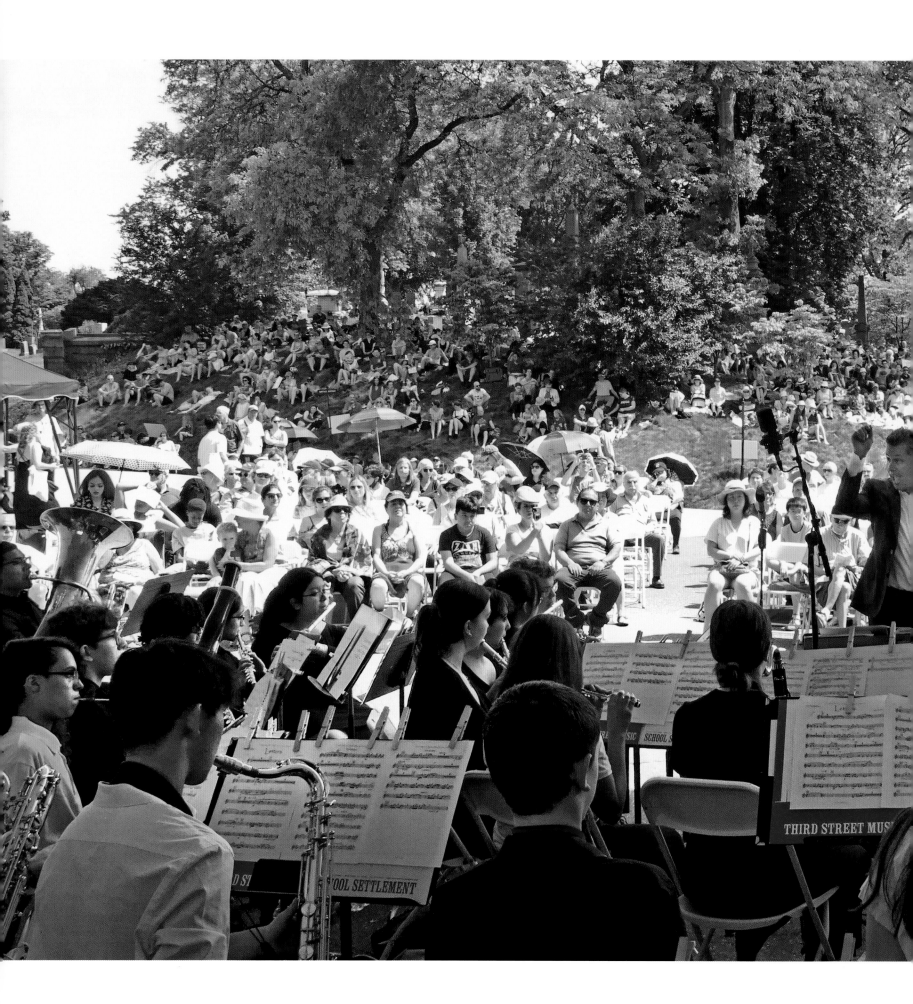

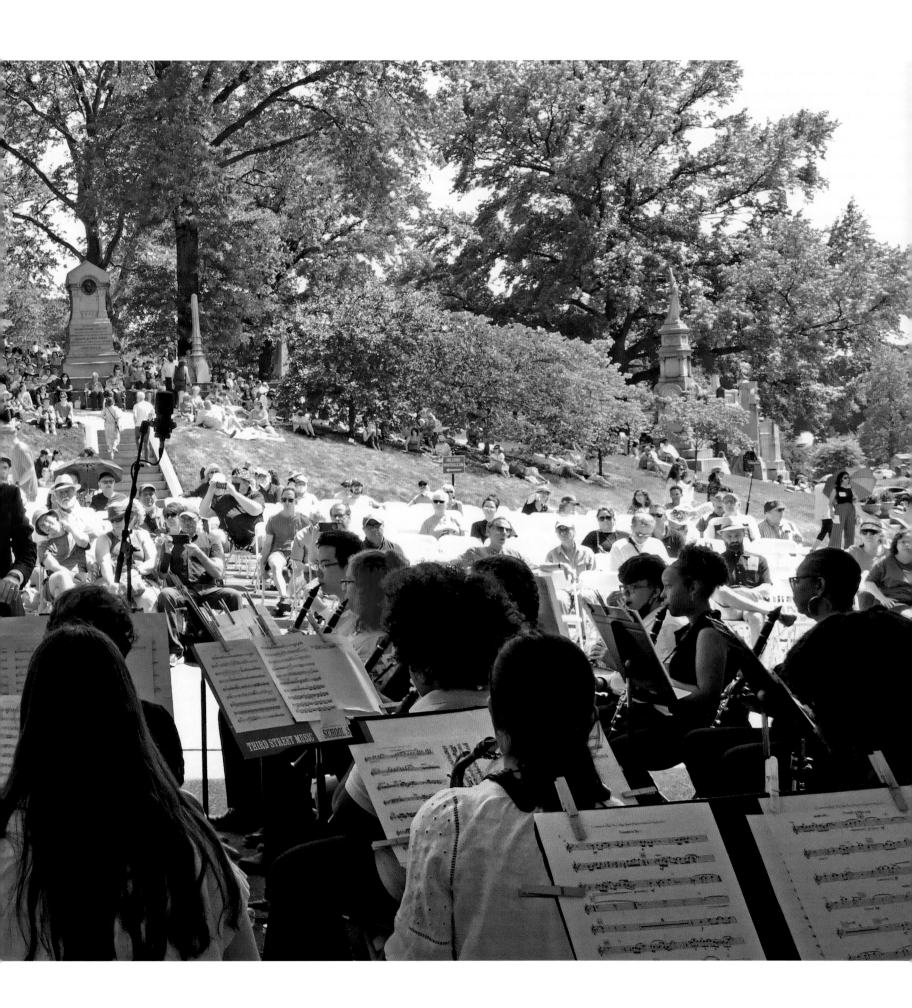

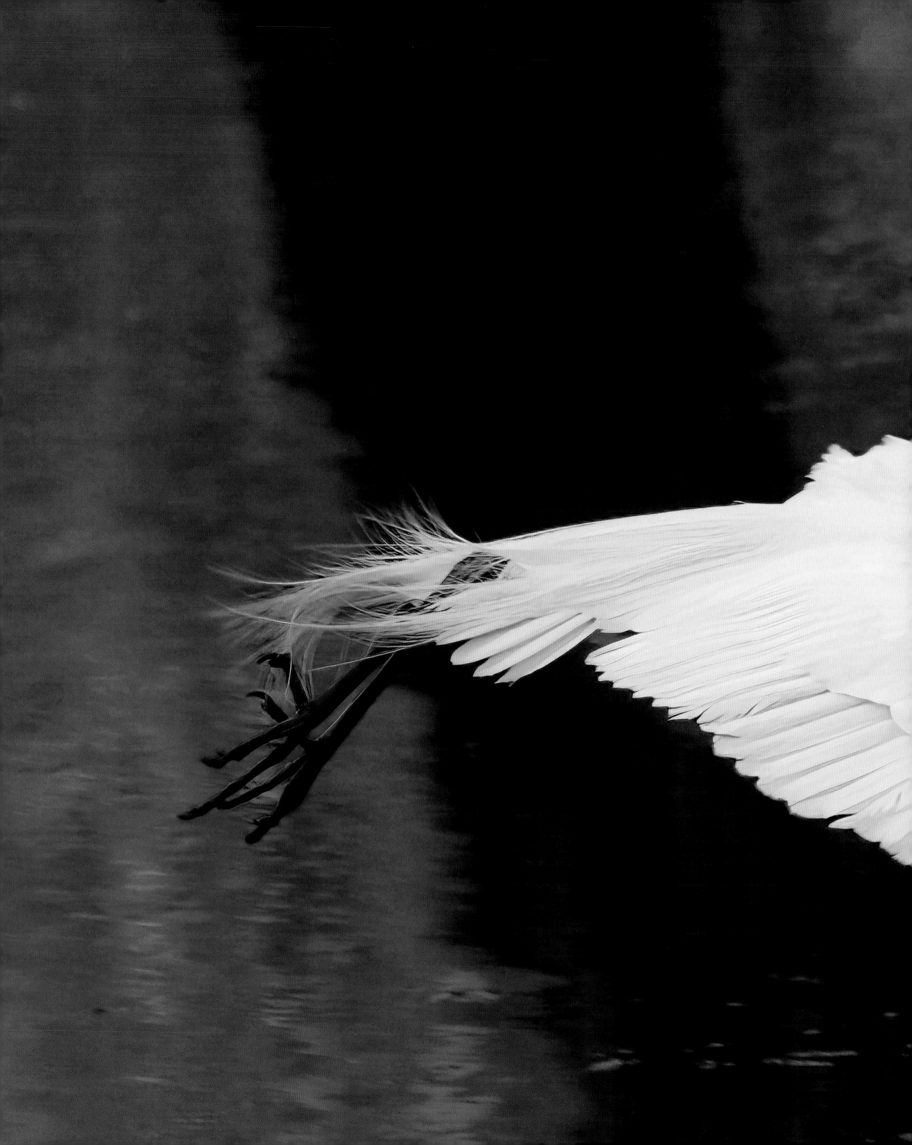

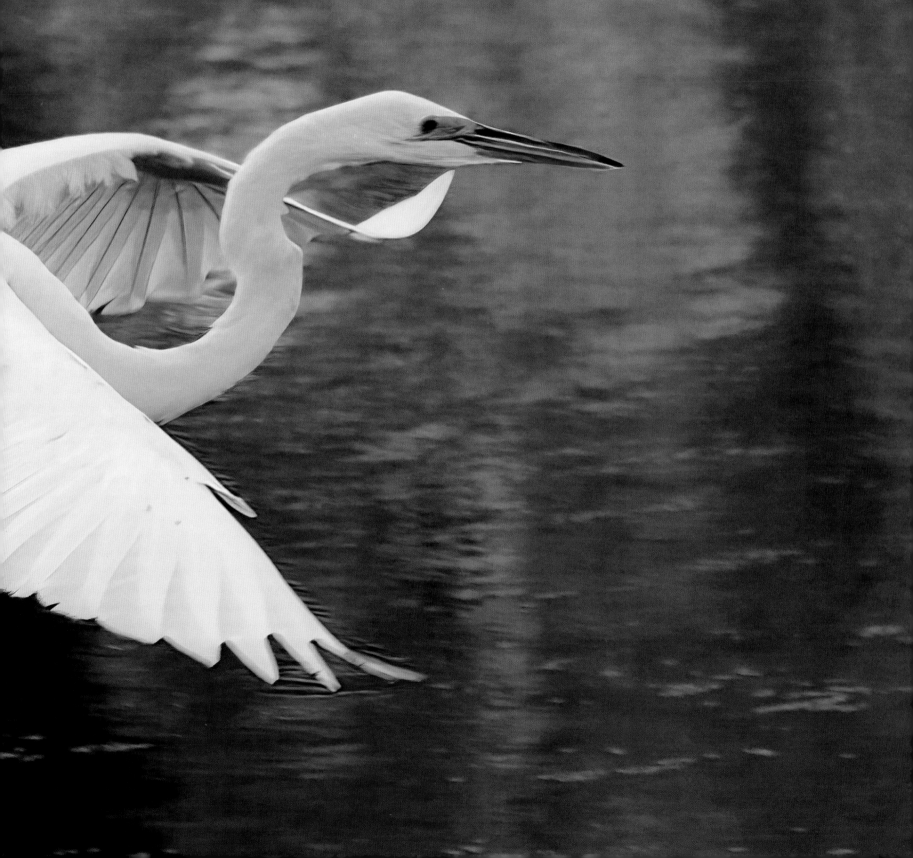

CHAPTER TWELVE

Fauna

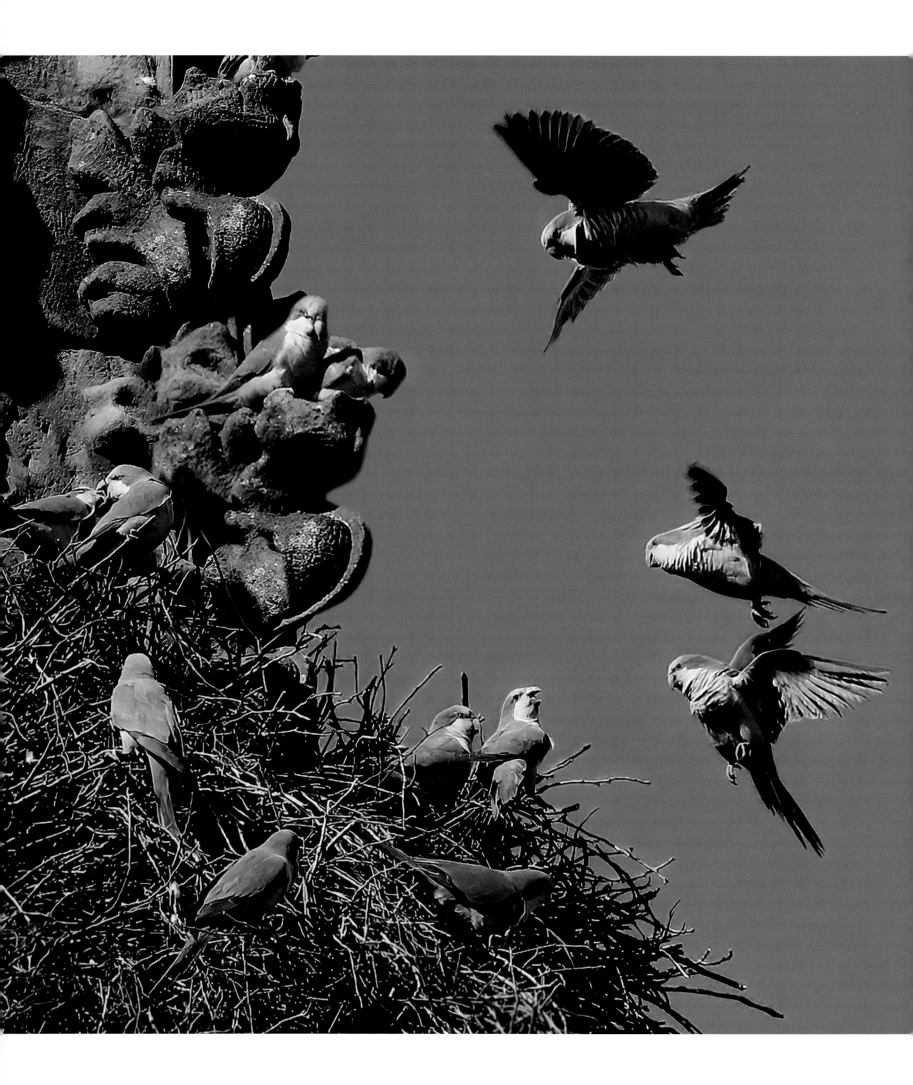

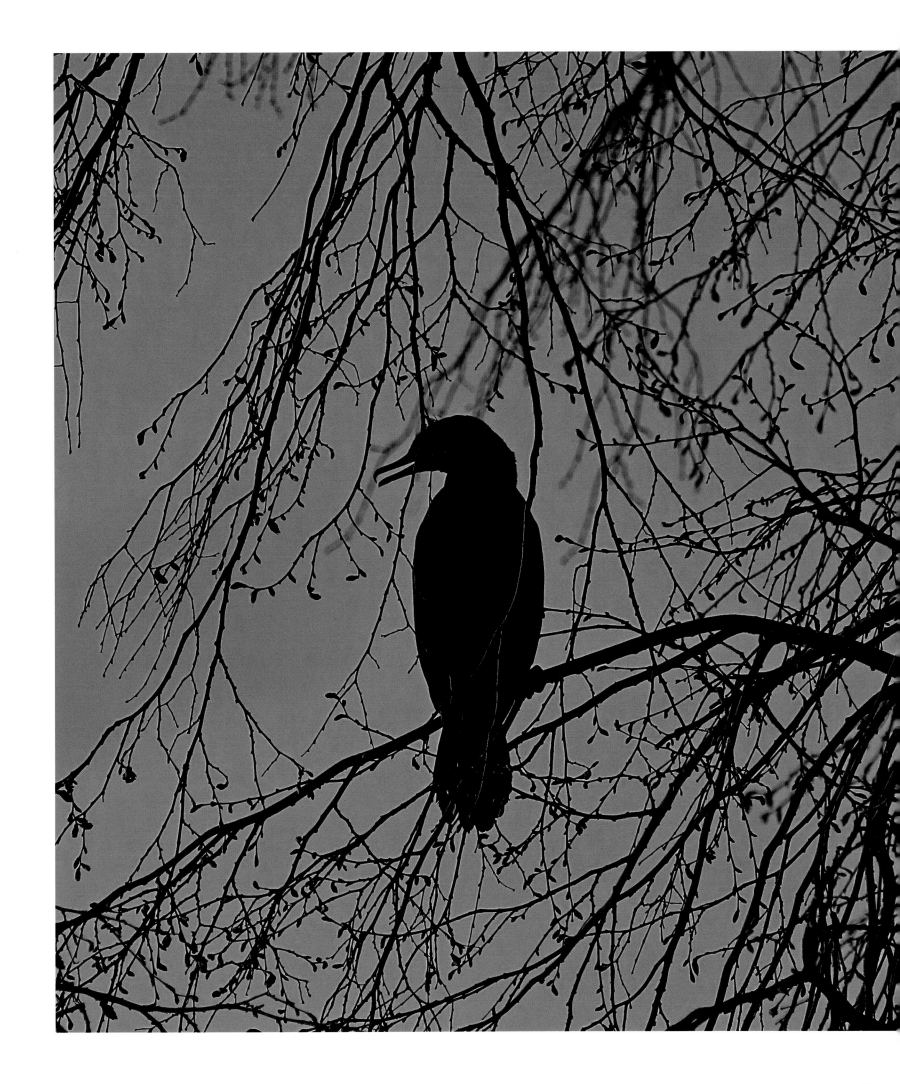

The Birds of Green-Wood

Gabriel Willow

The birds of The Green-Wood Cemetery provide a through line, the rhythms of their migratory patterns reaching back to a time long before the Cemetery inhabited this site. Nearly 250 species of birds have been observed in Green-Wood, most of them migratory species passing through New York City on their way from the tropics to points north in the spring, or the inverse in the fall, along the Atlantic Flyway, a migratory route used by millions of birds representing hundreds of species. The tall sweetgum trees, oaks, maples, persimmons, and elms of the Cemetery beckon to them, promising riches in the form of caterpillars and fruit, moths and seeds. The rolling bluffs and valleys of the Cemetery today largely retain the shapes formed during the last ice age, and then, as today, the songs of warblers, flycatchers, and orioles rang out across these hills on spring mornings. Some birds have shifted their ranges northward in response to climate change, both natural and human-caused. Many species have declined over the centuries, due to habitat changes and the loss of insects and other food. And a few have been lost to time altogether, victims of overhunting and other post-colonial pressures.

Walk along the shore of Sylvan Water today and you may spot a great egret, lithe and all-white except for its sharp yellow bill, staring golden eyes, and long black legs. Once they were hunted ruthlessly for their lacy breeding plumes, used to decorate women's hats in the late nineteenth and early twentieth centuries, and they slipped perilously close to extinction. The National Audubon Society was formed in 1905 in response to this senseless slaughter and within a few years, successfully advocated for a ban on hunting birds for their plumes. The great egret is to this day the logo of the Audubon Society, and has flourished once again, now breeding on small islands throughout New York Harbor and coming to fish in the quiet waters of the Cemetery.

At one time, European birds were thought to be superior to their indigenous American avian relatives, or at least more useful as natural pest-control agents. There was a fad in the mid- to late nineteenth century of importing European species and releasing them in American cities. This led to the introduction of the European starling, which today is one of the most abundant birds in the Americas, descended from an original small flock released in Central Park in 1890. The Green-Wood Cemetery wasn't spared this trend: in 1852, forty-eight skylarks, twenty-four woodlarks, forty-eight European goldfinches, twenty-four English robins, twelve European thrushes, and twelve European blackbirds were imported and released in the Cemetery. It is unknown how long they survived, or if they established breeding populations. However, there is a small breeding population of European goldfinches in Brooklyn to this day; they are occasionally spotted in the Cemetery. And Green-Wood's most celebrated avian inhabitants are another introduced species, this one native to southern South America. The Cemetery is home to a resident colony of monk parakeets, descendants of escaped pets that have resided in Brooklyn since the 1960s. This species, as the most southerly ranging of parrots, is tolerant of cold winters—they construct elaborate communal stick nests, and huddle together for warmth during the colder months. One such nest is prominently constructed atop the Gothic spire of the Cemetery's Main Entrance Arch.

Once a native parrot species, the Carolina parakeet roamed the vast deciduous forests of the eastern United States, feeding on wild chestnuts, acorns, and the seeds of cockleburs, which are toxic and possibly conferred their toxicity to the parakeet, rendering it distasteful to predators. Its bright green, yellow, orange, and red coloration may have advertised this unpleasantness. Tragically, this unique parrot, the most northerly of its family (its range a mirror image of the monk parakeet) was hunted to extinction in the early twentieth century, a victim of its taste for farmers' corn crops and to some degree the pet trade. But today, visitors to the Cemetery can enjoy a faint reminder of what it may have been like to witness raucous flocks of native parakeets speeding from tree to tree, gathering nesting material, and clambering acrobatically to gather nuts and berries. Green-Wood's monk parakeets are like the ghosts of the native parakeets we lost.

Previous two spreads:
178–179: A great egret takes flight over The Dell Water.

180–181:
Left: A colony of monk parakeets, native to South America, have nested in the spires of the Main Entry Arch for decades. Their playful squawking and raucous interchange welcome pedestrians as they enter.
Right: A double-breasted cormorant in silhouette near Sylvan Water at dawn.

Right: An American kestrel rests on a monument. The smallest member of the falcon family (about the size of a pigeon), they are the most widespread falcon in North America, seen from Canada to Mexico, the Pacific to the Atlantic Oceans. Despite their size, they are powerful raptors, with a diverse diet. Kestrels feed on small mammals, other birds, reptiles, grasshoppers, moths, beetles, dragonflies, frogs, and spiders.

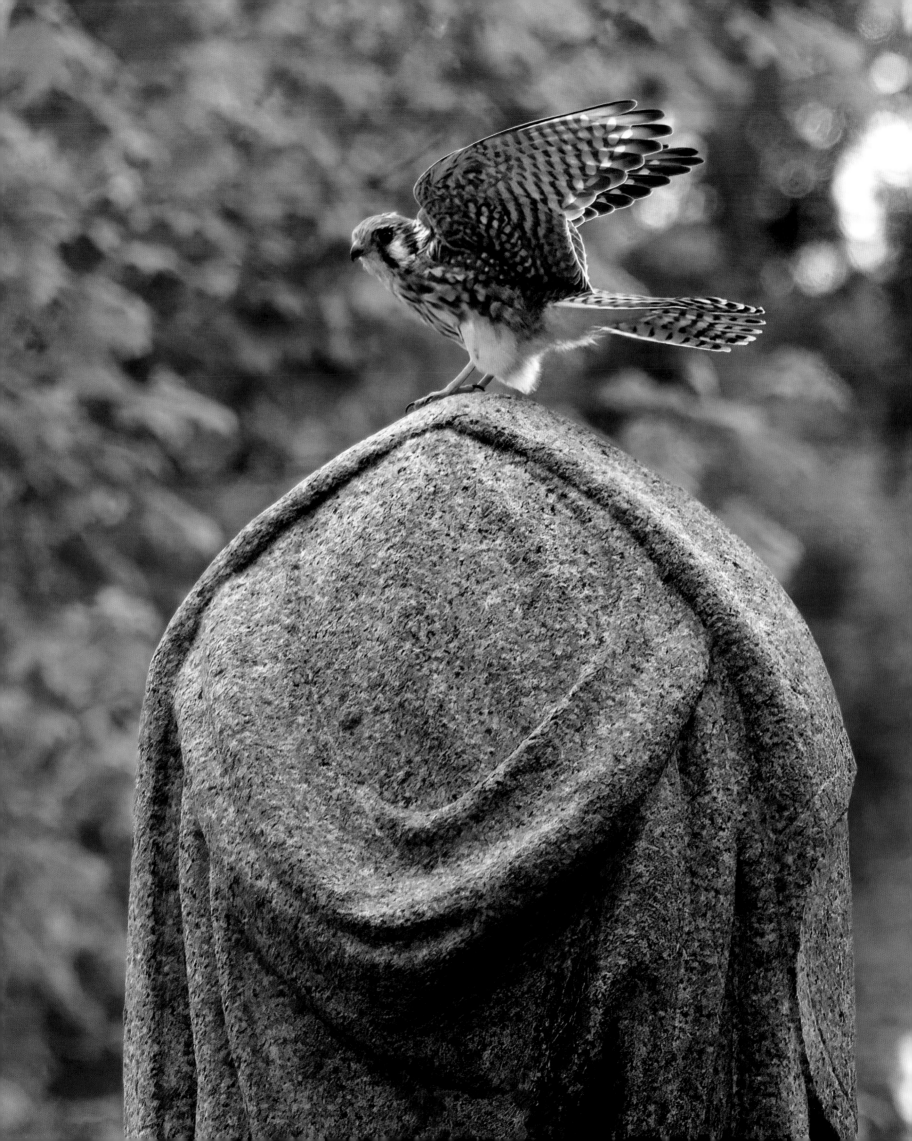

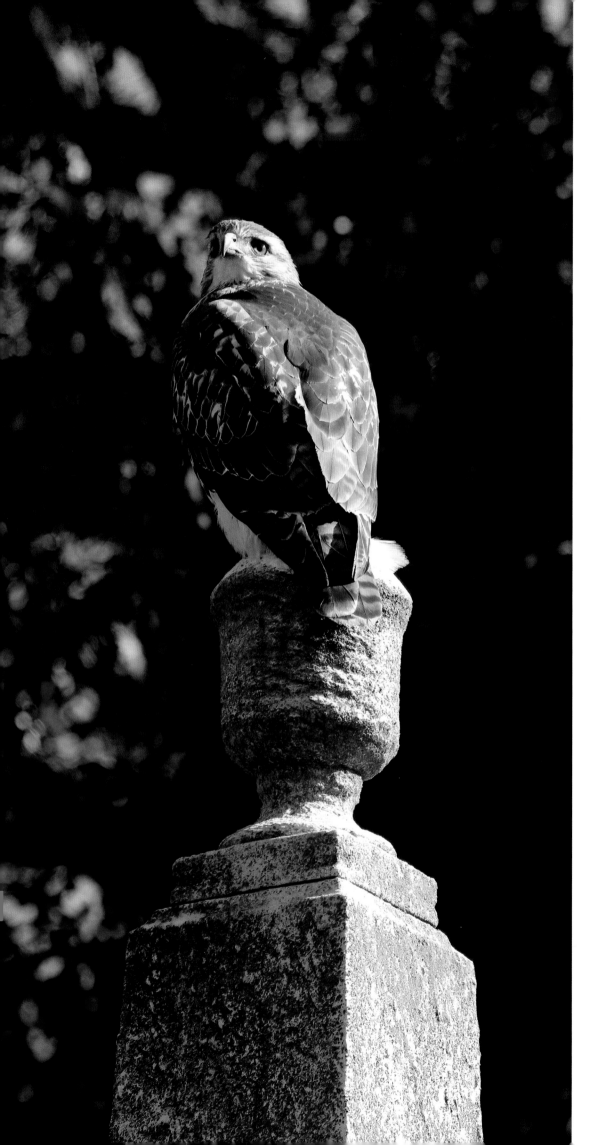

All of the birds in the Cemetery have stories, recalling patterns and eras of abundance and migration, loss and extinction, conservation triumphs and climate change. They are living reminders of history, but also a way for visitors to connect to the natural world, mesmerized for a moment, watching a jewel-like warbler hover at the tip of a branch in search of an insect, or an egret silently stalking along the edge of a pond, the weight of history forgotten, just here in this moment, watching a thing of beauty.

Left: A red-tailed hawk posing on an urn-topped monument near Crescent Water. Red-tails are common and widespread birds of prey, whose population has been increasing greatly since the banning of DDT in the 1970s. Red-tails are also adapting well to living in cities, with ample ledges and food sources, like bountiful pigeons, and squirrels a plenty. A hawk will watch from a high branch, ledge, or in this case a cemetery monument, swoop down, and grab its prey with its mighty talons. In less urban areas they will eat all types of birds up to pheasant size, as well as bats and reptiles; they have a special taste for snakes.
Right: A green heron surveys Dell Water for its next filling meal. A small and short heron, about the size of a crow, it is known for its daggerlike bill. They will stand motionless at water's edge patiently waiting for unsuspecting fish or amphibians.

Following spread:
186 (upper left): A beekeeper tends to Green-Wood's own honey bees near Dell Water.
186 (upper right): Red-eared slider turtles lounge in Valley Water.
186 (bottom): Male and female wood ducks glide about in the Dell Water. One of the most colorful North American ducks, they are comfortable perching and nesting in trees, unlike most other waterfowl.
187: The koi at Tranquility Garden, adjacent to the Modern Chapel, provide a calming presence.

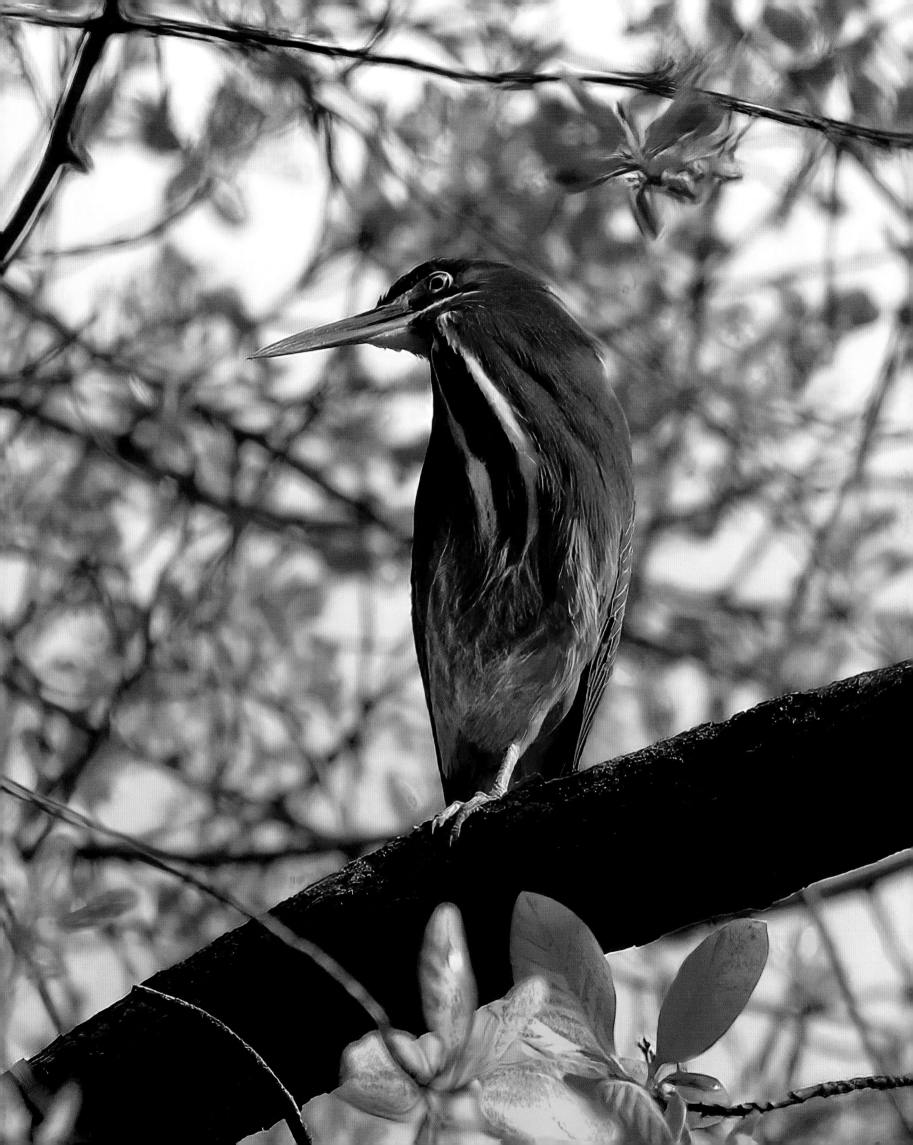

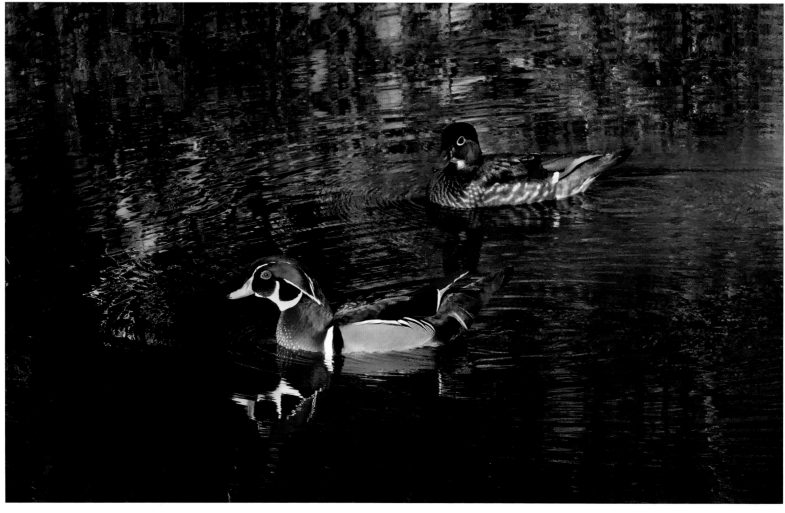

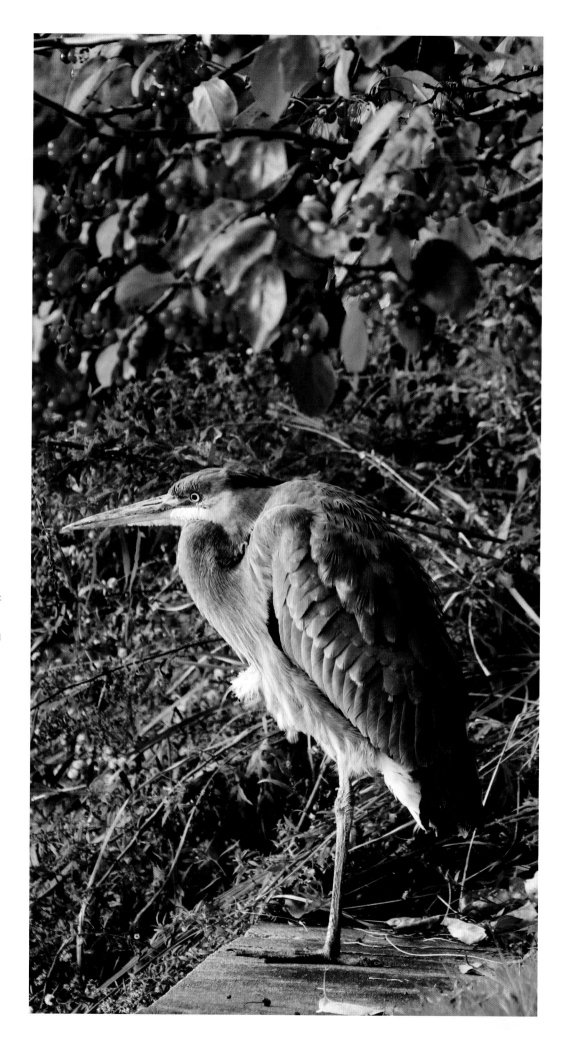

Right: A great blue heron loiters under a crabapple tree at water's edge. Very large wetland birds can stand up to four feet, when they take flight, their wide wingspan and slow wing beats most resemble those of a pterodactyl. While their flight could be described as languid, they hunt with lightning speed, grabbing large fish, turtles, or even gophers, and because of their large, long beaks, they are able to swallow them whole.

Opposite: A bald eagle passing over the Niblo vault and Crescent Water. Our majestic national bird, long a spiritual symbol for Indigenous people, a bald eagle is always a treat to see in Brooklyn. While eagles do not yet nest in Green-Wood, it should only be a matter of time, as their numbers have been exploding since the banning of DDT. The first baby eagles born in New York City in 71 years were recently seen in 2018 in Mt. Loreto Park on Staten Island.

Following two spreads:

190: A solitary stripped skunk takes a stroll at dusk by Forest Avenue. This skunk is one of ten species that live in diverse habitats in the Western Hemisphere. For an animal the size of a house cat, they are surprisingly bold and will challenge animals ten times their size. Their secret weapon: propelling a very stinky smell on any predator. This oily aroma shares enzymes with onions and garlic, which explains its pungency.

191: A fish that recently lost the lottery gets snatched up by a great egret at Sylvan Water at dusk.

192: The always-photogenic great egret cuts a fine silhouette in the reflection of the Niblo vault. This elegant egret is slightly smaller than a great blue heron. They were almost hunted to extinction for their fine plumes, which were used in ladies' hats during the late nineteenth and early twentieth centuries. The fight for this bird and others began the bird conservation movement and the founding of the Audubon Society.

193: A common grackle shows off its iridescent feathers as it takes off over Sylvan Water. The grackle has benefited from the expansion of human population due to its adaptability and proficiency to survive on a wide-ranging diet.

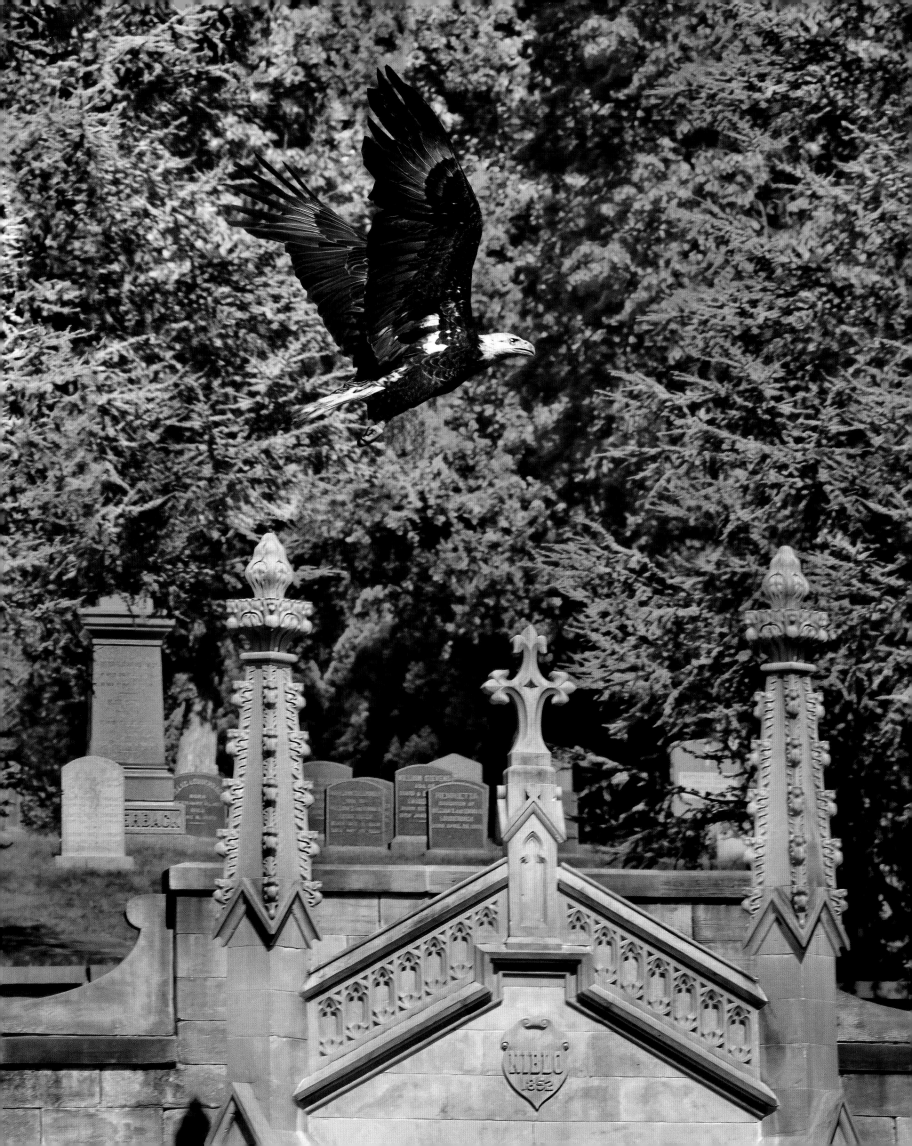

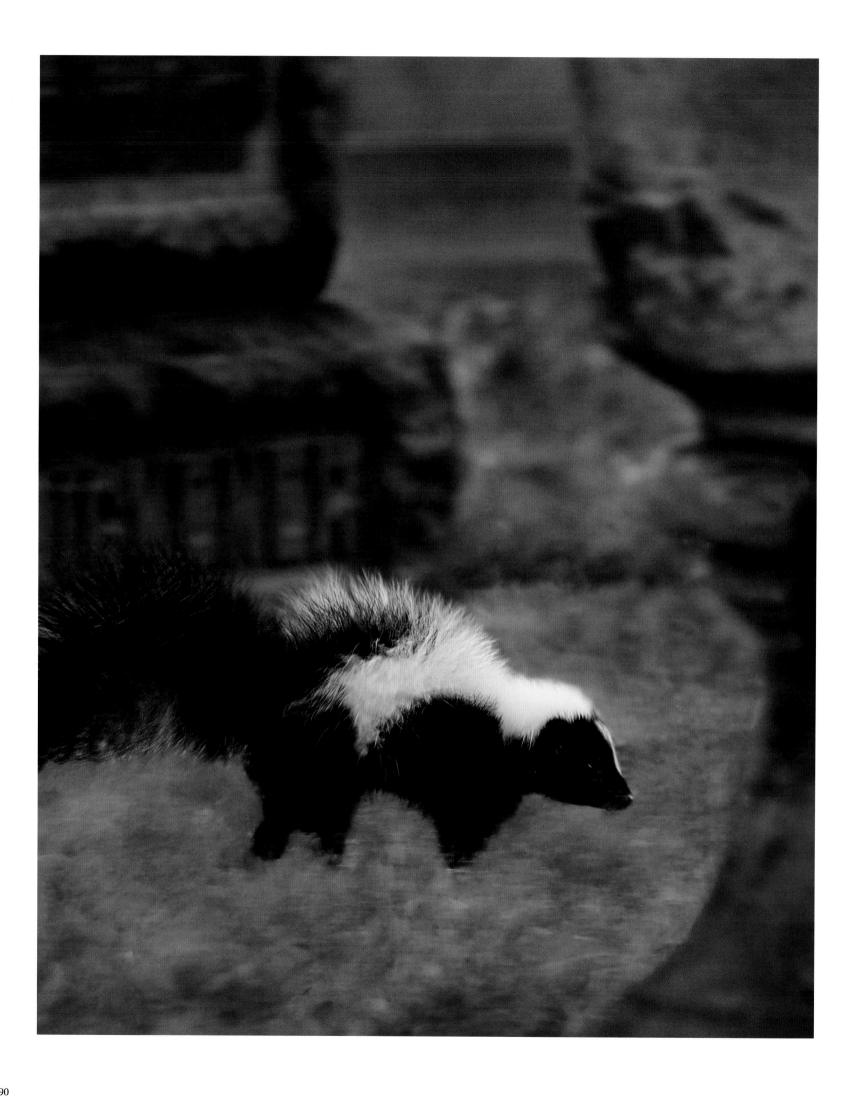

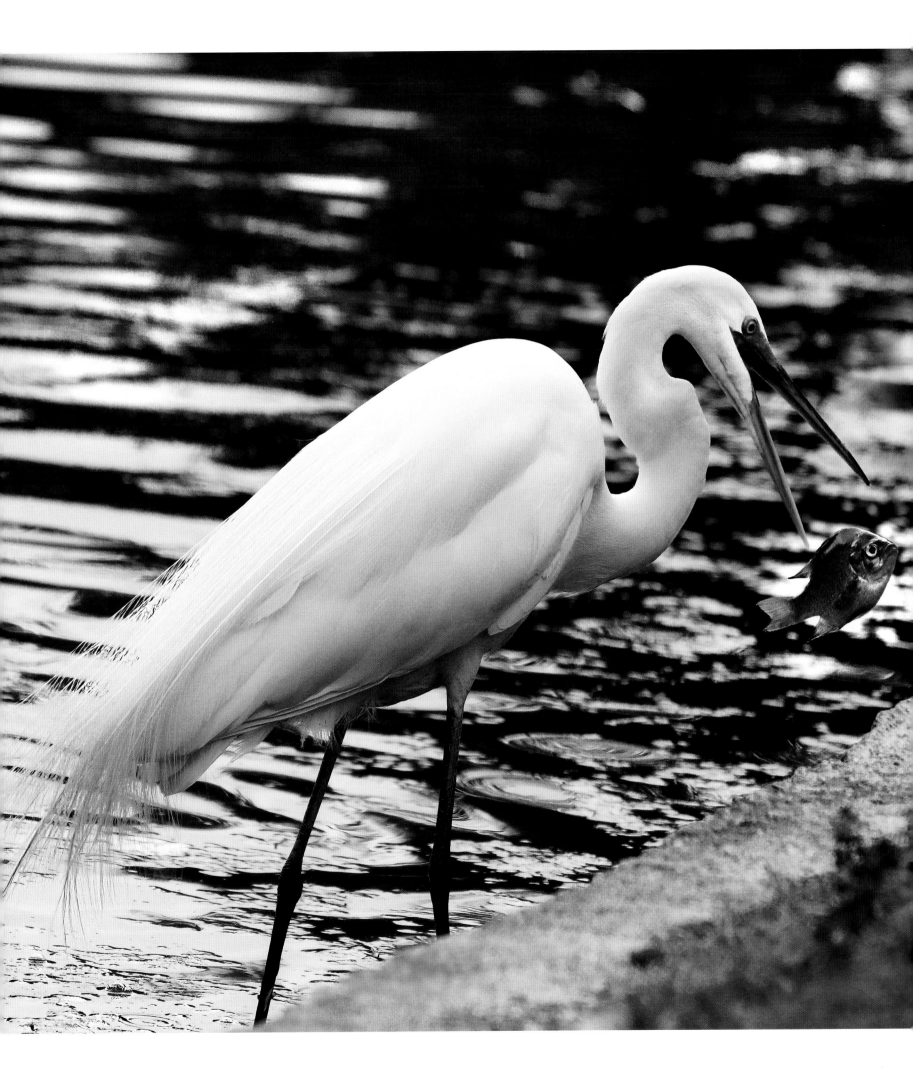

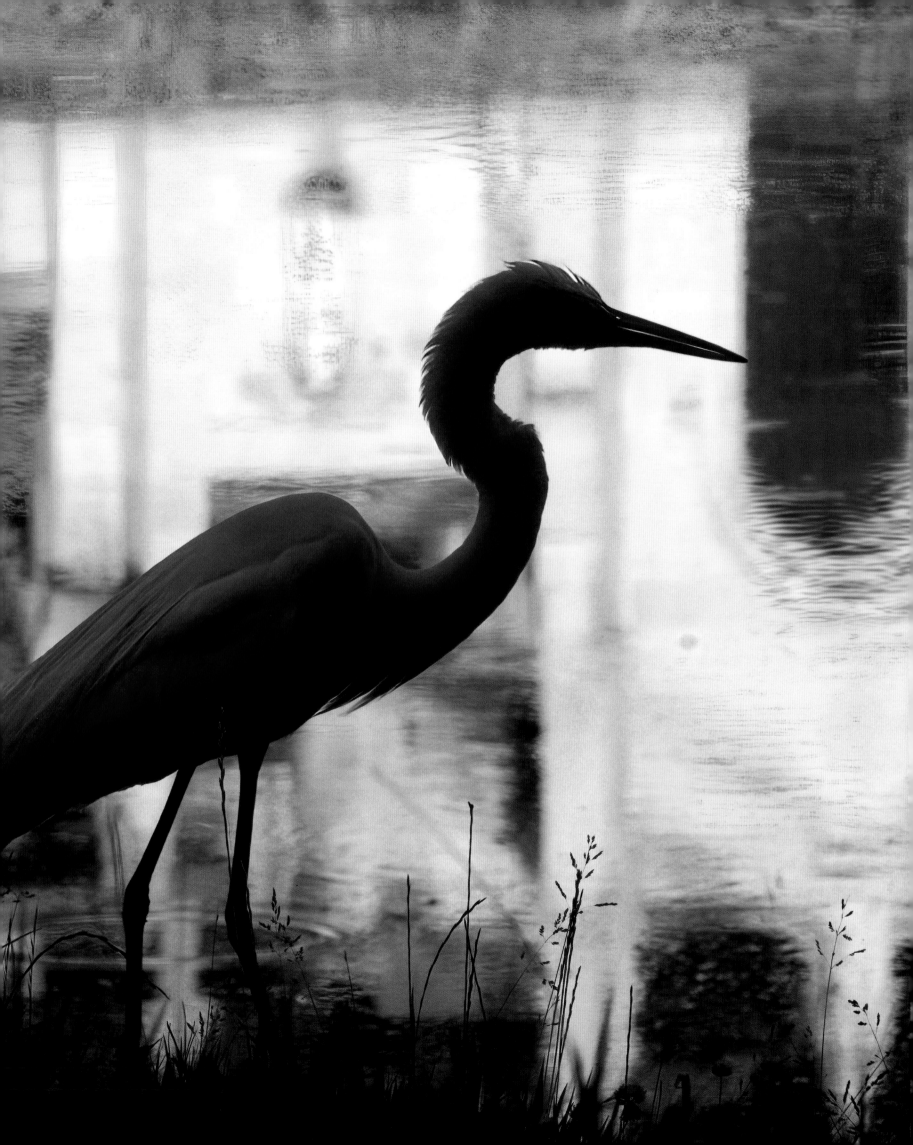

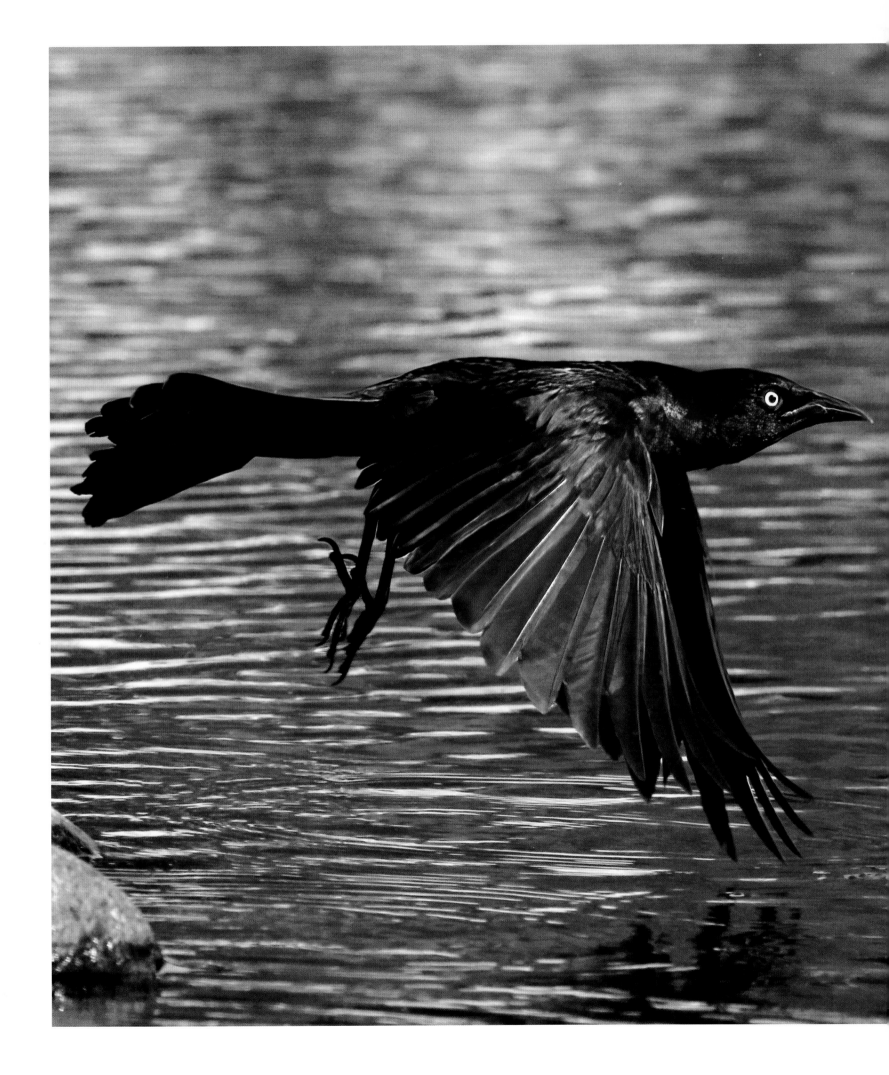

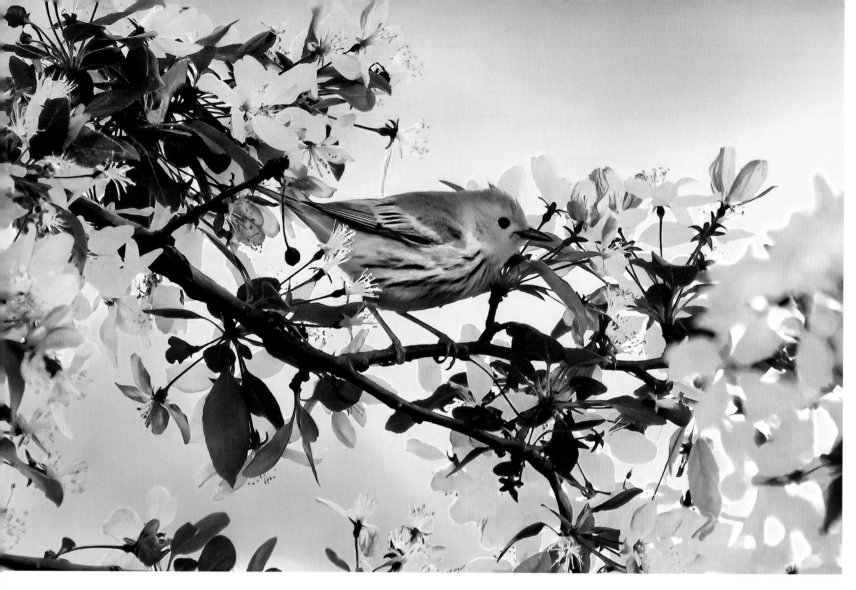

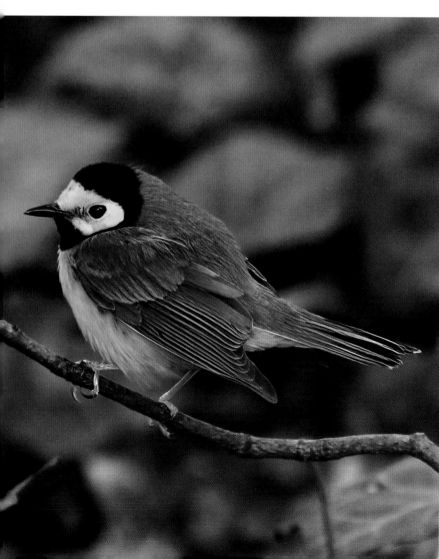

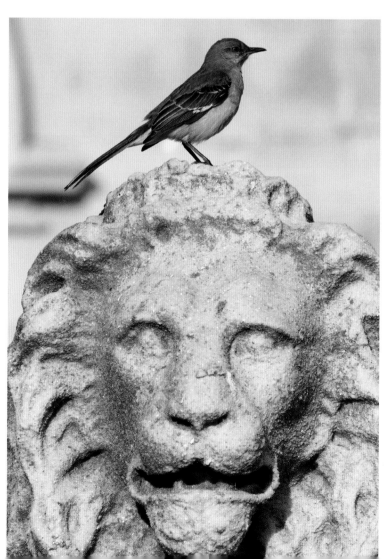

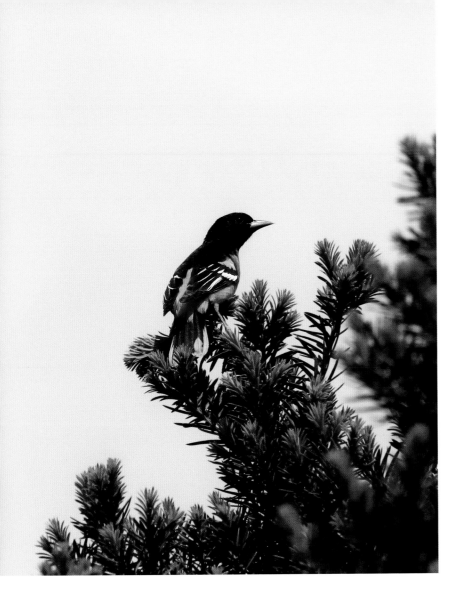

Surrounded on all sides by development, roadways, and railyards, the grounds of Green-Wood offer an oasis to animals and insects. With its quietude and wide range of habitats and plant species, it is a birder's paradise. Clockwise, from opposite top left: yellow warber in crabapple tree; a Baltimore oriole; a Northern cardinal; a brown thrasher; a mockingbird on a lion sculpture outside Niblo's vault; and a hooded warbler.

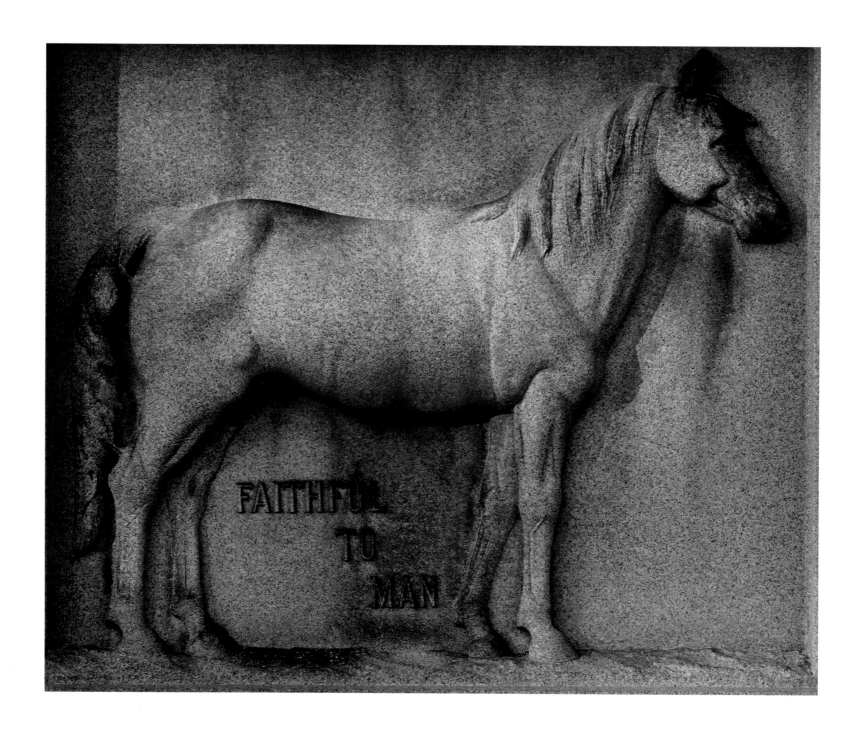

Although not now officially allowed, as pets cannot be interred in cemeteries in New York City, there is speculation that if you had enough money, you could essentially buy your way in. At last count, it is believed that there are about seven dogs buried in the Cemetery, as well as one horse.

Above: Seaman monument.
Opposite:
Top left: Memorial for "Our Daisy."
Top right: Contemporary monument to artist William Holbrook Beard (1825–1900),
who painted *Bulls and Bears in the Market*, adorned with a bear sculpture by Dan Ostermiller.
Bottom right: Marble greyhounds guard a family monument.
Bottom left: Famous Rex, who is always offered fresh sticks by cemetery visitors.

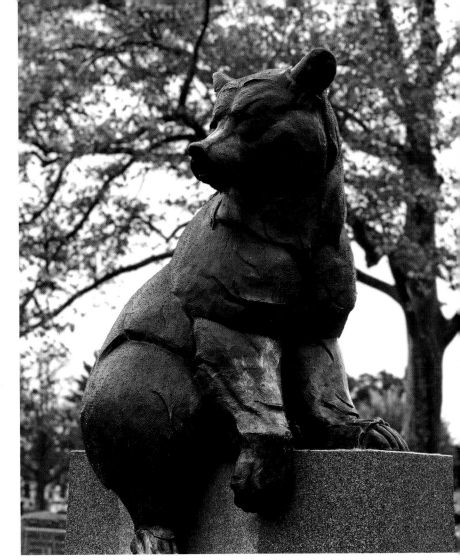
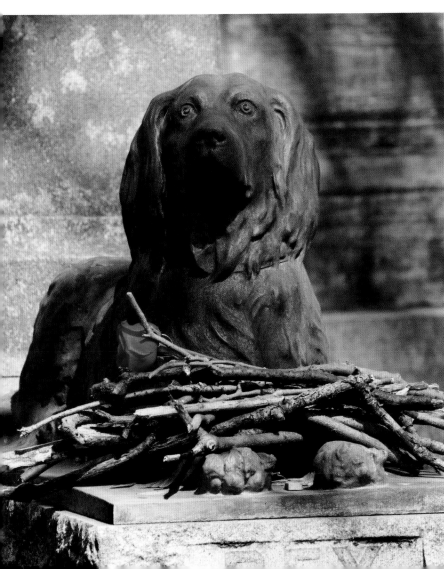
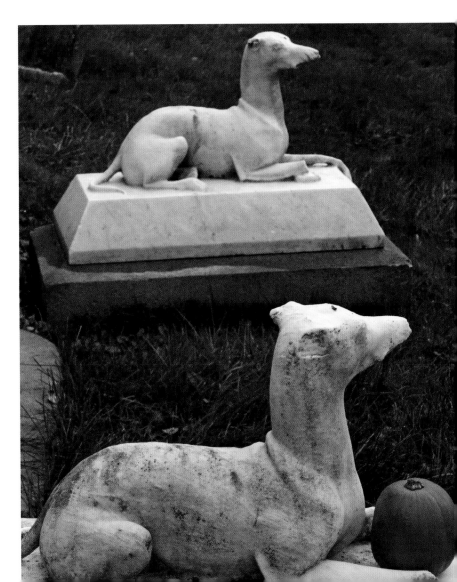

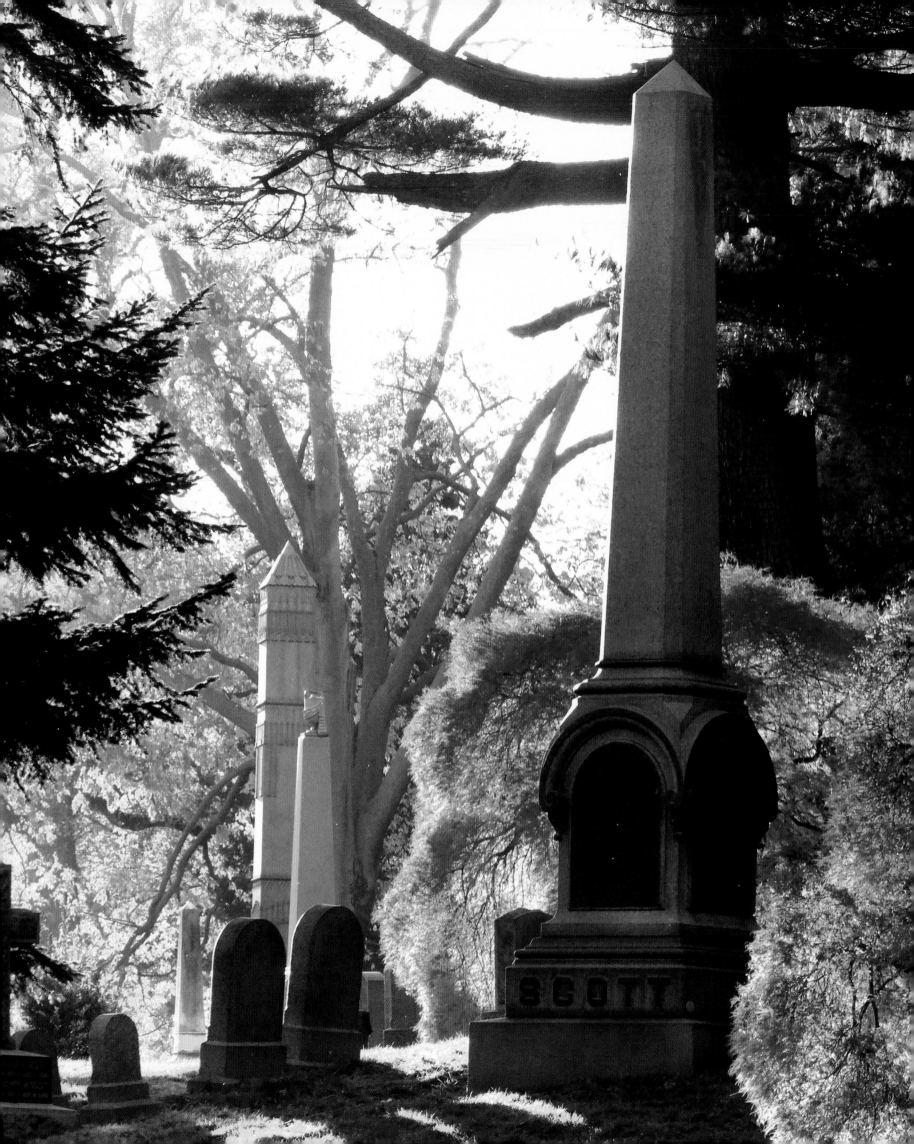

CHAPTER THIRTEEN

Trees

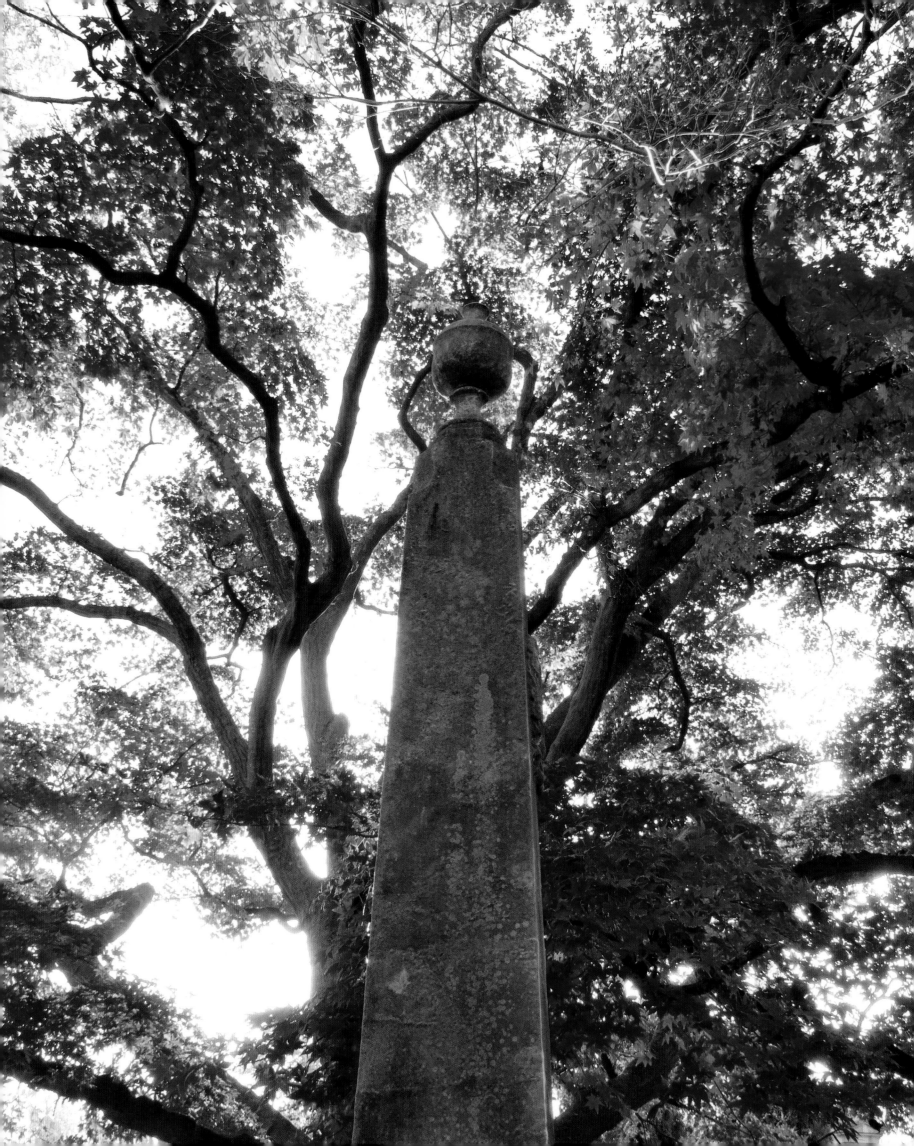

The Trees that Named the Cemetery

Allison C. Meier

Many human lifespans can take place within the life of a tree, and to view trees in a cemetery is to remember that there is a slower timeline of nature constantly growing, dying, and rejuvenating alongside the busy day-to-day pace of the city. These cycles offer hope and comfort just as they did when The Green-Wood Cemetery was opened over 180 years ago.

When Hurricane Sandy hit Brooklyn on October 29, 2012, numerous trees at the Cemetery were uprooted or damaged, knocking the heads off angels and crashing into mausoleums. One was the Gothic mausoleum of William and Sarah Brown, where a Kentucky coffee tree was toppled, its roots wrenched out of the soil. It appeared as if the tree had met its end. Yet on its stump every spring there are signs of resurrection. By the time the warmest months are underway, it is flourishing so well with shoots of green that it's hard to even see the stump. This is a small reminder of resilience against the odds in a sprawling landscape where each tree contributes to this enduring canopy of urban nature.

From its founding, the experience of nature at The Green-Wood Cemetery was central to its identity, with the *New York Evening Post* remarking in 1839 that "it is almost too beautiful a spot to be given up to the dead." From the dense growths of forest to more lightly wooded vistas, it offered a pastoral escape from an increasingly crowded city where trees and foliage were scarce and municipal parks had yet to be established. The plan and objects of the Cemetery published that year stated that the "fine old forest of native growth—the verdure and shade of which originally suggested the name of the Green-Wood . . . will of course be preserved and cultivated with care." Visitors to Green-Wood today can still enter a place that is distinct from the city around it, where the trees are now an important ecological resource in a city that has been thoroughly developed.

The Cemetery is an accredited Level III arboretum and has thousands of trees representing hundreds of species. The oldest have survived centuries of storms, climate change, invasive species, and shifting approaches to managing a cemetery as a landscape. A lofty American elm stands against a slope by Central Avenue, with Medusa-like twisting branches. Dutch elm disease wiped out about 75 percent of American elms in the twentieth century, but still there are rare old elms in New York City from what was once a ubiquitous street tree. Right across the road is the eldritch form of a Camperdown elm (one of a handful of examples in the Cemetery), a curious cultivar that dates to a tree discovered in Scotland in the mid-nineteenth century. Rather than growing upright, it contorts and stoops, "arching high, curving low, in its mist of fine twigs," as Marianne Moore described in her 1967 poem "The Camperdown Elm."

Some trees predate Green-Wood, such as a few veteran hickories and towering tulip trees. The dual sassafras trees near Cedar Dell are believed to be among the Cemetery's longest residents; lean in close or crush one of their mitten-shaped leaves in your hand for a smell reminiscent of the root beer traditionally made from its roots. Others are "volunteers," dropped by birds or brought in by the wind, or they were purposefully planted at graves as memorials. An incredible Catawba rhododendron has completely consumed whole monuments off of Meadow Avenue, where it was likely planted as an ornamental; peeking into its branches reveals a chamber of green that is adorned with lilac-purple flowers in early summer.

Sometimes the trees were selected for symbolism that resonated in a place of eternal rest and mourning, like evergreens or weeping trees such as the line of weeping mulberries that process from the Gothic Arch. Yew trees have a rich history in burial grounds, with many ancient examples found in the churchyards of England. Their long lives have made them a symbol of regeneration, while their toxicity has a meaning of peril; one at Green-Wood, fitting to its nickname "the tree of the dead," forms, with its reddish trunks, an evocative portal to a headstone.

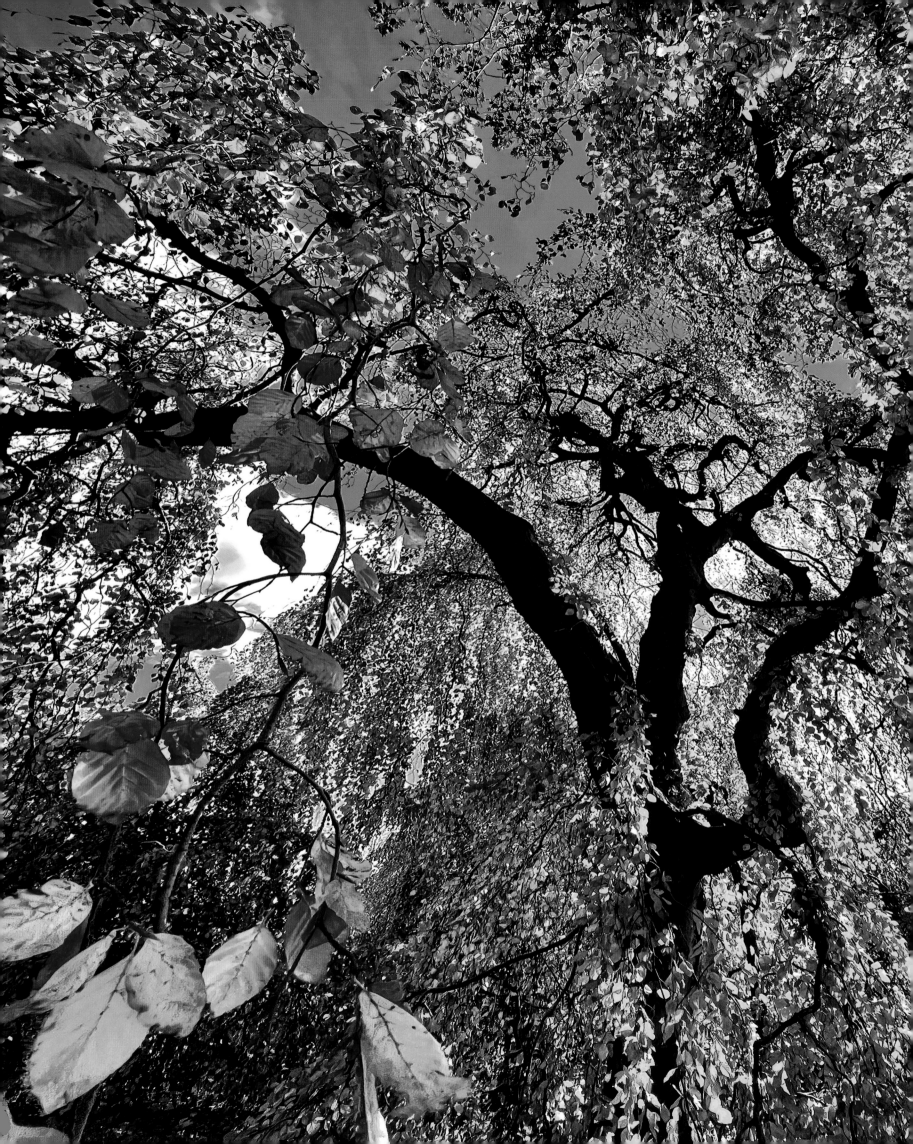

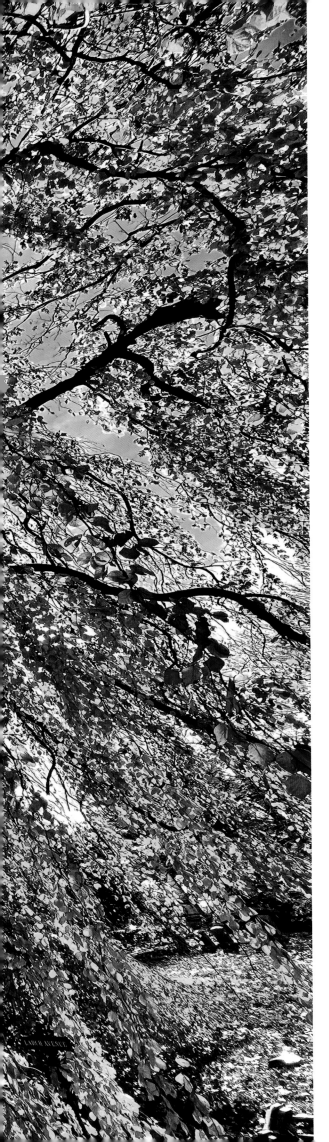

Other trees originate from across the world, from the blue Atlas cedar, native to the Atlas Mountains in northern Africa, with its striking bluish-green needles, to the Himalayan pines with their delicate hanging clusters of needles. One of the tallest is the dawn redwood, a tree thought extinct and known solely from fossils until it was rediscovered in China in the 1940s. It soars over Twilight Dell, where you can also witness more diminutive rarities such as the Franklinia trees, distinctive for their white flowers with an orangey fragrance. A few of these trees grow around Green-Wood and can be traced back to their 1765 identification in the wild by botanists John and William Bartram. They haven't been recorded again in the wild since 1803, with cultivated specimens being the only known examples.

Some trees were more recently added as the Cemetery looks ahead to a sustainable landscape that will be a crucial space of biodiversity for the city and its nature. These include shagbark hickory trees that from their fruit to leaves are food sources for wildlife, as well as species that can thrive in the warming conditions of climate change, such as blackjack oaks and the venerable southern icon, the live oak.

As the seasons shift and the years go by, so too do the trees grow and transform, each visit rewarding a close look. The cherry and magnolia trees burst into bloom each spring; the Japanese maples, sweetgums, and sourwoods are awash in fiery colors in fall. Winter is an opportunity to admire the furrowed bark of the willow oak and the smooth trunks of the beech trees. Return in summer to enter the tunnel of pendulous branches from the weeping beeches on Larch Avenue, where the sunlight makes their layers of green leaves glow.

Left: Weeping European beech in fall.

Following two spreads:
204–205: European beech root and bark details. This majestic beech tree is one of 182 at the Cemetery. The European beech evolved to thrive in dense forests in which they can reach heights of one hundred feet at maturity. The beech's morphology influences its success: its leaves are arranged so that there is minimal overlap, which allows them to capture the most sunlight possible and effectively shades out other plants growing beneath their canopy, reducing competition for soil moisture.

206: Smith family monument off Vine Avenue. Red maples in foreground left.
207: The alluring weeping beech tunnel on Larch Avenue has enchanted visitors for many years. The European weeping beech was developed in England in 1836 and imported to the United States 1847. Not only do the branches weep, but they also twist.

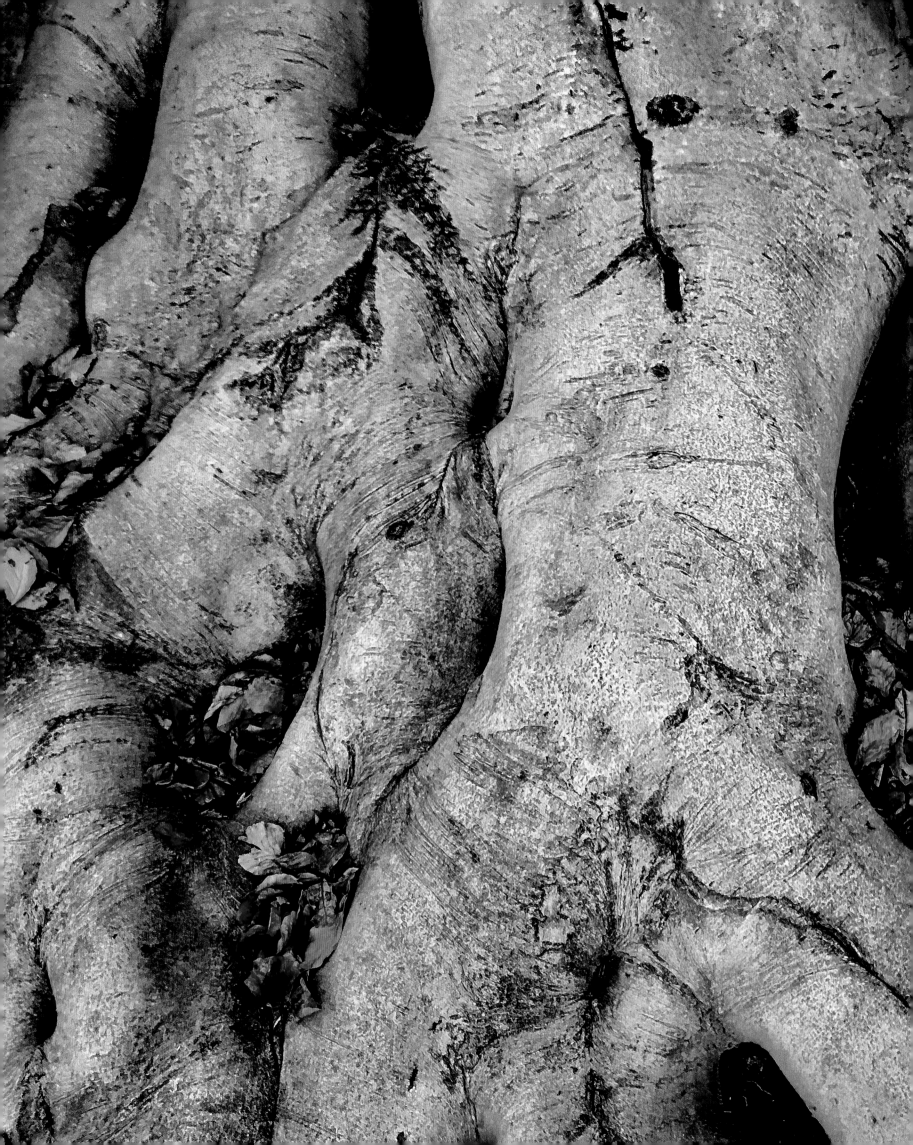

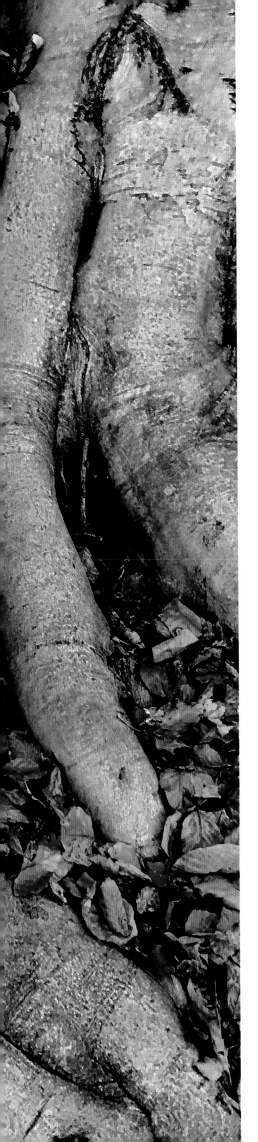
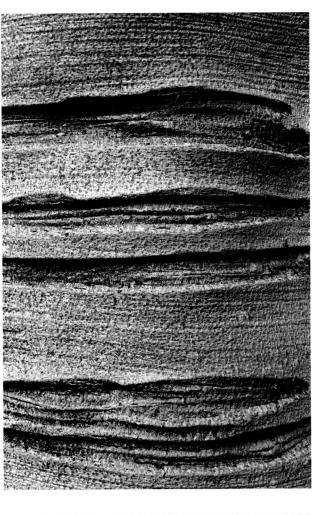

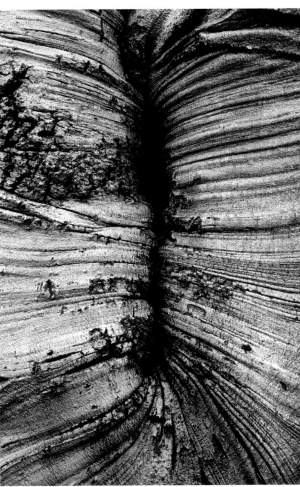

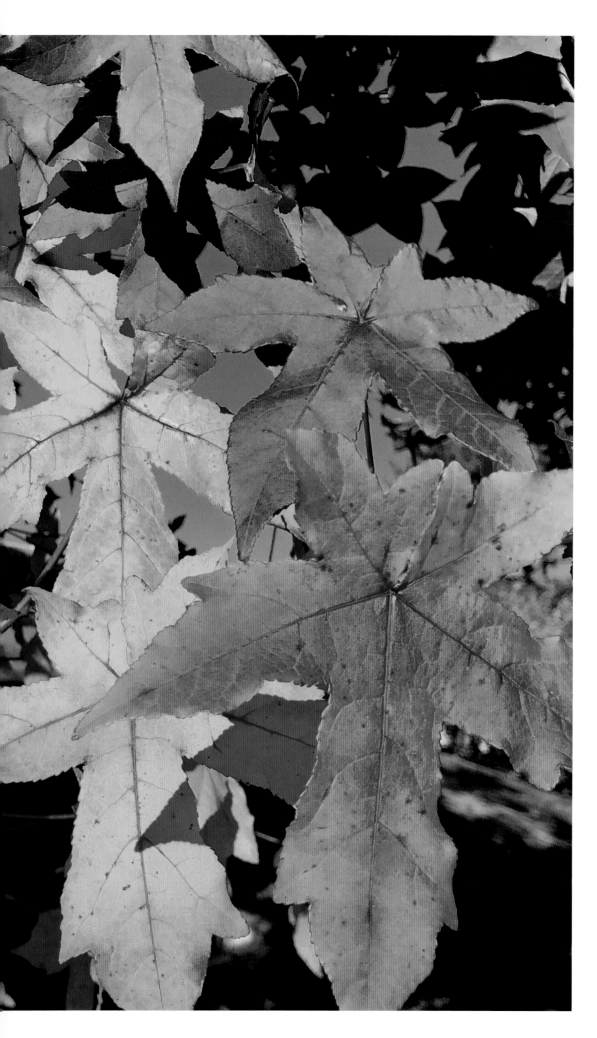

Sweetgum leaf and tree detail. The sweetgum's genus, *liquidambar*, comes from the tree's aromatic sap. In early spring, both its leaves and its unisexual flowers emerge simultaneously. Spiky sweetgum fruits ripen, and the capsules open, launching the seeds from their husk. The plentiful seeds are an important food source for overwintering songbirds at Green-Wood.

Next spread:
210–211: Fall leaf typologies.
Left: Sweetgum tree leaves. Middle: Ginkgo tree leaves. The only existing species of its genus, the ginkgo is considered a "living fossil," as its form has remained unchanged for over 200 million years. In autumn, fan-shaped leaves turn from a vibrant green to a brilliant yellow before dropping. Right: In fall, the black gum (or tupelo) presents colors of scarlet, amber, and gold, transforming the deep green of its summer canopy.

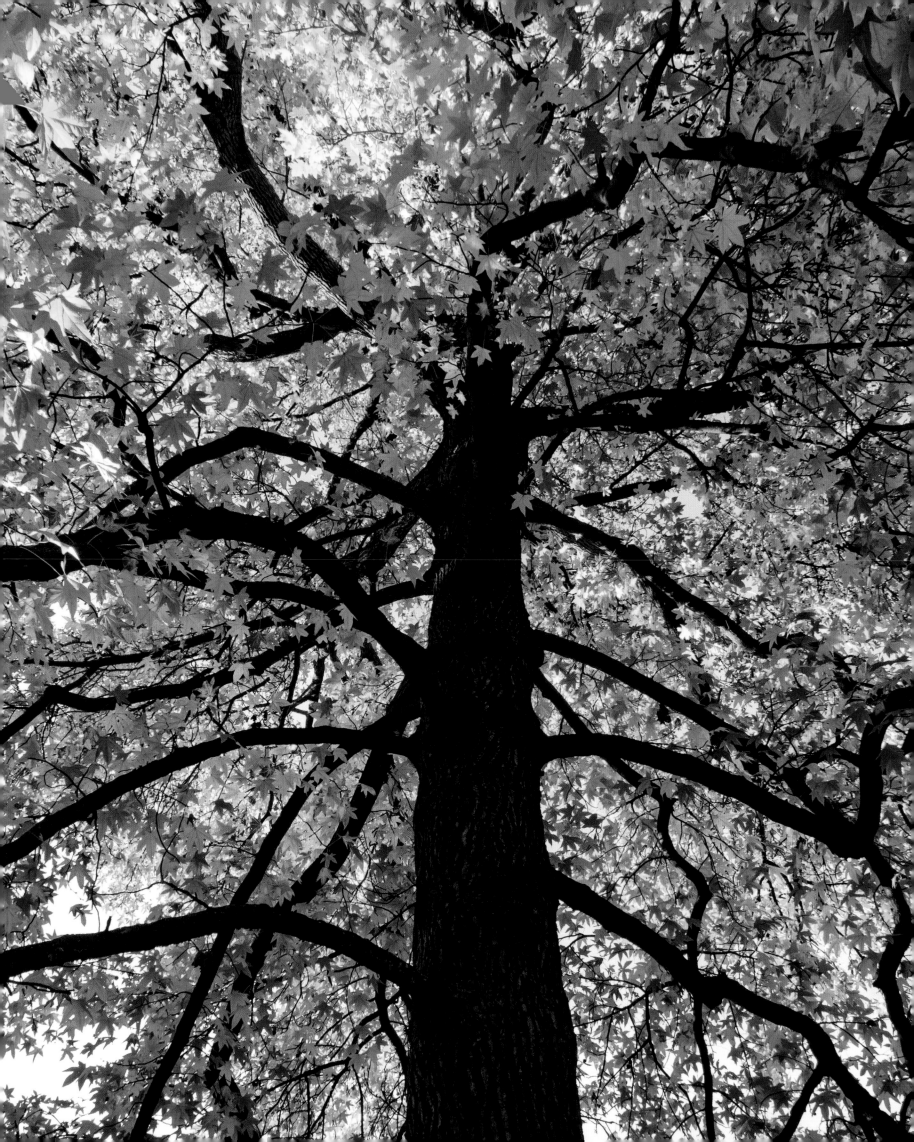

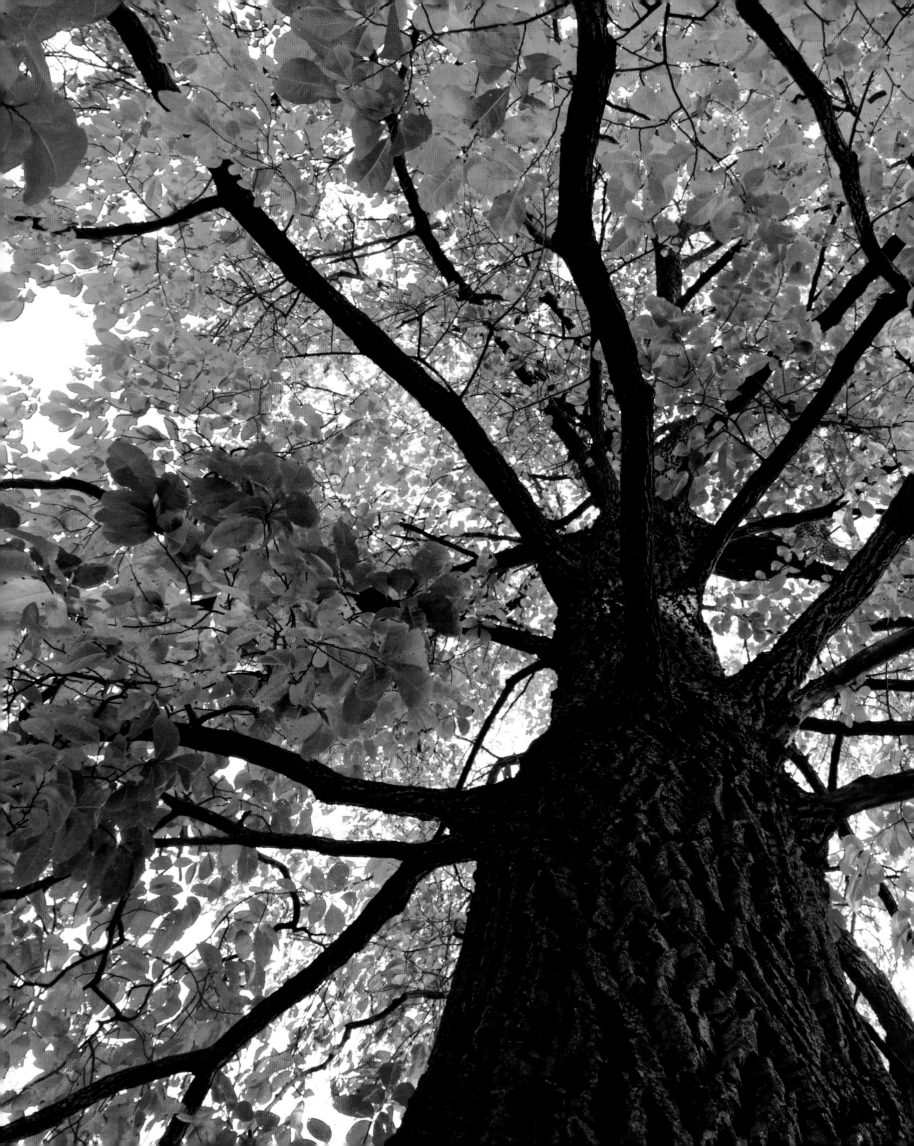

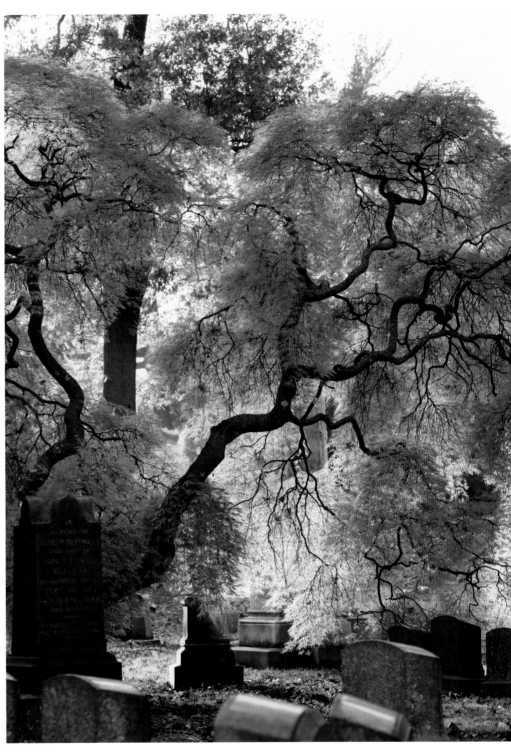

Left: Named for its sour-tasting leaves, the sourwood is native to the eastern and southeastern United States and is the sole existing species of its genus. In the fall, the oblong shiny leaves turn a vivid red.

Above: The always pleasing Japanese maple poses on a late afternoon fall day.

CHAPTER FOURTEEN

Flora: Wildflowers, Lichen, and Fungi

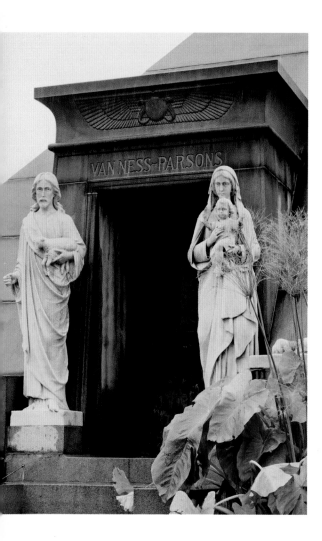

The Significance of Flora at Green-Wood

Andrew Garn

"The soil is the great connector of lives, the source and destination of all."

—Wendell Berry

The life that flourishes from the soil in the form of trees and plants has a special significance at Green-Wood. This living flora offers a counterpoint to lives lost, a contradiction to the death that lays in the ground, symbolizing the certainty that life is circular and continual. Each new sprout piercing up through the earth or bud unfolding on a stately tree represents rebirth and renewal.

When appointed to create Green-Wood's original two hundred acres from an existing forest in the 1830s, the engineer David Bates Douglas noted, "the land will be covered with appropriate plantations of shrubbery and trees, until the whole shall acquire a character of sylvan still-life in harmony with the quietness and repose of the grave."

A massive amount of earthwork followed, deliberately transforming untouched nature into a curated "natural setting." Green-Wood soon became a popular pleasure ground for people desperate to escape dirty urban neighborhoods.

Rural cemeteries in other large cities like Paris, London, Boston, and Philadelphia also became destinations where people flocked to celebrate the cycles of life, including its limitations. Carriage rides and picnics turned a setting of death and burial into an uplifting place that celebrated being alive. By the mid-1800s, Green-Wood attracted 500,000 visitors a year.

Today, the 478 acres of carefully tended trees, shrubs, and flowering plants makes Green-Wood a world-renowned, Level III arboretum. Its ever-changing dynamic landscape comprises a collection of approximately 8,000 specimens, representing almost 700 taxa and 159 different genera.

How did a cemetery in the midst of one of the largest cities in the world become a Level III arboretum? Joseph Charap, vice president of horticulture at Green-Wood, says it took almost two centuries, utilizing the well-documented record of plantings as a resource for design, maintenance, and planning for the future.

Some of Green-Wood's most iconic trees, like the European beech and massive white oaks, are succumbing to age and environmental stresses, so there is constant need for replacement. Many have been substituted with trees like hybrid swamp oaks, filberts, and buckeyes, natives of the southeastern United States, a place with milder winters and hotter, lengthier summers.

Climate change is already impacting Green-Wood. "With unpredictability the norm," Charap says, "warming temperatures in Brooklyn and more frequent storms have wreaked havoc on some of the stately oaks and beeches." He adds that, 2021 "was one of the wettest years on record followed by" 2022, "which presented one of the longest droughts in twenty years." The result was Green-Wood looking like late autumn in August, with brown fields and premature wilting and dropping of leaves.

Another adaptive modification has been the replacement of turf grass, which needs constant mowing and watering, with native wildflower meadows that require little maintenance, provide food for fauna, and prevent soil erosion.

As Green-Wood continues to evolve and grow, Charap and his crew and collaborators must look forward decades into the future to strategize the types of plants that can weather a rapidly changing climate. New plantings are selected for climate adaptability, resilience, wildlife value, and enhancement of the beauty of the landscape.

Currently, Green-Wood's plant life is responsible for removing 264,000 pounds of carbon dioxide and 12,000 pounds of other pollutants from the air. The Cemetery also helps absorb over 2.5 million gallons of storm water from overwhelming Brooklyn's sewage system.

Previous spread:
A bright yellow magnolia blossom welcomes spring.

Above: Papyrus plants grace the entry to the Van Ness-Parsons mausoleum.
Opposite: Fall colors, goldenrod, and rosehips overlooking the Historic Chapel. Roses, known as the "Queen of Flowers," have been a symbol of love, war, and beauty for as long as humans have collected and cultivated them. In parts of Europe during the seventeenth century, demand for roses was so high that the flower (or its essences) was considered legal tender.
The genus rosa contains 150 species and thousands of different hybrids and cultivars.

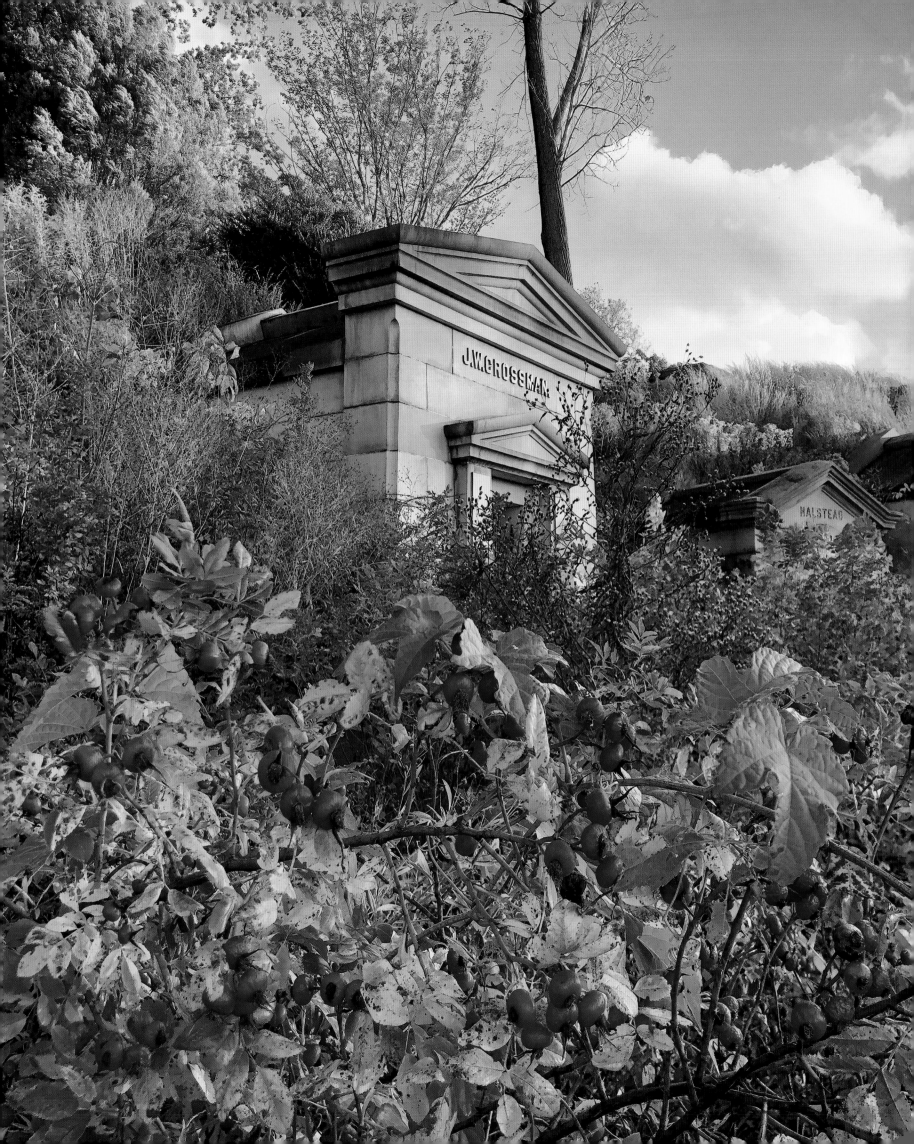

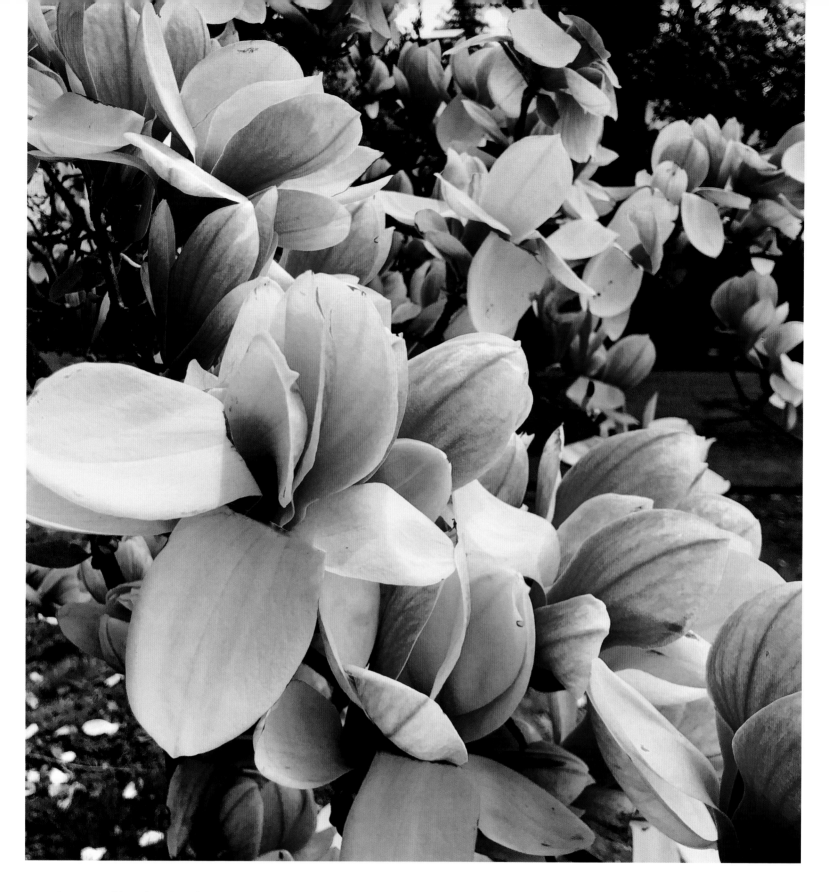

Green-Wood is an interdisciplinary landscape, as much prized for its topography and nature, as its human-created sculpture. "Trees share the same soil with the monuments," says Charap, noting "the stone structures are the backbone for trees, working in harmony, regeneration, and eternal life."

The flora of Green-Wood continually offer visitors a sensory experience to savor and enjoy throughout the year. In the early spring there is riotous competition among vivid blossoms, followed by the sweet scents of linden trees and honeysuckle. In autumn, vibrant reds and oranges decorate maples and black gum trees. There are the sounds of the wind passing through the tree leaves, and of course, the multitudes of bird calls. Even in the quiet of winter, the sculptural forms of trees, often in silhouette against the snow, is stunning, set against the backdrop of the city.

Above: Saucer magnolia blossoms near the Peter Cooper monument.
Opposite: Japanese maple winged samaras are the fruit of the tree that contains a small "nutlet," enjoyed by many birds and small mammals alike.

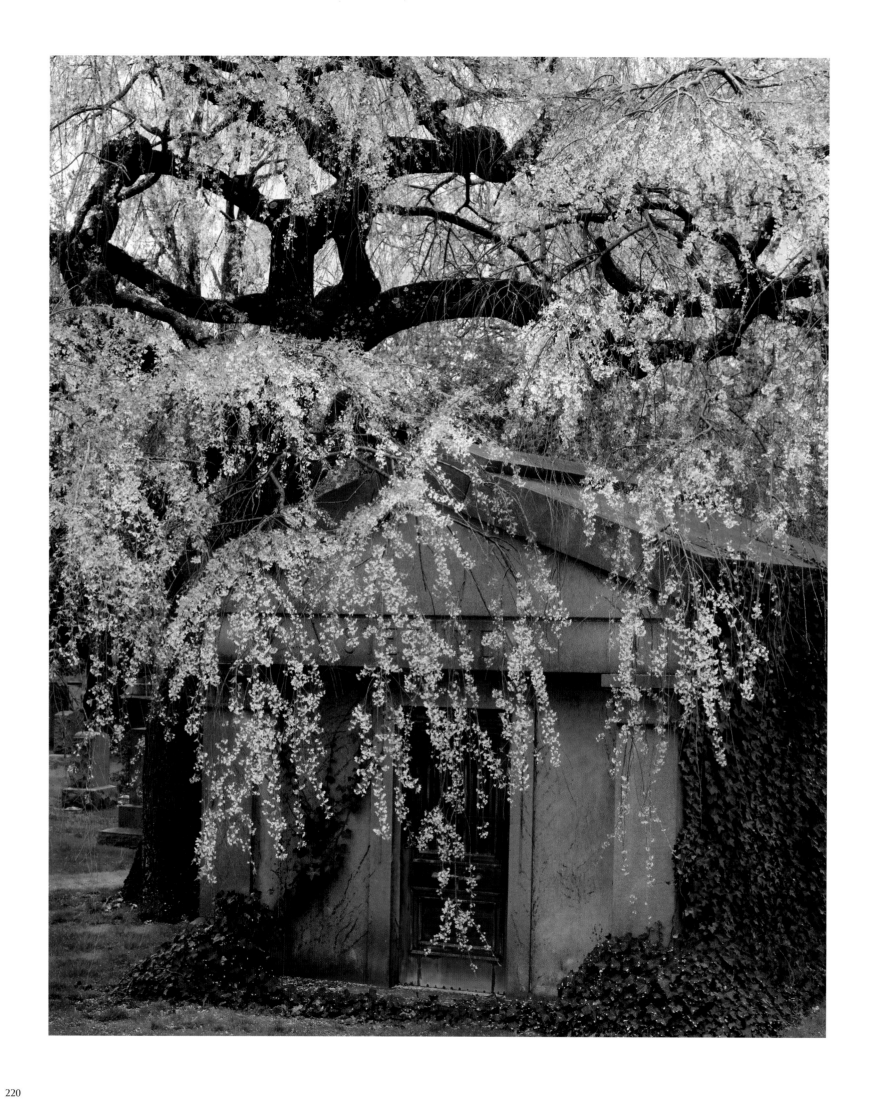

Opposite: A mature cherry tree appears to envelop a mausoleum near Hemlock Avenue.
Above: There are over fifty different species of lichens growing in Green-Wood;
clockwise from upper left: Candleflame lichen, common greenshield lichen,
golden moonglow lichen, fluffy dust lichen.

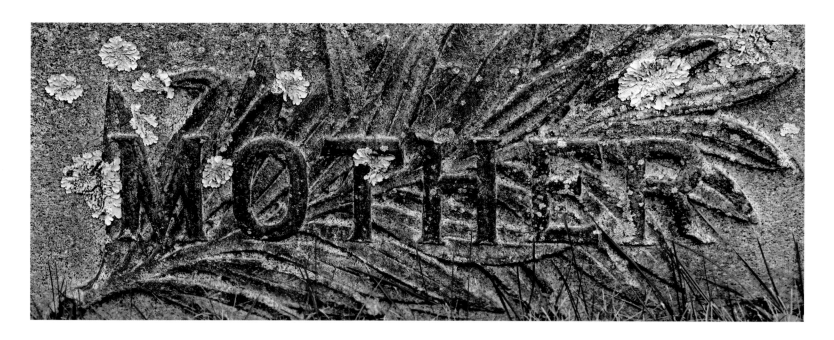

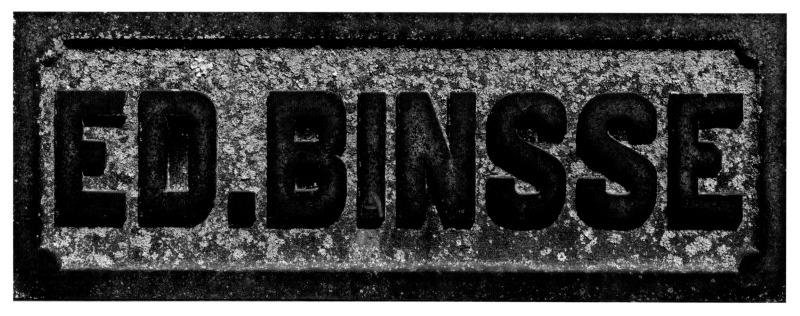

Above: Cemetery stones make an ideal environment for lichens.

Opposite: Native yellow trout lilies bloom on the Hamilton garden grave. A garden grave consists of a gravestone,
a footstone, and two low stone walls connecting them, creating a rectangle designed to hold plantings to
memorialize the person buried below. Sometimes known as a "cradle grave," it resembles a bed, with a headboard and footboard,
and the flowers planted resemble a lovely blanket of color and texture.

Following spread:
224: A cultivar of the knotweed, white fleece flower, planted around the Soldiers' monument.
225: The flowers of the American smoketree seen in detail here, appear as mist from afar.

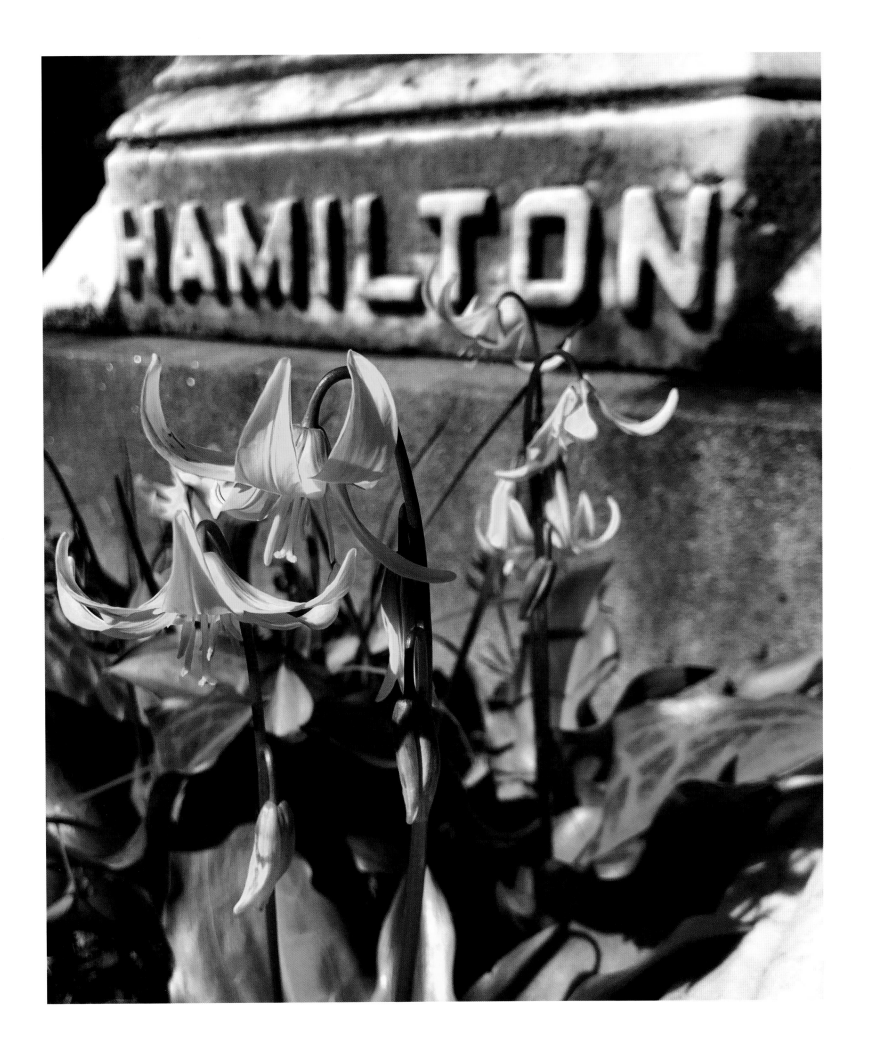

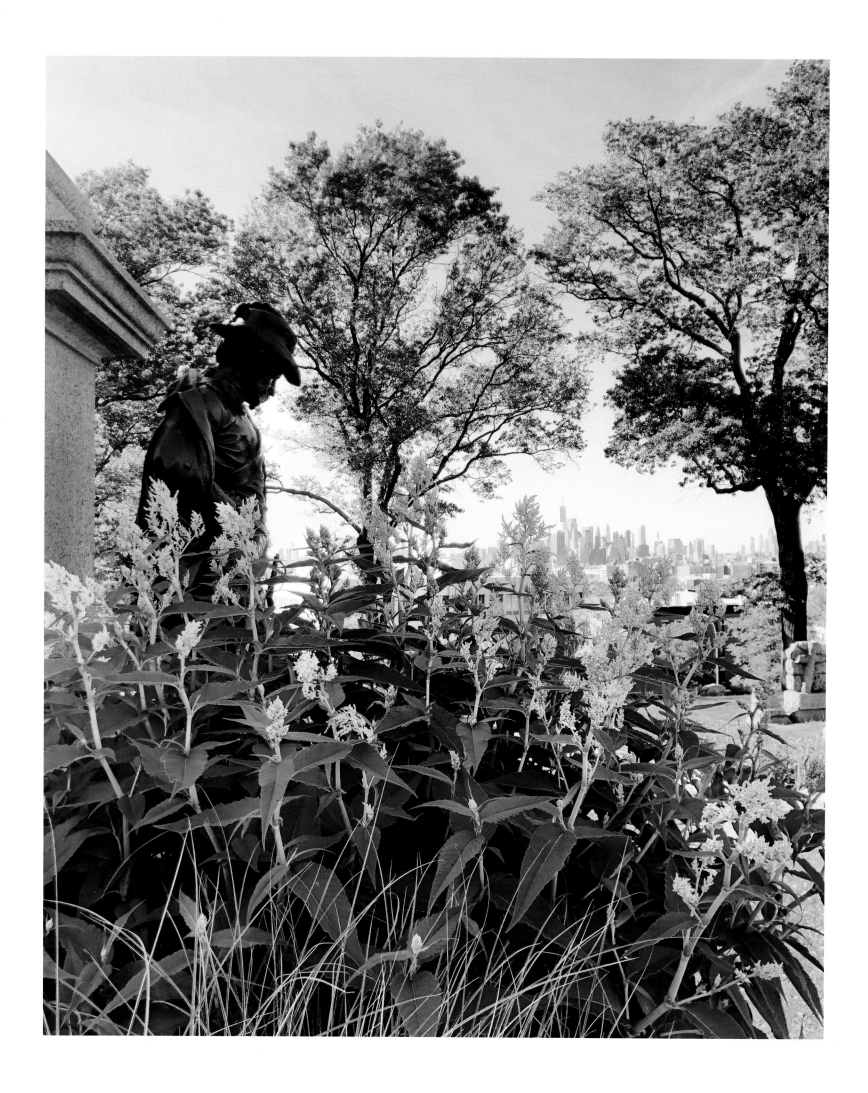

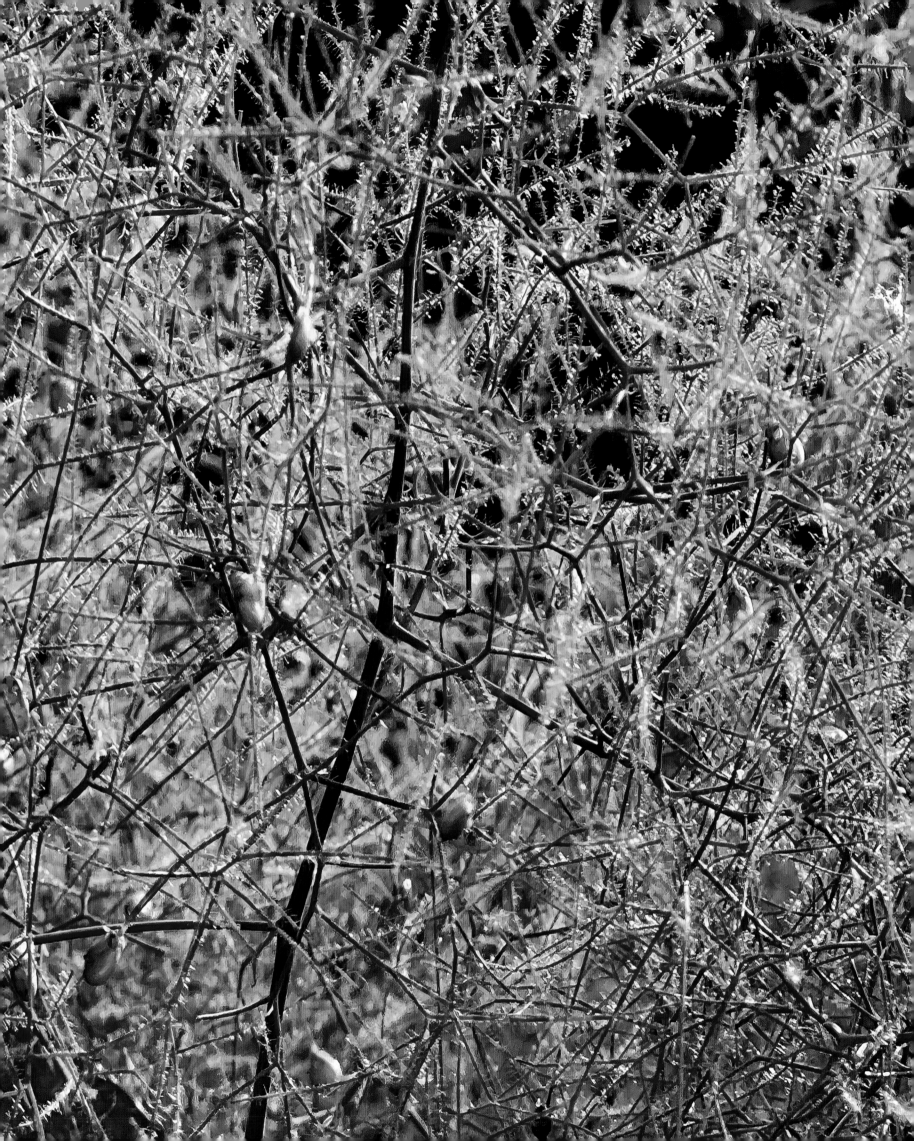

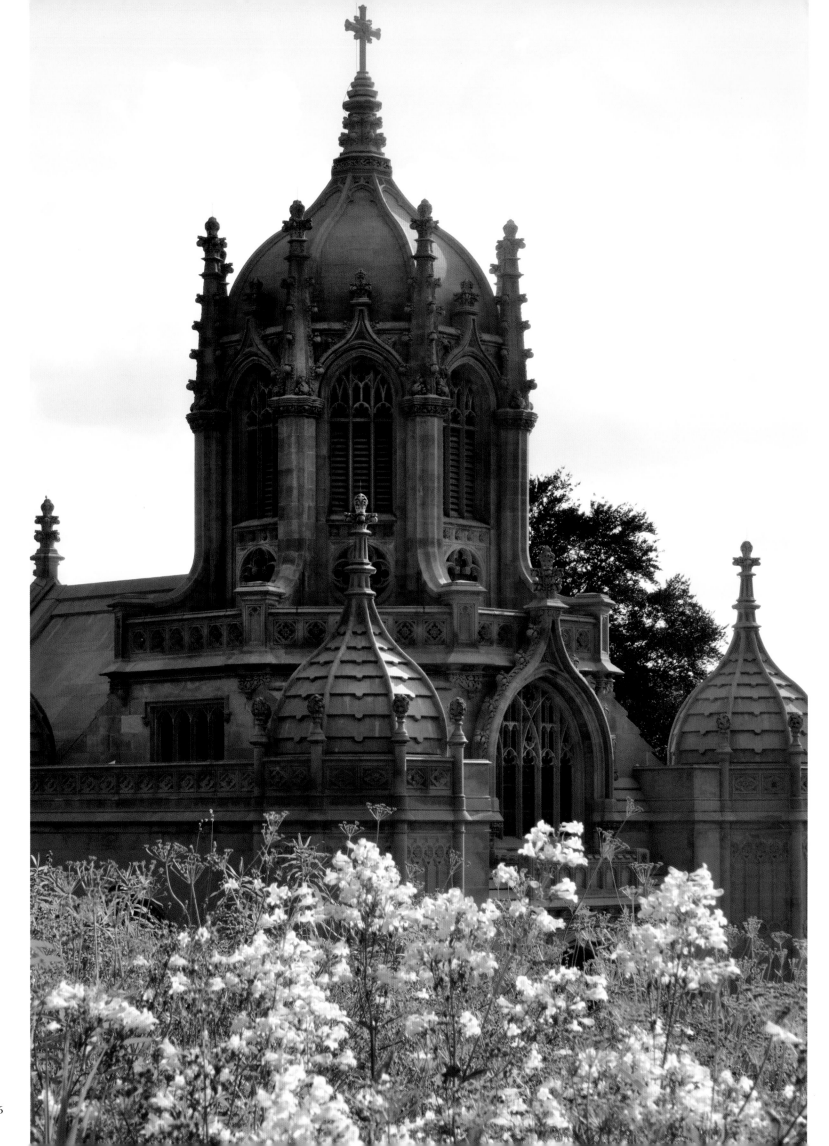

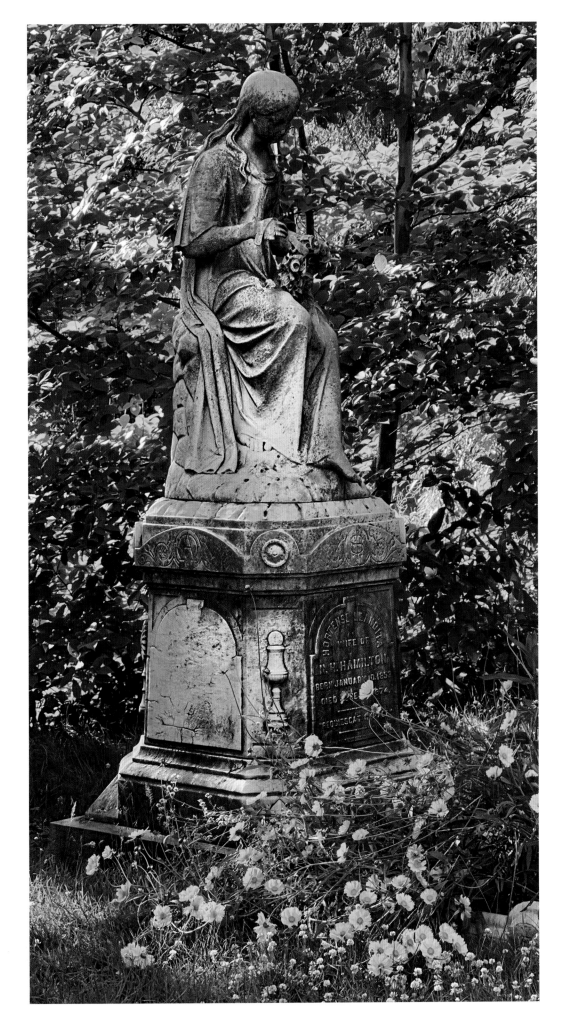

Opposite: Waves of wildflowers covering the hill above
Sycamore Avenue, looking down towards the Historic Chapel.
A happy haven for butterflies and bees that provide the
pollination for 75 to 90 percent of flowering plants
in Green-Wood.
Left: A quiet corner near Dell Water. Above: Water plants at the
surface of Crescent Water.

Opposite: Wilted ivy covers a tombstone.
Right: Oleander aphids enjoying the sap of milkweed. These aphids have a wide range of host plants in the dogbane family and can be winged or wingless. Only females appear in the wild. They reproduce quickly and can overwhelm a plant by sucking its juices. Along with their veracious appetites, they can be the vector of numerous plant viruses.

Next spread:
Lichens brighten up gravestones in the landscape with colors of yellow, green, blue, orange, and black.

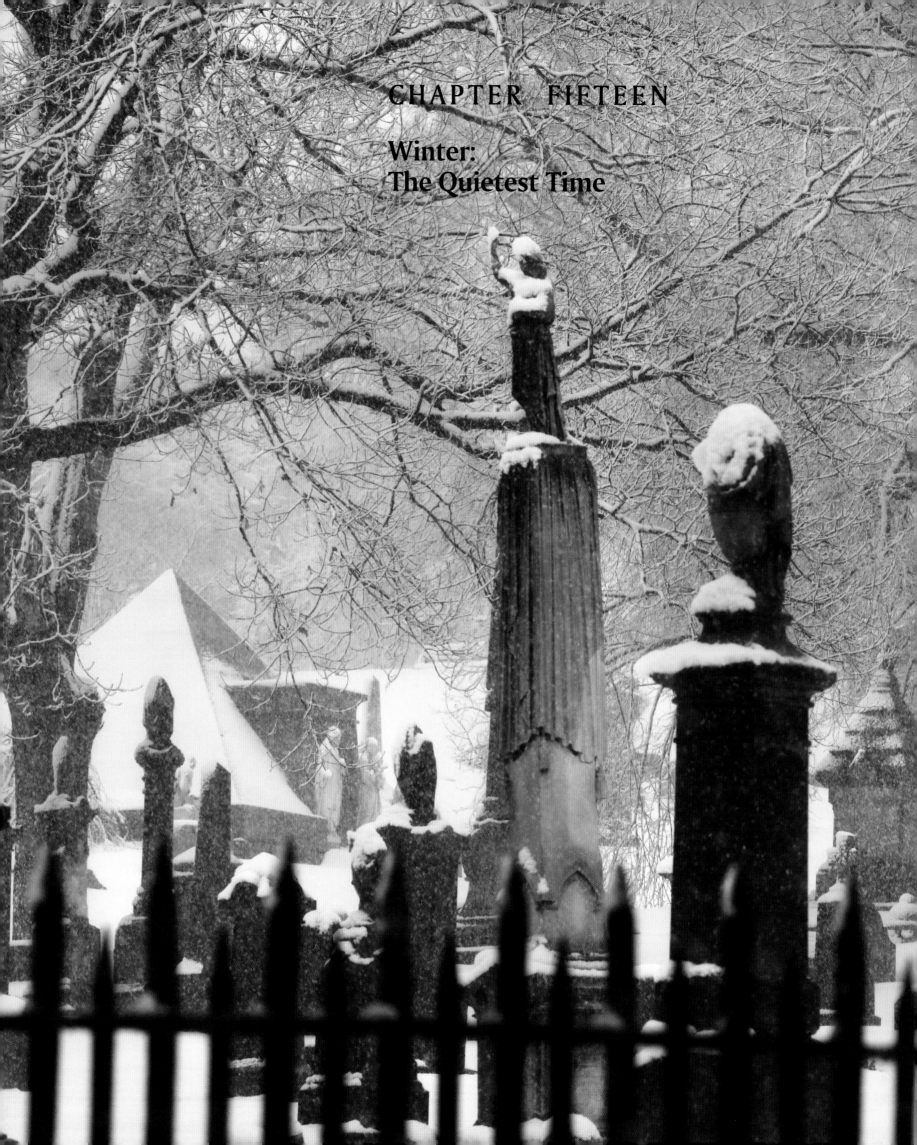

CHAPTER FIFTEEN

Winter:
The Quietest Time

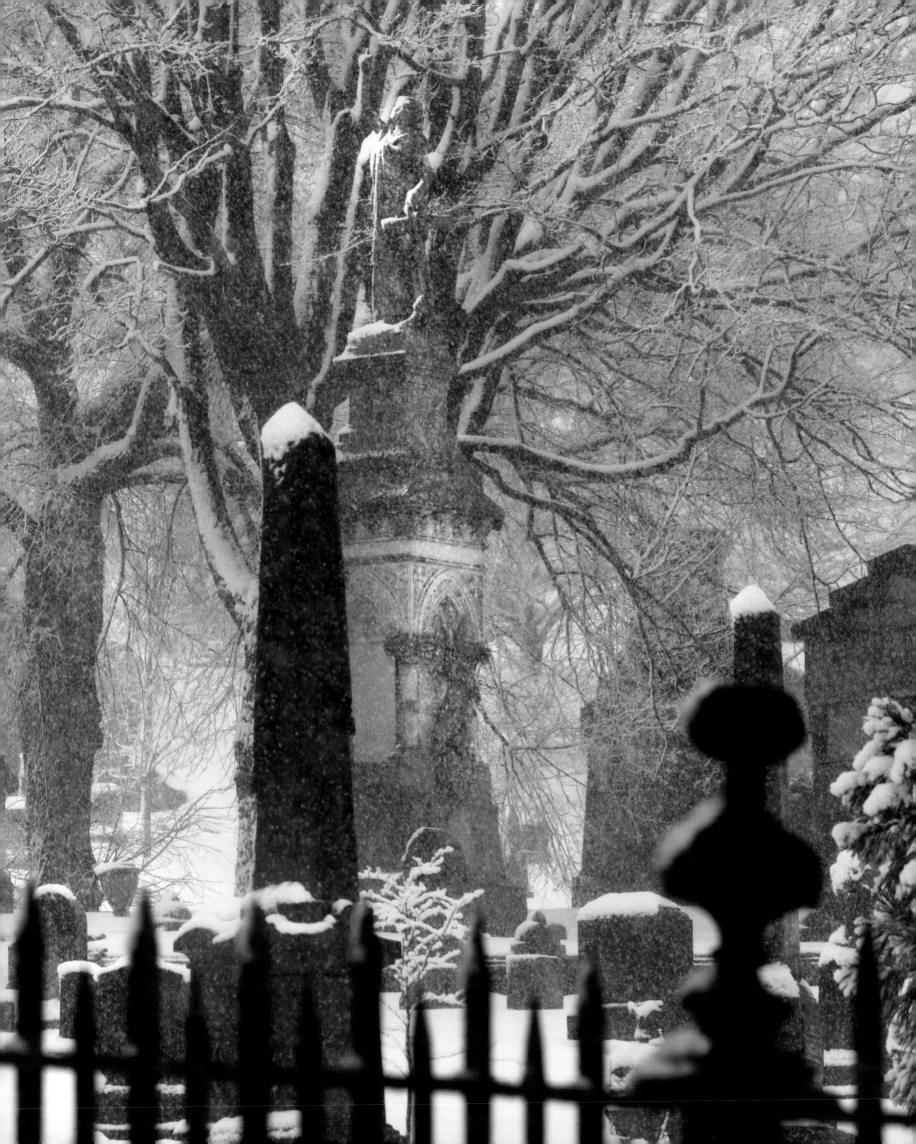

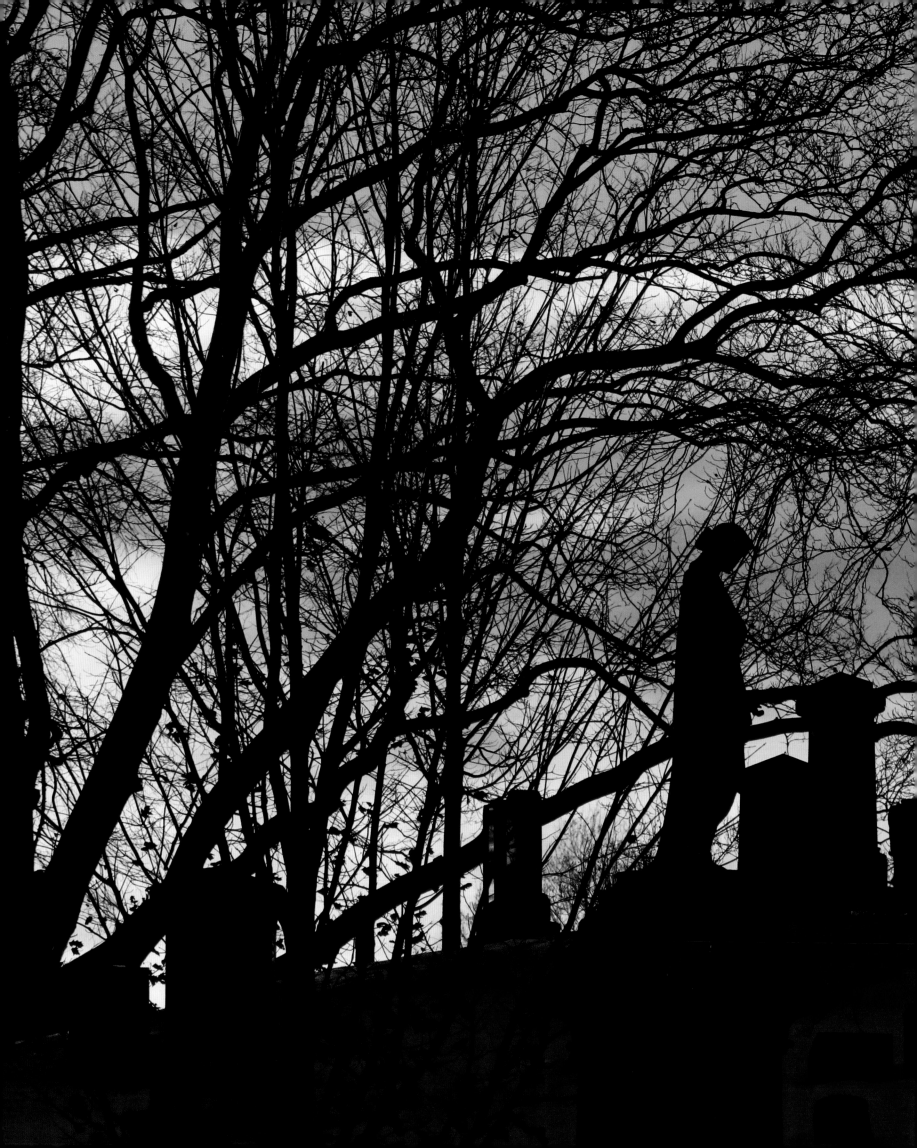

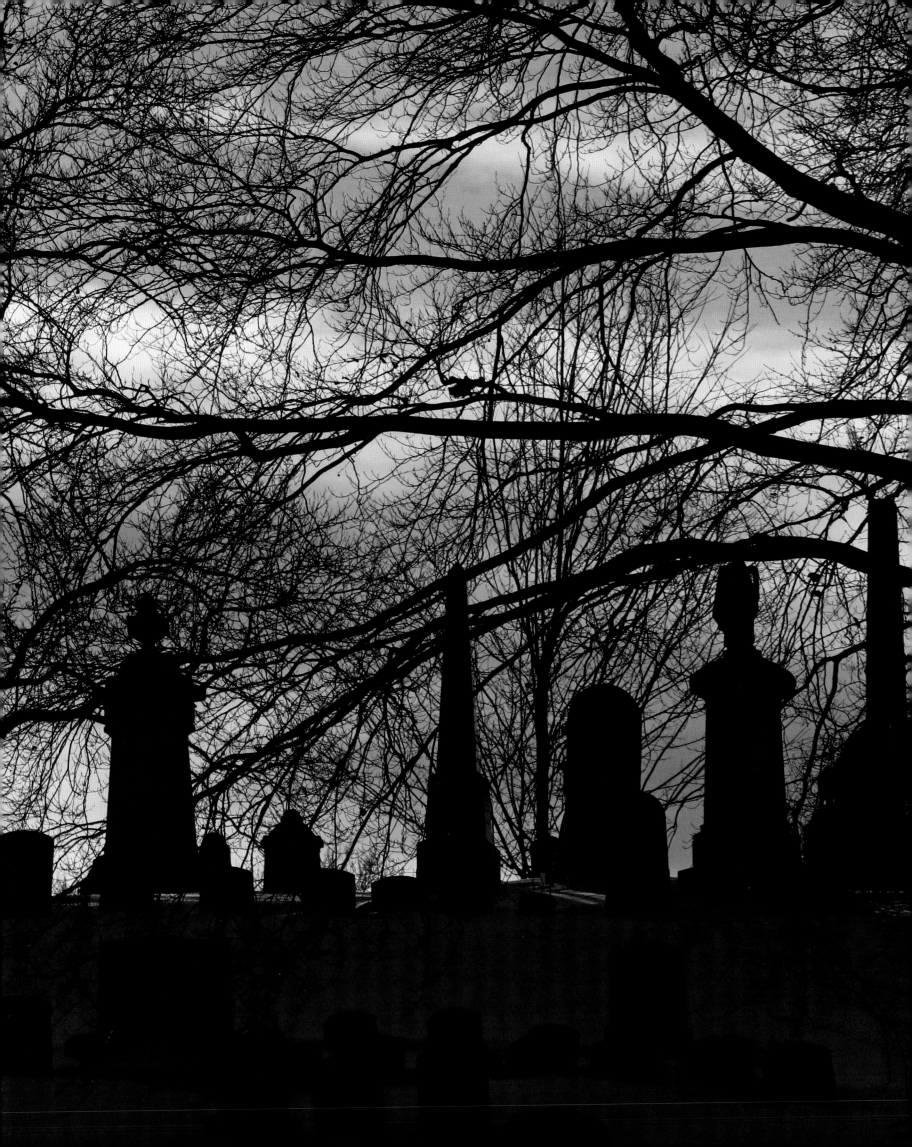

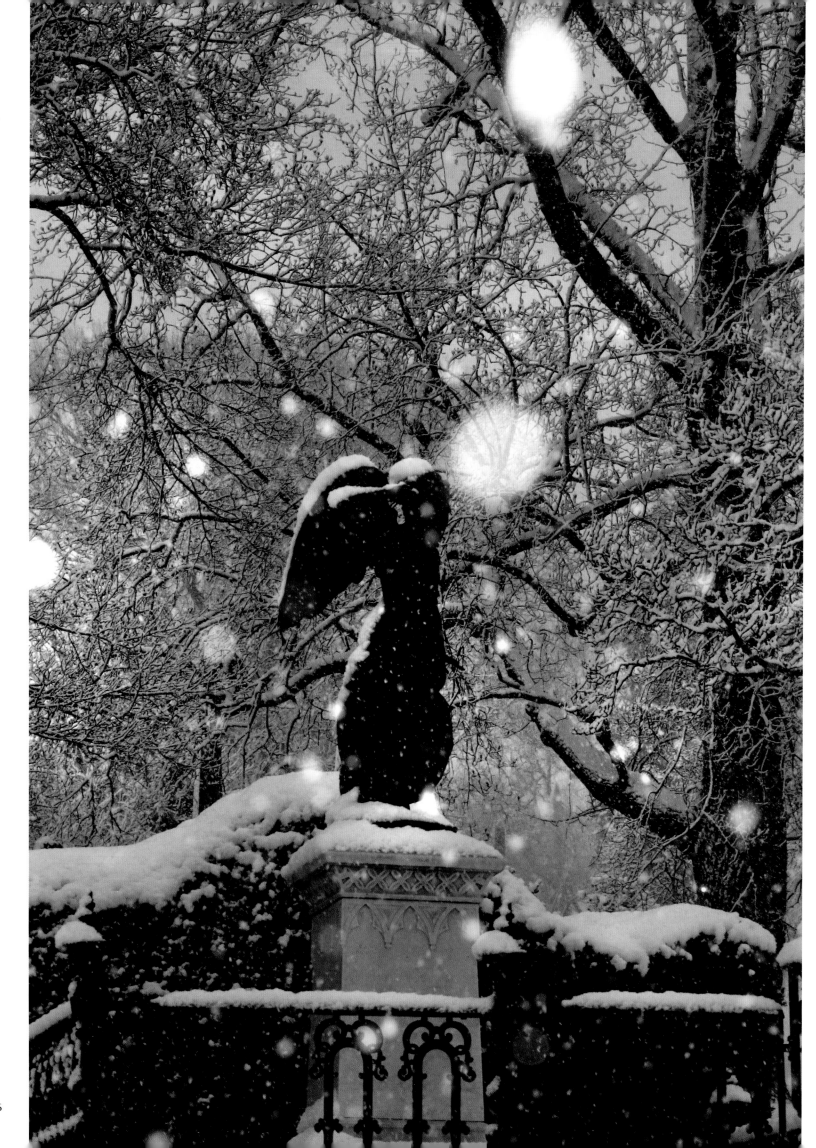

When Snow Shrouds the Tombs and Mutes the City Noise

Allison C. Meier

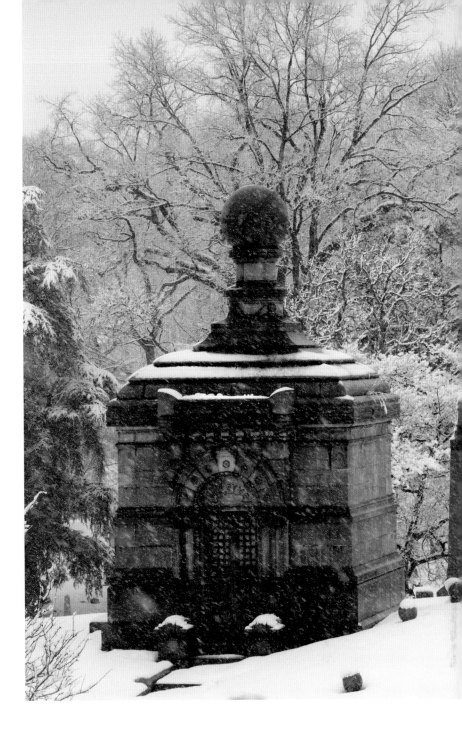

As the days shorten and the air gets crisper, leaves fall from the trees and the grass turns tawny colors. Birds migrate south while others stay to weather the cold, from the woodpeckers that tap against the bare trees to The Green-Wood Cemetery's colony of green monk parakeets that live year-round in their elaborate nests in the spires of the Gothic Arch at the Main Entrance. Flocks of geese walk over the Cemetery's frozen glacial ponds while evergreen trees, including the Douglas fir and eastern white pine, stand out against the muted landscape. By winter solstice in December, the shadows of the obelisks and mausoleums are stretching languidly across the ground, which may have already been covered by the first snow, an event that always turns Green-Wood into a place of transformative solitude.

While elsewhere in the city the luster of the snow can be brief before it melts or turns to gray slush under the traffic of cars and people, in the Cemetery it is preserved longer. With fewer visitors on these colder days, the paths remain untrodden and tombstones stay shrouded beneath untouched blankets of snow. The marble statuary blends into the powdery landscape while granite monuments become stark silhouettes in an expanse of white.

Green-Wood has long been a place of pause in winter. The old receiving tomb near the Historic Chapel recalls when bodies were held there temporarily while awaiting the snow-blocked roads to be cleared or the earth to thaw so they could be interred in their final resting places. The weather transforms the Cemetery's monuments, whether by dustings of snowflakes on bronze angels or icicles that hang from the mouths of gargoyles on the decadently decorated monument of John Matthews, New York's nineteenth-century "Soda Fountain King." The early setting of the sun casts a late-afternoon twilight over the hills, while the trees stripped of foliage offer a clearer view to the Manhattan skyline and the New York Harbor than, any other time of year.

Winter is often used as a metaphor for death, yet visiting the Cemetery during this season is a reminder that it is not always a time of things ending, but often a time of hibernation. Although the landscape is mostly dormant and the daylight is fleeting, spring will come again with its first crocuses and subsequent bursts of blooms. As Percy Bysshe Shelley wrote, in taking hope in the cycle of the seasons: "If Winter comes, can Spring be far behind?" Much of the symbolism on Green-Wood's memorials, such as the carvings of lily flowers, draws on the signs of spring to represent a belief in another life, beyond the grave.

Rather than look ahead and dream of warmer days, though, appreciate the peace of a cold winter's day. Walk among the monuments, where the decades have weathered the names and dates carved in stone, and notice the ephemeral clouds of your breath. Like the snow that transforms the city with temporary tranquility, these moments are fleeting, and recognizing their beauty makes that inevitable dawn of spring all the more meaningful.

Opposite: The Angel of Music (2012) monument honoring Louis Moreau Gottschalk (1829–1869), a famous musician and composer in the nineteenth century with fans in Europe and South America. During a performance of his piece "She Is Dead" in 1869 in Rio de Janeiro, with 600 musicians, Gottschalk suddenly fell ill and died a month later. New York residents turned out by the thousands, and his family brought his remains to Green-Wood, where he is interred in a lot with a fence decorated with lyres. The original marble angel statue was vandalized in 1959, and in 2009 the Green-Wood Historic Fund sponsored a competition for its replacement, unveiled in 2012.
Above: The Syms mausoleum stands alone on a snowy hillside.

Following two spreads:
238: Richard Upjohn's elegant Arch looks majestic in a heavy February snowstorm.
239: The Soldiers' Monument in snow.

240: Charles Feltman's angel topped mausoleum in the flats area in winter. Feltman became very prosperous with his sausage-on-a-bun revelation, called the hot dog. He eventually owned nine restaurants, a roller coaster, a carousel, a ballroom, an outdoor movie theater, and a hotel. His grand mausoleum is a testament to his success.
241: View from McDonald Avenue.

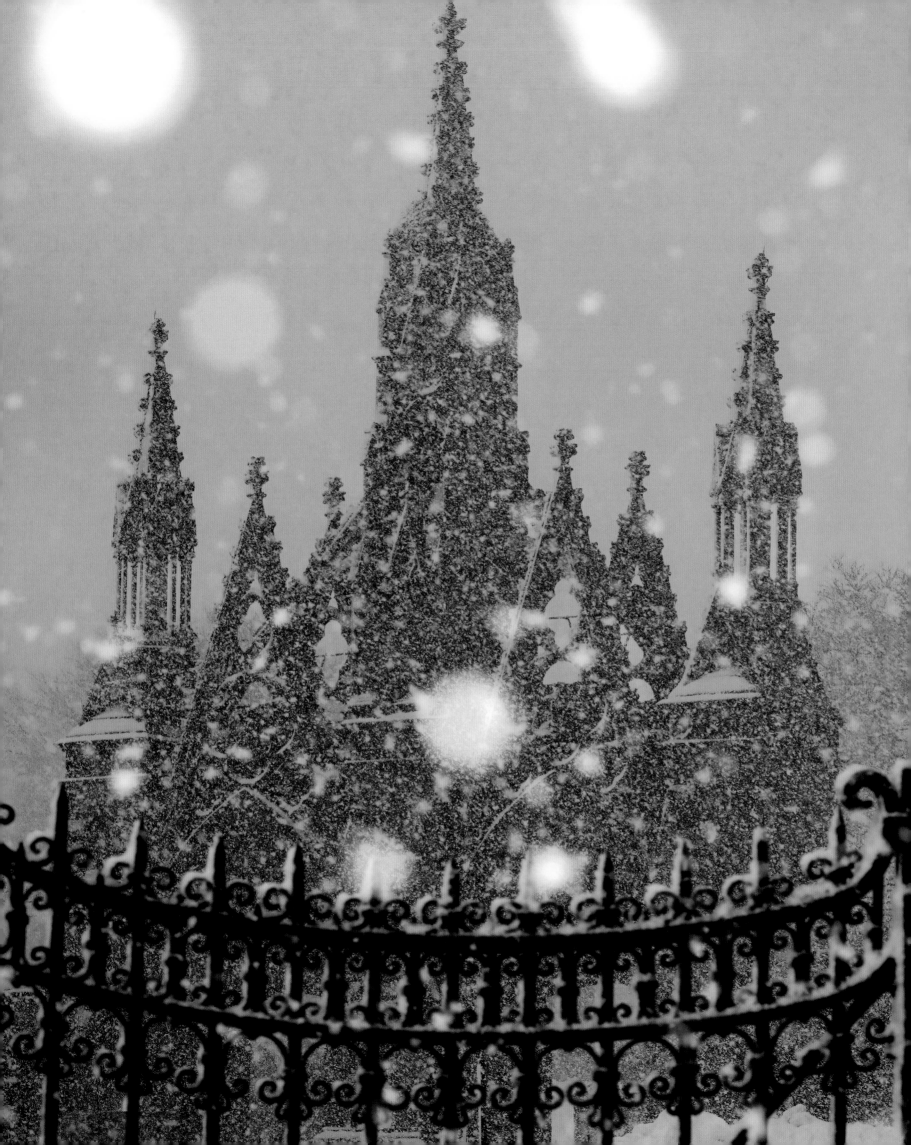

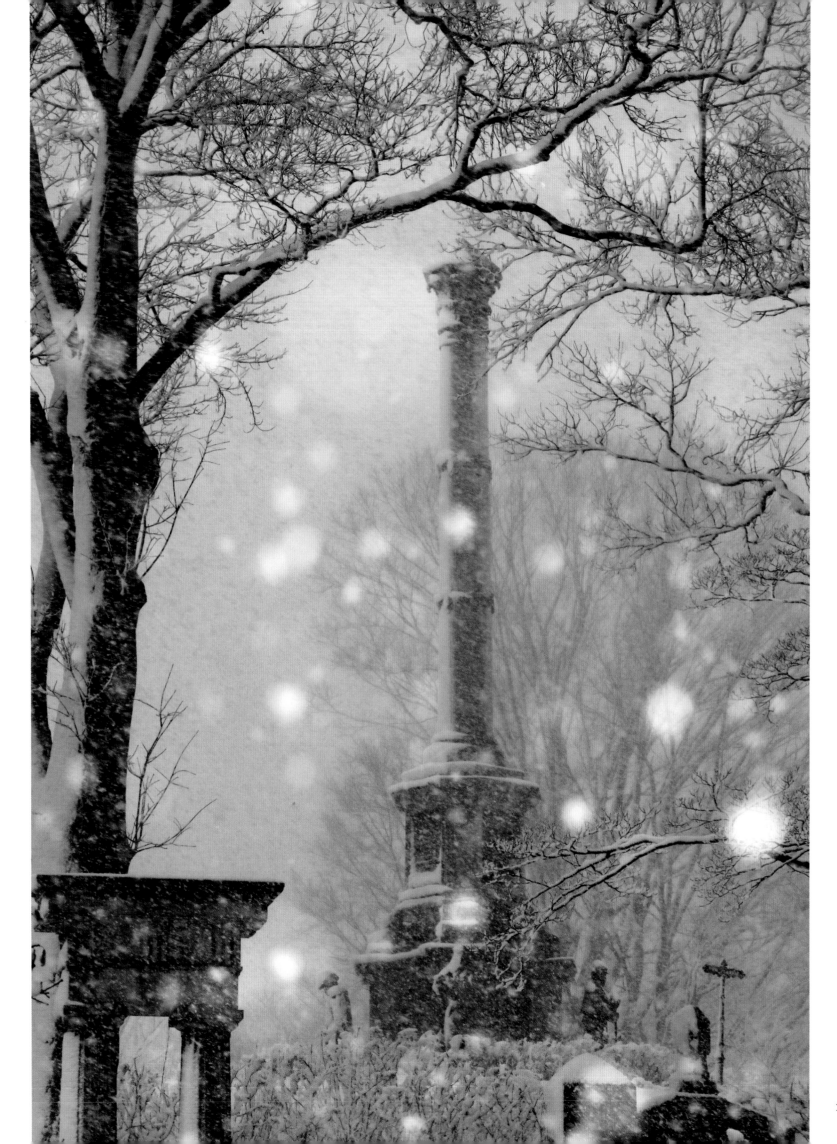

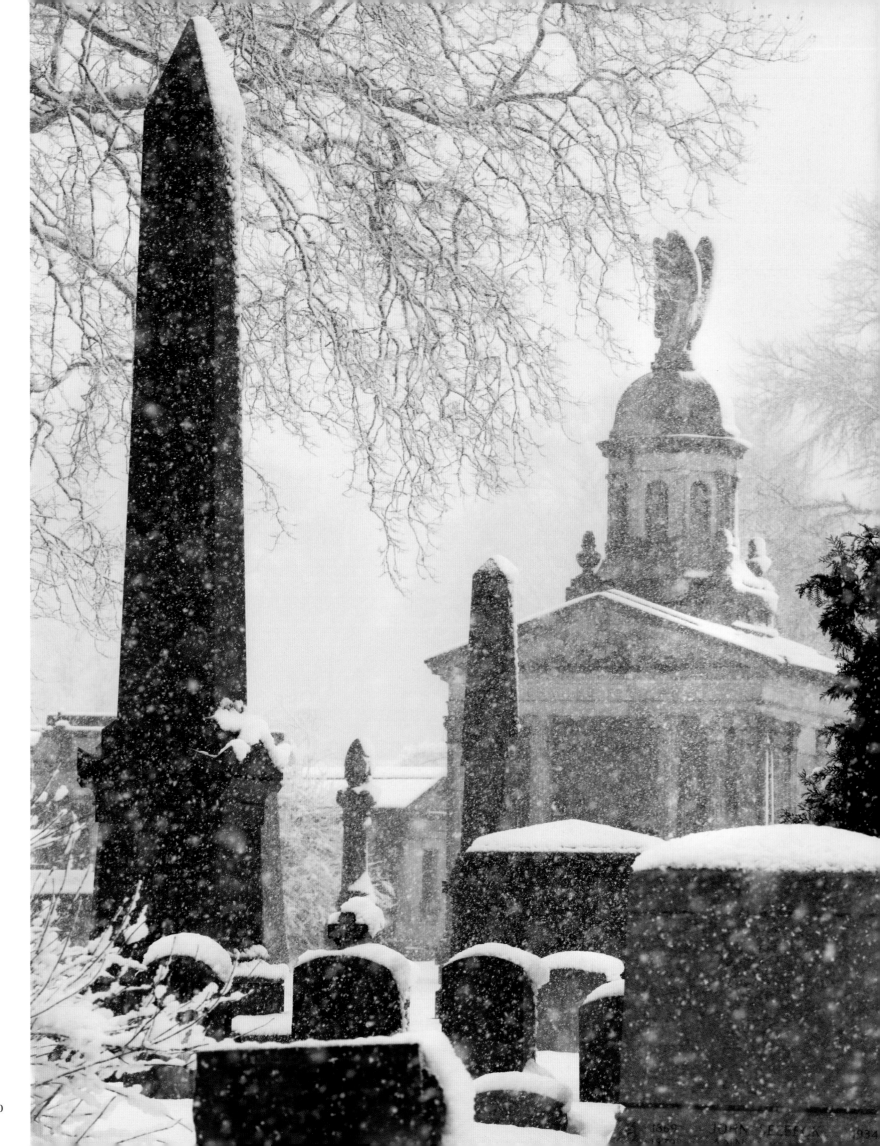

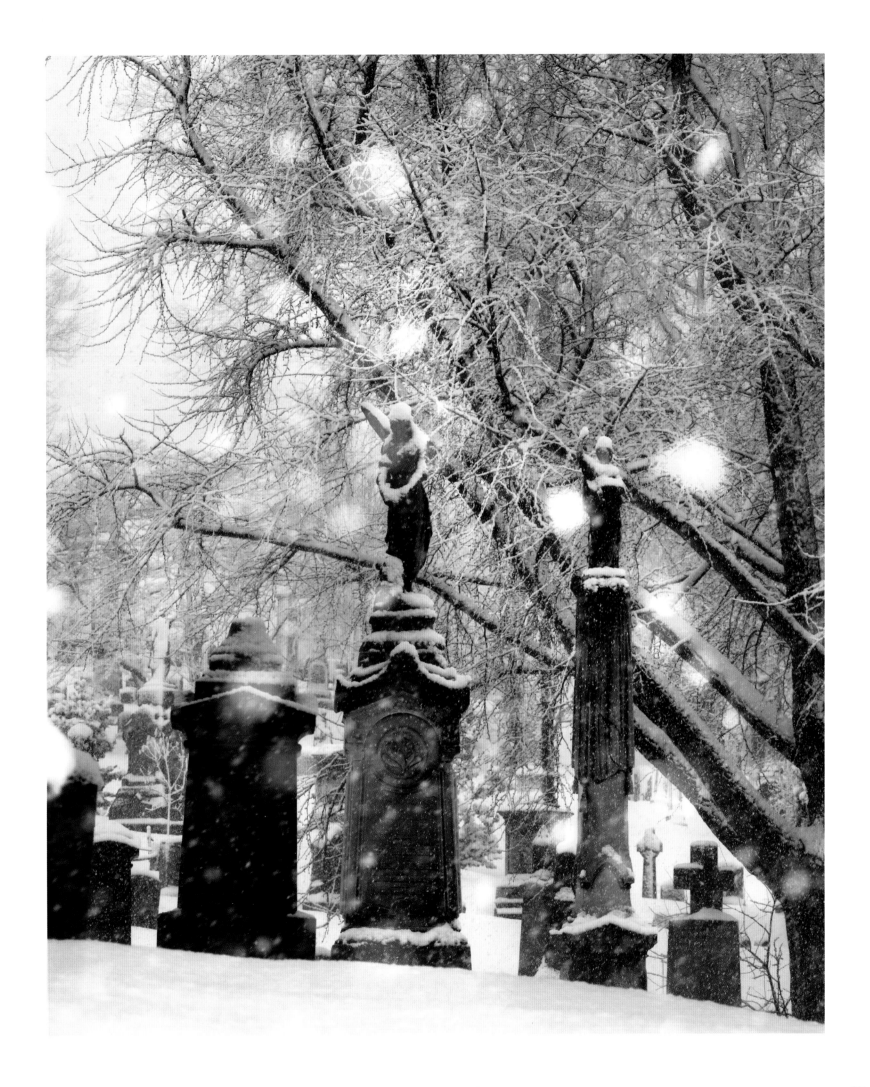

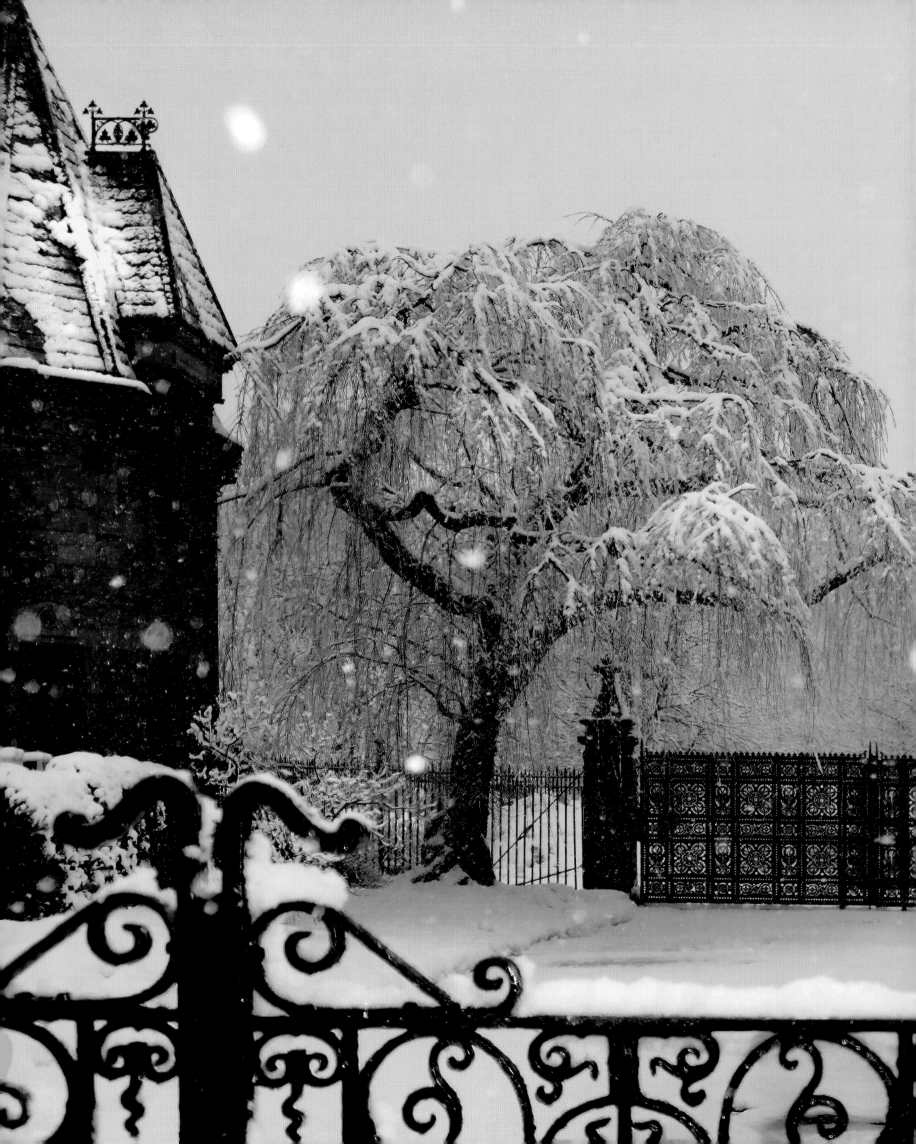

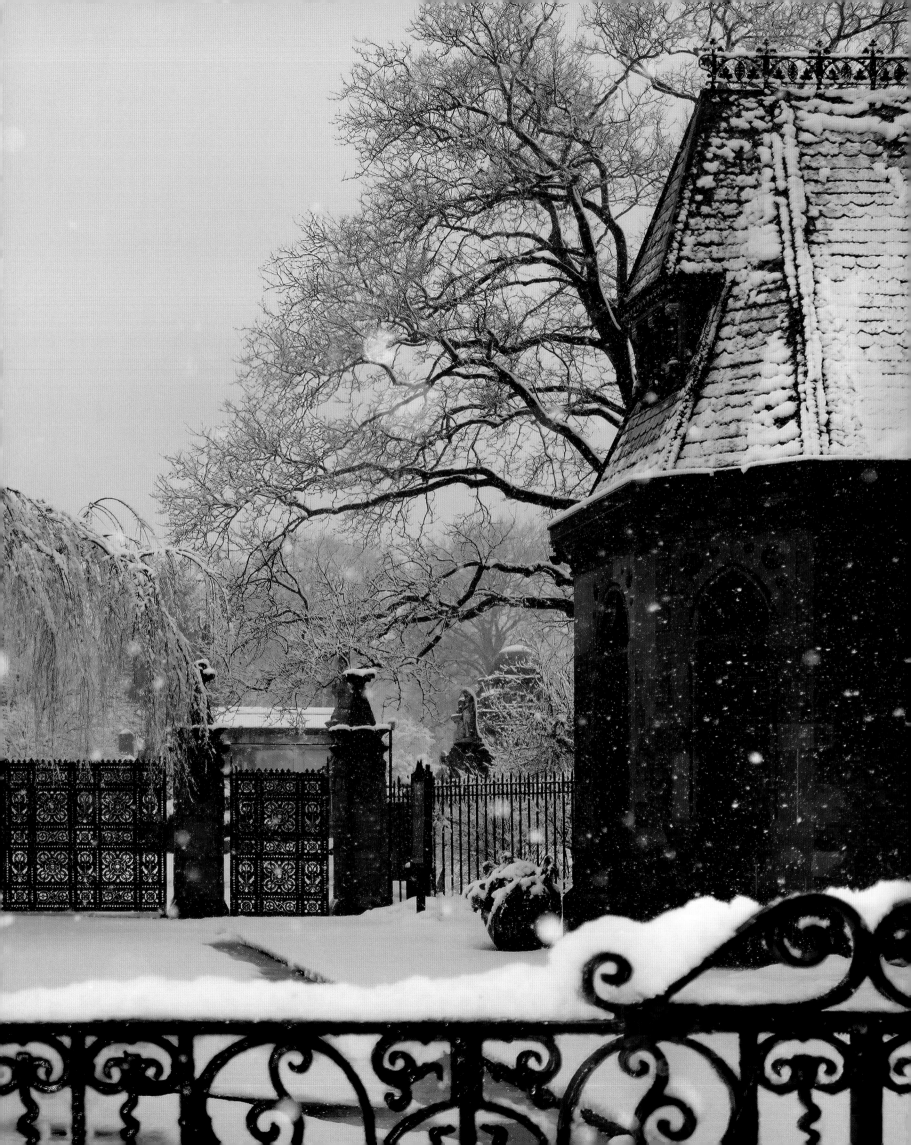

Restoration and Preservation at Green-Wood

Neela K. Wickremesinghe

As The Green-Wood Cemetery's Director of Restoration and Preservation, it is my job to document, maintain, and conserve the monuments associated with the over 570,000 permanent residents within the Cemetery gates—preserving them for visitors to enjoy for decades to come. Each year, my staff and I complete hundreds of monument repairs and restorations, including several large-scale mausoleum restorations. Our work plan responds both to immediate needs—such as addressing damage caused by ever more frequent large-scale storms and weather events—and preventative maintenance to address long-term deterioration. The predominant materials found within our monuments are marble, granite, brownstone, and bronze. Different materials were used to highlight a range of artistic styles and expressions, and each has its own unique set of restoration needs and challenges.

Adherence to professional conservation ethics, standards, and best practices is paramount when prescribing and carrying out repair treatments on historic monuments and in historic landscapes such as Green-Wood. Many of the best practices and professional standards revolve around three main ideas—documentation, reversibility, and dedication to craft. Making sure to document the existing condition of an art object or monument is an absolute must; future conservators need to know what treatments were done in the past to make educated decisions about future interventions. Documentation is also key to tracking deteriorating conditions over time. Reversibility is necessary to ensure that whenever possible conservation interventions can be undone if they are unsuccessful or if the materials used for the repair have been replaced by those with better outcomes over time. Craft within the world of conservation science describes a dedication to well-executed, neat, and artistic repairs that are beautifully done and do not distract or take away from the original intent of the artist or designer. A successful restoration blends into the work of art without drawing attention to itself.

Throughout my time at Green-Wood I have had the privilege of working on some of the finest examples of funerary art in the world. Their existence will continue to draw crowds to this place as long as our gates are open. However, to me, the most rewarding repairs seem to be the simplest—resetting a small stone to a person long forgotten. To complete the repair no special equipment is required. I often can lift these small stones by myself. What is required is that I take the time to stand and really look at the stone in front of me—check all the sides and make sure it is as stable as it was when it was first installed, with family watching, gathered together to remember someone special. These small interventions—repeated hundreds of times a year—make a significant visual impact on this landscape while also reminding us that each monument here represents a person and history worthy of preserving.

Previous spread:
The Fort Hamilton Parkway Entrance, flanked by the brownstone gatehouse (right) and residence (left) designed by Richard Mitchell Upjohn.

Opposite: Interior of the Anderson mausoleum.

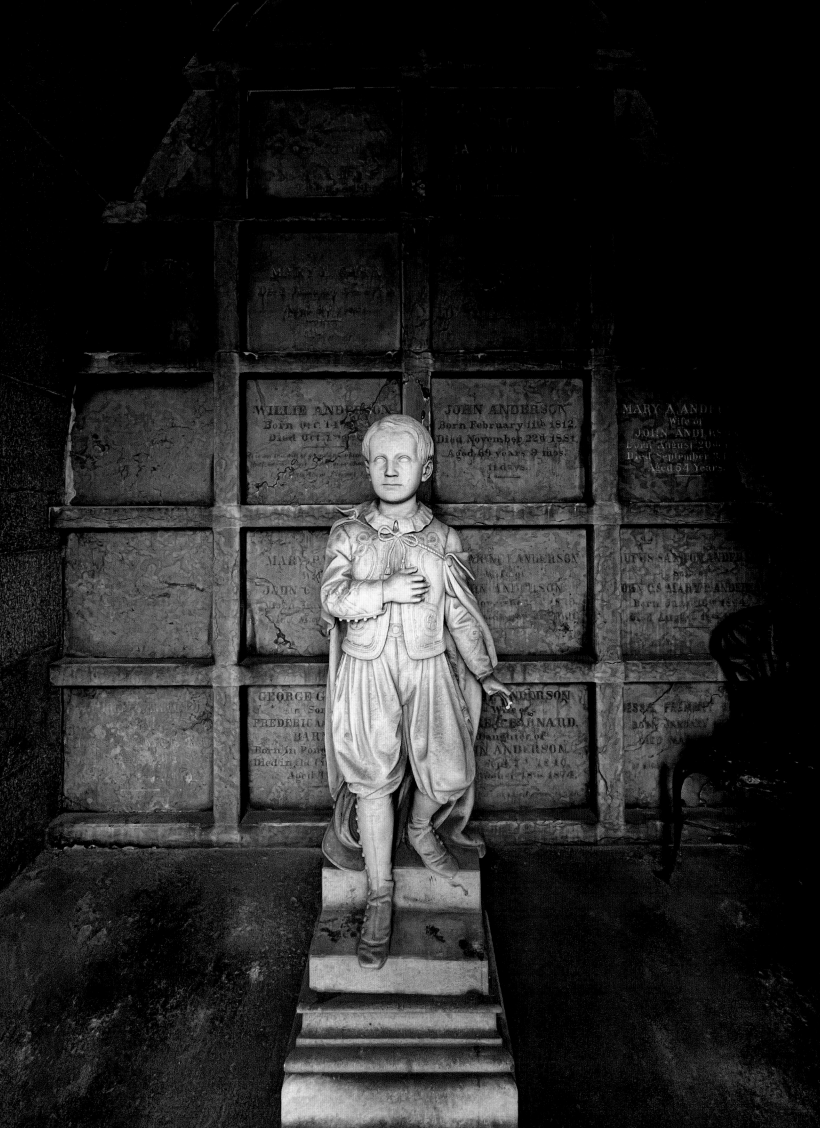

Notable Residents

Jeffrey I. Richman

Jean-Michel Basquiat (1960–1988). Born in Park Slope, Brooklyn, to a Haitian father and a Brooklyn-raised mother of Puerto Rican parentage, Basquiat launched his art career on the streets of Manhattan's Lower East Side in the 1970s. Without any formal training, he began painting in his distinctive Neo-Expressionist style, using motifs and references from many different cultures. By the early 1980s, his graffiti-inspired, Neo-Expressionist art had taken the international art world by storm. His work is exhibited around the world and is regularly sold for record-breaking sums at auction.

Henry Bergh (1813–1888). Through his lifelong dedication to protecting those who could not protect themselves, Bergh founded the American Society for the Prevention of Cruelty to Animals (ASPCA), the first humane society in the Americas, in 1866. Nine years later, he incorporated the New York Society for the Prevention of Cruelty to Children as world's first child protective agency. Both organizations continue Bergh's work today. When Bergh died, he was eulogized by Henry Wadsworth Longfellow as "That man I honor and revere, Who without favor, without fear, In the great city dares to stand The friend to every friendless beast."

Leonard Bernstein (1918–1990). Known to an entire generation simply as "Lenny," Bernstein may well be the most beloved musician in the history of New York City. He served as Music Director of the New York Philharmonic from 1958 to 1969 and composed the music for the Broadway musicals, *West Side Story*, *On the Town, Candide,* and more. His Young People's Concerts were a sensation that offered a generation a better understanding of music. Further, he was an avid champion of civil rights, nuclear disarmament, HIV/AIDS research, and an end to the war in Vietnam. In 1989, after the fall of the Berlin Wall, Bernstein led an orchestral celebration, highlighted by Beethoven's "Ode to Joy."

Pete Hamill (1935–2020). As the consummate Brooklynite, Hamill's skill as a journalist and writer made him one of America's most accomplished newspapermen. He served as editor in chief of two of New York City's leading newspapers, the *New York Daily News* and the *New York Post*. He was also a prolific writer (he authored eleven novels) and a dedicated teacher. Considering the perfect spot for his own interment at Green-Wood, Hamill searched for the most interesting neighbor he could find for his own eternal rest. He knew it as soon as he saw it: next to Boss Tweed, the infamously corrupt political boss of nineteenth-century New York.

Barry Commoner (1917–2012). Born in Brooklyn to Russian Jewish immigrants, Commoner trained as a cellular biologist. But it was for his political activism, particularly for his championing of ecology, that he is most widely and fondly remembered. In his pioneering and best-selling book, *The Closing Circle*, Commoner confronted the causes of our impending environmental crisis head on. In 1970, he was described by *Time* magazine as "the Paul Revere of ecology."

DeWitt Clinton (1769–1828). As New York City mayor, senator, and governor of New York State, and the driving force behind the Erie Canal, Clinton was one of the most revered men of early nineteenth-century America. After his failed run for presidency in 1812, he advocated for state and federal funding for a great canal. Initially scorned by many as "Clinton's Ditch," the Erie Canal successfully transformed New York City into the world's financial capital. Clinton died ten years before The Green-Wood Cemetery was founded, but it was his reinterment there that successfully raised the profile and popularity of the young cemetery.

Peter Cooper (1791–1883). Cooper is considered one of the greatest philanthropists of his time. In 1829, he invented the first viable steam engine for America's emerging railroad industry. He was also a successful industrialist and businessman, increasing his wealth further from iron mills and real estate investments. But perhaps his greatest contribution was in public education. In 1859, he founded The Cooper Union

for the Advancement of Science and Art, to provide a free and open education in art, architecture, and engineering to the working classes.

Chuck Close (1940–2021). As an artist who was internationally known for his large-scale photorealistic portraits, Close managed to overcome dyslexia, prosopagnosia (face blindness), nephritis, and paralysis, to create groundbreaking art, including paintings, tapestries, and prints.

Elizabeth Gloucester (1817–1883). A self-made real estate tycoon, upon her death, she was described in the *Brooklyn Eagle* as the wealthiest woman of color in America. Gloucester started her commercial activities selling used clothing and furniture, then expanded into New York City real estate to tremendous success. She gave back to her community, helping to fund John Brown's famous raid on Harper's Ferry as well as the Siloam Presbyterian Church in Brooklyn (where her husband was minister), and the Colored Orphan Asylum in Manhattan. She was a friend of Frederick Douglass.

Horace Greeley (1811–1872). As the founder and long-time editor of the *New York Tribune*, a newspaper with national influence, Greeley argued for feminism, socialism, agrarianism, temperance, and other causes. In 1872, he ran against incumbent President U.S. Grant as the candidate of the Liberal Republican Parties but lost in a landslide. Less than a month later, Greeley suffered a breakdown and was dead within weeks. *Harper's Weekly* wrote that "since the assassination of Mr. Lincoln, the death of no American has been so sincerely deplored as that of Horace Greeley." President Grant attended Greeley's funeral at Green-Wood.

Fred Ebb (1928–2004). A musical lyricist, Ebb is best remembered for his collaborations with composer John Kander. Together they wrote the music for myriad Broadway shows, including *Cabaret* and *Chicago*. Kander and Ebb are best remembered for their song "New York, New York," which has become a kind of anthem for New York City.

Violet Oakley (1874–1961). Oakley, who began her professional career as a magazine illustrator, was a member of The Red Rose Girls—a group of female artists who lived together in Pennsylvania. She was the first female artist in America to win a public commission for a mural; her spectacular work still adorns the Pennsylvania state capitol in Harrisburg. Her studio was added to the National Register of Historic Places in 1977.

Susan Smith McKinney-Steward (1846–1918). Born in Weeksville, Brooklyn, Dr. McKinney-Steward is known for being the first woman in New York State to graduate from medical school and only the third in America. In 1870, she was the valedictorian of her class at the New York Medical College for Women. Specializing in prenatal care and childhood, she kept offices in Brooklyn and Manhattan. She was also a founder of the Brooklyn Women's Homeopathic Hospital and Dispensary (1881) and the Women's Loyal Union, which fought to protect the rights of Black women. W.E.B. DuBois delivered the eulogy at her funeral.

Eunice Newton Foote (1819–1888). Trained as a scientist, Foote was the first to hypothesize that increased levels of carbon dioxide in the air would result in global climate change. She was also a leader of the Seneca Falls Convention of 1848, the first gathering devoted exclusively to the rights of women. She and her husband were signatories to the resulting Declaration of Sentiments, drafted by Elizabeth Cady Stanton, which demanded equal rights for women, including the right to vote.

Samuel Finley Breese Morse (1791–1872). A well-known portrait painter, in 1826 Morse became the founding president of the National Academy of Design and pioneered photography in the United States. He is best known for inventing the first practical means of moving a message faster than a person could carry it. His

single-wire telegraph and the eponymous Morse code changed the world, making rapid communication across continents and oceans possible.

James Weldon Johnson (1871–1938). A civil rights activist and poet, Johnson is perhaps best known as the lyricist of the song "Lift Every Voice and Sing" (1900), often referred to as the Black National Anthem. Born in Florida, Johnson studied law and was the first Black attorney to be admitted to the Florida bar. In 1900, Johnson's penned "Lift Every Voice" as a poem and, after moving to New York City in 1901, collaborated with his brother, J. Rosamond Johnson, to set the words to music. He went on to become a leader of the National Association for the Advancement of Colored People (NAACP) and a key figure in the Harlem Renaissance.

Samuel Cornish (1795–1858). Cornish was the founding minister of the first Black Presbyterian Church in New York City. In 1827, he co-founded *Freedom's Journal*, the first Black-owned and operated newspaper in America. Cornish was also one of the founders of the interracial American Anti-Slavery Society in 1833.

Mary Dreier (1875–1963) and **Frances Kellor** (1873–1952). From 1905 until Kellor's death in 1952, Dreier and Kellor lived together as partners and advocates of social justice. Among myriad civic causes, Dreier served as the president of the New York Women's Trade Union League and served as chair of New York City's Woman Suffrage Party. Frances Kellor was an 1897 graduate of Cornell Law School and championed the "Americanization" of immigrant workers to decrease exploitation and mistreatment. Kellor is interred in the Dreier family lot, along with Mary.

Louis Comfort Tiffany (1848–1933). Tiffany, an artist and designer who worked in decorative arts, creating mosaics, blown glass, ceramics, jewelry, enamel, and metalwork, is best known for his work in stained glass. He was the first design director of Tiffany & Company, founded by his father, Charles Tiffany (who is also interred at Green-Wood). Along with his rival, John La Farge (another Green-Wood resident), he pioneered American stained glass for churches and homes, beginning in the 1870s. Tiffany supervised the creation of Tiffany lamps, made with glass fragments from his stained-glass windows, by his talented staff, many of whom were women.

Selma Al-Radi (1939–2010). Born in Baghdad, Iraq, Al-Radi grew up in Iran and India, where her father served as Iraqi ambassador. After earning degrees in at Cambridge, Columbia, and the University of Amsterdam, she returned to Iran to work as an archeologist. In 1983, she began a twenty-year effort to restore the massive Amiriya Madrasa in Yemen (erected in 1504), using local craftsmen and experimenting to reclaim lost techniques. *The New York Times* noted, "That the Amiriya today stands resplendent after five centuries of neglect is due almost entirely to the efforts of one woman, the Iraqi-born archaeologist Selma Al-Radi."

William Magear "Boss" Tweed (1823–1878). Tweed was a notoriously corrupt New York City politician. It has been estimated that Boss Tweed and his cronies stole $200 million (roughly valued at $4.7 billion today) from the citizens of New York. His "Tweed Courthouse," still stands on Chambers Street in Manhattan as a monument to civic corruption. Tweed died in the Ludlow Street Jail on Manhattan's Lower East Side, where he was imprisoned for a civil judgment that he was unable to pay.

Abigail Hopper Gibbons (1801–1893). Born a Quaker in Philadelphia, Gibbons was an abolitionist and activist, cited in her obituary as "one of the most remarkable women of the century." She and her husband, James Sloan Gibbons, ran a station of the Underground Railroad out of their home on 29th Street in Manhattan, helping the enslaved to escape to safety in Canada. She volunteered as a nurse during the Civil War, aiding the formerly enslaved with medical and other issues and treating wounded and diseased soldiers. After the war, she founded New York City's Labor and Aid Society to help veterans find work and the New York Diet Kitchen to serve the hungry. She spent her lifetime advocating for prison reform and founded a halfway house for formerly incarcerated people.

Richard Isay (1934–2012). As psychiatrist and psychoanalyst, Isay successfully advocated for his own profession to no longer diagnose homosexuality as a disease. In his book, *Being Homosexual: Gay Men and Their Development*, Isay argued homosexuality is innate. He was also an early public advocate of gay marriage.

Nathaniel Currier (1813–1888) and **James Merritt Ives** (1824–1895). Initially established by Currier in 1835 and expanded with the addition of Ives in 1857, the world-famous printmaking firm of Currier and Ives was the largest printer of lithographs in nineteenth-century America. Calling themselves the "the Grand Central Depot for Cheap and Popular Prints," they produced affordable prints (by some counts 7,500 different prints) that hung in homes across America. Subjects ranged from domestic bliss to stunning landscapes to historical events.

Henry Ward Beecher (1813–1887). Beecher was an abolitionist, preacher, and once "the most famous man in America," according to Pulitzer Prize-winning author Debby Applegate. Shortly after Beecher became the pastor of Plymouth Church in Brooklyn Heights in 1847, his "Gospel of Love" sermons captivated the country. But his reputation as "The Great Divine" was left in tatters when the news of his affair with a congregant, Elizabeth Tilton, broke. The trial captivated the nation.

Charles Ebbets (1859–1925). In 1883, Charles Ebbets worked as a bookkeeper, clerk, and scorecard-hawker for the Brooklyn baseball club. Over the years, he rose to become the owner of the Brooklyn Dodgers baseball team. In 1913, his beloved Ebbets Field opened as the home to the team.

Next spread:
Undulating trees and hard-edged architecture, man and mother nature complement and contrast at Green-Wood.

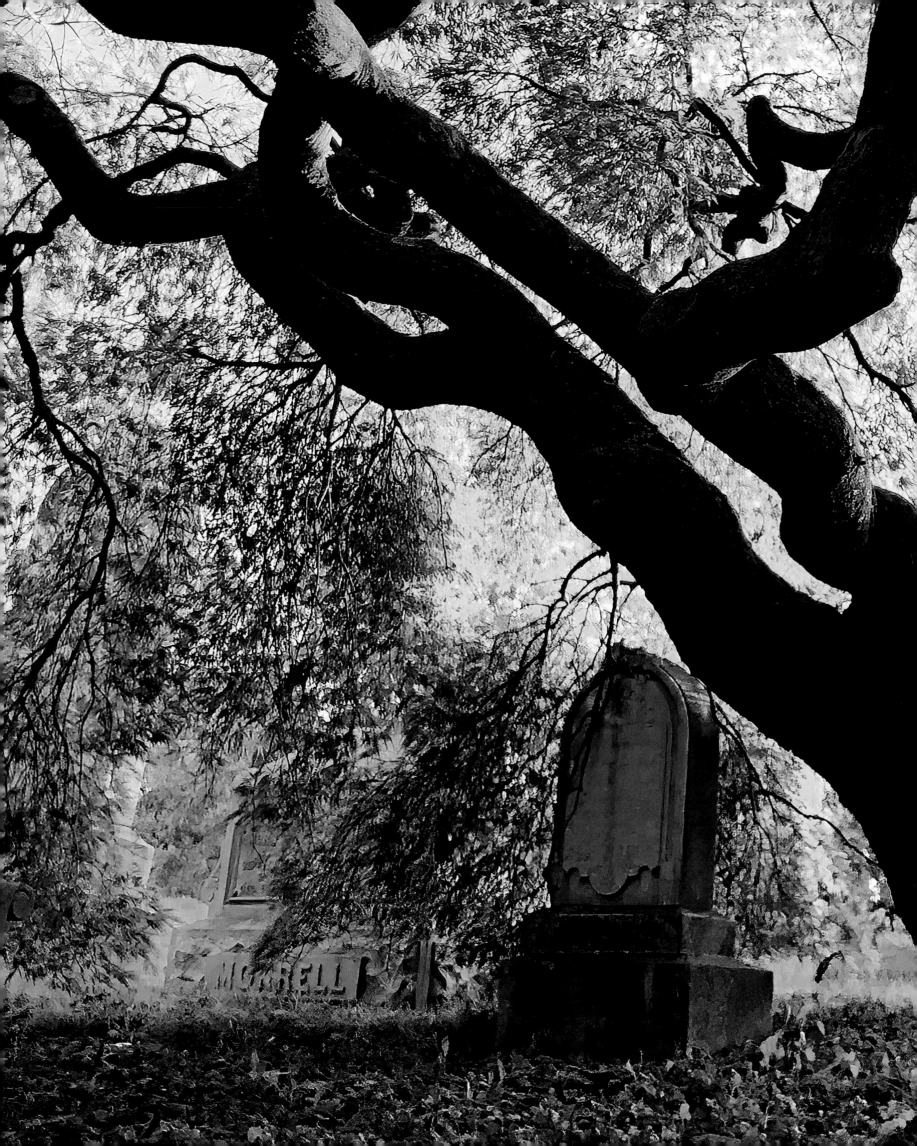

ACKNOWLEDGMENTS

A book idea can come during an aimless wander; in this case it was a pandemic that shut down the world. Green-Wood became a comforting relief for me, as well as for many other New Yorkers. Cultivating a project starts as a conviction and then becomes a plunge into an unfamiliar body of water.

Undertaking a book on Green-Wood was like leaping into a huge ocean, thrilling, but overwhelming. Of course, this publication, or any collection of photos and essays, could never capture the vast universe that is Green-Wood. In spite of over a hundred inspiring visits during all seasons, reading countless pages of history, and looking at multitudes of historic images, I am still a tourist.

I can say I do know which monument a family of skunks lives under, many secret corners, scores of vistas, and I am able to find my way out in the dark during a thunderstorm. But in its entirety—570,000 souls, hundreds of thousands of monuments, thousands of obelisks and angels, 8,000 trees, 800 mausolea, a myriad of birds and flowers—it is impossible to know it all.

That is the allure, there is always something to stumble upon that amazes. I will continue to visit Green-Wood, and I always hope to see something new and surprising. I am so very fortunate to have been able to complete a book project that was simultaneously energizing, awe-inspiring, comforting, spiritual, and calming.

Thanks goes out to many people, including Kaarina Roberts, who helped edit many thousands of photos, to Douglas Curran at Rizzoli who brought it all to fruition, and to Aldo Sampieri for his patience and inspired design. And thank you to all the knowledgeable and generous contributors, including Thomas Campanella, Julie Sloan, Allison C. Meier, Gabriel Willow, and Angela Voulangas.

Last, but not least, a huge amount of gratitude goes to the people of Green-Wood, who seemed to believe in this project from the get-go. Thanks to Lisa Alpert, Richard Moylan, Art Presson, Stacy Locke, Neela Wickremesinghe, Joe Charap, and Sara Durkas.

—Andrew Garn

Pediment detail of the Steinway mausoleum, the largest mausoleum in Green-Wood with room for 200 interments. The crossed downturned torches symbolize life extinguished.

253

CONTRIBUTORS

Andrew Garn, a native New Yorker, is a fine art and editorial photographer whose work has been widely exhibited and has appeared in the pages of numerous magazines including the *New York Times Magazine*, *National Geographic*, *Audubon Magazine*, *New York*, *Fortune*, *Interview*, *Elle Decor*, *French Photo* and many others. He is the recipient of grants from the New York State Council on the Arts, the Graham Foundation, the National Endowment for the Arts, and the J. M. Kaplan Fund. He was awarded a Fulbright scholarship in 2013 for his work documenting Stalin-era industrial plants in Siberia. Garn's previous books for Rizzoli and Universe include *New York Art Deco: Birds, Beasts & Blooms*, *New York by Neighborhood*, *Exit to Tomorrow: History of the Future*, and *The Houseboat Book*.

Richard J. Moylan has served as president of The Green-Wood Cemetery since 1986. His leadership and vision have expanded Green-Wood's role as an operating cemetery to include programming in arts and culture, preservation, nature and the environment, history, and education. Moylan has established the Cemetery as a must-see destination in New York City.

Thomas J. Campanella is Professor of Urban Studies and City Planning at Cornell University, and the author of *Brooklyn: The Once and Future City*.

Art Presson is Vice President of Design and Landscape at Green-Wood.

Julie L. Sloan, an adjunct professor of historic preservation at Columbia University, is a stained-glass consultant and author of Rizzoli's *Lightscreens: The Complete Leaded-Glass Windows of Frank Lloyd Wright* as well as *Conservation of Stained Glass in America*.

Allison C. Meier is a Brooklyn-based writer and cemetery tour guide. She is the author of *Grave* and has bylines on death and culture in the *New York Times*, *CityLab*, *Curbed*, *National Geographic*, *Wellcome Collection*, *Lapham's Quarterly*, and *Smithsonian*. Previously, she was a staff writer at *Hyperallergic* and the senior editor at *Atlas Obscura*.

Angela Voulangas is a creative director and partner at The Graphics Office. She is a native New Yorker, fact fancier, and esoterica aficionado based in Brooklyn.

Gabriel Willow is an urban naturalist and guide of wild places, from cracks in New York City sidewalks to tropical rainforests. He is also a fine artist and spins music as DJ Stylus.

Neela K. Wickremesinghe is The Robert A. and Elizabeth Rohn Jeffe Director of Restoration and Preservation, The Green-Wood Cemetery, and Professional Associate, American Institute for Conservation (AIC).

Jeffrey I. Richman serves as the historian at Green-Wood, where he has worked since 1990, introducing thousands of visitors to the Cemetery and those interred there. Richman has curated exhibitions, authored books, and created dozens of tours and programs at Green-Wood that immerse visitors in its extensive history.

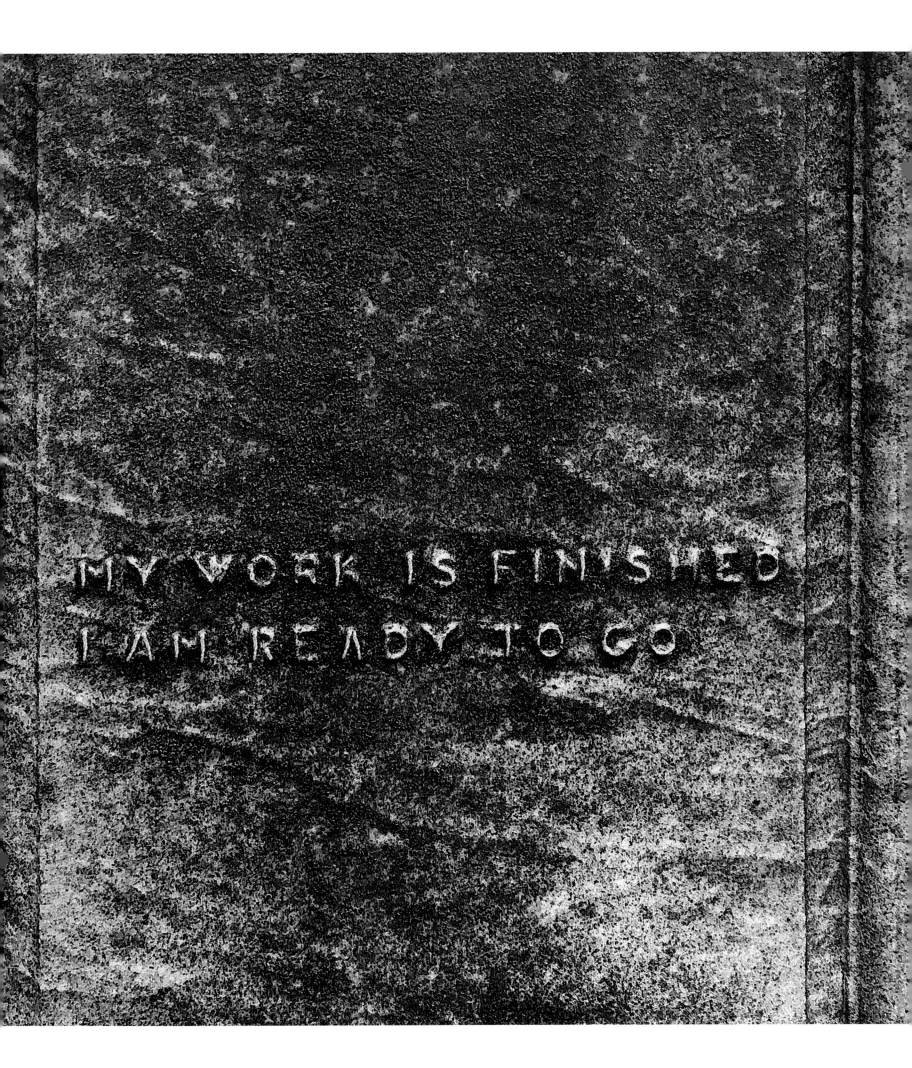

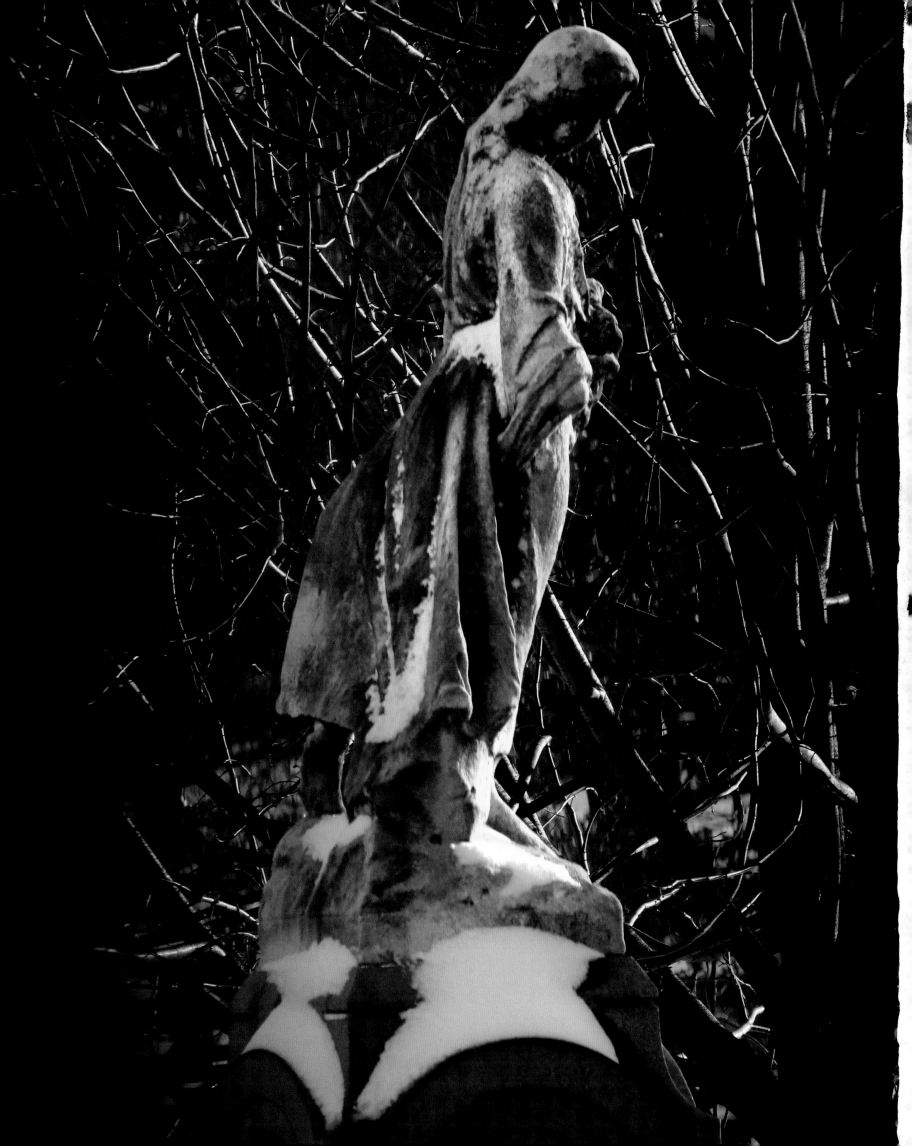

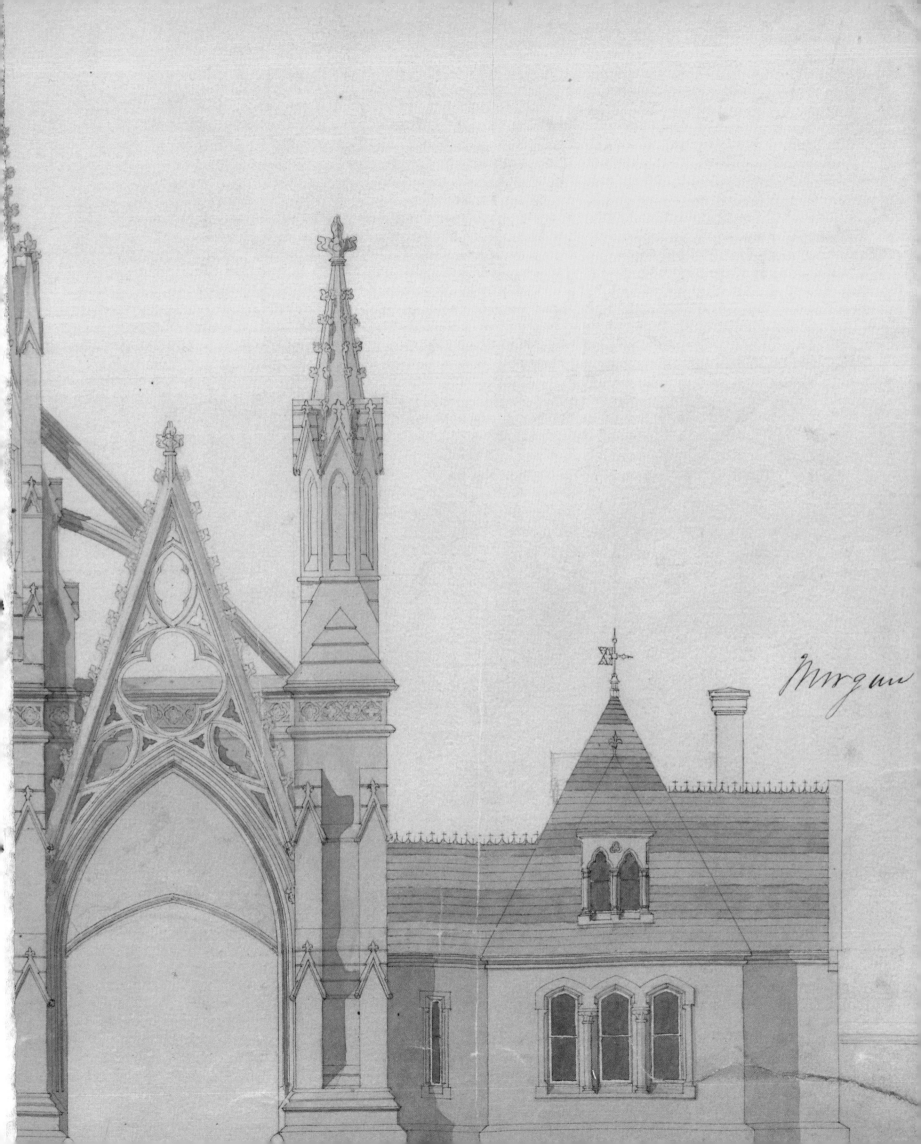

Morgan

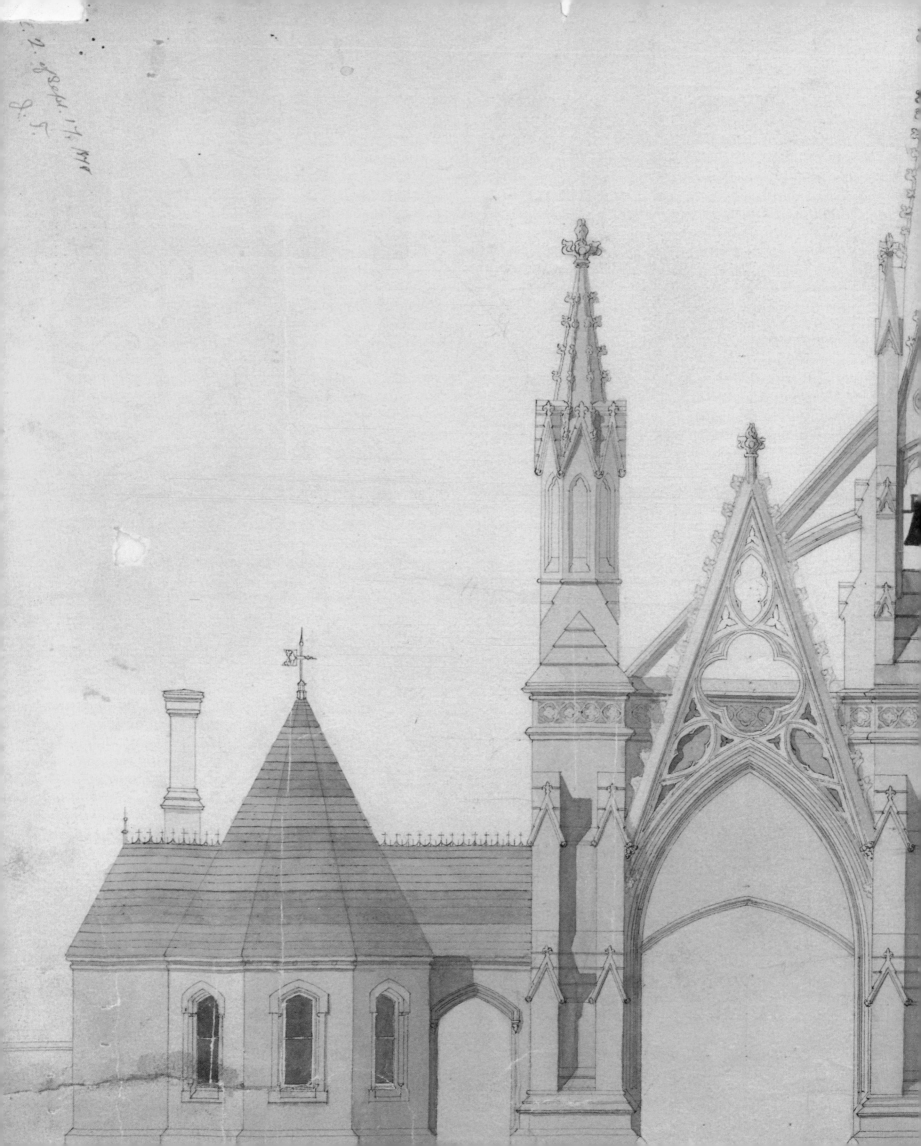